A History of
Collective Creation

A History of Collective Creation

Kathryn Mederos Syssoyeva, Editor,
and Scott Proudfit, Associate Editor

A HISTORY OF COLLECTIVE CREATION
Copyright © Kathryn Mederos Syssoyeva and Scott Proudfit, 2013.

First published in 2013 by PALGRAVE MACMILLAN® in the United States—a division of St. Martin's Press LLC, 175 Fifth Avenue, New York, NY 10010.

Where this book is distributed in the UK, Europe and the rest of the world, this is by Palgrave Macmillan, a division of Macmillan Publishers Limited, registered in England, company number 785998, of Houndmills, Basingstoke, Hampshire RG21 6XS.

Palgrave Macmillan is the global academic imprint of the above companies and has companies and representatives throughout the world.

Palgrave® and Macmillan® are registered trademarks in the United States, the United Kingdom, Europe and other countries.

ISBN: 978-1-137-33129-8

Library of Congress Cataloging-in-Publication Data is available from the Library of Congress.

A catalogue record of the book is available from the British Library.

Design by Scribe Inc.

First edition: July 2013

10 9 8 7 6 5 4 3 2 1

For Catherine Schidlovksy, without whose collaborative gift I might never have discovered collective creation. For Carl Weber, without whose mentorship I might never have discovered history.
—K. M. S.

For Kelly, Jack, and Emily: the best in the west.
—S. P.

Contents

Figures

Introduction

Toward a New History of Collective Creation

Kathryn Mederos Syssoyeva

"The group, not the individual," writes Theodore Shank at the opening of his 1972 article "Collective Creation," "is the typical focus of an alternative society."[1] In the 1960s and 1970s—decades marked in so many Western nations by utopic yearning—the theatre, as elsewhere, became a site of society building, and, in the alternative theatres of North America, Australia, parts of Latin America, and Europe, the group was ascendant. Collective creation—the practice of collaboratively devising works of performance—rose to prominence, not simply as a performance-making method, but as an institutional model. This was the heyday of The Living Theatre, years that saw the nascence of France's Théâtre du Soleil, The Agit Prop Street Players in England, El Teatro Campesino in the fields of Southern California, English Canada's Théâtre Passe-Muraille, and Quebec's Théâtre Euh!—companies associated, variously, with collective performance creation, egalitarian labor distribution, consensual decision making, and sociopolitical revolt.

The prominence of collective creation in the alternative theatres of the sixties and seventies has with time led to a vague sense that collective creation—along with sex, drugs, and youth culture—sprang more or less fully grown from the thigh of '68. This conflation derives from early historicization of collective theatre making, such as we find in Mark S. Weinberg's seminal work, *Challenging the Hierarchy: Collective Theatre in the United States* (1992).[2] For Weinberg, hacking a path through what was still a largely uncharted terrain of theatre history, collective creation and the social and political upheaval of 1960s America were virtually synonymous: "The generation of the sixties led this movement as part of its theatricalization of political life and its use of theatre as a weapon in its political struggles."[3]

But the sixties are hardly the only era in which human beings have entertained utopic longings for a more perfect social union. Nor are they the only time that alternative theatre companies have yearned not merely for more cooperative modes of work but to hold, in their daily practices of work and collegial interaction, to a higher standard of interpersonal relations—to make of the artistic group

a model for a better way of being together in the world, a space in which to enact, with a few likeminded collaborators, a backstage performance of a more civil society or, failing that, a refuge from an oppressive sociopolitical landscape.

The conflation of collective creation with sixties counter culture and New Left politics has resulted in a tendency to read present devising practices (frequently cited as less politically motivated than their predecessors)[4] as a rejection of—or failure in terms of—the theatrical politics of the sixties. An alternative framing simply divorces contemporary devising from its antecedents, giving rise to ruptured histories of practice.[5] Such a temporally and culturally bounded reading negates a rich tradition of collective creation practices of other types, in other countries, in other eras—preceding, running parallel to, and following from their more visible 1960s counterparts.

Historical writing on collective creation is a recent phenomenon. Significant English-language works[6] begin in 1972 with the publication of Theodore Shank's aforementioned article in *The Drama Review*, followed 15 years later by the first book-length study, Alan Filewod's 1987 *Collective Encounters: Documentary Theatre in English Canada*,[7] and half a decade after that by Mark S. Weinberg's *Challenging the Hierarchy*. Weinberg's 1992 study is followed by a gap of 13 years,[8] and then a sudden spate of new works (and, in the United States, a shift in terminology from *collective creation* to *devising*)[9] coinciding with a resurgence of practical interest in collectively generated performance. These include Deirdre Heddon and Jane Milling's *Devising Performance: A Critical History* (2005); Emma Govan, Helen Nicholson, and Katie Normington's *Making a Performance: Devising Histories and Contemporary Practices* (2007); Jane Baldwin, Jean-Marc Larrue, and Christiane Page, eds., *Vies et morts de la création collective / Lives and Deaths of Collective Creation* (2008); Bruce Barton, ed., *Collective Creation, Collaboration and Devising* (2008); and Alex Mermikides and Jackie Smart's *Devising in Process* (2010).[10]

Filewod, Shank, and Weinberg root major developments in collective creation firmly in the cultural and political landscape of the sixties and seventies. On the opening page of his study, Weinberg defines his subject area as "people's theatre": a reaction to the "exploitative nature of current social and economic policy."[11] His definition is thus ideologically rooted; for Weinberg, collective creation is "the creation of a production by a group that shares power and responsibility as fully as possible" and constitutes people's theatre *par excellence*—"the structure that has come to be most representative of the ultimate goals of the people's theatre, and that has produced some of its most exciting work."[12] Weinberg's perception of collective institutional practices derives from this specific historical and ideological lens. He emphasizes, for instance, the "frequent" use of consensus-based decision making: "Decisions are made only when agreement is unanimous, and the strenuous objections of even a single member are sufficient to demand the reevaluation of any decision."[13] Aesthetic questions are similarly read through a specific political filter (a Marxist view mediated through the writings of Terry Eagleton) and accordingly value laden: "Most collectives, in recognition that their productions should not be 'symmetrically complete . . . but like any product should be completed only in the act of being used' . . . include a variety of methods for making pre- and post-performance contact with their audiences,"[14] and again, "In artistic

terms, the process, regardless of the specific methodology of a particular group, is improvisational: ideas are more freely expressed and responses more immediate than in limited communication networks."[15]

More case-specific and less ideologically driven than Weinberg's *Challenging the Hierarchy*, Shank's article (contemporaneous with the work it discusses) is nonetheless rooted in the soil of the sixties, basing its claims about collective practice on collectives practicing between 1965 and 1972—though with an international focus, including companies based in London, Copenhagen, Paris, New York, Stockholm, Rome, San Diego, West Berlin, Holland, and Poland. Filewod's study concerns the role of collective creation and documentary-theatre making in the politics of English Canadian nationalism, anticolonialism, and local, regional, and national identity formation and expression. While Filewod's concerns are in their specifics distinct from those of either Shank or Weinberg, Filewod, too, locates the emergence of collective creation in leftist political rebellions of the 1960s.

Recent work has begun to redress this limited framing of the field. In *Devising Performance*, Heddon and Milling problematize some of the more ideologically bounded—and idealistic—readings of devising history, address processual and historical confusion raised by the recent terminological shift from *collective creation* to *devised theatre*, and, while focusing on developments in collective creation (in England, the United States, and Australia) since 1950, place new emphasis on collective creation's modernist antecedents (though these are viewed largely in terms of influence, rather than as fully formed manifestations of collective creation). Baldwin, Larrue, and Page's *Vies et morts de la création collective / The Lives and Deaths of Collective Creation* is marked by its broadened global scope (cultures represented include Algeria, Bali, France, Mexico, Quebec, Spain, Italy, and the United States) and contains a detailed consideration of one pre–World War II manifestation of collective creation, Jane Baldwin's "From the Côte d'Or to the Golden Hills: The Copiaus Model as Inspiration for the Dell'Arte," which traces a line of influence from early experiments in collective creation among the actors of Jacques Copeau's troupe to the contemporary Dell'Arte company and school in Blue Lake, California.

Despite an evolving scholarship, however, the notion that theatrical collective creation is a product of a particular ideological moment continues to hold sway. Thus, for instance, we still find in circulation the idea that collective creation is of necessity underpinned by an ideal of leaderlessness, as articulated by Alan Filewod:

> It must be pointed out that the concept of collective creation in the modern theatre has an ideological source. This does not mean that collectively created plays are about ideology; it means that we must be aware of the difference between a concept and a convention. Theatre is a collective art, and in one sense all plays are created collectively, just as an automobile is created collectively: the result of a number of talents working jointly to create a single thing. The modern experiment in collective creation differs radically in that it places the *responsibility* for the play on the shoulders of the collective; instead of a governing mind providing an artistic vision which others work to express, the collectively created play is the creation of a supra-individualist mind.[16]

Though Filewod originally made this statement in 1982, his article was repub-lished as recently as 2008 as the opening chapter of Bruce Barton's edited volume *Collective Creation, Collaboration and Devising.* Filewod's ideologically specific framework continues to circulate in the present conversation as much as the broadened paradigm of Heddon and Milling.

The aim of this book is to build upon—and at times, contest—these past studies and further broaden the terrain of research by positing new continuities and con-fluence of practice. We begin in Russia in 1905, with early experiments in collective creation led by Vsevolod Meyerhold, and end in the early 1980s, with an examina-tion of developments in collective creation in Europe, the United States, and Que-bec. Our second volume, *Collective Creation in Contemporary Performance*, picks up where *A History of Collective Creation* leaves off, tracing mid- and late-twentieth-century collective creation and devising practices into the contemporary period and closing with a first-person account of collective creation as applied theatre by Thomas Riccio, a teacher and theatre artist who since 1989 has been conducting performance research and facilitating collective performance making with indige-nous communities in Alaska, South Africa, Zambia, Tanzania, Kenya, Burkina Faso, Korea, China, Russia, and the central-Siberian Republic of Sakha. No attempt is made to arrive at consensus among the authors gathered in these two volumes as to the nature of collective creation. We aim instead to locate the history of collective creation in its particularities—to take a series of discreet objects of study, and from those specific instances to deepen our understanding of what has constituted col-lective creation and devising in a variety of geographic, political, and temporal con-texts since the rise of the modern director. This resistance to consensus as a mode of scholarship reflects the one trend that, in our group discussions, most if not all of the authors represented here agreed on: that in the history of collective creation, it is polyphony, not consensus, that is the norm—and arguably, the beauty—of both form and practice. Alan Filewod has argued that "collective creation derives its uniqueness from the synthesis of several different perspectives and experiences."[17] I would like to suggest that this book derives its value from the montage of several different perspectives and experiences.[18]

These perspectives are as varied as those of the artists studied—and thus pose interesting challenges to past histories. They include—and are by no means limited to—the proposition that a collectively devised mise en scène for an existing dra-matic work might constitute a form of collective creation; that collaboration—if collaboration is presumed to equal discussion, debate, and subsequent accord, acquiescence, or synthesis—is not the sole basis for collective work; that collective creation might accommodate authorial or directorial leadership; that, conversely, commercialization of collective praxis in contemporary devising, and attendant abandonment of radical democratic institutional structures, constitutes a betrayal of the most deeply held principles of a long-standing tradition; that the New Left's aspiration to leaderlessness is but one of many possible political models that have underpinned radical collective theatrical practice; that, historically, instances of collective praxis have served conservative as well as radical impulses; that the very concept of a "collective" might be problematized (and broadened) by contempo-rary philosophical investigations into the concept of an individuated self.

Heddon and Milling define their terrain in part on the basis of an *ex nihilo* mode of creation—that is, "those theatre companies who use 'devising' or 'collaborative creation' to describe a mode of work in which no script, neither written play text nor performance score, exists prior to the work's creation by the company."[19] By contrast, in our study we have chosen to focus above all on companies that have themselves defined their own processes as "collective creation" and to explore how that definition manifests in practice. We find that, as a result of this methodology, in combination with a broadened cultural and historical field, the *ex nihilo* model vanishes quickly from view as the defining factor; so too, do New Left politics—leaving understandings of the term *collective creation* that are very much contextual, defined by the time, place, and group in which the term is used.

The essays collected in this book suggest that, typically, notions of collective creation emerge in response to some prior mode of theatre making felt by a particular theatre artist or group of theatre artists to be aesthetically, interpersonally, and/or politically constraining, oppressive, or, in some manner, unethical. That is, a given understanding and method of collective creation is frequently defined against past experience, and those past experiences are frequently very specific. For Meyerhold, for instance, collective creation as he defined it in 1906 constituted a specific response to the methods of the Art Theatre as he had experienced them between 1898 and 1903. The perceived tyranny that lay at the core of Meyerhold's impulse to engage the group in a more collaborative process was not that of the writer or of the literary work but of a particular model of ensemble, which Meyerhold believed was constraining the idiosyncratic expressivity of the individual performer. The resultant alternative methodology thus focused on the collective generation of mise en scène, rather than the collective generation of a play text. The political yearnings that fueled that particular experiment were likewise specific to their place—Moscow—and their political moment—six months of revolutionary upsurge and its suppression unfolding between early spring and late autumn of 1905. Contested notions of group and leader to which Meyerhold and his collaborators give voice bear the distinctive imprint of that particular cultural tumult—and bear little resemblance to the concerns voiced by, say, members of The Living Theatre.

Taking such examples as the basis for our understanding, we find that the question "Was there a play in the room before everyone got started?" becomes instead "What is it that a particular collective perceives as extrinsic to their creative process—what is it that a particular group chooses to contest, change, or reveal through collective praxis?"

As we trace collective creation back in time, we find not only a proliferation of variegated social and political impulses but also a distinctly extrapolitical impetus. Early-twentieth-century collectives—much like their twenty-first-century counterparts—have been jolted into being as often out of aesthetic impulse as political.

By way of a working definition of collective creation, this seems to leave the following: There is a group. The group wants to make theatre. The group chooses—or, conversely, a leader within the group proposes—to make theatre using a process that places conscious emphasis on the *groupness* of that process,

on some possible collaborative mode between members of the group, which is, typically, viewed as being in some manner *more collaborative* than members of the group have previously experienced. Process is typically of paramount importance; anticipated aesthetic or political outcomes are perceived to derive directly from the proposed mode of interaction. Processual method may well be ideologically driven in so far as—historically, at least—collaborative creation has often constituted a kind of polemic-in-action against prior methodologies that the group has known: an investigation, a reinvigoration, a challenge, an overthrow. The extrinsic and/or oppressive structure, if you will, that the group perceives itself to be challenging through the generation of a new methodology may be aesthetic, institutional, interpersonal, societal, economic, political, ethical, or some admixture thereof.

Victor Turner's theories on the relationship between performativity and social structure offer some useful constructs for formulating a more inclusive articulation of the tendencies of collective creation. In his introduction to Turner's *Anthropology of Performance*, Richard Schechner reminds us that Turner "taught that there was a continuous process linking performative behavior—arts, sports, ritual, play—with social and ethical structure: the way people think about and organize their lives and specific individual and group values."[20] Building on Turner's formulations, we might think of collective creation as straddling the threshold between the performativity of social life and performance as such—positing that collective creation foregrounds the creative action of social and ethical structuring in a dynamic interplay with the creative action of performance making. That theatre should lend itself to such an encounter seems a logical outgrowth of the dialectical play between drama's traditional concern with the social and the intrinsically social nature of making and sharing drama. Viewed in this light, the particular politics of particular collectives become subsumed into a spectrum of possible socioethical impulses and outcomes—collective creation appearing less as a manifestation of any one ideological position than as a genre of performance making that positions itself at the intersection of social and aesthetic action.

Yet even this expanded notion of the ideological may prove insufficiently inclusive. For not all devising groups seek to contest, subvert, or overthrow an extant system—be it political, economic, or artistic. Some employ the tools of collective creation simply to create new theatrical forms or works through new artistic means. Indeed, as we continue forward in time through an evolving understanding of collective methodologies in the twenty-first century, even the notion of newness is subject to debate. As devising companies emerge with increasing frequency from devising workshops, devising programs, devising schools, creating collectively becomes less polemical exploration than a known alternative within an array of possible current practices. The increasingly institutionalized transmission of collective creation processes suggests that what in some spheres (mainstream BFA theatre programs in the United States, for instance) may continue to constitute the new or the countercultural, may in others already constitute a tradition.

The advantage of broadening our understanding of collective creation is that it allows us to better historicize a confluence of relationships and practices, drawing into the historical map companies whose influence on international devising

practice has been considerable and yet—as a result of apparently apolitical or nonegalitarian practices—have been marginalized or even written out of the conversation on collective creation. In particular, this approach permits consideration of influential figures more typically associated with authoritarian auteurism (e.g., Meyerhold and Copeau) as well as others who might better conform to the model of an actor-centered director but who certainly do not fit within the model of 1960s egalitarian institutional structure: Stanislavsky, Michel Saint-Denis, Jerzy Grotowski, Eugenio Barba. Going forward—though this is outside the scope of this particular book—broadening the definition of collective creation produces new tools for better unearthing instances of collectively generated performance in companies that make no public claim to such methods. For just as we may find authoritarianism lurking beneath the surface of an egalitarian rhetoric, we may find ample examples of collaborative devising lurking beneath the surface of directorial dominance.[21]

However, in broadening our definition to include companies whose relationship to an egalitarian ethos falls somewhere along the spectrum between tenuous and nonexistent, are we weakening political history? Speaking for myself—one voice among many within this book, some of whom might strongly disagree with me on this point—I think not. What I feel we are doing is, in a quiet way, politicizing our historical writing by better according creative attribution where attribution is due. Broad recognition of the multiform manifestations of collective creation has far-reaching implications for how we write the history of theatre practices, for how we archive its traces, for how we teach acting, directing, design, playwriting, theatre making.

Our collected research suggests that modern collective creation might usefully be understood as having evolved in three overlapping waves. The first spans the first half of the twentieth century, following rapidly on the heels of the emergence of the modern director and arising from an often contradictory array of impulses: aesthetic, political, and social. These include the search for the total artwork, necessitating new models of collaboration with designers, composers, and writers, and an actor capable of conceiving her work within a complex mise en scène—possessing, in other words, a directorial/choreographic sensibility. They also include the modernist fascination with popular, often physical, theatre traditions—especially mime, vaudeville, and commedia dell' arte, forms generated by a performer-creator. Institutional inspirations were likewise diverse and included models of group interaction at once collective and hierarchical, such as Catholic and Russian Orthodox monasticism and Soviet communism. Political impulses, too, varied, from the antimonarchist turn in prerevolutionary Russia to Bolshevik collectivism less than two decades later; progressive protest in the Depression Era United States; Polish nationalism following the collapse of the Russian Empire and defeat of Austria and Prussia in World War I; competing forces of nationalism and antifascism in interwar France; Communist leanings among the German left of the Weimar period. The second wave, spanning from the mid-1950s into the early 1980s, was marked in its most prominent manifestations by the utopic, communitarian ethos, antiauthoritarianism, and Marxist-inflected politics of the generation of '68 in noncommunist states (e.g., France, America,

Canada, and England). It was informed, too, by aesthetic possibilities arising from developments in avant-garde dance, music, and the visual arts. This is the period of collective creation associated with the striving toward fully participatory artistic democracy and the leaderless ensemble. These first two waves of development are the subject of this book.

The third wave can be said to have begun in the early 1980s and continues into the present; this is the subject of our companion volume, *Collective Creation in Contemporary Performance*. In the main, the third wave appears to be postutopic, dominated by an ethical imperative (over the ideological) and an interest in the generative creativity of the actor. It is impelled above all by the development and ever-widening dissemination of pedagogies of collective creativity and actor-generated performance (emerging in particular from Grotowski's brief tenure in the United States, successive waves of graduates from l'Ecole Jacques Lecoq, and workshop tours conducted by Théâtre du Soleil and SITI Company). It is spurred, too, by intermediality and resurgent interest in theatre as total artwork. Economic realities of the present decade have given it renewed impetus.

Moving through these three phases of development, we tease out what may be the most significant contradictory strand running counter to the thematic structure of our proposed chronology: an artistic lineage that runs from the nascent experiments in collective creation of Stanislavsky, through the companies of Reduta, Grotowski, Barba, and most recently the Workcenter of Jerzy Grotowski and Thomas Richards. These are artists whose group practices have rejected political ideologies as such, and for whom the concern with group dynamics is marked not by in ideal of leaderlessness but rather by a striving toward an ethical leadership that aims to facilitate and support the centrality of the actor in the creative act. In conclusion, we propose that the proto-collective-creation model conceived by Meyerhold and further developed by Stanislavsky has come full circle over the course of the century, reemerging in the dominant trends of contemporary practice, at least in the United States (and, it appears, in much of Europe as well—this question would make an excellent starting point for further investigation) with their emphasis on accommodated leadership, ethical group process, and the centrality of the actor-creator.

While pointing in the direction of a transnational approach, we are painfully aware of the cultural and geographic territories of research that are, of practical necessity, beyond the scope of this book.[22] Nor are we proposing that the turn of the last century is a necessary periodization for a history of collective creation, only that it is a productive starting point for the purposes of this particular book, intersecting as it does with the rise of auteurism and thus allowing us to investigate confluence between these two seemingly opposed movements. Our hope is that by demonstrating the prevalence, breadth, and significance of collective creation since 1900, our essays may serve to suggest new directions for continued scholarly investigation into this critical aspect of modern theatre making.

Notes

1. Theodore Shank, "Collective Creation," in *Re:direction, A Theoretical and Practical Guide,* ed. Rebecca Schneider and Gabrielle Cody (London: Routledge, 2002), 221. Originally printed in *TDR: The Drama Review* 16, no. 2 (1972): 3–31.
2. Mark S. Weinberg, *Challenging the Hierarchy: Collective Theatre in the United States* (Westport, CT: Greenwood Press, 1992).
3. Ibid., 5.
4. See, for example, Alison Oddey, who writes, "In the cultural climate of the 1990s, the term 'devising' has less radical implications, placing greater emphasis on skill sharing, specialization, specific roles, increasing division of responsibilities, such as the role of the director/deviser or the administrator, and more hierarchical company structures." Oddey, *Devising Theatre: A Practical and Theoretical Handbook* (London: Routledge, 1994), 8, as cited in Deirdre Heddon and Jane Milling, *Devising Performance: A Critical History* (New York: Palgrave Macmillan, 2005), 5. See also Kathryn Syssoyeva, "Pig Iron: A Case Study in Contemporary Collective Practice," in *Vie et morts de la création collective / Lives and Deaths of Collective Creation*, ed. Jane Baldwin, et al. (Sherborn, MA: Vox Teatri, 2008).
5. See, for example, Attilio Favorini's discussion of the "broken tradition" of collectively devised documentary theatre; Chapter 5 of this volume.
6. Enumerated in this list are works expressly concerned with collective creation as a movement; not included are works that focus on a single company or in which collective creation is subsumed under a broader category such as avant-garde performance.
7. Alan Filewod, *Collective Encounters: Documentary Theatre in English Canada* (Toronto: University of Toronto Press, 1987).
8. 1994 saw the publication of the first edition of Alison Oddey's *Devising Theatre: A Practical and Theoretical Handbook* (London: Routledge, 1994). I have not included it in this list because it is more practical than historical in its aims.
9. Heddon and Milling propose that *devising* is the British and Australian term, *collective creation* the American (2). While this has been historically true (as reflected in the literature), in the past decade the term *devising* has infiltrated US usage, above all, perhaps, in the academic theatre—circulating through list serves and in the work of young scholars, job talks, classrooms, and faculty meetings.
10. Deirdre Heddon and Jane Milling, *Devising Performance: A Critical History* (New York: Palgrave Macmillan, 2005); Emma Govan, Helen Nicholson, and Katie Normington, *Making a Performance: Devising Histories and Contemporary Practices* (London: Routledge, 2007; an introduction to the history and practice of devising, emphasizing developments in the United States, England, and Australia); Jane Baldwin, Jean-Marc-Larrue, and Christiane Page, eds., *Vies et morts de la création collective / Lives and Deaths of Collective Creation* (Sherborn, MA: Vox Theatri, 2008; this bilingual book investigates collective creation practices, politics, and companies across borders); Bruce Barton, *Collective Creation, Collaboration and Devising*, vol. 12 of *Critical Perspectives on Canadian Theatre in English* (Toronto: Playwrights Canada Press, 2008); and Alex Mermikides and Jackie Smart, *Devising in Process* (London: Palgrave, 2010; examines the creative processes of eight British devising companies: The People Show, Station House Opera, Shunt, The Red Room, Faulty Optic Theatre of Animation, theatre O, Gecko, and Third Angel).
11. Weinberg, 1.
12. Ibid., 5.
13. Ibid., 13.

14. Terry Eagleton, cited in Weinberg, 14.
15. Ibid., 16.
16. Alan Filewod, "Collective Creation: Process, Politics and Poetics," in *Collective Creation, Collaboration and Devising*, ed. Bruce Barton (Toronto: Playwrights Canada Press, 2008), 1.
17. Filewod, 2.
18. The very notion that collective creation necessarily results in synthesis is challenged in Michael Hunter's study (Chapter 9) of the collaborative process of Merce Cunningham, John Cage, and their various artistic partners.
19. Heddon and Milling, 3.
20. Richard Schechner, "Introduction," in *The Anthropology of Performance*, by Victor Turner (New York: PAJ Publications, 1987), 8.
21. One might think here of the music-driven, physical theatre collectively generated by the company of the Gardzienice Center for Theatre Practices under the direction of Wlodziemierz Staniewski or instances of collectively generated performance texts by the Maly Theatre of Saint Petersburg under the direction of Lev Dodin.
22. By way of but one (large) geographic example: Latin America. The importance of Latin American collective creation methods both locally and globally merits far greater scholarly study in Anglophone literature than that region has received in devising studies to date.

Part I

Collective Creation's First Wave

Preface to Part I: From Monastic Cell to Communist Cell

Groups, Communes, and Collectives, 1900–1945

Kathryn Mederos Syssoyeva

Let us see now if in all the dramatic impedimenta of the past there is anything for the people.[1]

—*Romain Rolland*

Something there is (to paraphrase Frost), that doesn't love a hierarchy; and something there is that loves a hierarchy very much. The history of modern collective creation is perhaps above all a chronicle of that tension—the counter-pull of autocracy and democracy, of creative authority and the generative capacities of the group—and perhaps at no time more noticeably than during the first half the twentieth century.

Collective creation in its modern manifestations arose out of a complex network of transnational influence, diverse political models, varied aims and impulses. The pre–World War II years remain the most underhistoricized and thus, perhaps, most intriguing period of collaborative theatre making. This volume presents four precedents of collective creation emerging in the first decades of the century, in diverse locations: the first, early experiments in collective creation and improvisation led by Vsevelod Meyerhold and Konstantin Stanislavsky in 1905 (Chapter 2); the second, the Reduta collective of Poland, established in 1919, forebear to the theatre of Jerzy Grotowski (Chapter 3); the third, the almost accidental discovery of collective creation, beginning in the 1920s, by the performers working under the intermittent and ambivalent leadership of Jacques Copeau (Chapter 4); and the fourth, not an account of a single company, but rather of a mode of practice—the long story of documentary theatre making from Soviet agitprop to Moisés Kaufman and the Tectonic Theater Project's *The Laramie Project* (Chapter 5).

But there are many other examples of early assays at collective theatrical practices still to be given their due in the context of collective creation studies. So little

work has been done to date to draw together the threads of these disparate early experiments that it behooves us here to sketch out a preliminary history. It is beyond the scope of this work to attempt an exhaustive account; rather, we offer a sort of historical gridwork, establishing some of the key dates, locations, crosscurrents, and modalities of early collective practice (with emphasis on the United States, Russia, and a small selection of European countries), which we hope may serve as the basis for ongoing historical investigation in the field.

In its modern manifestations, collective creation emerges out of a political climate similarly dominated by the tug and pull of what we may loosely term democratic and autocratic impulses. Beginning—in so far as any historical pattern can be said to "begin"—with the European Revolution of 1848, we enter a "long half-century" of global uprising and suppression, partition and unification, imperialism and revolt, the overthrow of power and its restoration. The year 1848 saw uprisings and thwarted revolutions that touched some fifty countries; the decades that followed brought India's First War of Independence, the Boxer Rebellion, the Paris Commune. 1848 also brought publication of the *Communist Manifesto*; the 1860s, the first volume of *Das Kapital*, and the (putative) abolition of slavery in America and serfdom in Russia, Poland, and Austria. These were the decades that witnessed the spread of socialism, communism, progressivism, trade unionism, and anarchism.

Collective creation emerges, too, out of an artistic climate that sees an almost messianic potential for art generally and the theatre specifically. In Russia above all—and it is in Russia that this present history begins—faith in the socially transformative power of art, articulated by philosophers, cultural theorists, and political thinkers of the mid-nineteenth century, was to reach mystical proportions by the dawn of the twentieth century. The art-for-art's-sake aspect of Symbolism notwithstanding, *fin de siècle* Russian theatre took from the nineteenth century a mandate to serve the social good. Russian radicals of the 1840s, 1850s, and 1860s approached art with a certain civic utilitarianism: theatre, as the most social of arts, had a central role to play in society building, be it to uplift, instruct, or protest. One can trace an arc from the leftist-Realist notion of art's mission of social transformation to the Symbolist vision of art's mystical capacity to transform the human being. If the Realists, for whom social function trumped artistic form, would seem odd bedfellows with Symbolists, for whom artistic imagination was a value unto itself, in Russia the two philosophic camps nonetheless shared certain underlying continuities. As cultural historian Olga Matich notes, "Despite their vociferous opposition to the 'new men' of the 1860's, the Symbolists were preoccupied with similar concerns: the 'transformation of life;' the 'heavenly kingdom on earth;' 'the reconciliation of all opposites;' and the coming of a 'new' religion."[2] For Realists and Symbolists both, the theatre was nothing if not *social* in nature and commission—understood, variously, as the art form of the people, the group, the community, the congregation. This evolving discourse concerning the theatre's transformative promise and potentially potent role in human communities was fertile terrain for the emergence of two visions of alternative theatrical praxis that would play a vital role in the development of modernist collective creation

practices: the ideal of a popular theatre and of the actor's primacy in a collabora-
tive creative act.

Central among Russian theorists of Symbolist theatre was Viatcheslav Ivanov
(1866–1949), a philosopher, playwright and critic, follower (if critically so) of
Nietzsche's work on the cult of Dionysus, and "adherent of Vladimir Solovyov,
whose mystical Christianity taught that the congregational and the individual
religious spirits must be mediated by an artist-hierophant."[3] Ivanov, writes the-
atre historian Lawrence Senelick, held that "by reverting to its ritual beginnings,
the theater will resume the choric or dithyrambic involvement of its audience,
which will become a participant rather than an observer, a communicant with the
higher truth." In Ivanov's own words, "The stage must step across the footlights
and draw the community into itself, or the community must absorb the stage,"[4]
and "out of the Dionysian sea of orgiastic emotions rises the Apollonian vision
of the myth, to disappear again in those same ecstatic depths, having illuminated
them by its miracle."[5] Ivanov's influence cannot be underestimated; as Senelick
remarks, "the inspiriting concept of a communion in the theatre, of a solidarity
of performer and spectator, of the dramatist as priest of a new cult, was conta-
gious ... his ideas can be found scattered through the dramatic theories of almost
every Russian writer of the time."[6]

It is against the background of this discourse that we begin to perceive a shift from
the authority of playwright—and the more recent authority of the director—to the
centrality of the actor—or rather, actors, for ideals of a performing ensemble and
ideals of a generative collective would coincide and overlap. Relative to France
and Germany, the director-auteur arrived late to Russia; the actor-auteur, early. In
1902—just four years after the opening of the Moscow Art Theatre—Symbolist
Valery Briusov introduces the notion of actor as creator in "The Unnecessary
Truth," a seminal essay challenging the hegemony of stage naturalism and calling
for a theatre in which the poetics of the actor is central: "The sole objective of the
theater is to help the actor reveal his soul to the spectator."[7]

Just three years later, in 1905—as Russian autocracy tottered but did not fall—
Meyerhold and Stanislavsky began experimenting with new approaches to their
work with actors, that might foster the performer's generative capacities and shift
the dynamics of creative authority within the rehearsal room. This is the subject
of Chapter 2, "Revolution in the Theatre I: Meyerhold, Stanislavsky, and Collective
Creation—Russia, 1905." Their experiments were perhaps tentative, and certainly
partial, and for all that both men spoke and wrote about the centrality of the actor's
creativity, they were far from prepared to relinquish their own creative authority.
But they laid a foundation in several areas that were to prove critical to the fur-
ther development of collective creation not only in Russia but, with time, inter-
nationally: the development of a "new" creative method—improvisation; a new
institutional model—the laboratory theatre; and a new theatrical term—collective
creation (kolektivnoe tvorchestvo), which Meyerhold used in print as early as 1907.
In the wake of this short-lived but fruitful experiment, Meyerhold and Stanislav-
sky would turn their attention to other artistic concerns. But an impulse to create
collectively had taken root in the Russian theatre, burgeoning, in the decade that
followed, like so many seedlings from an increasingly fertile soil. Two particularly

striking examples receive mention in Andre Malaev-Babel's 2012 study, *Yevgeny Vakhtangov: A Critical Portrait*. The first concerns the work of Leopold Sulerzhitsky, cofounder, with Stanislavsky, of the First Studio of the Moscow Art Theatre (MAT) in 1912. One of the earliest teachers of and contributors to Stanislavsky's System, Sulerzhitsky inculcated in his students an ethos, a mind-set, and techniques that fostered collaboratively generated performance: "Sulerzhitsky was a close friend of Tolstoy's. He took his MAT colleagues as well as his students to Ukraine and to the South of Russia and the Crimea, where he 'treated' them to a healthy diet of outdoor labor and improvisational performance parties . . . Sulerzhitsky was famous in artistic circles for initiating improvised concerts and entertainment. Moreover, he constantly instigated acting improvisations in the streets, in restaurants, and other public places . . . extending the creative process of transforming the dullness of everyday life into a theatrical festival."[8]

Among Sulerzhitsky's many students was Yevgeny Vakhtangov, who came to study with Sulerzhitsky in 1909 at the Adashev School in Moscow. And among the many ideas Vakhtangov appears to have absorbed from Sulerzhitsky was the notion of the actor's creative autonomy. In 1911—the same year that Stanislavsky began to cast about once more for the possibility of founding a new theatre laboratory—Vakhtangov noted in his diary, "I want to form a studio where we can learn. The main principle: we must accomplish everything on our own. *Everyone is a leader*."[9] Vakhtangov indeed founded a studio theatre shortly thereafter (the Vakhtangov Studio); in parallel, he taught and directed for the First Studio of MAT, taking over leadership in 1916 following Sulerzhitsky's death, and he would emerge as one of the most significant directors of the early Revolutionary period until his own untimely death from cancer in 1922. Over the course of his work in the two studios—his own, especially—Vakhtangov was to place an ever-increasing emphasis on the generative capacity of the actor and the creative autonomy of the collective. By the 1920s, those principles had become central to Vakhtangov's vision of theatre. "Like many of the Russian avant-garde artists of the 1920s, Vakhtangov was working toward freeing the human spirit—by enriching it with creativity. He saw the future of mankind as a community that will introduce a new man—a perpetual creator."[10]

In *Princess Turandot*, his modernist commedia of 1922, Vakhtangov succeeded in approaching the threshold between life and art, between the actors' story and the characters' story, between the improvisational and the staged.[11] But he dreamt of going much further. One of his students later recalled Vakhtangov describing his vision of the theatre of the future: "The time will come when the theatre will be an ordinary event of our life. Theatre will simply be in a square. Everyone, who feels himself capable, will act. Theatre will be free of charge—there will be no admittance fee, or performance honorarium. It will be a free art for free people. Narrow professionalism will disappear, all naturally talented actors will play."[12]

In 1922, Vakhtangov had cause to believe in such a future: along with death and destruction, the Russian Revolution had left in its wake an unprecedented theatrical flowering. "Everyone" was making theatre.[13] In the waves of theatrical transformation that followed 1917, ideas of collective, mass, and people's theatre played a central role—nowhere so obviously, perhaps, as in the mass spectacles

of 1918, 1919, and 1920. Soviet mass spectacle brought together the complex collaborative hierarchy of Russian Silver Age theatre with the dramaturgical structure of the pageant and the Marxist ideal of an art by the people, for the people. It was also an overtly propagandistic form—but that is clearer from the vantage point of hindsight. While not overstating the case that such state-sanctioned events constituted an ideal of "peoples' theatre," it is equally important not to conflate the experience of this participatory (if hierarchically organized), celebratory theatre of the streets, in the earliest years of Bolshevik power, with the compulsory public demonstrations of the decades that followed. The notion that art in general, and theatre in particular, has a central role to play in social transformation had held sway in Russian cultural theory for three quarters of a century; Mass spectacles, with their glorification of the Revolution's highpoints, were a logical revolutionary manifestation of this impulse.

By the 1920s, the Soviet avant-garde would have taken up collective creation in multiple forms: mass spectacles, Blue Blouse agitprop, Living Newspapers—manifestations of collective practice explored by Attilio Favorini in Chapter 5. However much Soviet historians of Stalin's time might have sought to distance the Bolshevik theatre from Silver Age "decadence," Russian theatre in the period from 1918 to 1924, with its admixture of creative explosion, populist celebration, educative mission, and society building, can be said to have achieved a resolution of (cultural) opposites: synthesizing the social utilitarianism of the radical left of the mid-nineteenth century with the Dionysian congregationalism of Ivanov (who continued to play an influential role in the early twenties, alongside more radical colleagues, such as Platon Kerzhentsev). As Andrei Malaev-Babel has noted, "At the heart of the avant-garde philosophy lies the forward-looking belief in the infinite possibilities of the human being . . . According to the philosophy of the avant-garde the liberating effect of art—both psychological and social—is meant to transform the genetic makeup of the nation, thus engineering a new breed of man."[14]

Within less than a decade, this idealized vision of the creative possibilities unleashed by communist revolution would be crossing borders into Germany, England, and the United States.

Collective Creation between the Wars: France, Poland, and Germany

Russia was hardly alone in seeing a social—and progressive—role for the theatre. In 1900, Romain Rolland commenced work on what was to be one of the most highly influential texts of the popular theatre movement: *Le Théâtre du peuple* (*The People's Theatre*). Rolland opens by remarking, "A curious phenomenon has occurred during the past ten years. French art, the most aristocratic of arts, has come to recognize the masses." Bemoaning the fact that, having had their attention directed toward "this new sovereign" by the rise of Socialism, "authors and actors . . . have discovered the people . . . in much the same manner that explorers discover a new market for their wares," he proceeds to rewrite theatre history to investigate the traces of people's theatre of the past. He concludes with a call for a people's theatre of the future, freed from the constraints of both commercial and

state interests (for "it is the function of the State to petrify everything with which it comes into contact, and turn living into bureaucratic ideas"):[15] a theatre "of men, not merely a Theatre of writers," of pantomime, of the spectacle of action, of improvised comedy, and of legends, music, and poetry.[16] Rolland's essay was completed in 1902, the same year that he staged the storming of the Bastille as a mass spectacle titled *Le Quatorze Juillet*. Between 1900 and 1903, *The People's Theatre* emerged in parts in the *Revue d'Art Dramatique*; in the coming years, it would be reissued in book form and widely translated, continuing to have international impact well into the 1960s.[17]

Despite this revolutionary debut, the impulses that would lead most directly to an initial wave of collective creation in 1920s France derived from aesthetic and religious, rather than political, concerns; this is the subject of Chapter 4, Jane Baldwin's "The Accidental Rebirth of Collective Creation: Jacques Copeau, Michel Saint-Denis, Léon Chancerel, and Improvised Theatre." Nonetheless, the work of the Copiaus under the leadership of Jacques Copeau, and subsequently, of the Compagnie des Quinzes under the direction of Copeau's nephew, Michel Saint-Denis, engendered a lineage of collective creation companies spanning several "generations" that would include among its kith several decidedly political collectives of the sixties and seventies, including (with varying degrees of proximity to the source) le Théâtre du Soleil, the Dell'Arte Company, and the San Francisco Mime Troupe—a subject taken up in greater detail in Chapter 6, "Crossroads and Confluence: Collective Creation, 1945–1985."

Poland, too, saw an emergence of collective creation following World War I, beginning in 1919 with the founding of the Reduta company, subject of Chapter 3, "Reduta's Reorigination of Theatre: Radical Collectivity in Poland's Interwar Theatre Laboratory," by Kris Salata. As in the work of Jacques Copeau, a monastic ideal informed Reduta: the image of the artist-collective in retreat from the world, in singular devotion to theatre as a kind of semisecular religion. It is worth noting here that interwoven among the native forces (such as Polish Romanticism, Catholicism, and nationalism) that informed Reduta's conception of a sacral theatrical collective were impressions gleaned from Stanislavsky's work circa 1915, with which Reduta's founders, Juliusz Osterwa and Mieczysław Limanowski, had become acquainted as a result of their internment (as Austrian citizens), by the Russian army.[18] As Salata discusses in his chapter, Reduta's model would prove central to Grotowski's thought—making the Reduta collective, among other things, one of the living conduits by which certain ideals of the Russian theatre would be made manifest (and transformed) in Grotowski's theatre. Another such conduit was Yuri Zavadksy, under whose supervision Grotowski studied directing at GITIS (The Lunacharsky State Institute of Theatre Arts) in Moscow from 1955 to 1956. An actor with the Moscow Art Theatre from 1924 to 1931, Zavadsky is credited with having been instrumental in Grotowski's understanding of Stanislavsky's work. Less emphasized in this context is Zavadsky's proximity to Vakhtangov; a leading member of the Vakhtangov Studio from 1915 to 1922, Zavadsky played Saint Anthony in Vakhtangov's productions of Maeterlinck's *Miracle of Saint Anthony* (1918 and 1921) and Calaf in *Turandot*. Thus Grotowski's introduction to

the Russian perspective on Stanislavsky'spractical research was through the filter of Vakhtangov's influence.[19]

In Germany, the move toward collectively generated art (which, in peformance, first emerges in the cabaret scene) would gain sudden momentum in the Weimar period, immediately following the fall of the monarchy and the rise of liberal democracy. Beyond the theatre, its most famed manifestation was the Bauhaus movement, founded in 1919 under the direction of Walter Gropius, whose *Bauhaus Manifesto* declared that "the ultimate goal of the Bauhaus is the collective work of art in which no barriers exist between the structural and decorative arts. Artists and architects would work together towards the great goal of the building of the future."[20] Within the theatre, its chief proponent was Erwin Piscator, credited (among his many achievements) with initiating the German Agitprop movement, beginning in 1920 at the Proletarisches Theater in Berlin, and with laying the foundation for collectively created epic theatre, at the Piscator-Buhne in the late 1920s. Piscator's influence on collaborative methods would be vast: directly through the medium of agitprop and through his own peripatetic life, which took him—sometimes by choice, more often (as discussed at the close of this chapter) as a result of politics and war—from Germany to the Soviet Union to France to the United States and back again to Germany; and indirectly by way of Bertolt Brecht, who joined Piscator's "dramaturgical collective" in the late 1920s, collaborating with Piscator, Felix Gasbarra, and the visual artist George Grosz on the 1927 adaptation of Jarek Hasek's *Adventures of the Good Soldier Schweik*. Brecht's influence on a subsequent generation of collective creation was broader still, touching practitioners across the globe: we might think (to name just a few) of Joan Littlewood (England), Augusto Boal (Brazil), Athol Fugard, John Kani, Winston Ntshona, and the Serpent Players (South Africa), and Judith Malina and Julian Beck (whose own peripatetic theatrical life would take them from the United States to Europe and South America, and back).

America

In the United States, meanwhile, the idea of a people's theatre was ascendant. Driven by progressivism, socialism, trade unionism, women's suffrage, the progressive education movement, immigration, and concern for the urban immigrant poor, American theatre at the turn of the century was awakening to a sharp sense of social and artistic purpose, and the ways and places in which theatre was being made were rapidly changing. Several distinct movements pertinent to this inquiry emerge in this period: settlement house theatre, the Little Theatre Movement, protest pageantry, and labor college theatre. These movements, in turn, would feed directly into a flowering of politically driven collective practice in theatre and dance in the late 1920s and early 1930s.

The Settlement House Movement

The role of settlement houses in providing avenues of artistic training for young immigrants, venues for the development of workers' theatre, a platform for the exploration of European theatrical forms on American soil, and a wellspring of experimental practices and theoretical positions that would become the basis for American collective creation can hardly be overstated. The US settlement house movement began in 1886 with the founding of the Neighborhood Guild in New York City (just two years after establishment of the first British settlement, Toynbee Hall, in East London, 1884). Within a year of the opening of the Neighborhood Guild, 74 settlements had sprung up across the United States; by 1890, there were more than four hundred—among them, Chicago's Hull House, founded by Jane Addams and Ellen Starr in 1889.[21] The chief aim of settlement houses, broadly, was to facilitate the acculturation of new immigrants; some settlements, such as Hull House, conceived their mission in pronouncedly activist terms and provided social services, political advocacy, and education. The progressive educational mission of Hull House was marked by a belief in the role of art in human development—a sentiment that would spread through progressive education theory in the United States in the first decade of the twentieth century (John Dewey, then on the faculty at the University of Chicago, where he ran a laboratory school for the investigation of new methods of teaching, was deeply influenced by Addams's work). In her desire to combat the dehumanizing effects of industrialization, Ellen Starr, in particular, "juxtaposed art against the machine," maintaining that "increased mechanization meant decreased artistic expression and, it followed, only increased artistic expression could combat the evils of mechanization."[22] Starr and Addams made artistic activities central to the Hull House educational program; Addams worked especially hard to establish the settlement's Dramatic Section (launched in 1893), which gave theatrically gifted members of Hull House opportunities to perform in the plays of Shaw, Ibsen, Galsworthy, and Hauptmann, and has been cited by some as the unofficial start of the Little Theatre Movement in the United States. It would be under the joint auspices of Hull House and the Chicago School of Civics and Philanthropy (itself an outgrowth of the settlement house movement, with deep ties to Hull House)[23] that sociologist Neva Boyd, a leading proponent of the recreational play movement, would establish a Recreation Department in 1914 (later known as The Independent Recreation Training School of Chicago, and informally, The Hull House School), which offered a yearlong training program in group games, gymnastics, dance, dramatic arts, play theory, and social problems.[24] Boyd maintained that play was central to socialization, and dramatic games and dance central to play. It was from Neva Boyd that Viola Spolin received training in recreational play, working with poor immigrant children at Hull House from 1924 to 1926. Spolin would go on to teach, further developing her own training methods under the auspices of the Works Progress Administration (WPA) from 1939 to 1941. Spolin's groundbreaking work in the development of improvisational games—her seminal textbook, *Improvisation for the Theater*, was published in 1963—changed the course of actor training in the United States and profoundly impacted two lines of collective creation practice: the collective creation scene of

1960s New York alternative theatre (particularly The Living Theatre, The Open Theater, and The Performance Group), and the Chicago-born comedy-improv movement that developed out of Second City, cofounded in 1959 by Spolin's son, Paul Sills, who put Spolin's methods to work as a basis for the creation of sociopolitical satire in a cabaret-theatre format.

Other settlement houses followed Addams and Stars's lead in making the arts and theatre central to social group work—predominant among them, the Henry Street Settlement, established by social activist Lillian Wald in 1893 on the Lower East Side of New York City. The Neighborhood Playhouse, Henry Street's theatrical wing, was founded in 1915 by the young German-Jewish philanthropists Alice and Irene Lewisohn, and rapidly emerged as an edgy, community-based alternative within the already alternative Little Theatre Movement. The Neighborhood Playhouse's contributions to the development of political, community, and collective theatre practices over the coming decade were several, including providing a space for women theatre artists; emphasizing a synthetic approach to staging that integrated dance and drama (necessitating, in turn, a team approach to production); providing training and performance opportunities to the impoverished immigrant communities of the Lower East Side; developing street festivals and pageants that celebrated the diverse performance traditions (especially dance) of an immigrant population; facilitating the coexistence of professionalism and amateur, community-centered work; and providing a venue for such workers' theatre collectives as the *Freie Yiddishe Volkbuhne*, the radical Jewish performance group of the Bundist Arbeiter Ring (Workmen's Circle).[25]

The most enduring institutional offshoot of the Playhouse's multifarious activities was the Neighborhood Playhouse School of Theatre, established by Rita Morgenthau (a Playhouse board member with a commitment to "theatre as an instrument of social action") and Irene Lewisohn in 1928 to provide theatre and dance training for the working-class community in which it was based.[26] Together, Neighborhood Playhouse and Neighborhood Playhouse School (which, from 1935, would house the training program developed by former Group Theatre actor Sanford Meisner) would play midwife to the radical dance movement of the 1930s: two generations of experimental dancers—a great many of them Jewish immigrants—trained or taught there, including Blanche Talmud, Helen Tamiris (who later directed the Federal Dance Project of the WPA), Edith Segal, Anna Sokolow, and Martha Graham.

The Little Theatre Movement

With the rise of Little Theatre, too, comes the development of component parts of collective creation, though still fragmentary and nascent. Together with those concerns that might be broadly associated with the art theatre movement—interest in the development of new dramatists and new drama (especially drama expressive of social concerns); raising the level of artistry in staging, performance, and design; and reaching a wider, less bourgeois audience—comes a series of institutional shifts, directly significant for the move toward collective practices, especially

leadership by committee and the ideal of the group. From the founding of the Provincetown Players in 1916, with the battle cry "organization is death!"[27] to the Mass Dance movement of the thirties, we find a trend toward experimentation with institutional structure. Many of these alternative models take a form that, on the surface, maps poorly onto the contours suggested by the collective creation paradigms of the sixties—tending less toward participatory democracy than toward decision by executive committee. In part, this is due to a continual shift (specific to the time, the place, and the group) in the perceived tyrannies to be "overthrown" by new institutional structures: the star; the director; the playwright; the producer; Broadway; the bourgeoisie; the committee itself. Thus we find, in 1919, the Theatre Guild appearing to offer a subversive new alternative to the dominance of Broadway producers; by 1931, it appeared—in the eyes of Group Theatre founders Harold Clurman, Lee Strasberg, and Cheryl Crawford, who attempted to forge a cooperative production arrangement with the Guild—as an institutional behemoth stifling the creative possibilities of collective endeavor.[28]

The ideal of the group in the Little Theatre movement reaches its apogee with the founding of the Group Theatre in 1931 under the tripartite leadership of Clurman, Strasberg, and Crawford. If Clurman, and even more so, Strasberg would remain ambivalent, at best, toward matters of power sharing, the Group nonetheless strove toward a new ethics of collective praxis: increased participation for the ensemble in decision making; an increasingly egalitarian approach to salary; and demotion of the playwright (only recently elevated) to collaborative partner, working cooperatively with the acting group (understood to have an equal investment in the statement made by the play) to modify the text to suit the company. The Group was also marked by a tendency toward communal living—both in the first years of the company's existence, when the ensemble would retreat to the countryside between seasons for periods of training and experimentation,[29] and during the harshest periods of the Depression, when several of the most impoverished company members (including Strasberg, Clurman, and Clifford Odets) took an apartment together on 10th Avenue and West 57th Street (which they flippantly dubbed "Groupstroy" after the Dniepstroy Dam in Ukraine, a Stalinist symbol of Soviet achievement).[30] The group ideal was also reflected in the company's early theatrical investigations, which included experimentation in improvisationally generated scenes and mise en scène.[31] In the Group Theatre, in short, we witness an emergence of all the tools of collective creation—but without their full implementation.

1913: The Protest Pageant

Modern American pageantry began as a form of civic spectacle, aimed at celebrating and inculcating a sense of national pride and social cohesion. In the first decades of the twentieth century, the United States, in the words of one observer, went "pageant mad"—to the extent that an American Pageant Association was formed "to promulgate standards for the new pageantry movement and . . . guide its development through publications, training programs, and even certification

of pageant masters."[32] The cause of pageantry was taken up in a series of essays and books by Percy Mackaye, among them *The Civic Theatre in Relation to the Redemption of Leisure* (in which Mackaye called for the establishment of a civic theatre: national, subsidized, and noncommercial). Himself a director of spectacular pageants involving thousands of performers engaged in choral readings and lavish tableaux, the rather patrician MacKaye took a quasi-Fabian approach to pageantry, seeing in it an opportunity to educate the immigrant masses in poetic drama (mostly his own) and American history and values, as well as a redemptive pastime for the urban poor and a cooperative, civic-oriented form of leisure generally—a cultural tool, in short, of nation building.[33] He also, somewhat unexpectedly, saw it as a "new profession for women."[34] He may have been thinking of his sister, Hazel, for just one year after publication of *The Civic Theatre*, Hazel Mackaye would take American pageantry in a whole new direction.

1913 was a fertile year, bringing, in France, book-length publication of the entirety of Romain Rolland's *A People's Theatre*; in Russia, establishment of the Meyerhold Studio in Saint Petersburg, which conducted experiments with commedia dell'arte, physical theatre,and improvisation; and in England, foundation of the Women's Theatre Company by suffragist Inez Bensusan, to establish "a permanent season for the presentation of dramatic works dealing with the Women's Movement."[35] In America, 1913 witnessed a series of pageants whose purpose was, variously, to protest political and economic injustice and to celebrate the achievements of the politically and economically disenfranchised. This de facto "season" began on March 3 with *Allegory*, written for the Congressional Committee of the National American Suffrage Association by Hazel Mackaye, and staged on Pennsylvania Avenue in Washington, DC, one day before Woodrow Wilson's inauguration, to capitalize on the crowds and the political and press attention. The centerpiece of an enormous march and rally organized by suffragist Alice Paul (who had spent several years working with Emmeline Pankhurst in England, where suffragists had already begun mining the political potential of pageantry in 1910), the pageant combined an allegorical tableau with a procession of upwards of ten thousand women from all over the nation (including a contingent that garnered much attention in the national press by hiking 225 miles from New York City to Washington, DC),[36] interspersed with floats dramatizing the international struggle for women's suffrage, heralded by "maidens blowing trumpets, dressed in flowing white Grecian robes,"[37] and led by the elegant suffragist Inez Mulholland, astride a white horse, as Joan of Arc ("Helen of Troy was not more upsetting," remarked one admiring participant).[38] The spectacle culminated at the marble steps of the Treasury Building, where the allegorical tableau-in-motion (featuring professional artists as the womanly virtues, dozens of costumed "maidens" choreographed à la Delsarte, and flags, banners, balloons, and doves) unfolded to swelling music over the course of an hour, then froze in salute as 10,000 women marched past before a crowd of 250,000.[39]

Because march and pageant were a more or less unified event, we see a breakdown of the border between performer and witness, in particular at the level of the marchers, who are at once participants in a kind of planned happening and witnesses to its more formally theatrical moments. By thus taking performance

to the street in the context of political activism, the inherent theatricality of the public demonstration was heightened, and lines between performance and politics more than usually blurred. The entire structure was marked by elements of agitprop, *avant la lettre*. Pageant tableaux, generally, drew their aesthetics from the mural movement (another art form pulled between national pride and political revolt), which would become a staple feature of agitprop a few years later, albeit on a much smaller scale.[40] Moreover, the magnitude of the production invited pluralism. Though the pageant was nominally written by Hazel Mackaye, the processional aspect exceeded her control: it was the creation of multiple delegations, working across the nation from one another, bringing together their aesthetic contributions and particular sociopolitical concerns in DC just days before the event. The scale of the entire spectacle was such that it necessitated a team of directors and producers, including Mackaye, Glenna Smith Tinnin (like Hazel Mackaye, an experienced pageant director), and suffragists Alice Paul, Lucy Burns, and Crystal Eastman.[41]

The National Woman Suffrage Pageant was followed, in short order, by *The Paterson Strike Pageant* (a dramatic reenactment of the Paterson, New Jersey, silk workers' strike), staged by John Reed and Robert Edmond Jones, on June 7, 1913, at Madison Square Garden; *The Henry Street Settlement Pageant* (celebrating immigrant culture on the streets of New York's Lower East Side), also June 7, written by Alice and Irene Lewisohn, and produced by the "women of the Neighborhood Playhouse," including the Lewisohns, Aline Bernstein, Ethyl Frankau, and Rita Morgenthau;[42] and *The Star of Ethiopia* pageant, staged by the NAACP on October 22, 1913, to commemorate the fiftieth anniversary of the Emancipation Proclamation (written by W. E. B. DuBois, *The Star*, according to Susan J. Moore, was at least as political as commemorative, staging the argument "that racism was a defining aberration of American culture").[43]

To date, there appears to have been little investigation into collaborative process in pageantry. But the episodic and large-scale nature of the productions, together with vague references by their putative directors, strongly hints at a cooperative or at least tiered structure of creative endeavor, with subgroups contributing scenes to the whole. While such a process hardly implies anything so antihierarchical as directorless devising (to the contrary, ones senses here the kind of complex hierarchy that facilitated the creation of Soviet mass spectacle), the civic orientation that underpinned pageantry generally, combined with the populist and political impetus at work in *The Star of Ethiopia*, *The Paterson Strike Pageant*, and *The National Woman Suffrage Pageant*, speaks to the rising influence of the ideals of a people's theatre. Significantly, in *The Civic Theatre*, Percy Mackaye emphasizes (literally, with italics) the notion that it is in the cooperative work of the group that the theatre's deepest significance lies: "*Association in the creation of art is of import far more constructive than association in mere receptivity to art.*"[44] It is a perception that finds echo in Hazel Mackaye's recollections of the suffrage pageant: "Not one of those women or girls who participated in the pageant would ever feel indifference toward the cause of Equal Rights."[45] The pageant's transformative impact, she implies, was greatest for its collected participants.

The Workerist Turn: Labor College Theatre, Agitprop, and Mass Dance

By the late 1920s, alternative theatre in America was shifting left. The problem play, introduced in America by the settlement houses and Little Theatres, had opened the way toward edgier offerings, at once more explicit in their social critique and more formally adventurous. Several of the Provincetown Players would go on to develop overtly political theatre in the 1920s and 1930s—including playwright Mike Gold, who returned from a visit to the Soviet Union in 1925 "convinced . . . of the need for a more politically engaged theatre."[46] In 1926, Gold, together with Jasper Deeter (director of Philadelphia's Hedgerow Theatre) and activist Ida Rauh (another former member of the Provincetown Players), founded the Workers Drama League, "proclaiming itself the first worker's theatre in America." The League succeeded in staging one production of note, Mike Gold's *Strike*, "a mass recitation about the textile workers strike taking place at the time in Passaic New Jersey," inspired by the German and Soviet agitprop Gold had observed overseas. Within a year of its debut, the company folded, but its members regrouped shortly thereafter as The New Playwrights' Theatre. New Playwrights', too, took as its mission the staging of revolutionary drama, with an increasing emphasis on revolutionary form—understood as "the technical and aesthetic innovations of Soviet theatre."[47]

As theatre artists like Gold, John Reed, Hallie Flanagan, Stella Adler, Harold Clurman, and Lee Strasberg made their way to Moscow and back, and successive waves of German and Russian immigrant artists found their way to the United States, agitprop, Expressionism, and the innovations of the Soviet Theatre (biomechanics, constructivist design, futuristic visions of the machine age, and integration of popular forms such as jazz, vaudeville, and music hall into dramatic production) were making their presence felt throughout the Little Theatre from settlement houses to the Theatre Guild. But whereas Soviet constructivism celebrated the machine as a tool of the worker's liberation and a means toward a more perfect society, American machine-age aesthetics gave concrete form to concerns about the power relations of the industrial era and the plight of the urban poor, in such dramas as Elmer Rice's *The Adding Machine* (1923), Paul Sifton's *The Belt* (1927), Sophie Treadwell's *Machinal* (1928), and John Dos Passos's *Airways Incorporated* (1928).

The same period brought the rise of Labor Colleges, and within Labor Colleges, the establishment of dramatic divisions. "During the 1920s," writes Collette A. Hyman in *Staging Strikes: Workers' Theatre and the American Labor Movement*, "nearly every large and medium sized city boasted a labor college."[48] With philosophic roots in the progressive education movement, labor colleges saw an important role for theatre in the education of workers and labor organizers: "The emphasis on 'learning by doing' gave dramatic activities a place of honor in workers' schools"; theatre was viewed as having the capacity to help "students understand the world around them and their place in it"; and "the belief in the ability of ordinary citizens to affect social change infused theatrical productions at workers' schools with sense of possibility."[49] In the autumn of 1925, activist pageant director Hazel Mackaye was hired to teach playwriting to union

organizers at Brookwood Labor College in Katonah, New York—whose advisory board included John Dewey, and whose founders included labor leaders Fannia Cohn of the International Ladies Garment Workers Union and Joseph Schlossberg of the Amalgamated Clothing Workers of America ("whose roots in Jewish labor circles had endowed him with an equal commitment to the visionary and the practical potential of education for creating a more just social order").[50] Mackaye's association with Brookwood is emblematic—a thread in the complex weft and warp of America's burgeoning people's theatre movement. The dramatic divisions of labor colleges such as Brookwood would, in turn, play a central role in the development of labor theatre.

America's immigrant activist community, too, was developing a heightened sense of theatre's potential as a tool of education, protest, and transformation. Foreign-language workers' theatres, such as the German Proletbuehne (inspired by Weimar agitprop) and the Yiddish Arbeiter Teater Farband (better known by its Soviet-style acronym, "Artef," it began as a theatre-studio founded by Russian-Jewish émigré theatre artists and grew into a coalition of Yiddish-speaking radical theatre-artists) would feed directly into the emerging Workers' Theatre Movement.[51]

Initiated by communist and communist-sympathizing activists (some, young, working-class revolutionaries with little or no theatre background—others with ties to Little Theatre, labor college theatre, and immigrant activist theatre), and supported by the Communist Party's national and international networks of exchange, the Workers' Theatre Movement (WTM) emerged in the United States starting in 1926 and spread rapidly across the nation between 1928 and 1930. The mission of the WTM (in practice, a loose, sprawling confederation of ever-changing radical theatre troupes) was the creation of agitational performance in support of political activism. From the beginning, workers' theatre understood itself as collective action. Scripts, ideas, methods, and personnel were shared. One of the several achievements of workers' theatre with regard to collective creation was the establishment of organs of distribution for playtexts in order that scripts might circulate among workers' theatre groups locally, nationally, and internationally. Plays and scenes—along with theories, methods, reviews, and accounts of new developments in political-theatre making in Europe, the Soviet Union, and Japan—traveled between Germany, England, and America, sometimes with guidance for staging, always with the admonishment to rework the material to suit the working group. Authorial attribution of scripted material was rare, the goal being to make plays and sketches available for appropriation and reworking. Plot and structure were a gridwork to be filled with new content in response to the present local moment. Strongly influenced by German and Russian agitprop, the short-form, cabaret- and music-hall-inspired structure of most workers' theatre lent itself to collaborative writing, an approach further strengthened by the communist emphasis on review by committee of the political content of scripts.

That fertile circulation extended not just to the realm of ideas and texts but also to people. Both through WTM exchanges (which sent artists abroad and brought foreign theatre workers to the United States) and through the diaspora engendered by the successive political and economic upheavals of the early twentieth

century, the influx of foreign artists and intellectuals in this period (above all, to New York) was unprecedented. Valleri J. Hohman, in her 2011 *Russian Culture and Theatrical Performance, 1891–1933*, has painstakingly documented the critical role played by so-called Russian émigrés (in truth, emigrants from across the Russian, and later, Soviet empire—above all, Jews of Russia and its republics). These immigrants brought with them not just artistic techniques and aesthetic values but also ethical-philosophical positions about the nature and structure of groups, the role of art and the artist, and above all, the relationship of politics to art. The émigrés of the Russian empire played a particularly significant role in both the settlement house movement and the American Workers' Theatre Movement, introducing avant-garde theatre practices and methods of training, and translating texts by the experimental directors of the Russian left. As may be expected in such periods of diaspora, when the talents of émigrés become submerged beneath daily struggles for survival in a new land, the impact of the "Russians" at times made itself felt in a manner at once profound and marginalized: thus, for example, in Wendy Smith's account of the Group Theatre, we find Mark Schmidt, a Russian-born translator, supporting himself washing dishes for the Group in the summer of 1932 and reading aloud to the company in the evenings from his own hastily worked out translations of Pavel Markov's history of the First Studio of the Moscow Art Theatre, director Boris Zakhava's profile of Vakhtangov, and Boris Alpers's study of Meyerhold.[52]

Dance would undergo a shift in the late 1920s and early 1930s parallel to that of drama, as developments in American modern dance converged with developments in labor politics. Dance historian Mark Franko places modern dance at the center of labor-theatre aesthetics: "At the radical end of the spectrum, the primary physical practice of 'movement culture,' a euphemism for the culture of the Communist Party (CP-USA), was indubitably 'modern' dance."[53] Social activism through modern dance took multiple forms: "Modern dance of the early thirties had a significant amateur infrastructure. This relatively new form of modern movement was practiced in open dance classes for working-class people, and improvisation study was based on 'mass dance' for both men and women. Pageants using amateur dancers, such as Edith Segal's *The Belt Goes Red*, which was performed at the Lenin Memorial Meeting in 1930, satirized labor efficiency by showing assembly line work develop into a workers' insurrection."[54] The aim of the left modern dance movement was akin to that of Ellen Star at Hull House: to counter the mechanization of a laborer's life with the freedom of artistic expression. Franya Geltman, a dancer and political activist, recalls, "We felt that the workers had to dance, they had to ... We went to all the factories, the garment industry, which was a big thing, the IGLWU [International Ladies Garment Workers Union]. We went there, we handed out, and the first night, I shall never forget. They came in hordes, 10 cents we charged, 10 cents a dance. And they came and they came, and they left their machines at night, you know, and they came to dance."[55]

Of particular interest to collective creation studies was the movement in "Mass Dance." Fundamentally collectivist in philosophy and structure, mass dance was community-oriented, a pedagogical and choreographic form involving upwards of twenty to fifty amateur performers in collective improvisations.[56] Its proponents

included the dancer and choreographer Edith Segal, who established the New Dance Group in New York City in the early 1930s, a center for mass dance. Beyond creative freedom and expressive pleasure, amateur dance was viewed, in a communist context, as having radical potential as preparation for the anticipated insurrection, cultivating "the physical alacrity and interactive responsiveness needed to cooperate effectively with others in . . . spontaneous action."[57] The institutional structure of mass dance, informed by communist models, integrated the hierarchical with the collective: "In addition to performers, mass dance classes required a chairman, a dance leader, and a committee. The chairman's role was to lead preclass discussion, and to facilitate postperformance discussion. The dance leader was someone 'who can direct large groups of people, who understands the nature of a mass class, and who understands the theme as a revolutionary dance leader.' The committee chooses the dancer leader, and sees that the leader 'thoroughly understands the theme.'"[58] Like workers' theatre, mass dance was a "propertyless" form, eschewing the notion of ownership of ideas: "The subject-matter is social and is the concern of all the participants in the dance . . . It is therefore not the private property of the director, or even the group, but that of the audience and society."[59]

The Federal Theatre Project

The Federal Theatre Project (FTP), established in 1935 under the leadership of playwright and professor Hallie Flanagan, was at once the flowering and the death knell of collective workers' theatre in the United States. The FTP absorbed into itself the artists, methods, and politics of the Workers' Theatre Movement—which, as Colette Hyman notes in *Staging Strikes: Workers Theatre and The American Labor Movement*, ultimately made it "a favorite target of anti-communists, and led to its closing at the height of its activity and success," in 1939.[60] Viewed in terms of its federal funding, decentralization of theatre production, emphasis on social and political relevance, and deployment of such collective (Soviet-inspired) theatre-making practices as the Living Newspaper, the FTP was in many ways the manifestation of Percy Mackaye's dream of a civic theatre. Seen as collective, populist creativity subsumed, institutionalized, and killed off by governmental involvement, it is a manifestation of Romain Rolland's warning that a people's theatre must be free from state interests.

England

The line of development of modern collective creation in England followed a pattern not unlike that in America: emerging gradually from the theatrical sensibilities fostered within the left-leaning (socialist and Fabian) Little Theatres arising at the turn of the century and the wave of feminist and suffragist drama and pageantry that emerged circa 1910, the first, full manifestation of collective creation in England appears to be the collectively created agitprop of the British Worker's Theatre Movement in the late 1920s through the early 1930s. Where the two traditions diverge most strikingly, perhaps, regards the outcome of the Workers'

Theatre Movement. For if workers' theatre died an abrupt death in the United States in 1939, in England it underwent a metamorphosis, transformed in 1945 into the Theatre Workshop of Ewan MacColl and Joan Littlewood.

The British Workers' Theatre Movement has been excellently documented by social historian Raphael Samuel in *Theatres of the Left, 1880–1935*.[61] In addition to Samuel's own meticulous chronicle of the development of British left theatre from the period of the Second International (1890–1914) through the demise of radical collective theatrical action with the emergence of the People's Front, the volume includes archival documents (including instructions, circulated at the Workers' Theatre Movement First National Conference, in June of 1932, for "collective writing" and "agitprop style"),[62] play scripts, interviews, and memoirs—among them, Ewan MacColl's lyrical and deeply moving recollections of his personal theatrical development from the age of 14, when he cofounded the Red Megaphones in the industrial city of Manchester, through his meeting with Joan Littlewood in 1934. A "theatre of action" whose purpose was to provide dramatic representations of the grievances of striking workers throughout the Manchester region, the Red Megaphones was composed of impoverished, working-class adolescents. With little formal education and no background in the theatre, company members trained for their self-appointed task by organizing themselves into study groups for the purpose of researching the theoretical writings of Vakhtangov, Meyerhold, and Stanislavsky at the Manchester Reference Library:

> We weren't merely exploring the theories, we were having to learn the words that described the theories. When you went into the public library to read about something, you got the dictionary out automatically to help you over the hurdles of those big words. It was very exciting. We'd meet in the evenings and discuss all the things we'd found out that day, and we'd talk for hours and hours and hours after the work was finished, exchanging ideas. We were teaching each other . . . In the end, of course, we divided up the formalized research, "Right, you do this, and you do that, you read about this and tell us what you found out."[63]

MacColl's recollections are a testament both to the collective nature of the workers' theatres and to the transnational circulation of ideas fostered by communists' international networks and internationalist mind-set. The sources of exchange were many: Soviet theatre magazines, *Proletarian Literature*, chance encounters with immigrant radicals, formally organized exchange with communist theatre workers from the United States and Germany, correspondence with theatre workers overseas, global sharing of play scripts. MacColl's memoir is threaded through with such references: "I'd met someone who'd been to Germany and seen the Blue Blouses there . . . a Russian girl . . . known as 'Comrade Ludmilla.' . . . I remember her telling me about these groups she'd seen in Germany and Czechoslovakia. She told me what they did, how they had megaphones and would appear on a street and do very short political pieces. This stuck in my mind as something absolutely marvelous."[64] . . . "I started to correspond with a YCLer in Leipzig. He used to send me newspapers—like the *Arbeiter Illustrierte Zeitung* . . . I've still got things he sent me—like a script by Bert Brecht and Hans Eisler called *Auf den Strassen zu singen*. I

picked up a second-hand dictionary at Shudehill market in Manchester for a penny, and began to study German as best I could."[65] . . . "Our group were now in communication with the Workers Laboratory Theatre in New York. We'd got their address from a Manchester guy called Lazar Copeland, who'd been in America as a garment worker."[66] . . . "After the coming of Hitler, two guys turned up, representatives from the International Revolutionary Theatre Committee, a fellow called Otton, and one called Philip Minner . . . a member of the Kolonne Links—the troupe of the Left Column, one of the most highly praised of all the German Agitprop troupes."[67]

When MacColl and Littlewood met in Manchester in the early 1930s, Littlewood was an unemployed actress, fresh from the Royal Academy of Dramatic Art; MacColl was a radical theatre artist beginning to tire of the limited production values offered by agitprop. The worker, he reasoned, deserved his own theatre— for workers, by workers—but a theatre of quality. When Littlewood joined the troupe (now called the Theatre of Action), the company expanded, added a rudimentary training program for its actors, and took on the staging of full-length plays in indoor venues, complete with makeshift lighting ("Alf Armitt went out and pinched road lamps, took the lenses out of them, and made spotlights out of biscuit tins")[68]—and quickly ran afoul of Communist Party leadership. Refusing to accept Party recommendations for a restructuring of Theatre of Action, the company disbanded and reconfigured itself in 1935 as Theatre Union.

Littlewood and MacColl's Theatre Union in Manchester lasted four years, producing skits and pageants for the antifascist movement, and full-length antiwar plays: Hans Schlumberg's *Miracle at Verdun*, the Piscator-Brecht version of *The Good Soldier Schweik* (in a translation by MacColl, who had apparently mastered his Shudehill-market German dictionary),[69] Lope de Vega's *Fuente Ovejuna*, and Aristophanes's *Lysistrata*. The company's final production, *Last Edition* (1939), was "a living newspaper dealing with the events which had led up to the war." *Last Edition* marked the culmination of the group's years in agitprop, refined by their four-year exploration of full-length drama: "In it we used dance, song, mime, burlesque, mass declamation, parody . . . everything we had learned went into it." During the run of *Last Edition*, Littlewood and MacColl were arrested on a charge of disturbing the peace, fined, and bound over for two years. "This," MacColl recounts, "brought nine years' work in revolutionary theatre to a close."[70] But if Theatre Union died, group continuity did not. The collective of theatrical autodidacts sent itself off to war with a reading list.

Our last task in Theatre Union was to draw up an advanced study syllabus before actors and technicians were called up for services. Comprehensive reading lists were assembled covering every aspect of the theatre—history, theory and dramaturgy. Each member of the theatre nucleus undertook to study a different period aspect of the theatre: one would study classical Greek theatre, another the Commedia dell'Arte, another the Chinese theatre, another the Elizabethan and Jacobean theatre, and so on. At the same time, it was decided that each person would communicate his or her findings to the other members of the group. It didn't always work, but it gave us a sense of continuity, and when the war came to an end we were able to set up a full-time company (Theatre Workshop) immediately.[71]

Purge, War, Rupture, and Continuity

Stalinism and fascism cast a peculiarly long shadow across the cultural landscape as well as the political, warping and destroying artistic expression not only at home but across the European continent—indeed, across the Atlantic and into North America. In England, the demise of the WTM in the mid-thirties resulted on the one hand from the proclamation of Socialist Realism (in 1934) as the new modus operandi of the Soviet theatre—bringing about the end of agitprop as an expression of communist ideas internationally—and on the other, the rise of fascism with the attendant emergence of the People's Front and the call for unity and cohesion across all factions of the left—putting an end to the sectarianism that had been the hallmark of communist agitation in England between 1928 and 1934. Similar forces were at play in the United States, compounded by the government closure of the Federal Theatre Project.

And then came the war.

Arguably, it is the war, ripping across time, that leads to the erasure of those ties that link the culture of the thirties to the culture of the sixties—engendering the sense that the politics of theatrical collectivism were, somehow, born of the culture of '68. In the United States this would prove especially true, as artists on the left tamped down their politics or lost their jobs in the face of the anticommunist hysteria of the McCarthy years.

But World War II also left in its wake new waves of diaspora, and diaspora brought, as it always does, new confluences, collaborations, and legacies. This is perhaps nowhere so movingly attested as in the 2012 publication of Judith Malina's *The Piscator Notebook*. Judith Malina was 19 years old when she came to study at Dramatic Studio of The New School for Social Research (The New School, famously, had become a de facto haven for German intelligentsia in flight from the Hitler regime). It was 1945. Erwin Piscator, director of the Dramatic Studio since 1940, was 51. Piscator had left Germany at the beginning of the thirties to work in the Soviet film industry; with Hitler's rise, Piscator's sojourn became exile. Piscator believed in the Russian Revolution; however, as Europe moved toward war, Russia had little love for the Germans. Piscator had the good fortune to have made a trip to Paris in the summer of 1936; there, in early October, he received a warning telegram from a friend in Russia: "Don't Return (Nicht Arbreisen)."[72]

In 1938, Piscator left Paris for America, where, for a time, he found a new home. Appointed head of the Dramatic Studio of The New School, Piscator gathered around him an extraordinary team of American and immigrant theatre teachers: Raikin Ben Ari, a former member of the Habima theatre and colleague of Vakhtangov; Margrit Wyler, a former actress in the Vienna Deutsches Volkstheatre and the Zurich Schauspielhaus; Stella Adler; Lee Strasberg; Herbert Berghof. Under Piscator's leadership, the Dramatic Studio trained a generation of American theatre artists—among them, Judith Malina, Marlon Brando, Tony Curtis, Tennessee Williams, Elaine Stritch, and Walther Matthau.

The instatement of legacies of transmission into the seemingly broken history of collective creation matters, for such tales testify to the endurance of the ideal of the group and of a people's theatre. As we continue to sketch in the gaps in the

history, what we discover is not so much a "movement" but an alternative tradition, running parallel to the theatre of hierarchy and the dominance of the box office. Perhaps the most poetic testament to this peripatetic, multigenerational tradition lies in a brief journal entry made by Judith Malina during her year at the Dramatic Studio:

Monday March 5, 1945

I spent the morning in the 42 Street Library trying to find two letters for Mr. Piscator, and had the library staff helping me, though no one succeeded in finding either Romain Rolland's letter to Tolstoy or Rolland's letter to Gerhardt Hauptmann, which Mr. Piscator wanted for a Romain Rolland Memorial that he is organizing for the New School. Mr. Freedly, head of the drama department, who is always helpful, was not there. I had to cope with the impatient library staff. Now for my dancing class . . .[73]

Bibliography

"Aspiration, Acculturation and Impact: Immigration to the United States, 1789–1930." Harvard University Open Collections Program. Accessed December 1, 2012. http://ocp.hul.harvard.edu/immigration/settlement.html.

Barba, Eugenio. *Land of Ashes and Diamonds: My Apprenticeship in Poland, followed by 26 letters from Jerzy Grotowski to Eugenio Barba*. Aberystwyth, UK: Black Mountain Press, 1999.

Blair, Karen J. "Pageantry for Women's Rights: The Career of Hazel Mackaye, 1913–1923." *Theatre Survey* 31 (May 1990): 23–46.

Boyd, Neva L. *Handbook of Recreational Games*. New York: Dover, 1945.

Briusov, Valerii. "Against Naturalism in the Theatre (from *Unnecessary Truth*)." In *Russian Symbolist Theatre*, edited and translated by Michael Green, 25–30. Ann Arbor, MI: Ardis, 1986. Originally published as "Nenuzhny Pravda," in *Mir Isskusstva*, 1902, no. 4.

Franko, Mark. *The Work of Dance: Labor, Movement and Identity in the 1930s*. Middletown, CT: Wesleyan University Press, 2002.

Gropius, Walter. *Bauhaus Manifesto*, 1919. Reprinted in *Bauhaus, 50 Years*. London: Royal Academy of the Arts, 1968.

"Guide to the Chicago School of Civics and Philanthropy. Records 1903–1922." University of Chicago Library, Special Collections Research Center. Accessed December 1, 2012. http://www.lib.uchicago.edu/e/scrc/findingaids/view.php?eadid=ICU.SPCL.CSCP.

Hanley, Clifford. *Dancing in the Streets*. Long Preston, UK: Magna Print Books, 1958.

Harrington, John P. *The Life of the Neighborhood Playhouse on Grand Street*. Syracuse, NY: Syracuse University Press, 2007.

Hecht, Stuart J. "Social and Artistic Integration: The Emergence of Hull House Theatre." *Theatre Journal* 34, no. 2 (May 1982): 172–82.

Hohman, Valleri J. *Russian Culture and Theatre Performance in America, 1891–1933*. New York: Palgrave Macmillan, 2011.

"How the Vote Was Won." Aurora Metro Press. Accessed December 1, 2012. http://www.thesuffragettes.org/campaigning-performance/hidden/sapdd-biographies.

Hyman, Collette A. *Staging Strikes: Workers Theatre and the American Labor Movement*. Philadelphia: Temple University Press, 1997.

Innes, C. D. *Erwin Piscator's Political Theatre: The Development of Modern German Drama*. Cambridge: Cambridge University Press, 1972.

Ivanov, Viatchislav. "The Need for a Dionysian Theatre (from *Presentiments and Portents*)." In *Russian Symbolist Theatre*, edited and translated by Michael Green, 113–20. Ann Arbor, MI: Ardis, 1986. Originally published in *Zolotoe Runo*, 1906, nos. 5–6.

Krasner, David. "'The Pageant is the Thing': Black Nationalism and *The Star of Ethiopia*." In *Performing America: Cultural Nationalism in American Theater*, edited by Jeffrey D. Mason and J. Ellen Gainor, 106–22. Ann Arbor: Michigan University Press, 1999.

Mackaye, Percy. *The Civic Theatre in Relation to the Redemption of Leisure*. London: Mitchell Kennerly, 1912.

Mackaye Ege, Arvia. *The Power of the Impossible: The Life Story of Percy and Marion Mackaye*. Falmouth, MN: Kennebec River Press, 1992.

Malaev-Babel, Andrei. *Yevgeny Vakhtangov: A Critical Portrait*. New York: Routledge, 2012.

Malina, Judith. *The Piscator Notebook*. New York: Routledge, 2012.

Markov, Pavel A. *The Soviet Theatre*. London: Victor Gollancz, 1934.

Matich, Olga. "Dialectics of Cultural Return: Zinaida Gippius' Personal Myth." In *Cultural Mythologies of Russian Modernism*, edited by Boris Gasparov, Robert P. Hughes, and Irina Paperno, 52–72. Los Angeles: University of California Press, 1992.

Moore, Sarah J. "Making a Spectacle of Suffrage: The National Woman Suffrage Pageant, 1913." *Journal of American Culture* 20, no. 1 (Spring 1997): 89–103.

"Neva Leona Boyd Papers, An Inventory of the Collection at the University of Illinois, Chicago." Accessed December 8, 2012. http://www.uic.edu/depts/lib/specialcoll/services/rjd/findingaids/NBoydf.html.

Paperno, Irina, and Joan Delaney Grossman, eds. *Creating Life: The Aesthetic Utopia of Russian Modernism*. Palo Alto, CA: Stanford University Press, 1994.

Rolland, Romain. *The People's Theatre*. Translated by Barrett H. Clark. New York: Henry Holt, 1918.

Samuels, Raphael, Ewan MacColl, and Stuart Cosgrove. *Theatres of the Left, 1880–1935: Workers' Theatre Movements in Britain and America*. London: Routledge and Keegan Paul, 1985.

Senelick, Lawrence, ed. and trans. *Russian Dramatic Theory from Pushkin to the Symbolists*. Austin: University of Texas Press, 1981.

Simon, W. Paul. "Neva Leona Boyd, a Biographical Sketch." The Social Welfare History Project. Accessed December 1, 2012. http://www.socialwelfarehistory.com/people/boyd-neva-leona.

Slowiak, James, and Jairo Cuesta. *Jerzy Grotowski*. New York: Routledge, 2007.

Smith, Wendy. *Real Life Drama: The Group Theatre and America, 1931–1940*. New York: Alfred A. Knopf, 1990.

Williams, Jay. *Stage Left*. New York: Charles Scribner's Sons, 1974.

Notes

1. Romain Rolland, *The People's Theater*, 8.
2. Olga Matich, "Dialectics of Cultural Return: Zinaida Gippius' Personal Myth," 60.
3. Lawrence Senelick, *Russian Dramatic Theory from Pushkin to the Symbolists*, xxxix. A scholar of Hellenic religion, Ivanov departed from Nietsche's theory of the Apollonian-Dionysian synthesis and "singled out the latter as the true fount of tragic inspiration" (xxxix).
4. Viatchislav Ivanov, "The Need for a Dionysian Theatre," 116.
5. Ibid., 118.
6. Senelick, xl.

7. Valerii Briusov, *The Unnecessary Truth*, cited in Senelick, xlvii.

8. Andrei Malaev-Babel, *Yevgeny Vakhtangov: A Critical Portrait*, 28.

9. Malaev-Babel, 51–52, emphasis mine.

10. Malaev-Babel, 231.

11. See generally, Malaev-Babel, Chapter 24: "*Princess Turandot*: The Threshold of Creativity or the Making of a New Man," 209–30.

12. Leonid Volkov, in Malaev-Babel, 232.

13. For a period account of the phenomenal flowering of theatricality in the first years after the Revolution, see P. A. Markov, *The Soviet Theatre*, Chapter 1: "The Dramatic Forces Unleashed by the Revolution," 9–26.

14. Malaev-Babel, 241.

15. Rolland, 3–4.

16. Ibid., 133–35.

17. In Russia, *Le théâtre du peuple* appeared in 1919, with a forward by Viatcheslav Ivanov.

18. Kris Salata, Chapter 3 in this volume.

19. Given that Zavadsky (who, during the years immediately following Vakhtangov's death, was running his own avant-garde, experimental theatre studio) was, during the period of Grotowski's Moscow studies, of political necessity directing in a "strict social-realist style" (James Slowiak and Jairo Cuesta, *Jerzy Grotowski*, 5), it is far from clear just how much of Vakhtangov's insight was transmitted through Zavadsky's teaching. On the other hand, what is known is that, according to Grotowski, Zavadsky had enormous impact on Grotowski outside of the classroom. Eugenio Barba recounts how Zavadsky, much taken with Grotowski's work with actors, invited him to his home; showing Grotowski his awards and other perks of his professional status, Zavadsky whispered, "I have lived through dreadful times, and they have broken me; remember, Jerzy: *nie warto*, it is not worth it. This is the harvest of compromise." (Cited in Eugenio Barba, *Land of Ashes and Diamonds: My Apprenticeship in Poland, followed by 26 letters from Jerzy Grotowski to Eugenio Barba*, 24). Grotowski, who considered Zavadsky one of his greatest mentors, credited that whispered exchange with having given him "the strength to resist the pressures of compromise during his years of working under a repressive political system" (Slowiak and Cuesta, ibid.).

20. Walter Gropius, *Bauhaus Manifesto*, 9.

21. "Aspiration, Acculturation and Impact: Immigration to the United States, 1789–1930," Harvard University Library Open Collections Program, accessed December 18, 2012, http://ocp.hul.harvard.edu/immigration/settlement.html.

22. Stuart J. Hecht, "Social and Artistic Integration: The Emergence of Hull House Theatre," 173.

23. "Guide to the Chicago School of Civics and Philanthropy. Records 1903–1922," University of Chicago Library, 2010, http://www.lib.uchicago.edu/e/scrc/findingaids/view.php?eadid=ICU.SPCL.CSCP.

24. W. Paul Simon, "Neva Leona Boyd, a Biographical Sketch," The Social Welfare History Project, accessed December 11, 2012, http://www.socialwelfarehistory.com/people/boyd-neva-leona. See also, "Neva Leona Boyd Papers, An Inventory of the Collection at the University of Illinois, Chicago," accessed December 14, 2012, http://www.uic.edu/depts/lib/specialcoll/services/rjd/findingaids/NBoydf.html.

25. For an account of the Neighborhood Playhouse and its relationship to the Henry Street Settlement, see John P. Harrington, *The Life of the Neighborhood Playhouse on Grand Street*.

26. Ibid., 264.

27. Ibid., 90.

28. Measured in terms of longevity, the Guild was the most successful of the Little The-
atres; it was this very success that made the Guild suspect in the eyes of the next gen-
eration of insurgent theatre makers, for success had necessitated compromise between
experimentation and commercial appeal. It was also, perhaps, success that made the
Guild's executive committee oppressive; having struck a balance that worked, insofar
as it allowed the Guild to survive long enough to propose and maintain new standards
of quality in the New York theatre, the Guild's board was hardly likely to take on the
kinds of commercial risks proposed by the visionary triumvirate Clurman-Strasberg-
Crawford. In this respect, the Guild played a role vis-à-vis the young Group Theatre
reminiscent of that of Nemirovich-Danchenko toward Stanislavsky (discussed in
Chapter 2): having set in motion a successful experimental model of theatre making,
Nemirovich-Danchenko in Moscow, like the Theatre Guild in New York, would prove
loathe to risk the long-term stability of the institution he had cofounded for the sake
of further experiment.

29. For a detailed treatment of the Group Theatre's development, see, generally, Wendy
Smith, *Real Life Drama: The Group Theatre and America, 1931–1940.*

30. Ibid., 107.

31. See generally, Smith, Chapter 4: "New Horizons (Summer, 1932)," 84–106.

32. Sarah J. Moore, "Making a Spectacle of Suffrage: The National Woman Suffrage Pag-
eant, 1913," 89.

33. See generally, Percy Mackaye, *The Civic Theatre in Relation to the Redemption of Lei-
sure,* and more particularly, the section "American Pageants," 161–77.

34. Ibid., 68–69.

35. "SAPDD Biographies," accessed December 18, 2012, http://www.thesuffragettes.org/
campaigning-performance/hidden/sapdd-biographies. TheSuffragettes.org, compiled
by Aurora Metro Press, an independent British publisher, is devoted the history of the
Actresses Franchise League: "It aims to document their work in creating campaigning
theatre and record the histories of individuals active in and around the League, but
also the wider use of performance in the women's suffrage movement" (http://www
.thesuffragettes.org/about-us/our-project).

36. Moore, 92.

37. Karen J. Blair, "Pageantry for Women's Rights: The Career of Hazel Mackaye, 1913–
1923," 34.

38. Moore, 92.

39. Blair, 35.

40. Moore, 94.

41. Moore, 91–92.

42. Harrington, 40–43.

43. Moore, 90.

44. Percy Mackaye, 67.

45. Hazel Mackaye, cited in Blaire, 38.

46. Collette Hyman, *Staging Strikes: Workers Theatre and the American Labor Movement,* 20.

47. Hyman, 13; see also, Jay Williams, *Stage Left,* 35.

48. Hyman, 20.

49. Ibid., 22.

50. Ibid., 20–21.

51. Ibid., 28, 30, and Williams, 38.

52. Smith, 91.

53. Mark Franko, *The Work of Dance: Labor, Movement and Identity in the 1930s,* 3.

54. Ibid.

55. Fanya Geltman, cited in Franko, 3–4.
56. From Jane Dudley, "The Mass Dance," in *Dancing Modernism/Performing Politics*, ed. Mark Franko (Bloomington: Indiana University Press, 1995), cited in Franko, 24.
57. Franko, 27.
58. Franko, 24.
59. Edith Segal, "Directing the New Dance," *New Theatre* (May 1935), quoted in Franko, 25.
60. Hyman, 30.
61. Raphael Samuels, Ewan MacColl, and Stuart Cosgrove, *Theatres of the Left, 1880–1935: Workers' Theatre Movements in Britain and America*. The book also includes important material concerning the parallel development of workers' theatre in the United States assembled by Stuart Cosgrove.
62. "The Basis and Development of the Workers Theatre movement," in Samuels, MacColl, and Cosgrove, 102–5.
63. Ewan MacColl, "Theatre of Action, Manchester," in Samuels, MacColl, and Cosgrove, 244–45.
64. Ibid., 228.
65. Ibid., 229.
66. Ibid., 245.
67. Ibid.
68. Ibid., 247.
69. C. D. Innes, *Erwin Piscator's Political Theatre: The Development of Modern German Drama*, 224.
70. Ibid., 253.
71. Ibid., 253–54.
72. Malina, *The Piscator Notebook*, 10.
73. Ibid., 65.

Revolution in the Theatre I

Meyerhold, Stanislavsky, and Collective Creation, Russia, 1905

Kathryn Mederos Syssoyeva

On a long since forgotten day in March of 1905, Konstantin Stanislavsky and Vsevolod Meyerhold met at an unrecorded location and, talking together for an unknown number of hours, laid the aesthetic and organizational foundations for Russia's first research theatre. It was an event as momentous, if less well documented and less romanticized, as the legendary 18-hour meeting between Vladimir Nemirovich-Danchenko and Stanislavsky at the Slavianskii Bazaar restaurant on June 22, 1897, that had given rise to the Moscow Art Theatre—for it launched Russia's second wave of theatrical transformation: the emergence of the theatre studio as a laboratory for the generation of new methodologies and new forms.[1]

Established eight years after the founding of the Moscow Art Theatre (MAT), the Theatre-studio was conceived, in Stanislavsky's words, as an alternative to the "daily performances, complex obligations, and tightly calculated budget" of the commercial theatre. For Stanislavsky, this "special institution" was "a laboratory for actors"[2]—for Meyerhold, "a theatre of research into new scenic forms."[3] Those research-based principles of production were soon to become the foundation of Russian and Soviet theatrical experimentation.

Launched in a period of political and economic turmoil, the Studio lasted a scant half-year and never gave a public performance. Yet in those six months Meyerhold and Stanislavsky together laid the aesthetic and institutional foundations for their respective, divergent theatrical revolutions. Meyerhold's experimental rehearsals engendered new scenic forms (synthetic theatre, symbolic and conventionalized staging, music-driven drama, compositional use of the acting body), new modes of collaboration, and new rehearsal processes. And Meyerhold and Stanislavsky's shared institutional vision brought into being a new model of production.

If the measure of an epistemological rupture is the degree of resistance and debate it provokes, the longevity of its influence, and the degree of change in

its wake, then the Theatre-studio's six-month existence constitutes a rupture in the history of theatre practices. In the wake of the Studio's closure, the notion of theatre-as-research evolved and spread throughout Russia. Studio, laboratory, and research theatres proliferated. The succession of studios subsequently established by Stanislavsky and the studios and schools created by Meyerhold were founded upon the model of the research theatre. Likewise the numerous studios established in Petersburg and Moscow throughout the 1910s and 1920s, by directors of greater and lesser fame—Nikolai Evreinov, Grigori Kozintsev and Leonid Trauberg, Boris Ferdinandov, Nikolai Foregger and Vladimir Mass, and the filmmaker Lev Kuleshov, to name but a few. It was a model of practice that was to know significant periods of resurgence, notably during the 1980s under the presidency of Gorbachev in the years leading to *perestroika*. And it was to have significant impact on practitioners outside of Russia—most famously, Jerzy Grotowski. Through the inspirational force of Grotowski's work, in turn, the research-theatre model would work its way around the world, in varied guises: Poland (Włodzimierz Staniewski's Gardzienice Center for Theatre Practices), Paris (Peter Brook's Centre International de Recherche Théâtrale), Oslo (Eugenio Barba's Odin Teatret), Italy (The Workcenter of Jerzy Grotowski and Thomas Richards), and back to Russia (Anatoly Vasiliev's School of Dramatic Art).

This chapter focuses on a triad of investigations into collaborative method, conducted by Stanislavsky and Meyerhold during the period of their creative partnership under the auspices of the Povarskaia Street Theatre-studio: improvisation, collaboration with scenic artists, and collective creation. Each of these investigations must be understood as emergent—an idea articulated through practice but not, quite yet, brought to fruition. Stanislavsky's early assay at improvisation, though it would in the long run lead to development of the System, in the short run produced only miscomprehension and conflict. Meyerhold's first collaboration with scenic artists, though it opened the way for Russian synthetic theatre movement and the rise of the scenic designer, would pass almost unnoticed by historians—and dismissed by Stanislavsky. As to Meyerhold's exploration of collective creation, it might best be thought of as a prototype, partially tested in practice, further articulated in subsequent theoretical writing. The Theatre-studio itself, by November, would "fail"—collapsing under the combined weight of personal and institutional conflicts, aesthetic disagreements, economic crises, and political revolution.

And in the process of all these tenuous ventures, new terrain was mapped, new paths opened.

Politics and theatre had much in common in Russia of 1905: it was a season of ambivalent autocracies and stillborn revolutions. The nature of leadership, the role of parliamentary debate, the rights of individuals—these concerns dominated public discourse that summer and autumn. Russia's monarchy teetered on the brink of collapse; the empire seemed poised for radical change.

It was amid this upsurge of social, political, and economic turmoil that Stanislavsky made the decision to launch a new theatre company. Since 1904, he had been dreaming of founding a network of provincial touring companies, offshoots of the Art Theatre, to carry the aesthetic and educative values of MAT into the

distant reaches of the Russian Empire. He set his project in motion in February 1905 with a telegram to Meyerhold inviting him to lead what he projected would be the first in a series of such touring companies. Meyerhold was at that time running a company of his own—The Fellowship of the New Drama, in the provincial city of Kherson, on the Black Sea in Ukraine—and dreaming of a return to Moscow.[4]

Meyerhold and Stanislavsky met in Moscow in March—a catalytic encounter, of which we have no written trace. We know only that by the time Meyerhold returned to Kherson to finish out the theatrical season, Stanislavsky's plan for the nationalization of the Moscow Art Theatre had been replaced by a vision at once more modest and more far reaching: a "special institution," Stanislavsky tells us in *My Life in Art*, "to which Meyerhold gave the fortuitous name, Theatre-studio."[5] This new institution was to operate in Moscow in loose affiliation with the Art Theatre, though in a venue of its own;[6] touring plans were deferred. It was to be staffed by a company of young actors: a mix of recent Art Theatre graduates, a pair of students from the Alexandrinsky Theatre School, and the best of Meyerhold's Fellowship of the New Drama. At its helm, in addition to Meyerhold and Stanislavsky, was the opera impresario and art patron Savva Mamontov. Together, Stanislavsky, Meyerhold, and Mamontov made up the directorate, with administrative support from managing director Sergei Popov, an industrialist and amateur actor, and artistic support from a team of three associate directors. The young modernist composer Ilya Sats was placed in charge of the theatre's music department; symbolist poet and theorist Valery Briusov, its literary department; and associate director Valery Repman, its scenic design department, overseeing a design staff of some half a dozen fine artists. The company's mission was to develop new theatrical methods and forms that might breathe life into the "New Drama"—antirealist plays by such contemporary dramatists as Przbyszewski, Maeterlinck, Hauptmann, and Ibsen.

Between March and May, Stanislavsky and Meyerhold put the infrastructure in place, and on May 5, the newly founded company gathered in the foyer of the Moscow Art Theatre for its first meeting. Through the month of May, Meyerhold worked with his design and directing team in Moscow, conceptualizing scenic space for a series of proposed productions. He also assisted Stanislavsky during preliminary rehearsals for the Moscow Art Theatre production of Knut Hamsun's *Game of Life*. June through August, Meyerhold and his Theatre-studio retreated to the countryside north of Moscow (to the Abramtsevo and Pushkino estates, site of the Moscow Art Theatre's first months of developmental work seven years earlier), where they rehearsed three productions slated to open in Moscow that autumn. In late August, the Theatre-studio returned to Moscow to rehearse in a theatre on Povarskaia Street, which Stanislavsky had rented and renovated at his own expense. From September through October—two chaotic months of social, political, economic, institutional, and personal turmoil—the young company attempted to bring their productions to completion. On November 7, the Theatre-studio permanently closed its doors, without ever having opened to the public.

The creative blossoming of the Theatre-studio occurred in the period from May to August. This is likewise the period in which the presence of the studio, and

the proximity of Meyerhold, had the most direct impact on Stanislavsky's think-ing. The first phase of creative shift occurred in May in Stanislavsky's own rehears-als. Under the influence of his new collaborator, Stanislavsky began to improvise.

Scholars Deirdre Hedding and Jane Milling have done a great deal of work establishing the centrality of Stanislavsky's improvisational techniques to the Brit-ish, American, and Australian collective creation movements of the 1950s, 1960s and 1970s.[7] The first part of this chapter aims to return to the moment in which improvisation emerges as rehearsal method; to reinstate Meyerhold into that his-tory; and to map the confluent development of related practices, deriving from a constellation of concerns about the nature of collaboration, creativity, group interaction, and leadership, unfolding within a particular moment of social flux, in which analogous issues of leader and group, control and cooperation, were at play within the political sphere.

More than any other experiment in collaboration conducted during those six months of 1905, Stanislavsky's attempt to shake up the methods of the Moscow Art Theatre "failed." We are left to glean the details of efforts and aims through a close reading of the backlash they provoked. And yet, not unlike the political revolution without, Stanislavsky's artistic attentat—his assault on the creative dic-tatorship of the director—was a critical first step in a longer process of upheaval. Drawing strength from resistance, Stanislavsky in the coming months and years would retreat, rethink, and reemerge with a clearer, stronger vision of those meth-ods that were to revolutionize aesthetic practice.

Improvisation

In May, Stanislavsky invited Meyerhold to participate as a second director in pre-liminary rehearsals for MAT's production of Knut Hamsun's *Game of Life*. Direct-ing at the Art Theatre in this period was a team endeavor: the principle director (normally Stanislavsky, occasionally Nemirovich-Danchenko) prepared the mise en scène, supervised scenic artists, ran key rehearsals, and guided the artistic devel-opment of the show; the second director ran general rehearsals and worked closely with actors in accordance with the directorial plan. The position of second direc-tor differed from that of assistant director in that it afforded a larger measure of creative freedom within the strict aesthetic limits established by the lead director. The division of labor among directors at the Art Theatre was in flux in this period: under discussion and subject to revision from season to season and show to show. This chronic state of change was further complicated by the joint artistic director-ship of Stanislavsky and Nemirovich-Danchenko.

At the time of Meyerhold's return to the Art Theatre, the directing team consisted of Stanislavsky, Nemirovich-Danchenko, and the actor-directors V. V. Luzhski and I. M. Moskvin. Meyerhold's unexpected incursion into this closed world provoked anxiety, competition, and resentment. The arrival of Meyerhold, marked as an "innovator" whose task it was to revitalize their floundering company (inevita-bly prompting the inference that Stanislavsky judged his present team artistically insufficient), was destined to provoke resistance.

Stanislavsky gathered directors and cast for the first read-through. Normally a MAT first reading would begin with a conversation about the play, led by the director, laying out the aesthetic structure, with the dual aim of inspiring the actors and guiding them, from the outset, in a predetermined direction. A reading of the play would ensue, followed by further discussion and analysis; design models would be shown to the actors, visual research shared. Typically, this conversation would in turn influence the refinement of the mise en scène, much of which had been prepared in advance.

Stanislavsky commenced this particular read-through with the announcement that new methods would be employed in this production. No directorial plan. No group discussion and analysis. No predetermined "tone." The actors were to get on their feet and enact scenes under the sole guidance of their individual, internal impulses. Their choices and discoveries would provide the material from which the director's staging concept would be constructed.

With none of the preparatory discussion to which they had become accustomed over the past eight years, the company commenced to read Hamsun's text. Upon conclusion of the read-through, the actors were at a loss: variously perplexed, bored, resistant, indifferent—only two or three, we are told, expressed enthusiasm.[8] They did not understand the play; they did not understand the anti-analytic approach.

Nemirovich-Danchenko would later say that he had been on the verge of intervening: "What should I have done after such a read-through? What I wanted to do. Launch straight into a discussion to inspire the company, draw them into the artistic atmosphere by means of drawings and prints, which will in turn inspire a series of scenic incarnations, and awaken the director as well." But Meyerhold, Nemirovich tells us, spoke out first: "Then, suddenly, a director says, 'I don't know how to stage this play, but the one thing I do know is that no discussion is needed: you need to get on stage and act.' Or, rather, this was said not by a director, but by a gentleman who risks nothing; whatever nonsense he speaks, it's our heads on the block . . . Meyerhold."

The proposal to abandon analytic discussion in favor of improvisation constituted a radical departure from established Art Theatre methods. The shift in approach appears to have grown out of a private dialogue (an outgrowth of their planning sessions for the new Theatre-studio) between Stanislavsky and Meyerhold about new rehearsals methods—a dialogue to which Nemirovich-Danchenko had not been privy. But neither Stanislavsky nor Meyerhold left a record of the event—perhaps because it was only a first step in a long process (very different for each director) of rethinking the director's work with the actor, and did not yet produce measurable results. Indeed, before the evening was out, Stanislavsky's first attempt at altering the methods of the Moscow Art Theatre proved abortive: Upon hearing what Meyerhold had to say, Nemirovich called a halt to the rehearsal.

> It was either such genius that my modest brain can't grasp it, genius to the point of madness, or the useless ramblings of a tired mind, raving on and on. But given that Meyerhold, whom I have known since his first year, has never shown signs of genius, and now seems to me merely one of those poets of the new art who are for the new

because they have proven themselves utterly incapable of doing anything of note in the old; and given that, on the other hand, I saw you clutching at straws just so as not to lose time, and then simply turn stubborn, offended, and capricious; and, finally, given that I sensed immediately that such a way of working would immediately create an all too familiar chaos, dissatisfaction, loss of time, even destroy the play—I gathered up all my energy in protest.

It is thanks to Nemirovich's bewildered fury that we have a record of what transpired. That June he wrote a long and damaging letter to Stanislavsky: a 28-page, rage-fueled analysis of their artistic partnership, foreshadowing and contributing to the eventual demise of their collaboration. That letter provides a glimpse into a fraught debate—on the nature of groups, leadership, and creative process—and the intense emotions that debate provoked. Nemirovich's recollections of the May read-through lie at the heart of his critique. For Nemirovich, Stanislavsky's foray into improvisation symbolized, on the one hand, a streak of willful caprice at the heart of Stanislavsky's artistry—on the other, the threat posed by Meyerhold's "influence": "Under the influence of that babbling idiot Meyerhold about the need to rehearse any old way, you had an urge to employ methods of which, it seems, you had 'long dreamt.' This is a particularly vivid illustration of your longing to throw off the guardianship of reason."

In refusing to permit the proposed improvisation to proceed, Nemirovich believed he was fighting for the very existence of the Art Theatre. As to Stanislavsky, his immediate reaction to that intervention is lost to us. But Stanislavsky's anger runs like a subtext between the defensive lines of Nemirovich-Danchenko's letter: "I had to do this. I did not dare act otherwise. In my place, you would have done the same. It was not I, like some usurper, who took into my own hands the right to protest, but you, you yourself, who has for all these years entrusted in me the right to uphold the institutional structure of the theatre. And to uphold this structure means, at times, to impede even you, in those situations where you begin 'to destroy with one hand' what you create with the other."

Just what was it Nemirovich found so alarming in the proposal to improvise? In part, it was the notion of the actor as collaborative partner—what we might now term the *actor-creator*. He is unable to envision an actor capable of independently generating original scenic material. We are not speaking here of devised text, but of mise en scène, even line readings. Art Theatre actors, at this early stage, were constrained by a fairly rigid interpretational schema, largely predetermined by the director. Nemirovich hints at this working method in fragments throughout his letter to Stanislavsky: "When you are on stage, showing the actors how to express this or that, gripped by the profundity of the scenic image . . . you are a very great director"—"The actors' tone for the first act, we investigated together"—"A director must, at the minimum, arrive at rehearsal knowing the play's 'diction'"—"You yourselves look for tone first of all." Nemirovich implies that an actor, without the inspiration of a directorial vision, is incapable of offering an interpretation ("tone") of his own: "You wanted the actors to go up on stage and enact excerpts from the play, for which neither they nor the director had a single image!! Without yourself decisively conceiving of either character or tone, you wanted to get

material for the show from their enactment! To derive a new tone for the production, from these strange performances of the characteristics and temperaments of actors familiar to you down to the last detail."

Thanks to Nemirovich's dialogic gifts (he was a playwright, after all), the letter affords tantalizing glimpses into Stanislavsky and Meyerhold's proposals and intentions: "Above all, you liked that there would be no need for discussion, for analysis, for psychology . . . Suddenly, you wanted actors to learn scenes, and up and rehearse without any mise en scène—play tricks—satirize—just play something. I offered a list of examples, a long series of examples, when we had done exactly this . . . But you say, 'that's not the same.' You say, 'Then the director still had a stock of images, but in *Game of Life* there is no such reserve, the actors must provide it themselves through trial and error.'"

Nemirovich is disturbed by the seeming lack of leadership improvisation implies. Improvisation in search of expressive techniques, a commonplace today, represented a sharp break from the (so recently established) tradition of director as absolute authority. It required a willingness on the part of the director to begin rehearsal from a position of uncertainty, of public not-knowing—a position that Nemirovich-Danchenko viewed as a dangerous relinquishing of necessary authority over the creative group. For Nemirovich-Danchenko, authority equals certainty—above all, the outward display of certainty.

> I understand the director who arrives at rehearsal (or the first discussion, no matter) with a fully developed vision of the play, formed in his singular, individual soul, independently, under the pressure of his individual, artistic world view, those artistic details that he perceived in the text, those tones—of color and sound—which conveyed to him his feeling of the play, his scenic experience.
>
> Perhaps he doesn't yet know the staging in detail, doesn't yet know where he will have to modify his concepts under the influence of the actors and designers with whom he is going to work (but modify without changing the overall image, the general tone), but he has a good sense of the atmosphere of the play, into which he is going to draw the performers—knows the play's color, it's diction.

He offers examples of greater and lesser talent: MAT director Karpov, staging Ostrovsky, "trivially, shamefully, but confident and convinced"; himself, setting to work on *When We Dead Awaken* and *Pillars of Society*, "My imagination might prove inartistic, my plan flawed, my investigation might be tentative—but I know with absolute clarity what I want and what I don't want"; Stanislavsky, developing *The Sunken Bell*, *The Ascension of Hannele*, *Merchant of Venice*, and *A Law Unto Themselves*,[9] "You don't yet know how to express the forces of nature with which Henry contends, how to convey the ghostly shadows in *Hannele*, but you know the impression you're going after—you don't yet know the period costumes for *Law Unto Themselves*, but you have a feeling about them, sensing that they are not from the 1770's, but from the very end of the century."

Interwoven with this aesthetic argument we find a concern with power—with the qualities of leadership. Talent, he tells Stanislavsky, varies, of course, but while talent determines "the artistic significance of the result," it is not talent that is key

to the "success" of the work; it is certainty: "a confident attitude, unanimity." Such confidence is a personal quality, independent of experience—and there is no conflict between confidence and innovation: "An absolute innovator might possess this same confident attitude. A director whose every artistic detail is new, with a flair for suggesting new methods of acting, design, and light. That was you with the fourth wall, with pauses, with the importance of sounds on the stage, and so on. That was that someone who staged *The Seagull*, consisting of the strange combination of you and me, when one (I) sensed the play's atmosphere and direction, and the other (you) divined the staging. We—I in my sphere, you in yours—were the confident bearers of particular artistic ideas."

For Nemirovich-Danchenko, the source of ideas is established knowledge (texts, artworks, discussions with knowledgeable people) and verbal exchange: it is only in the realm of conversation (table work) that he can credit the actor's collaborative capacities at the early conceptual phase. The appropriate response to uncertainty is research—conversation, image research, planned experimentation:

> One must immerse oneself in the play itself, talk about it right and left, with anyone who might even be the least bit useful—designers, actors, critics—to have two or three more discussions than usual (by no means burying it in so much detail that the feelings dry up)—one must look at tens, hundreds, thousands of paintings and engravings—until, at last, some sort of imagery, detail, color, sound, begins to tremble in the soul of the director, responding at once to the play and to him, to the director, as is characteristic of the artist. If these tremulous images do not yet create the complete staging image for him, then they provide him some fragments. If he tries them out on stage, all the better. For example, you envisioned a market in the shadows, and tents, and you try it, you tell your colleagues, "prepare me this and this and this, and give me twenty people"; to these twenty people you say, "Move this way and that way, light the stage for me this way . . ."; etc. You *make manifest the images already born in your soul* . . . If it works, good; if it doesn't, nothing terrible, I've confirmed that it doesn't work.

This, Nemirovich stresses, is how MAT has worked for seven years; they have always experimented; there has always been room for innovation. "It is," he continues, "just one step from there to the director freed up from the responsibility of arriving at the first rehearsal with a ready plan." In short, the "new" Meyerhold-Stanislavsky approach is less radical than wrong. "The essential thing is what I underscored above: the director tries things he has *already felt*, tries to stage images already *formed* in his soul." To do less is to indulge caprice, and caprice is the province of the dilettante.

According to Nemirovich, Stanislavsky, since his early days as director of the Society of Art and Literature, has matured from dilettante to professional—and Nemirovich-Danchenko is the self-appointed guardian of that professionalism. Nemirovich's role in their collaboration, as he sees it, is to curb Stanislavsky's caprice for the greater glory of Stanislavsky's artistry and the health of their shared institution. The theatre, he explains, unlike solitary art forms such as writing or painting, is a group activity, and groups require strong leadership:

The painter, musician, poet or sculptor might be led by whatever whim he pleases. That is a matter between him and his brush, or plume, or chisel . . .

Why shouldn't the great artist Alekseev also be capricious, having gathered round himself those who came to fulfill his every whim in productions at the Hunting Club?[10]

But Stanislavsky did not confine himself to the role of artist-dilettante. He sensed that he could play the leading role not in an amateur club (though doubtless one with artistic aspirations), but in a great artistic institution, regulated—because it *is* an institution—by a specific system, incorporating within itself a great many people and striving towards the growth and strengthening of the souls and artistic talents of these people.

Can a director-artist in such an institution follow his whims in the search for tone?

He might proceed in confusion, yes. He might make a mistake in the expression of this or that scenic image that he temporarily cherished—yes. And in this case there have been few situations in which you were impeded either by me or by the actors.

But to be capricious, to play with time, the actors' energy, their self-esteem, to spin them about, literally like pawns—no, that is impermissible.

In setting forth the aesthetic and managerial rationale behind his actions, Nemirovich strikes at the heart of a crack emerging in the foundations of the Art Theatre: a tug of war between commercial endeavor and experimentation. What he would call his "directorial *profession de foi*" is an articulate defense of the theatre as a commercial institution. In this Nemirovich was a man of his political, as well as artistic, moment; his intertwined impulses—his will to maintain Stanislavsky in a position of authority while constraining the terms of that authority, to exalt while resenting—seem to double the national mood, the uneasy attitude toward autocracy in these early, ambivalent days of the 1905 Revolution: "When you spoke to the company about the affiliated division, you were a very great human being. With all my soul, the soul of a mature man, I admired you deeply—one wants to look up to such a human being. When you are on stage, showing the actors how to express this or that, gripped by the profundity of the scenic image . . . you are a very great director, and with all of my artistic exigency, I admire you. This is Stanislavsky, deserving of his glory."

Nemirovich alternately assaults and fawns, sets Stanislavsky on a pedestal and castigates him for his humanity. Slipping into increasingly personal attack, Nemirovich reveals an inability to recognize any possible connection between Stanislavsky's phases of apparently directionless creative experiment and periods of focused innovation: only the latter has value; the former he treats as a kind of cancer to be excised from the body of the artist.

But when, unbeknownst to yourself, from intellectual fatigue and a slackening of real artistic force, you turn serious business into a plaything for yourself, or, without noticing, fool around gratifying your pride . . . then you are a talented brat, engaged in trifles. At such times I can no longer look up to you as someone engaged in serious work; the sharp discord between what you do in these moments and the seriousness you demand of the actors provokes negative feelings toward you. Dilettantes like Stakhanovich or Zinaida Grigorievna, present at such rehearsals, get carried away along with you, because for them these rehearsals are games, and you, a talented

playmate. But for myself, and for all of those who are, by nature, not dilettantes, there is in these games something downright offensive, which is forgiven you for the sake of all your great strong points.

Stanislavsky's response to Nemirovich-Danchenko's letter was brief, pained, and characteristically fraught with self-doubt. Its essence may be summed up in one brief excerpt: "I beg only one thing of you. Make my life in the theatre— possible. Give me at least some satisfaction, without which I cannot go on working. Do not let the time come when love for and faith in our theatre is snuffed out *forever*. Remember that at this moment I, like all of us, am too caught up in what is happening to Russia."[11]

A long struggle ensued—indeed, it would last for years: Nemirovich and Stanislavsky were wrestling with their collaboration, with the nature of artistic process, and with the shape of the institution that might best nurture those processes. At issue was the structure of collaborative partnership: individual freedom versus institutional responsibility; the right of each partner to dictate artistic terms; the appropriate channels of communication; responsibility to the collective.

We witness here a shifting attitude toward the role of the theatre director, only a few years after the profession first makes its appearance in Russia. The nature of directorial authority is in flux. In making space for a greater creative contribution by the actor to the mise en scène, Stanislavsky and Meyerhold are, de facto, calling into question the conceptual dominance of the director. Directorial authority is hardly something either man would have wanted to relinquish: they were autocrats of the theatre. But their creative autocracy is of a different order than that of Nemirovich-Danchenko, who cannot imagine the actor as a creative partner, and who places implicit emphasis on a certain efficiency of the creative process: each phase of the work must either produce a viable result or reveal a misstep; conscious decisions must be made at each step of the process; periods of generative activity that produce delayed creative results are excluded from his thinking. It is this division, on the nature of creative process, that will ultimately divide the Art Theatre.

Stanislavsky would slip into a depression that year. The causes were many—war, personal losses, the failed and frightening revolution—these certainly numbered among them, as did his failed effort to carve out a place for artistic research within what he was finding to be the increasingly oppressive structure of the institution he had built. In the summer of 1906, he would retreat to Finland to recuperate. There he would begin his first writings on the System. In the years between 1906 and 1911, Nemirovich and Stanislavsky would continue to struggle over the direction of the Art Theatre; much of their conflict would revolve around questions of improvisation and preparation. And in 1911, Stanislavsky would establish the First Studio—an institutional space within which he could pursue his ever-deepening research into the internal, creative freedom of the actor.

Designer-Director Collaboration

Meyerhold spent the better part of May closeted in the model workshop provided for the Theatre-studio by MAT, with his own directing team (A. S. Kosherov, G. S. Burdzhalov, and V. E. Repman)[12] and four young painters: Nikolai Sapunov, Sergei Sudeikin, Nikolai Ulianov, and Vasilii Denisov. The team's pragmatic objective was to produce the set designs for both the autumn season and for several projected productions beyond. Their research goal was to devise staging techniques appropriate to the literary forms of the new drama and to revitalize scenic art with new technical methods.

Sapunov and Sudeikin, possessing a modicum of theatre experience that the other painters lacked, worked in relative independence on designs for Meyerhold's upcoming production of Maeterlinck's *The Death of Tintagiles*; Ulianov and Denisov worked in close collaboration with the directors on a selection of plays planned for later in the season, including Hauptman's *Schluck and Jau*, and *Colleague Crampton*. At the Moscow Art Theatre, exploring design possibilities meant producing a series of three-dimensional models until the artists had arrived at a scenic concept satisfactory to the director.[13] In keeping with the realist-historicist underpinnings of MAT's naturalism in this early period and the theatre's emphasis on rigorous preparation, the approach emphasized architectural accuracy and mathematic precision even at the conceptual phase. Having no theatre background, none of the younger artists engaged by the Theatre-studio were trained in this process. In his memoir, the painter Ulianov tells us that Stanislavsky would drop by the studio to monitor progress, personally instructing the artists in the techniques of model construction and conceptualization of the three-dimensional scenic space, supervising their work, "ruler in hand, measuring, calculating, cutting away the excess, tightening."[14] Ulianov expresses gratitude to Stanislavsky for his involvement in their professional formation. But his descriptions of that May also reveal the tedium and frustration of working three-dimensionally in this early phase of the creative process: "Models were glued together and broken apart, variations discussed, countless variations. The lack of success was infuriating; even more infuriating, those endless collations of scale, of yards and inches."[15] The atmosphere among the painters was tense, and intense: "It was crowded, hot, airless in the model workshop. There were passionate discussions, and the seeds were planted for projects for a theatre that was not to be a repeat of the ordinary, commonly accepted, already dying scenic forms."[16]

The Russian term for building set models, клеить макет—"to glue the maquette"—evokes the fussiness of an activity that the design team quickly found to be an encumbrance to innovation and the flow of ideas. Ulianov and Denisov, having dutifully completed a series of models representing true to life interiors and exteriors, found they had achieved none of the desired innovation; the results pleased neither Stanislavsky nor Meyerhold. The collective mood, wrote Meyerhold, grew uneasy: "After many models had been built, depicting interiors and exteriors such as they appear in life, the model studio turned suddenly gloomy, everyone was angry and tense, and awaiting the moment when someone would yell, 'Time to smash and burn all the models.'"[17]

It was an objection at once mechanical (gluey fingers), processual (mathematical invasions into the visual process), and aesthetic. The young artists working for the Theatre-studio were under the sway of Impressionism: most had trained under the foremost Russian Impressionist, Valentin Serov. There was, in their desire for a lightness of process, a correspondence with the expressive form of their painting. Lightness of process, lightness of concept—these principles were rapidly becoming linked in Meyerhold's mind as well. The painters' search for new methods of conceptualization was consonant with his emerging belief that techniques of artistic process correspond directly to aesthetic result. Meyerhold was coming to see problems of process as an impediment to creativity, impacting the entire act of theatre making: "Everyone realized that if model making was overcomplicated, the entire machinery of the theatre was overcomplicated. Grasping the models in our hands, we seemed to grasp the contemporary theatre. Wanting to crush and burn the models, we were already close to crushing and burning the obsolete techniques of the Naturalistic theatre."[18]

There was mutiny in the design studio. Sapunov and Sudeikin sparked the rebellion. They had set to work on *Tintagiles* "with trepidation," since, according to Meyerhold, "both loved set painting and both loved Maeterlinck; but they promised only sketches, refusing outright to build models. Only when the designs were complete did they agree to glue and paint models, and then only so that the crew could see the blocking plan; in other words, so that the placement of painted flats, flooring, platforms and so on should be clear."[19]

Resistance was contagious: "When word went round the model workshop about Sapunov and Sudeikin's work, that they'd worked out the stage plan for the *Death of Tintagiles* two dimensionally, in a conventionalized manner, the other artists simply let their own work drop from their hands."[20]

And work began afresh, with sketchbooks in place of models. The collective thought of this new mode of work as the production of "impressionistic stage plans."[21] The change of method both freed up the imaginations of the artists and facilitated creative exchange. An "impressionistic" collaborative process was born, which prioritized ease of communication between director and designer; at the same time, the shift from an architectural to a painterly method gave rise to a new emphasis on the painterly qualities of the set. "If the director and artist subscribe to the same school of painting," wrote Meyerhold, "then the director provides a sketch (ground plan), and the artist, on the basis of this sketch, provides tonal harmonies, and distribution of highlights. This collaborative work of director and artist produces a series of designs. The director's sketches, with schematic lines of movement drafted in charcoal or pencil (or, if the latter can't paint, the artist's colored designs) are very nearly sufficient to move onto the stage without resorting to models."[22]

This reconceptualization of the design process engendered a reconceptualization of scenic space. Like the new method, the new scenic style was characterized by spareness. And from that shift in process and concept, there emerged a cascade of stylistic innovation: impressionism, minimalism, symbolism, gestus— for each production, Meyerhold and the design team proposed a distinct visual/ spatial solution.[23] In the process, the designer emerged as a collaborative partner

at the conceptual stage of theatrical creation. This new model of director-designer collaboration formed the basis for the synthetic theatre practices that would dominate the Russian avant-garde for decades to come.

Collective Creation

In June, Meyerhold and the cast took up residence in Abramtsevo and Pushkino, outside of Moscow, to rehearse *The Death of Tintagiles, Schluck and Jau,* and Ibsen's *Love's Comedy* while the theatre on Povarskaia Street was under renovation. The location was both pragmatic and symbolic: Abramtsevo was the estate of Savva Mamontov—the industrialist impresario whose artists' colony had nurtured three generations of creative revolt in the visual arts. Pushkino was birthplace of the Art Theatre, whose troupe had worked in residence there during the summer of 1898. The site spoke at once of continuity and revolt.

A building was rented for rehearsals—a large stone warehouse—from a cloth factory between Pushkino and the Mamontov estate. Meyerhold, his wife, and his sister-in-law, the actress Olga Munt, moved into an apartment for factory employees; the actors were housed variously, near the rehearsal space, or collectively in dachas along the river near the center of Pushkino. In her memoirs, actress Valentina Verigina recalled the Pushkino sojourn as joyous, the riverbank dacha she shared with seven other actresses a social and creative center, their retreat an immersion into theatrical discovery: "It was already quite warm and the trees were in bloom, when the studio troupe arrived in Pushkino—a summer retreat outside of Moscow . . . Ours was the dacha that everyone gathered in: directors, actors and artists would come over; visitors came . . . The life of the Theatre-studio commenced: a summer of creative work, which Meyerhold in a letter once called, 'the Studio's fiery months.'"[24]

In the rehearsal shed at Pushkino, Meyerhold continued to "burn and destroy" the mechanisms of the naturalistic theatre, extending his experiment with new collaborative models to the entire company, evolving new methods of rehearsal toward the generation of new staging concepts. For *The Death of Tintagiles,* this meant finding a scenic embodiment of Maeterlinck's theory of a static theatre, and the acting analogue of Impressionism (kinetic, vocal, and relational). With *Schluck and Jau,* the aim was a grotesque sociopolitical satire, set in an antirealist environment and informed by the minimalist, linear exaggerations of graphic caricature. For both plays, Meyerhold's search also entailed developing a compositional use of the acting body, rendered as theatrically effective performance style; determining what it would mean to drive the scenic action with music; and integrating the performances of MAT and Alexandrinsky-trained actors into a nonnaturalistic environment (scenic naturalism was a young movement still, but these were young actors: naturalism was the style in which they had been, aesthetically, raised). Each aspect of this vision was an untried experiment. Each entailed evolving new methods of collaboration with actors, scenic artists, associate directors, and musicians.[25]

Looking back at the production in 1906, Meyerhold described *The Death of Tintagiles* as having come "very close to the ideal conventionalized theatre."[26]

A key aspect of that conventionalism lay in the voice. Meyerhold sought a new style of delivery, expressive of Maeterlinck's symbolist poetics: a vocal timbre that would depart from the tonal qualities of dramatic naturalism, dialog *not* driven by psychological impulse—a musicality of speech, in short, and yet distinctly dramatic. Summarizing his aims in 1906, he wrote, "The words must ring out coldly,[27] entirely free of vibration (*tremolo*) and weepy, whiny acting. A complete absence of tension and gloomy tones. The sound must always be *supported*, and the words must fall like droplets into a deep well: the strike of each droplet distinctly audible, with no prolongation of sound through space . . . The inward shiver of mystical thrill reflected in the eyes, the lips, the sounds, the manner of articulating words is the calm before a volcanic eruption. And all of it executed without tension, with a light touch."[28]

In search of these new vocal qualities, Meyerhold turned to his actors as a creative source. Rehearsals began with a series of textual improvisations.

> The poetry and excerpts were read by each actor in turn. This work was to them as the *étude* is to the artist, the exercise to the musician. *Etudes* hone technique; only once the technique is perfected does the artist set to work on the painting. Reading poetry and excerpts, the actors look for new means of expression. The auditors (everyone, not just the director) make observations, steering the one working on the *étude* in a new direction. And all creativity is directed toward finding those colorations through which the author "rings true." When the author emerges in this collective work, when even one of his poems or excerpts "rings true" in someone's work, then the auditors set to work analyzing the expressive means which communicate the style, the tone of the author.[29]

Verigina notes that the company read Maeterlinck's poetry in both French and Russian and that, in addition to striving for "clarity of tone, lightness, a similar flow of breath," they "collectively" corrected the translation.[30]

The improvisations aimed, at one and the same time, at generating and refining expressive techniques. In one sense, this was not unlike the working mode of the Art Theatre: in the early years of the Art Theatre, too, new approaches were created and refined over the course of rehearsal. But whereas Art Theatre directors, at the turn of the century, first conceived a performance style then conveyed it to the actors, Meyerhold entered the conceptual phase together with his actors: the creation of expressive technique was a collaborative process.

This collaborative-improvisational method was perhaps the most significant result of Meyerhold's poetic études. The quality of delivery toward which Meyerhold's actors strove seems to have been only imperfectly and inconsistently realized; Meyerhold repeatedly expresses frustration with the performance skill of his troupe, which he felt was greatly hampered by prior, naturalistic actor training.[31] But the processes by which they evolved these new techniques shook up the Art Theatre and opened the way to new methods of theatrical creation.

In his subsequent writings, Meyerhold states that he sought a new creative freedom for the actor. He first makes mention of a "collective work" of the entire company in *Towards a History and Technique of the Theatre*, begun in 1906 and

first published in 1907: "When the author emerges in this collective work . . ." And several paragraphs further in, in what may well be the first modern reference to collectively engendered theatre, Meyerhold introduces the word "collective creation" (колективны творчество).[32]

Meyerhold's collective creation model had less to do with the relationship between actor and script (he was not exploring actor-generated text) than with that between actor and director: his primary concern was to put the actor at the center of the process of generating mise en scène. It was an extension of the modes of collaboration he had begun one month earlier with designers, facilitating a collective engagement in the conceptual phase of production development.

What Nemirovich-Danchenko had effectively disallowed at the Art Theatre, Meyerhold continued in the Theatre-studio. Meyerhold's creative power sharing was far from the conceptual helplessness anxiously envisioned by Nemirovich. Meyerhold arrived at his rehearsals prepared with strong new concepts, defined in broad strokes. These included the set designs for *Schluck and Jau* and *The Death of Tintagiles*, which defined not just space but performance style: the grotesque (*avant la lettre*) sociopolitical satire of *Schluck and Jau*, the symbolist impressionism of *Tintagiles*; music-driven rhythms of text and gesture; painterly, antirealist blocking concepts; and, in the case of *Tintagiles*, an antipsychological vocal concept.

Nor was it an early essay at the directorlessness of mid-twentieth century collective creation. It bore more in common with the devised theatre movement of recent decades: actor-generated concepts providing a raw material to be sculpted (shaped, cut, refined) by a director. Nemirovich was not alone in his implicit concern that a collaborative environment could give way to creative anarchy; Meyerhold addresses the question explicitly, defining the role of the director within the theatrical collective:

> The directing *plan* is revealed during *discussions* of the play. The director infuses[33] the entire production with *his own* view of the play. Enticing the actors with his love of the production, the director fills them with the spirit of the author and his own interpretation. But *after discussions* all of the artists are granted complete autonomy. The director then once again gathers everyone together, in order to create harmony among the separate pieces. How? Only by bringing into balance all those pieces freely created by other artists within this collective creation. And having established this harmony, without which the show is meaningless—not in order to strive towards a precise reproduction of his own conception, but united only for the harmony of the show, in order that the collective creation not fragment—he awaits the moment when he can hide in the wings, allowing the actors to either "set fire to the ship," if the actors are at odds with director and author (as happens when they are not "new school"), or bare their souls in almost improvisatory additions, not to the text, of course, but to the director's suggestions, making the audience understand both author and director through the prism of the actor's work. *The theatre is acting.*

In his theoretical writing, Meyerhold is responding to what has, under his influence, emerged by 1906 as a debate among the theatrical avant-garde. Playwright Alexander Blok, writing in the Moscow journal *Pereval*, expressed his concern that

collaborative process might destroy the production—"the actors might set fire to the ship of the play." Meyerhold, whose collaboration with Blok was pivotal in his early development as a director, cites Blok in a footnote and answers him directly: "This danger is avoidable if the director's interpretation is true to the author, if he transmits him faithfully to the actor, and if the latter truly understands the director."[34] Collaborative generation of text was *not* a part of Meyerhold's vision of collective work. For Meyerhold, there was, and would remain, a certain inviolable primacy in the role of the dramatist; the drama was, and would remain, his source of inspiration—the soil from which innovation emerged: "Somewhere I have read that the stage drives literature. Not so. If the stage has any influence on literature, it is only in this one respect: it delays its development."

In simultaneously defining the term *collective creation* and the role of the director within the theatrical collective, Meyerhold not only anticipates the theatrical collectives of the mid-twentieth century; he moves beyond them—in effect, skips a step—conceiving a model closer to contemporary devised and collective practice such as we find, for example, in recent work of the Gardzienice company of Poland, or certain productions by the Taganka theatre of Russia (such as Liubimov's *Marat/Sade*) in which a directorial interpretation of an existent text inspires actors to generate their own staging concepts, which are integrated and refined by the director into a conceptual whole.

Meyerhold's rehearsal methods were elaborated in reaction to the early work of the Art Theatre. In "The Naturalistic Theatre and the Theatre of Mood" (part of *Towards a Technique and History*), Meyerhold articulates his critique of the director-actor relationship practiced at MAT.[35] The flaw of the existing theatre, in his view, is the dominance of the director. He calls such director-centric theatre "Triangular Theatre," depicting author and actor as the base and director as apex, with the director's art functioning as a lens through which the audience perceives the art of the actor and author.[36] The work of the director is foregrounded; the arts of playwright and actor are subsumed by the direction. Meyerhold compares the Triangular Theatre to a symphony orchestra under the leadership of a conductor. The Triangular Theatre, he argues, has required of its actors a technical virtuosity analogous to that of the symphonic musician. The artistry of the symphony player (according to Meyerhold) lies in perfect execution of the conductor's conception. The artistry of the ensemble actor at the Art Theatre, likewise, lies in perfect execution of a fully preconceived directorial plan.

He identifies three problems with this approach: first, that actors, in contrast with musicians, perform unassisted by the "conductor" (director), resulting in a gradual loss of the sharp precision of the original concept; second, that the theatre was never meant to provide a place for the conductor ("The theatre itself, its very architecture not affording the director a conductor's podium, demonstrates the difference between the techniques of conductor and director");[37] and third, that such an artistic structure admits no creative individuation on the part of the actor. The Triangular Theatre reduces the art of the theatre to the art of the director. But "the theatre," Meyerhold declares, "is acting." It is not the actor and playwright who must be enfolded into the director but rather the actor who must "internalize both author and director, and himself speak from the stage."[38]

According to Meyerhold, then, a major failing of the Art Theatre was to have put directorial concept front and center, subordinating the actor to the director's art.[39] Accustomed as we are to associate the Art Theatre with Stanislavsky's later work with actors, it gives one pause to realize that one of Meyerhold's principal critiques of the Art Theatre at this juncture was that its methods left little creative freedom for the actor. But Stanislavsky's work with actors had barely begun; there was no System in 1905, and the work of the Art Theatre in that period would have looked very different from the psychological realism of a later period. At this early stage, Stanislavsky's principal contributions to acting were the replacement of declamation with naturalistic delivery and of the star-driven production with ensemble style, as well as the use of the pause to punctuate the flow of dialogue. Deep work on the creative apparatus of the individual performer lay in the future. Meyerhold stood in opposition to all three methods: the first, because it limited the actor to a single style of dramatic text; the latter two, because they presupposed a uniformity of performance style that Meyerhold felt left little space for the creative idiosyncrasy of the individual performer.

It is above all MAT's directorial predetermination of delivery of text that Meyerhold polemicizes in "Towards a History and Technique of the Theatre"—that directorially established "tone" for which Nemirovich-Danchenko fought so desperately. Arguing that the theatre is first and foremost the art of the actor, Meyerhold calls for a creative synthesis of author-director-actor, which he calls the "straight" or "direct" theatre (Театр Прямой). Meyerhold envisions the "Direct Theatre" as a line extending from the author, through the director, to the actor—and, via the actor, to the audience.[40] He seeks an ideal synthesis of playwright, director, and actor that will accord each creative freedom within merger: "In the 'Direct Theatre,' the director, transforming himself into the author, brings the actor his creation (here, director and playwright are fused). The actor, receiving the author's creation via the director, finds himself face to face with the audience (with author and director backing him up)."[41]

In historical perspective, the image of Meyerhold defending the creative freedom of the actor against the encroachment of the director's theatre is not an easy notion to reconcile. As his directorial style matured, and the spatial, musical, and gestural structure of his mise en scène grew vastly more complex, many (typically those outside of his theatre) would accuse him of treating his performers as puppets. This critique first emerged in response to his direction of Vera Komissarzhevskaya, during his brief tenure as director of the Komissarshevsky Theatre (1906–7); critics and audience perceived Meyerhold as constraining her individual gifts and bending her style to fit his, and Komissarzhevskaya, reiterating the critique of her followers, eventually let him go on precisely these grounds. The same critique would reemerge in the 1920s, intensifying, for political reasons, in the 1930s and beyond. In part, it was a criticism formulated on the basis of the contrast between the demands of Meyerhold's synthesist mise en scène, predicated on complex rhythmic-visual-spatial interactions of the entire ensemble, and the more obviously actor-centered focus of Stanislavsky's System (as the System was understood by mid-Soviet-era practitioners, who largely ignored Stanislavsky's explorations of the actors' kinesthetic creativity).

Above all, Meyerhold sought idiosyncrasy: "The 'Triangular Theatre' requires actors who lack individuality, but are gifted virtuosi . . . In the Direct Theatre, the brilliance of the actors' individual qualities is essential."[42] It was, indeed, his own theatrical idiosyncrasy—his "problematic" predilection for "sharply etched, eccentric characterizations" in his days as a young MAT actor[43]—returning with a vengeance in his directorial experiments. As he moved through his directing career, Meyerhold's rejection of the uniformity of the MAT troupe would lead increasingly toward the formation a company of actors more akin to a clown troupe than a corps de ballet.[44]

Conclusion

Stanislavsky and Meyerhold in 1905 were tentatively moving toward new understandings of the art of the actor, and these new ideas of acting would eventually give rise to new structures of theatrical collaboration. Each in his distinct way would come to ask much more of the actor's creativity: Stanislavsky, a more highly refined psychophysical imagination; Meyerhold, more complex tools of kinesthetic expression. Like Jacques Copeau in the 1920s, whose creative demands on the actor (his own authoritarian nature notwithstanding) paved the way for one of the twentieth century's first collective creation troupes, the Copiaus—as well as for Michel Saint-Denis's Compagnie des Quinze—Meyerhold and Stanislavsky, playing with the possibilities of improvisation and a creative partnership of equals, lay groundwork for theatrical developments far beyond the scope of their intended aims.[45] The desire for a richer and more complex array of performance abilities, together with this new emphasis on the generative capacities of the performing body, would give gradual rise to an actor prepared to make creative contributions to, and therefore greater claims on, the conceptual process.

Bibliography

Archive: Музей МХАТ (Moscow Art Theatre Museum): Архив студии, Архив КС №5182, Архив Н.-Д. №1614, 1615 (Studio Archives, Stanislavskii Archives, and Nemirovich-Danchenko Archives).

Archive: RGALI (Russian State Archive of Literature and Art, Moscow): Ф 998 ед. хр. 186, Ф 998 ед. хр. 187, Ф 998 ед. хр. 188.

Baldwin, Jane. *Michel Saint Denis and the Shaping of the Modern Actor*. Westport, CT: Greenwood, 2003.

Baldwin, Jane, Christiane Page, and Jean-Marc Larrue, ed. *Vies et Morts de la Création Collective / The Lives and Deaths of Collective Creation*. Sherborn, MA: Vox Theatri, 2008.

Barba, Eugenio. "Grandfathers, Orphans and the Family Saga of European Theatre." *New Theatre Quarterly* 19, no. 2 (2003): 108–17.

Benedetti, Jean. *The Moscow Art Theatre Letters*. New York: Routledge, 1991.

Bowlt, John E. *Khudozhniki Russkogo Teatra, 1880–1930*. Moskva: Izd. Iskusstvo, 1991.

———. *The Silver Age: Russian Art of the Early Twentieth Century and the "World of Art Group."* Newtonville, MA: Oriental Research Partners, 1979.

Braun, Edward, trans. and ed. *Meyerhold on Theatre*. New York: Hill and Wang, 1969.

Feld'man, O. M. (editor). *Meierkhol'd i Drugie: Dokumenty i materialy. (Meierkhol'dskii sbornik.* Vypusk vtoroi). Moskva: Izd. O.G.I., 2000.

Figes, Orlando. *A People's Tragedy: The Russian Revolution, 1891–1924.* New York: Penguin, 1996.

Gerould, Daniel. "Valieri Briusov, Russian Symbolist." *Performing Arts Journal 3,* no. 3 (Winter 1979).

Green, Michael. *The Russian Symbolist Theater: An Anthology of Plays and Critical Texts.* Ann Arbor: Ardis, 1986.

Grover, Stuart Ralph. "Savva Mamontov and the Mamontov Circle, 1870–1905: Art Patronage and the Rise of Nationalism in Russian Art." PhD Dissertation, University of Wisconsin, 1971.

Gurevich, L. Ia., N. D. Volkov. *O Stanislavskom; sbornik vospominani, 1863–1938.* Moskva: 1948.

Hauptmann, Gerhardt. *Schluck and Jau: An Ironical Masque with Five Interruptions.* In *The Dramatic Works of Gerhart Hauptmann,* Volume 5: *Symbolic and Legendary Dramas,* edited by Ludwig Lewisohn. New York: B. W. Huebsch, 1915.

Heddon, Deirdre, and Jane Milling. *Devising Performance: A Critical History.* New York: Palgrave MacMillan, 2006.

Kamensky, Aleksandr. *The World of Art Movement in Early Twentieth Century Russia.* Leningrad: Aurora Art Publishers, 1997.

Leach, David. *A History of Russian Theatre.* Edited by Robert Leach and Victor Borovsky. New York: Cambridge University Press, 1999.

———. *Vsevolod Meyerhold.* New York: Cambridge University Press, 1989.

Margarshak, David. *Stanislavsky: A Life.* London: MacGibbon and Kee, 1950.

Markova, Elena. *Off Nevsky Prospekt: St Petersburg's Theatre Studios in the 1980s and 1990s.* Translated by Kate Cook. Amsterdam: Harwood Academic Publishers, 1998.

Meierkhol'd, V. E. *Meierkhol'dovskii sbornik.* Moskva: Tvorcheskii tsentr imeni Vs. Meierkhol'da, 1992.

———. *Nasledie 1: 1891–1903.* Red. O. M. Fel'dman. Moskva: O.G.I., 1998.

———. *Nasledie 2: Leto 1903—Vesna 1905.* Red. O. M. Fel'dman. Moskva: Novoe Izdatel'stvo, 2006.

———. *Perepiska, 1896–1939.* Red. V.P. Korshunova, M.M. Sitkovetskaia. Moscow: Iskusstvo, 1976.

———. *Stat'i, Pis'ma, Rechi, Besed'i. 1891–1917.* A. V. Fevral'ski, Ed. Moskva: Izd. Iskusstvo, 1968.

———. *Teatr,* Moskva: Izd. Shipovnik, 1908.

———. *Tvorcheskoe Nasledie V. E. Meierkol'da.* Red. Valentei, M. A., P.A. Markov, M. A. Fevral'skii, i. t.d. Moskva: V.T.O, 1978.

Nemirovich-Danchenko, Vl. I. *Tvorcheskoe nasledia.* Tom 1. *Pis'ma. 1879–1907.* Moskva. Izdatel'stvo Moskovskii Khudozhesvennyi teatr, 2003.

Osinski, Zbigniew. "Why Laboratory? Jerzy Grotowski and Ludwig Flaszen." Unpublished lecture, Aarhus, October 5, 2004.

Parshin, S. *Mir iskusstva.* Moskva: Izd. Izobrazitel'noe iskusstvo, 1993.

Petrov, Vsevolod. *Mir Iskusstva,* Moskva: Izd. Izobrazitelnoe iskusstvo, 1975.

Radischeva, O.A. *Nemirovich-Danchenko,Stanislavskii: Istoria teatral'nykh otnoshenii. 1897–1908.* Moskva: Artist—Rezhisser—Teatr, 1997.

Rudnitskii, K. (Rudnitsky). *Rezhisser Meierkhol'd.* Moskva: Izd. Nauka, 1969.

———. *Meierkhol'd.* Izd. Iskusstvo, 1981.

Rudnitsky, Konstantin. *Russian and Soviet Theater 1905–1932.* Translated by Roxane Permar. Edited by Dr. Lesley Milne. New York: Harry N. Abrams, 1988.

Stanislavskii, K.S. *Sobranie sochinenii.* Tom 1. *Moia zhizn' v iskusstvie.* Moskva: Iskusstvo, 1988.

Stanislavskii, K.S. *Sobranie sochinenii.* Tom 7. *Pism'a: 1874–1905.* Moskva: Iskusstvo, 1995.

Ulianov, N.P. *Moi vstrechi.* Moskva. Izdatel'stvo Akedemii Khudozhestv SSSR, 1959.

Verigina V. P., «По дорогам исканйи». *Vstrechi c Meierkhold'om: Sborknik vospominanii.* Red. kol. M. A. Valentei, P. A. Markov, M. A. Fevral'skii, i t.d. Red-sost. L. D. Vendrovskaia Moskva: Vse-rossiiskoe teatral'noe obshest'vo, 1967.

Vinogradksaia, I. *Zhizn' i tvorchestvo K.S. Stanislavskii.* Tom 1. *1863–1905.* Moskva. Izdatel'stvo Moskovskii Khudozhesvennyi teatr. 2003.

Volkov, N.D. *Meyerhold.* Moskva: Academia, 1929.

Notes

1. Unless otherwise indicated, all translations are mine. For a full account of the Theatre-studio's establishment, accomplishment, and closure, see Kathryn Mederos Syssoyeva, "Meyerhold and Stanislavsky on Povarskaia Street: Art, Money, Politics, and the Birth of Laboratory Theatre" (PhD diss., Stanford University, 2009).

2. Stanislavskii, K.S. *Sobranie sochinenii.* Tom 1. *Moia zhizn' v iskusstvie.* Moskva: Iskusstvo, 1988. 350. Unless otherwise indicated, all translations are mine.

3. Vs. Meyerhold, *Stat'i, Pis'ma, Rechi, Besed'i,* 111.

4. Meyerhold founded his company after departing from the Art Theatre in 1902—on bitter terms—for reasons partly attributable to the backstage manoeuverings of Stanislavsky's partner, Art Theatre cofounder Vladimir Nemirovich-Danchenko.

5. Cited in K. Rudnitskii, *Rezhisser Meierkhol'd,* 49.

6. Stanislavsky's initial plan had been to utilize the performance space of the Moscow Hunting Club, a venue he had previously used for performances by the Society of Art and Literature. But lured by the thought of a dedicated theatre for the sole use of his new company, he leased the 663-seat Nemchinov Theatre on Povarskaia Street, personally funding rent and renovations—a financial risk that was to play a significant role in the Theatre-studio's demise.

7. Deirdre Hedding and Jane Milling, *Devising Performance,* 29–33.

8. Vl. I. Nemirovich-Danchenko, *Tvorcheskoe nasledia,* vol. 1, 550–569, Letter 418, Nemirovich-Danchenko to Stanislavsky, June 8–10, 1905. Unless otherwise indicated, subsequent statements by Nemirovich-Danchenko are extracts from this same letter.

9. *A Law Unto Themselves (Samoupravtsy),* (1867) a tragedy in five acts by Aleksei Feofilaktovich Pisemskii.

10. Stanislavsky's real name was Alekseev (he took the stage name Stanislavsky on founding the Art Theatre); by invoking it, Nemirovich-Danchenko alludes to Stanislavsky's work as an amateur prior to cofounding the Art Theatre.

11. K. S. Stanislavskii, *Sobranie sochinenii,* vol. 7, 587, Letter 391, Stanislavsky to Nemirovich-Danchenko, June 10–24, 1905. In place of *Russia,* Stanislavsky uses the ancient word *Rus* (на Руси), evoking Russia's long history.

12. Kosherov was cofounder of the Company of Russian Dramatic Actors (1902), the first incarnation of Meyerhold's provincial theatre company; Bardzhalov was an actor with the Moscow Art Theatre; Repman, an actor and director, would subsequently work for the Art Theatre from 1907 to 1910.

13. Edward Braun, *Meyerhold on Theatre,* 41.

14. N. P. Ulianov, *Moi vstrechi,* 133.

15. Ibid. Ulianov employs the old Russian system of measurement: *arshin* (.71 meters) and *vershok* (1.75 inches).

16. Ibid., 131.

17. Vs. Meierkhold, *Stat'i, Pis'ma, Rechi, Besed'i*, 109.

18. Ibid., 108.

19. Ibid.

20. Ibid.

21. Ibid.

22. Ibid., 107.

23. A detailed account of the designs for each production is beyond the scope of this chapter; see Syssoyeva, "Meyerhold and Stanislavsky at Povarskaia Street," Chapter 3.

24. Valentina P. Verigina, in *Vstrechi s Meierkhol'dom*, 32.

25. Of the stylistic aims of *Love's Comedy*, we know little. The play was given over to Repman to direct; Meyerhold's involvement was minimal; no traces remain of the process. *Schluck and Jau* appears to have been only partially staged by Meyerhold, with Repman as associate director. *The Death of Tintagiles* was Meyerhold's alone.

26. Vs. Meierkhold, *Stat'i, Pis'ma, Rechi, Besed'i*, 128.

27. Meyerhold uses an untranslatable theatre term, холодная чеканка слов, literally "a cold minting" (as of coins) of the words; in the theatre, the term evokes a metallic quality of voice, like the striking of metal on metal.

28. Ibid., 134.

29. Ibid., 129.

30. V.P. Verigina, *Vstrechi s Meierkhol'dom*, 32.

31. See, for example, Vs. Meierkhold, *Stat'i, Pis'ma, Rechi, Besed'i*, 111 and 133.

32. Ibid., 133. Edward Braun's collection, *Meyerhold on Theatre*, contains a fine translation of this essay. We do, however, depart on certain details that I consider significant, most important, the translation of the term "*kolektivny tvorchestvo*," which Braun, writing in 1969, translates as "collective enterprise" and which I have translated, more literally, and in keeping with both contemporary Russian theatre terminology and my understanding of Meyerhold's intent, as "collective creation."

33. Окрашивает—literally, "tints" or "dyes."

34. Ibid., 133.

35. Ibid., 113–27.

36. Ibid., 129–30.

37. Ibid., 130.

38. Ibid.

39. Ibid.

40. Ibid.

41. Ibid.

42. Ibid., 132.

43. Rudnitskii, *Rezhisser Meierkhol'd*, 33.

44. Ibid. Cf. Chapter 2, page 22.

45. See generally, Jane Baldwin, *Michel Saint Denis and the Shaping of the Modern Actor*, Chapters 3 and 4.

3

Reduta's Reorigination of Theatre

Radical Collectivity in Poland's Interwar Theatre Laboratory

Kris Salata

In 1970, a remarkable book appeared in Poland: *O zespole Reduty: Wspomnienia* [On the Reduta Company: Recollections], a collection of essays by former company members published to commemorate the fiftieth anniversary of the founding of the theatre institute. In the spirit of Reduta, whose playbills never listed individual names and whose members collectively shared all organizational, artistic, and pedagogical responsibilities, this collective creation by great Polish actors lists neither author nor editor, and the unsigned short preface bears the scant title, "A Few Words from Us."

Formative for Polish theatre, even if practically unknown outside Poland, Reduta (1919–39) was perhaps Europe's only modern "true sacral theatre," with a monastic style of operation, far-reaching idealistic code of ethics, and radical approaches to collective creation, going as far as eliminating a single stage director. In Reduta, "not the actors, the director, the designer, the musician, the electrician, but the *ensemble*,"[1] which included the spectators as witnesses, was the creative force.

In the second half of twentieth century, with the worldwide recognition of Reduta-inspired Polish director and researcher, Jerzy Grotowski, many of Reduta's ideals and ideas spread internationally, even though indirectly and with no proper credit, as scholarship on the company has been rather obscure, and until very recently, available only in Polish.

In this chapter, I introduce Reduta's extraordinary way of practice and the fundamental ideas behind it, which remain valid, if not vital, to contemporary theatre.

Radical Collectivity in Poland's First Theatre Laboratory

Founded in Poland during the interwar period, Reduta [Readout] evolved as a theatre, an institute, and a touring company (though not always at the same time)

in the context of specific cultural, political, and ethical needs. The two decades between World War I and World War II followed the reemergence of the Polish state, which had vanished from the map of Europe in 1795 when Prussia, Austria, and Russia performed the third and final partition and annexation of the country and engaged in various forms of cultural and political action directed at complete assimilation. Poland rose from under the dominance of these foreign powers after the defeat of Austria and Prussia in World War I and the collapse of the Russian Empire under the Bolshevik Revolution. Key to winning back Polish independence was the sense of national identity, vividly maintained for more than a century, that held the Poles culturally united despite the efforts of the oppressive foreign governments. Polish Romantic poets—who, unlike others in Europe in the early nineteenth century, focused their interest on existential questions and the individual's confrontation with religion and the national cause—played a major role in this fight for national survival. With Juliusz Słowacki and Adam Mickiewicz as the frontrunners, Polish Romantics delivered poems and poetic dramas of the highest artistic merit—works celebrated far beyond intellectual and artistic circles, gaining the status of national treasures. Paradoxically, it appears that the hardships of statelessness gave Polish literature its golden age.

It was to these Romantic dramatic poems that Reduta naturally turned its full attention, and it was these historical circumstances that kept the company principally occupied with Polish drama, issues of cultural education, and integration of the nation. This unique and complex context greatly weighed on the birth of the modern Polish theatre.

Reduta's founders—Juliusz Osterwa, a famous actor, and Mieczysław Limanowski, a renowned geologist with an unquenched interest in theatre—met in Russia in 1915, while interned by the Russian army as Austrian citizens. They both became acquainted with the Moscow Art Theatre and with Konstantin Stanislavsky and his Studio-based research into the art and craft of the acting profession. The Russian experience became for Osterwa and Limanowski inspirational and even formative to their concepts and ideas about the possibilities for theatre in modern times. They became bonded as friends and critics of theatre, which they both saw degenerated by low ethics, poor craft, attachment to foreign farce, glorified self-indulgent stars, and an overall lack of higher purpose. Upon their return to Warsaw, they formed a company with which they were hoping to renew theatre in the newly reinstated Poland. Their Reduta, similarly to Stanislavsky's Moscow Art Theatre (MAT), and in opposition to the existing practice, would work in service of Art in the theatre and would submit to this main idea all aspects of craft, practice, production, training, and organization. In addition, unlike MAT or others theatres of this period, Reduta would be in service of the national cause. Osterwa formulates his intentions on the inception of Reduta in the following lofty way:

> I am to lead a group of people, small in number and gathered by happenstance, mostly young, with whom I want to search for paths and ways to reveal the face of Polish Theatre. This is not as much an ambitious as a necessary undertaking resulting from certain consequences of artistic evolution and the responsibilities brought

to us by the blessed wave of our Fatherland's history ... If we do not get there our-
selves, then somebody else will do it after us, and perhaps we will warn them, direct
them toward the path.

I am afraid, though, to talk about that which we are aiming to do, to avoid imply-
ing some "program." ... Our artistic efforts will bear the name of the theatre (Reduta)
on the outside, while on the inside they will be treated as a "Studio."[2]

The founding principles of the newly formed company aimed, on the one
hand, at laboratory research similar to that of Stanislavski and, on the other, at the
restoration of theatre as a vital cultural phenomenon in a new world. Polish the-
atre historian Zbigniew Osiński describes Reduta as a site of an integrated artistic,
social, and societal action:

> For all its members (the technicians were treated as part of the artistic company ...),
> it was supposed to be first and foremost "a family house," "a familial community,"
> "a house of theatre craft," "a house of Art," and not "a trade business," or "bureau-
> cratic institution." The Reduta founders exalted the theatre as a sacred office, instill-
> ing within the company a feeling of reverence towards the work and the Reduta
> community, a reverence for Art (with a capital A). The Reduta's principles were
> developed and grafted onto it: a working atmosphere, friendship, comradeship, soli-
> darity, companionship as a fundamental demand, understanding work to be at the
> service of ideas. The Reduta's educational ideal was the actor being active in soci-
> ety, and the studio-laboratory became the battlefield for the new theatre. The goal
> was not the "reform of the theatre" but rather a fundamental and total change and
> transformation.[3]

This "total transformation" involved a thorough ontological reexamination of
theatre and a restoration of its centrality in modern life based on fundamental
questioning of all assumptions and conventions. As Michał Orlicz, one of Reduta's
members, states in *O zespole Reduty*, "In the small, quiet refuge of white-painted
Reduta rooms in Warsaw, the Reduters quaffed the happiness of total focus, the
madness of hard labor, the yearning for beauty sailing against the unruly wave
of automatism, convention, and buffoonery."[4] To put it in a more objective lan-
guage, undertaking a radical reorigination of theatre, the Reduta founders sought
a new ideology and resulting modes of operation, methods of creative work, and
pedagogy—in other words, they wanted to start at the originary beginning of the
theatrical phenomenon. As Jerzy Grotowski's main collaborator, Ludwik Flaszen
states, "[A] look into Reduta often takes us to the essence of the thing."[5]

In the spirit of this essence-seeking makeover, as early as 1921, Osterwa and
Limanowski opened their own theatre school. A long-term experiment in radical
pedagogy, the school (soon known as the Reduta Institute) aimed not merely at
teaching the actor's craft in a new key but rather at the fundamental reshaping of
the ethics of the theatre artist, whose higher purpose was to serve society as an
"activist through theatre." Stressing the higher mission of the acting profession, as
well as the uniqueness of its own position in the world of commercial theatre, the
Reduta Institute consequently refrained from referring to its students as actors,
using instead the term *Redutowiec* [the Reduta-person, or the "Reduter"]. Another

related word, *redutowość* [Redutaness], refers to the ideologically united ensemble, or an ideal collective. Recalling her Institute experience, Hanna Małkowska notes that Osterwa "wanted to raise not merely an actor, but above all, a *man of theatre*, for whom none of the aspects involved in a production is strange." For her and her colleagues, theatre was no longer a place of employment but "a place of [their] whole existence."[6] It may only seem natural to accept the fact that according to company member and Institute graduate Tadeusz Byrski, when auditioning prospective students, "Reduta accepted people not actors."[7]

The Institute students were occupied from 12 to 18 hours a day with a 2-hour dinner break.[8] Men and women wore specially designed identical uniforms: grey, loose, coat-like, tied at the waist with a rope, with long, wide cuffs, which could by tied or left to hang loose.[9] In a homelike atmosphere, they all shared meals, managed communal money, and had kitchen and household chores. The students paid fees set according to their individual financial situation, and those in need received free dinners.[10]

With this ethical and ideological framework, and the required dedication, discipline, and time investment that practically eliminated the division between work and private life, the Institute and the Reduta company (of which the Institute was an integral part as an apprenticeship program) resembled a monastic order rather than a commercial theatre. But the resemblance with a monastery went beyond structural and organizational issues and reached the level of ethics as well as of satisfying the spiritual needs of the members. Osterwa's famous remark, "God created theatre for those for whom the church is not enough," gives essential clues about the nature of his enterprise. Commenting on this remark, in his volume on the history of Polish theatre, Zbigniew Raszewski claims that "without these strange words it is hard to understand the meaning of Reduta in [Polish] culture."[11] Indeed, the new moral fiber that Reduta brought to theatre has its resemblance with the tradition of the nineteenth-century Polish religious societies that amalgamated spiritual and patriotic mission, such as Koło Sprawy Bożej [God's Matter Society], to which the great romantic poet Adam Mickiewicz dedicated the last years of his life. Osterwa and Limanowski frequently referred to Christian ideology and mythology in their rethinking of the ethical foundations and civil duty of theatre. Their religious beliefs as well as their dedication to Polish romantic literature, which thrived on the fused Christian and national iconography (e.g., the Polish state, through its ultimate sacrifice, becomes the savior of all nations), situate Reduta in the tradition of religious theatre, but as a uniquely Polish phenomenon in that genre. With these two substantial limitations that kept Reduta's direct influence hermetically contained within Polish culture, its radically conceived theatrical practice deserves a closer look, not merely that of theatre historians with obscure interests, but also of theorists and practitioners interested in the phenomenon of rebirth of the art of theatre resulting from the overhaul of its ethics. Phrasing it this way puts Reduta's project among other major reformers, with Stanislavski, Meyerhold, Copeau, Brecht, and later Grotowski, all of whom rethought the ethics of the acting profession as the basis of theatre's new aesthetics.

In accordance with that monastic sense of higher mission, and against the commonly held professional attitudes formed by the star system, the Reduta members

dedicated their service to Art, "a service that is real, concrete, and for life."[12] They were taught to care for rather than compete against one another:

> When something did not work well in a colleague's role, Osterwa did not hesitate to put the responsibility for it on the entire company. It wasn't some foggy mysticism. No. We were not able to help our colleague—all of us, even those not cast in the play. A Reduter was someone who not only surrendered to the Reduta discipline, but also who demonstrated a higher sense of comradery and team solidarity.[...]A Reduter had to deeply feel, see, and understand at every moment of his life that by serving the art, he serves his country and his nation.[13]

Armed with this noble purpose, Reduta members were taught to identify themselves as a team rather than as individuals recognized by the importance of their contribution to the work. As a result, neither the production posters nor even the programs listed the actors' names. In addition, quite unusually for its times, the actors did not come out for the curtain call. As Antoni Cwojdziński, one of the dramatists associated with Reduta, notes, "Only when one loses oneself this way can one reach what lies at the base of all creative work, enter into something beyond oneself. Or rather, unite with something beyond oneself—in an actor's case, with the character in the play."[14] Limanowski states it in a revealing way: "Religious theatre must be apostolic. It must work in humility. [...] Religious theatre must be anonymous."[15]

In this creative ensemble that treated all theatre trades and all company members as equally important collaborators, the function of the singular director also had to undergo a "communal reformulation": "Stage directing is a collective activity—it results from collective creation. [...] The ensemble in a given production must consist not only of the players, but also of those who watch, listen, and witness in a communal spirit, contributing to the excavation of the visible whole from the soul and from chaos."[16]

Sharing the directing responsibility among the whole group naturally augmented the existing practice of communal responsibility for the individual problems of each actor. With this attitude in place, however, the main tasks of directing generally fell under the leadership of Limanowski and/or Osterwa, who would inspire and encourage the actors to create their personal work in relation to the group without subjecting them to a directorial choice. Working individually but in a close connection with the ensemble, the actors slowly developed and shaped their own scores as an integral part of the collective score. As Osiński notes, this kind of stage directing was sometimes compared to the work of a midwife assisting birth.[17] Remarkably, and paradoxically, Reduta, with its collective actor-oriented director, marks the beginning of the golden era for stage directing in Poland.[18]

Dedicated to an ongoing investigation of the creative process, Reduta was the first theatre laboratory in Poland, pursuing research in a wide range of pedagogy from text analysis, acting, directing, design, playwrighting, theatre history, and theory to conducting an impressive outreach program that involved touring distant provinces.[19] As Grotowski's Laboratory Theatre would do a few decades later, Reduta rehearsed its productions for as long as it needed to meet artistic rather

than commercial goals, and it kept creating, adding, and editing the work during the run.

Similarly, Reduta was the first to treat the spectators as witnesses in front of whom (not *for* whom) the actors performed their work. In this self-proclaimed "religious theatre," this kind of approach seems to draw from Catholic liturgy, in which the parishioners serve as witnesses in a ceremony of communion with Christ. It is important to note, however, that even if motivated by Christian philosophy, Reduta had neither ideological nor institutional ties with the Catholic Church. Theatre, for Osterwa and Limanowski, was a site of holistic performance in which Art and religion remain inseparable, even if only by the means of Christian ethics implemented in the process of its making. Thus liturgy served in Reduta as a model that structured theatre in the communal life as a ritual-based cultural production and a different entity from an institution of religious practice—a difference often difficult to negotiate in Catholic and Romanticism-bred Poland of the interwar era. Grotowski, who adopted the idea of the witness in theatre while operating in communist Poland, bluntly describes his work in theatre as a search for the secular objectivity of ritual. In both cases, however, part of the motivation was the refusal to treat theatre as a commercial transaction defined by the exchange of money for pleasure, in which the spectator becomes reduced to a customer.

An interesting and little-discussed aspect of Reduta's rejection or reconsideration of even the most basic theatre conventions was their treatment of studio space, which they painted white and illuminated with daylight coming through the unscreened windows. Stefan Jaracz recalls that "Reduta taught [him] to rehearse in a bright, sunny room, and even outdoors, when it was warm. It is a little detail of which nobody knows, neither the critics nor the audience, and at which many actors laughed. [. . .] Is it necessary [. . .] to crowd [. . .] the coffin called the stage?"[20] This seemingly trivial element (also picked up by Grotowski) has a deeper meaning, not in its violation of the black box convention, but as a rejection of the illusion-making devices, which forced the actors to confront one another in plain daily visibility and reality, as characters, but also as themselves.

Reorigination as Key to Reduta's Collective Creative Work

A great portion of the prolific writing by Reduta's leader and cofounder,[21] due to neologisms and peculiar pathos, may remain impenetrable despite the effort and skill of the translator. In fact, Osterwa's texts prove to be difficult and unappealing even to Polish students of theatre. Just to give a few examples, *scena* [stage] becomes in Osterwa's vocabulary *słowospełnia* [word-fulfillment-place, word-realization-place] or *spełnia* [fulfillment-place, realization-place]; *aktor* [actor] becomes *spełnik* [fulfiller, realizer] or *żywosłowca* [living-word-*erer*]; and *reżyser* [director] becomes *słowostawca* [word-putter, word-layer]. None of these words exists in Polish. This is what Grotowski warns us about as laughable in Osterwa, while at the same time claiming that "there is something in it that moves [him] deeply," a yearning for something greater than success or fame. Indeed, in these fearless

notes to self one can find the drive to uncover the living content and possibility of a modern theatre and to rethink and reoriginate the theatrical phenomenon.

The editor of the most recently published selection of Osterwa's notes, Ireneusz Guszpit, warns the reader about the obscurity of the text and justifies the neologisms with the necessity of creating a new terminology for a reimagined theatre: "The theatrical neologisms of Osterwa came from the belief that the revived and transformed theatre cannot employ the terminology of the discredited and morally worthless theatre of the past. Old nomenclature carries only negative connotations; so then an ethically dead word depreciates the *living* qualities of the new art."[22]

I insist that there is something greater at stake here than the renewal of language as part of the "public relations" strategy of reforming theatre, or putting it differently, that the old names bring old associations. The word doesn't become dead merely by being associated with deadly theatre. It is the opposite: theatre becomes deadly when those who work in it forget to ask about the meaning of basic words. Osterwa's restoration process exactly begins with the restoration of the basic meanings. He engages in the ontological and phenomenological investigation of the theatre as a phenomenon.

Osterwa considers three key components of great theatre: "the word (substance), exhibit (outsideness), and an alive execution (the soul, essence)."[23] The trichotomy of mind-body-soul serves him as a triadic model made of theatrical substance, plastic form, and living essence. It is the work of this trichotomy that delivers the deepest insight about theatre—not merely the form and substance (i.e., a staged play), but rather the living, inspirited, embodied word. Osterwa comes to these conclusions through a close study of the ideals of Polish Romanticism, as a scholar of texts as well as a practical researcher working with these texts in the studio. (Notably, the Romantic poets often performed their work or improvised poetry publically, making the "living word" of the oral performance a part of the Romantic tradition.)

Unable to practice theatre during the Nazi occupation of Poland, Osterwa put all his energies into writing and formulated his most courageous vision of new theatre, which "*externally* would not differ much from what has been"[24] but internally would become a completely transformed entity, feeding from the Polish Romantics. In his extensive notes from this period, quite scandalously, Osterwa refers to the era of foreign rule over Poland (1795–1919) as fortunate times in which Polish dramatic poets (unlike any others in Europe) were not subjected to the tastes and conventions of the stage and the expectations of the audience (because their work was banned). In his typical poetic style, Osterwa writes:

> Our Bards did not look upon the audience.
> While writing, they had the nation on their mind, which needed spiritual heartening.
> The Poets heartened the nation with the Word.
> They wrote the Word so that it could become full in the imagination of the illuminated compatriots—those who were reading it.
> But that written Word was destined to become the Living Word, loud, and full.
> After liberation [. . .], their Word truly became Alive, loud, and full.
> From that moment a new Spirit entered Polish theatre.

[…] How could we name the field of the Living Word that we serve with our work?
The Living Word—because we let it through our living body, which together with our soul is the instrument of the Word.
The-Living-Word. […]
The place where the-Living-Word is to realize itself, we can name, the Living-Wordness.[25]

Osterwa notes that *teatr* [theatre], a word of foreign origin, has no vital meaning for the Poles. In its place, he demands a native term, which would reflect the true spirit and full potential of Polish theatre, honoring the-Living-Word. The term he tries to coin, *Żywosłowie* [most literally, "Living-wordness"], signifies "theatre" as a concept and also a place/building, so it could be translated as "the-Place-for-the-Living-Word." This neologism functions similarly to the Greek word *teatron*, "a place of seeing." They both spell out the elemental purpose. For Osterwa, the soul of theatre comes through the Word that must be spoken, or done as a deed by the actor. The actor, the doer and a person of high purpose, becomes the "instrument of the Word" and at the same time its inspirited essence—its aliveness. I should say that *Żywosłowie* never made it to the theatre vernacular and that it merely amuses the readers of Osterwa (as do many other terms he proposed), but it is hard not to agree with Grotowski that the intention and the impulse to rename in such a way reveal the desire for theatre to be a human encounter "in the context of something that makes sense, something that has a purpose, something that is pure, something one could not be ashamed of."[26]

"For whom should the actor play?"

We must ask about the full meaning of the adjective *living*, as it persists through Osterwa's writing as well as his artistic and pedagogical lifework. The answer should be contextualized by Grotowski's work and consequently by the practice of Thomas Richards (at the Workcenter of Jerzy Grotowski and Thomas Richards), who continues to investigate the complexity of the phenomenon. Not only is this context necessary because of Grotowski's claimed identification with Reduta's tradition, but it is also mainly because of the recent scholarly interest in the ontology of *liveness* in mediated and unmediated performance, which seems to operate on the assumption that *living* and *live* are mostly synonymous. Great practical researchers from Stanislavski onwards focused on the phenomenon of "true liveness," or *aliveness*, not as a mode but rather as a quality in ascension, in which "*being alive*" rises toward the adverb *truly*. The obvious limitation of language in addressing the phenomena of "being," or "presence," often causes those who know something about it experientially to reach out to neologisms. A good example might be Martin Heidegger's notion of "presencing," the action that the common noun *presence* fails to represent. Other examples that I could draw from Heidegger's project involve his attempt to restore the original intention behind the words whose meanings have deteriorated in mechanical application, such as *caring* or *dwelling*.

Osterwa states that on some level the Word reaches basic vitality when it is unmediated and spoken (not read) and accompanied by a minimal gesture.[27] The next level involves the acting craft developed through methodical training that includes movement, dance, diction, song, and text analysis. He considers acting on four ascending levels: *imitation, experiencing, transformation,* and *ceremony*[28]—a radical concept for its time.[29] Imitation, or pretending, was what, per Osterwa, most Western actors practiced on the stages of Paris, London, or Berlin. Its purpose was mimetic representation of the external features of the natural world "in order to create an impression."[30] The next level, experiencing,[31] comes with the Stanislavski System and is characteristic of the Slavic theatre. Osterwa explains "experiencing" as the actor's ability to be authentically affected by the fate of the character—to feel real compassion for that character and to care to such a degree as to be able to speak the words written by the playwright as if they were the performer's own: "While the French-European actor pretends to be moved, the Russian-Slavic actor is really, truly, honestly moved, and expresses that feeling using the words written by the author."[32]

The actor of this quality affects the audience by his or her own affectation. This level of acting craft may lead the actor to "become" the character and act not *for* but *despite* the audience[33]—aphrase quite familiar to the readers of *Towards a Poor Theatre.* The highest level of the actor's craft is ceremony, where the actor is capable of "pulling the spectator into the world of the creator."[34] On that level, as Osterwa claims, "someone's spirit speaks through me; I speak the truth in the name of that spirit."[35] This highest quality of *aliveness* allows for the presence of the actor as a person who does the deed in his own name but on behalf of another entity.

The ascent in the acting craft, as Osterwa sees it, restructures the actor's relationship with the audience from playing "for the audience" in order to please or affect it to playing "despite the audience" but "in connection with it." Thus the performer-spectator relationship transforms around this question: For whom should the actor play? The answer Osterwa gives shifts from for the audience and thus himself to for neither the audience nor himself, but rather for the *third* entity, whose presence becomes possible through the work. Grotowski's own answer to the question is the following: "The actor must give himself," and his gift "must be directed from within himself *to* the outside, but not *for* the outside," and thus he should play "neither for himself nor for the spectator." Instead, he should play to his "ideal partner": someone who will accept him unconditionally.[36]

Grotowski, who read in Osterwa his own desire and aspiration, also practiced naming and renaming but usually did so after completing extended work in a new direction and after having already established solid qualities or territories of new work—for example, paratheatre, active culture, doer, witness, objective drama, vibratory songs, verticality, or induction. His postpresentation work (which many incorrectly consider posttheatrical) that eventually led him to the Workcenter and Art as vehicle consists of propositions for a reimagined theatre, or in other words, of possibilities for the "truly alive" performer to create new circumstances in which his art is considered, received, or utilized.

Certainly, at the Workcenter, the word *theatre* needed first to be questioned but not entirely eliminated, even if only because of Stanislavski's method of psychophysical actions that Grotowski and then Richards employed there. Richards reminds the witnesses of his opuses (the spectators of the Workcenter's performances) that while theatre is directed for the spectator, their work can be fully realized with nobody watching. It is in the subtleties of this (perhaps purposefully questionable) division that we might find the possibilities for theatre that Osterwa and his Reduta were after.

Bibliography

Fischer-Lichte, Erika. *Theatre, Sacrifice, Ritual: Exploring Forms of Political Theatre.* New York: Routledge, 2005.

Flaszen, Ludwik. "Kilka kluczy do laboratoriów, studiów i instytutów." *Dialog* 7 (July 1998): 108–17.

Guszpit, Ireneusz. "Wstęp" [Introduction]. In *Juliusz Osterwa, Przez teatr, poza teatr.* Kraków: Towarzystwo Naukowe Societas Vistulana, 2004.

Osiński, Zbigniew. *Pamięć Reduty: Osterwa, Limanowski, Grotowski.* Gdańsk: słowo/obraz terytoria, 2003.

Osterwa, Juliusz. *Listy Juliusza Osterwy* [Juliusz Osterwas's Letters]. Warsaw: PIW, 1968.

———. *Przez teatr, poza teatr.* Kraków: Towarzystwo Naukowe Societas Vistulana, 2004.

O zespole Reduty: Wspomnienia. Warsaw: Czytelnik, 1970.

Raszewski, Zbigniew. *Krótka historia polskiego teatru* [Short History of Polish Theatre]. Warsaw: PIW, 1990.

Schechner, Richard, and Lisa Wolford, eds. *The Grotowski Sourcebook.* London: Routledge, 1997.

Notes

1. Zbigniew Osiński, *Pamięć Reduty: Osterwa, Limanowski, Grotowski*, 442.
2. Juliusz Osterwa, *Listy Juliusza Osterwy*, 51–52. All translations from Polish in this text are mine.
3. Osiński, 32.
4. Michał Orlicz, "Historyczne dzieło Juliusza Osterwy," in *O zespole Reduty*, 103.
5. Ludwik, Flaszen, "Kilka kluczy do laboratoriów, studiów i instytutów," 116.
6. Hanna Małkowska, "Wspomnienia o pierwszym Instytucie Reduty" [Recollections about the first Reduta Institute], in *O zespole Reduty*, 87.
7. Tadeusz Byrski, "Jak to się stało, że znalazłem się w Reducie?" in *O zespole Reduty*, 179.
8. Osiński, 36.
9. Stefania Kornacka, "Teoria" [Theory], in *O zespole Reduty*, 137.
10. Osiński, 75.
11. Zbigniew Raszewski, *Krótka historia polskiego teatru*, 201.
12. Wilamowski, "Reduta i Redutowcy" [Reduta and the Reduters], in *O zespole Reduty*, 107.
13. Ibid., 117.
14. Osiński, 67.
15. Ibid., 83.
16. Ibid., 85.
17. Ibid., 84.
18. Raszewski, 207.

19. Reduta regularly collaborated with the leading scholars who regularly visited the Institute to lecture and contemporary playwrights who would workshop their plays there. A truly unprecedented aspect of Reduta's operation involved frequent expeditions conducted with the purpose of cultivating Polish culture in the remote eastern parts of Poland. Osiński notes,

> From 20 May to 16 July 1924, seventy members of the company and Institute led by Limanowski held their first large tour of the country. They left Warsaw by train, and in Dęblin, special railway carriages adorned with the name "Reduta" awaited them. With five productions, [. . .] the Reduta visited thirty four cities and villages, mainly in the eastern and southern regions of Poland. From this moment on, the "Reduta expeditions" were organized systematically, usually with two, and eventually three groups traveling simultaneously. [. . .] Its zenith came in the summer of 1927, during which sixty two outdoor performances of *The Constant Prince,* directed by Osterwa with himself playing the lead role (or with Wierciński doubling up), were held throughout the country. The play was performed in squares and sports stadia, in castle courtyards and in front of churches, on military bases, in gymnasiums, and citadels. Including nineteen performances in 1926, a total of eighty one performances of *The Constant Prince* were presented in sixty different cities. The production was seen by tens of thousands of people. (Osiński, 37)

20. Stefan Jaracz, "Czego nauczyła mnie Reduta" [What Reduta Has Taught Me], in *O zespole Reduty,* 30.
21. Osterwa's private notes are 14,000 pages long. The adjective *private* is quite meaningful here, as Osterwa wished for the notes to be destroyed after his death. Instead, his wife Matylda made the decision to save them and make them available to theatre scholars.
22. Guszpit, "Wstęp" [Introduction], 61, my italics.
23. Juliusz Osterwa, *Przez teatr, poza teatr,* 166.
24. Ibid., 175.
25. Ibid., 176. Osterwa creates neologisms: *żywosłowie,* which signifies the phenomenon of the Living Word, and *żywosłownia,* which indicates the place where the Living Word can be practiced.
26. Osiński, 459.
27. Osterwa, *Przez teatr, poza teatr,* 272.
28. Ibid., 196.
29. Although "theatre as ceremony" could be found Europe in the early part of the twentieth century (e.g., in Max Reinhardt's pre–World War I mysteries; see Erika Fischer-Lichte, *Theatre, Sacrifice, Ritual: Exploring Forms of Political Theatre*), Osterwa goes forward with applying this concept to actor's training and, further, to reconsidering the ethical foundations of the art of the actor.
30. Ibid., 196.
31. Osterwa refers to the Russian term *perezhivanye.*
32. Osterwa, *Przez teatr, poza theatr,* 199.
33. Ibid., 200.
34. Ibid.
35. Ibid., 193.
36. Richard Schechner and Lisa Wolford, *The Grotowski Sourcebook,* 38.

The Accidental Rebirth of Collective Creation

Jacques Copeau, Michel Saint-Denis, Léon Chancerel, and Improvised Theatre

Jane Baldwin

In the early twentieth century, France witnessed the advent of a collective creation movement—derived in part from the commedia dell'arte—presided over by Jacques Copeau in its initial stage.[1] Although the form that collective creation took from the beginning is familiar to us from its later incarnations in the1960s and beyond, the concerns of collective creation à la Copeau were more theatrical than political. Its emergence was closely tied to education. Thus it is not surprising that Michel Saint-Denis and Léon Chancerel, Copeau's two disciples whose careers concentrated on realizing his unfinished work, were educators. As is often the case with disciples, Chancerel and Saint-Denis had competing views of Copeau's vision and how to achieve it. This chapter focuses on what might be called an accidental rebirth of collective creation under the auspices of its key players who struggled, each in his own way, to bring it into the world.

Any reconstruction or examination undertaken today of Copeau's struggles, achievements, and failures depends in large measure on a study of the *Registres du Vieux Colombier*, a six-volume compilation of Copeau's correspondence, diary entries, and publications, as well as newspaper and journal articles, contemporaneous commentary, and personal accounts of colleagues, which cover his career from its beginning in the first years of the twentieth century until 1924.[2] The first volume appeared in 1974; the last in 2000. Prior to their publication, academics and critics had limited access to Copeau's papers, the reason for many errors in Copeau scholarship—errors that were repeated in successive works.

In 1913, the drama critic Jacques Copeau opened his playhouse, the Vieux-Colombier, with the aim of "renovating" (or renewing) rather than reforming the theatre. The distinction is significant, since Copeau looked to the past to find the form, style, and relevance lacking in the French theatre of the period. Parisian

theatrical offerings largely consisted of the commercial theatre of the boulevards, which Copeau found shoddy, banal, and star ridden; the naturalism of the more serious theatre, condemned by Copeau as giving "the illusion of things themselves";[3] and the stultifying classicism of the Comédie-Française, which appalled him. As he put it, the problem was "to build a new theatre on absolutely solid foundations"[4] and by doing so restore its centrality to society. Those foundations were the theatres of Ancient Greece, the medieval period, Molière, and Renaissance England.

He laid out his objectives for the Vieux-Colombier in a manifesto published in the Nouvelle Revue française (a journal he edited) titled "Un essai de rénovation Dramatique." His plans, clear and straightforward—and very far from collective creation—left him enough wiggle room to adjust them. The repertory was to consist of the classics—revivals of "the best plays of the past thirty years"[5]—and new works. Copeau was convinced then that the theatre's salvation depended in large measure on developing dramatists capable of writing stage-worthy plays that met his critical standards. For Copeau, the playwright superseded the actor and certainly the director, whose "role [was] not to have ideas, but to understand, and convey those of the author, neither to force them nor to weaken them in any way, but to translate them faithfully into the language of the theatre."[6]

Looking back to the Greeks and "Elizabethans," Copeau opted for a bare stage with an apron that extended far enough into the auditorium to modify the actor-audience relationship.[7] With this decision, for all practical purposes, he rejected scenery in toto—whether it be realistic, or the lavish settings of the commercial theatres, or the experimental stagecraft of avant-gardists such as Meyerhold. Platforms, steps, and draperies served the productions' needs.

The company would be made up of talented actors willing to subsume their individuality to the ensemble in order to serve the theatre. Ever the pedagogue—at least in spirit—Copeau intended to instill a "morality of art" into the new company.[8] Stardom and commercial success were to be eschewed.

Two paragraphs of the eight-page manifesto sketch out a future drama school, whose immediate goals would be providing small-part actors and supernumeraries for the company. In the long term, Copeau intended to draw the majority of his actors from the school once they were thoroughly trained to his specifications. Regretfully, he had to put the school on hold until a time when he could devote all his attention to it.[9] It would be another eight years before the school came into being and with it tentative steps toward collective creation in the form of improvisation.

Nonetheless, Copeau initiated two months of exploratory actor training in July of 1913 prior to the Vieux-Colombier's premiere in October. No detailed records exist about this phase of Copeau's work. He brought his new company of ten actors—six men and four women, including Charles Dullin, Louis Jouvet, and Suzanne Bing, soon to become Copeau's lover—to the village of Le Limon, where he had a house, to prepare them for the upcoming season. The actors were young, enthusiastic, and idealistic; their experience varied, but none had yet been in the profession long enough to acquire the stereotypical playing habits that Copeau inveighed against. While most of the actors' professional experience was slight,

Copeau's was almost nonexistent. It consisted of a stage adaptation[10] of Dostoyevsky's *The Brothers Karamazov*.[11] His work as a critic had developed his taste; his reading informed him about the new theatre emerging in Europe.[12] Although he intended to act with the company, he was a novice. It may be that discomfort about his inexperience accentuated his naturally authoritarian behavior. To company members, he was always *Patron* or Boss.

The summer schedule of seven-hour days combined acting classes—focused on text analysis and reading aloud—and rehearsals once the shows had been cast. In addition to working on plays, the actors sight read texts by Rimbaud, Verlaine, La Fontaine, de Vigny, and Tacitus, among others. Copeau found this exercise particularly beneficial, since it trained the mind, emotions, and voice production. In his words, "tone, pacing, movement, style, everything is in the text, only in the text."[13] Several weeks into the training program, Charles Dullin, the company's most experienced and self-confident actor, took Copeau to task in a letter over his love affair with the text.[14] Dullin found Copeau so enraptured by the words that he was not paying sufficient attention to the actors, with the result that he was accepting work he would have denounced as a critic. Moreover, as an actor, Copeau was approaching his part as if it were a reading, rather than a characterization.

At the end of a month, Copeau added a daily half-hour of exercise to the actors' regime[15] under the supervision of company member Roger Karl.[16] If the sole photograph that we have is any indication, their physical work was rudimentary. The company, dressed in street clothes, awkwardly performs calisthenics as Karl watches. At approximately the same time, Dullin was also given the responsibility of working with the company on occasion.[17] Given Copeau's need for control and reluctance to collaborate, it seems obvious that he was having difficulty coping with his own impulse to share some authority. His actors, confused by these changes, did not fully trust him—with reason. Copeau was adrift, his ideas on teaching still unformed. In a letter to a friend, Copeau laid the blame at the actors' feet, complaining that they were mechanical and mannered.[18] More optimistically, he added that within two or three years, with patience and hard work, he might be able to turn them into "*hommes*," by which he meant honest artists.

Most studies and biographies of Copeau, beginning with Maurice Kurtz's 1950 *Biographie d'un théâtre* (a translation of his dissertation),[19] claim that the Le Limon group improvised during the evening, sometimes going so far as to describe the improvisations as based on the characters and situations of the plays.[20] None of the authors, however, document the assertion. If true, it would imply a freer, more imaginative, and less text-driven Copeau than he appeared to be at this juncture.

Copeau carried out his repertory plans in an extremely ambitious first season, particularly for a young company seeking to develop a new audience. No matter the risks involved, developing the public's taste was an imperative on the same level as training the actors. He directed and acted in 16 plays of diverse styles. His classics were Thomas Heywood's Jacobean tragedy *Une Femme tuée par la douceur* [*A Woman Killed with Kindness*]; Molière's *L'Amour médecin* [*The Love Doctor*], *L'Avare* [*The Miser*], and *La Jalousie du Barbouillé* [*The Jealousy of the Barbouillé*]; Alfred de Musset's poetic *Barberine*; and Shakespeare's *La Nuit des rois* [*Twelfth Night*]. His "best plays" of the 1880s to 1913, mostly unknown outside

the French theatre, have been forgotten even in today's France. The four premieres of the season included Paul Claudel's *L'Échange* [*The Exchange*];[21] the rest were written by Jean Schlumberger, Henri Ghéon, and Roger Martin du Gard, friends and colleagues of Copeau. Two medieval plays originally on the list—Adam de la Halle's thirteenth-century pastoral *Jeu de Robin et de Marion* [*The Play of Robin and Marion*] and the anonymous fifteenth-century *Farce du savetier enragé* [*The Farce of the Enraged Shoemaker*]—appear to have been dropped.[22]

Early productions were generally ignored by newspaper critics; more attentive were "little magazines" with little readership. *A Woman Killed by Kindness*, the first play, bewildered many, as did Copeau's mise en scène. Monotonous, dull, puritani-cal, and dimly lit was the general opinion.[23] Once adjusted to Copeau's methods, however, audiences and critics began to see their value, at least for a time. The penultimate production of the season, Henri Ghéon's ill-conceived, melodramatic *Eau de Vie* [*Water of Life*], "drove spectators away,"[24] raising the company's anxi-ety about the future. However, the Vieux-Colombier's legendary *La Nuit des rois* (*Twelfth Night*), the season's last show, took the company to a new level.

With this production, Copeau became more collaborative: he reworked Théo-dore Lascaris's translation in company with his actors, and he brought in the mod-ernist British artist Duncan Grant to design the colorful, extravagant costumes and abstract, minimalist set. And it was the comic and even slapstick aspects of *Twelfth Night* that Copeau emphasized. In a standout cast of male farceurs, Louis Jouvet demonstrated his mastery of comedy as a waddling, huffing and puffing Sir Andrew Aguecheek, in "flame-colored" stockings and "an azure-colored top hat in which two rose-colored wings [had] been inserted."[25] Praised and promoted by critics, *La Nuit des rois* would be a box office smash. Copeau could regard his aspirations validated.

The company's euphoria collapsed with the outbreak of World War I in the summer of 1914. The Vieux-Colombier was transformed into a wartime shelter and the male company members were drafted—apart from Copeau, deferred for health reasons (a pulmonary infection). Although disappointed by the loss of his theatre, Copeau took the unexpected free time to plan for the future, aided by his prolific correspondence with Jouvet and Dullin, both at the front. Foremost in Copeau's mind was the development of a school that would serve as his labora-tory, and for this he needed to talk with and observe arts educators with novel and proven methods.

In 1915, Copeau visited Gordon Craig in Florence for two months. Craig's school—closed for lack of funding—had trained designers and technicians but refused actors. While Copeau's focal point was now the training of a new actor for a renewed theatre, Craig saw the theatre as a composite art in which the director reigned supreme. Nonplussed, Copeau deemed Craig's ideas colossal, overwhelm-ing, and impractical, summing him up as a "man of genius" but "disconcerting."[26] Only later did Copeau realize how much of Craig's conception he had absorbed.

Next Copeau visited Émile Jaques-Dalcroze in Geneva. Although Copeau's pro-ductions had incorporated corporeal comedy, he had been skeptical about physical training until he happened upon *The Eurhythmics of Jaques-Dalcroze*, which awak-ened him to the possibilities of movement and rhythm for the actor. Although

Jaques-Dalcroze was primarily a music educator for children, Copeau found his work methods compatible and integrated some into his training, only to repudiate them later.[27] Jaques-Dalcroze's approach synthesized sound, music, and the body, using exercises that, because they were fun, freed up his pupils.

Toward Improvisation

Back in France, Copeau consecrated himself to the development of the school he intended to open after the war. During the winter of 1915, his preparation consisted of twice-monthly working sessions with the Vieux-Colombier actresses, those few actors not serving in the military, and several amateurs.[28] Judging from his description,[29] these classes differed little from those held in 1913. More significant was the children's group he established with his collaborator Suzanne Bing, who taught most of the classes. Jaques-Dalcroze's influence could be seen in the children's sound and movement exercises and warm-ups that included marching and throwing a ball in various combinations. But the classes went beyond Jaques-Dalcroze's in their practice of improvisation, perhaps Copeau's first attempt to use the technique. Unlike the 1913 training, the children's classes were carefully documented by Bing.[30] She writes of the children's "exultation" when they improvised La Fontaine's animal fables. This exercise would be carried further, with each child basing the animal he or she played on real-life observation. The children's responsiveness was not lost on Copeau and Bing. Although the children's classes were led by Bing, Copeau too had been thinking about improvisation and a modern incarnation of commedia dell'arte, as his correspondence, particularly his letters to Jouvet, indicates. The question for Copeau was how to stimulate a similar receptiveness in adult actors.

Like most directors who believe in the primacy of the text, Copeau had despaired of the actor's tendency to ad lib. However, attending music hall performances and other popular entertainments, where improvised farcical dialogue was a source of amusement, gave him insights into this predisposition—perhaps an inborn trait of the actor. It could be put to use as a training tool to make the actor "suppler," "bolder," and more "spontaneous."[31] He envisaged a fraternity of farceurs working together on improvised comedy, la *comédie nouvelle*,[32] where each actor would gradually develop his or her own character, much as the commedia actors had their stock characters. These characters might also serve to inspire dramatists to write for them. Although this idea carries the germ of collective creation, Copeau viewed himself as the authority who would guide the actors, dispensing knowledge as he thought fit.

In 1916, Copeau's work on the school was interrupted by a request from the Ministry of Culture to take the Vieux-Colombier company to the United States as part of a propaganda campaign to demonstrate the superiority of French culture. He agreed but had to wait until the War Ministry released his actors from military service.[33] In preparation for their American début, Copeau engaged singer Jane Bathori and her husband, the tenor Émile Engel, to coach the company on the

sung sections of their repertoire[34] and eurhythmic teacher Jessamin Howarth to work with them on physical technique.[35]

Copeau's efforts during the two years the company spent in the United States were often unappreciated by both audiences and resistant actors. In line with his revised thinking, he modified his rehearsal techniques. Rather than preblocking the play, he experimented with having the actors improvise scenes and eventually incorporated their discoveries into the staging. Charles Dullin and Louis Jouvet, talented improvisers, were most successful with this phase of the work. Suzanne Bing explored new trends in childhood education, observing classwork and then teaching what we now call theatre games at a Montessori-based school in New York for a brief period.

The Vieux-Colombier reopened in Paris in February 1920, and the school began operations in November 1921. Copeau believed this school constituted a greater step in the renewal of the theatre than the founding of the Vieux-Colombier in 1913.[36] The school was an opportunity to make an impact not only on the theatre but also, in its own way, on society. Transformation of the theatre was impossible without "a transformation of society."[37] Copeau's much heralded new drama, he believed, would appear only in response to new ways of living, thinking, and feeling. He envisaged the school expanding into a research institute of theatre and literature, which would provide training and study in every aspect of theatre, and also "a site to educate and purify the public's taste."[38] Copeau's high-minded ideas were the antithesis of the hidebound approach of the Conservatoire National, then France's only other drama school, where students learned by imitation. Copeau's unusual and well-publicized views attracted followers, as well as detractors.

Enter Michel Saint-Denis and Léon Chancerel

Charles Dullin left the company before it resumed its life in Paris; Louis Jouvet followed in 1922 for similar reasons.[39] Copeau refused to share power and did not allow them to direct. If he were to collaborate on any level, it would be with people who acquiesced to him, as did Suzanne Bing.

With the war's end and the Vieux-Colombier's reopening, 23-year-old, newly decommissioned Michel Saint-Denis fulfilled his childhood dream of participating in his uncle's great experiment. Before going into the military service, Saint-Denis had confessed that he wanted to be an actor; Copeau advised him to study shorthand. And it was as general-secretary of the Vieux-Colombier that Saint-Denis began his theatrical career. He rapidly and conscientiously worked his way up the administrative ladder, eventually working alongside Copeau as rehearsal assistant and stage manager. He gained Copeau's trust, becoming his confidant and, in 1922, his right-hand man, replacing Louis Jouvet in that capacity. That same year, Saint-Denis made his acting début in the small part of Curio when Copeau revived *Twelfth Night*. Although he was never formally a student, the school played a very important role in Saint-Denis's life, laying the foundations for his future work. He observed classes, took them when he could, and learned much.

His growing craft was acknowledged with the directing assignment of *Amahl ou la lettre du roi* [*Amahl or the King's Letter*] for a student presentation.

A contemporary of Copeau, Léon Chancerel had been attracted to the world of art, particularly literature, since boyhood. He had explored poetry, fiction, nonfiction, and even drama, making little impact. His novel *Cendres de mercredi* [*Ash Wednesday*] was a *succès d'estime*. Like Copeau—and many of his generation—Chancerel castigated the commercialism of French society and looked to art as a civilizing force with the power to make social change.

Despite Chancerel's frequent theatre attendance, participation in amateur performances as an actor and puppeteer, acquaintanceship with professional practitioners, and circle of intellectual friends, he was unaware of Jacques Copeau's activities until 1920. He went to see Georges Duhamel's satire *L'Oeuvre des athlètes* [*The Work of Athletes*] at the Vieux-Colombier; the production, "a revelation," "captivated" him and changed his life.[40] A meeting with the charismatic Copeau, whose asceticism, willingness to sacrifice for his art, and mission to save the theatre, converted Chancerel into an acolyte. Chancerel hoped that he might be one of the new dramatists;[41] Copeau assigned him the thankless task of playreader. Shocked (but heartened) by the poor quality of the scripts, Chancerel wrote and submitted plays to Copeau that were severely criticized. His full-length manuscripts rejected, Chancerel began writing farcical curtain-raisers for the company, and, in December of 1921, his *Le Conférencier* [*The Lecturer*] preceded Molière's *Le Médecin malgré lui* [*The Doctor in Spite of Himself*].[42]

Chancerel yearned to have greater responsibility in the company but had to content himself with playreading, hours of library research on the commedia dell'arte, the occasional small part, and even rarer directing opportunities when he was allowed to stage a prologue.[43] Nonetheless, as was the case with Saint-Denis, these years constituted a practical theatrical education. He talked with Copeau, watched him work, observed classes at the school, and sketched out a couple of scenarios for the students.

The Vieux-Colombier School

The actor can become through his own movement the director's collaborator and render the latter's work more and more useless.[44]

—*Suzanne Bing*

The Vieux-Colombier School first made its appearance in embryonic form in March 1920 as a one-woman operation. Suzanne Bing taught 12 students accepted via audition. Among them were Marie-Madeleine Gautier (called simply Madeleine) and two young Vieux-Colombier actors, Jean Villard and Auguste Boverio—all key figures in the years ahead. Bing's all-day class covered the fundamentals: text analysis, oral interpretation, beginning sound and movement, gestural expressiveness, and elementary improvisation. For the first time, however, we encounter exercises with a very narrow focus: finding a range of ways of expressing exclamations such as "oh, oh, oh!"; experimenting with grimaces, a precursor to mask

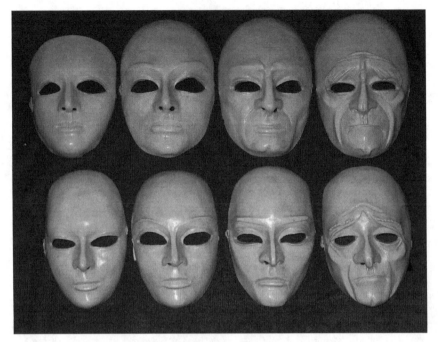

Figure 4.1 Neutral Mask from the Collection of Brian Smith
Photo by Lawrence Baldwin.

work; and exploring the possibilities of expressing meaning through a specific part of the body, to name only a few. Students relished the work, so similar to play—not surprising given that the basis was Bing's pedagogical discoveries in the United States.

Copeau appeared in class from time to time. Like a school principal, he observed for several minutes and gave Bing feedback after class. In addition to directing and acting at the theatre, he was busy looking for funding, a location for the school, and faculty, while designing the curriculum with input from Suzanne Bing.

Extant documents reveal various conceptions of the school before Copeau settled on the model for its formal début in 1921. He established three sections; one for the general public; another for professional actors, playwrights, and technicians; and a third composed of 12 young hand-picked student-apprentices, subjects of Copeau's experiment. (Future mimes Étienne Decroux and Jean Dorcy were among the beneficiaries.) Copeau had realized that to achieve his goals he needed the malleability, inexperience, and idealism of youth. Thus the group ranged in age from 15 to 23. To keep his apprentices "pure," he located his school several blocks away from the Vieux-Colombier Theatre, so that they would have little contact with the professional actors. On two occasions, however, the apprentices appeared in a Vieux-Colombier production playing nonspeaking roles based on their improvisational study: André Gide's *Saül* in 1922 and René Benjamin's *Il faut que chacun soit à sa place* [*Everyone Must Be in His Place*] in 1924.

Jacques Copeau appointed author Jules Romains director of the school with the proviso that all decisions regarding students, faculty, and curriculum be approved

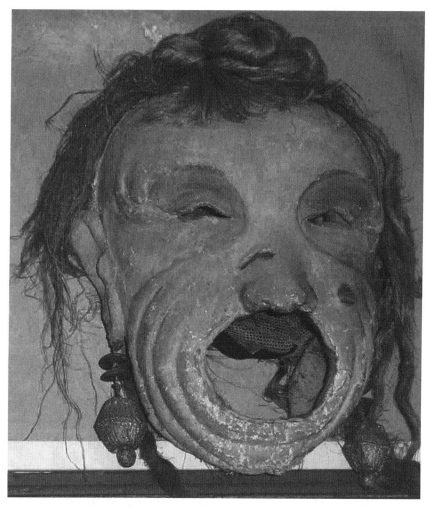

Figure 4.2 Mask Made by Marie-Hélène Dasté and Worn by Suzanne Bing in the Copiaus' Production of *La Celestine*
Photo by Lawrence Baldwin.

by Copeau—an arrangement he called collaboration.[45] Although extremely innovative in the 1920s, aspects of the three-year course of study resemble today's BFA programs in the United States, due in part to the long-term, if sometimes obscure, influence of the Vieux-Colombier School. French, general culture, poetry study, theatre history, and theory were all part of the curriculum. Guest lecturers and artists such as the Fratellini Brothers, clowns at the Medrano Circus, enriched the classwork. Academic courses alternated with practical classes in diction, singing, movement, voice and speech, and Suzanne Bing's "Dramatic Instinct," which combined theatre games and both silent and spoken improvisation. Bing was responsible for most of the teaching. Copeau's pedagogical role was limited to lecturing on theory and history, critiquing student work, monitoring the teaching, and

occasionally rehearsing students on the year-end projects. His daughter, Marie-Hélène, then 19, was at once student and teacher; in these capacities, she also served as a link between Copeau and the students. She gave a studio course in stagecraft, with a concentration on mask making.

Formal mask study—one of the school's most pioneering practices—was introduced to the students in the advanced phase of Dramatic Instinct as part of its objective of discovering new dramatic forms. The neutral full-faced mask they wore evolved from the simple act of covering the actor's face with a stocking to encourage physical expressiveness by eliminating dependence on facial and vocal expression—impossible behind the mask. Students took ownership of this work by modeling their own masks. Initial exercises were as slow and simple as choosing a mask with the left hand, remaining immobile for a moment, sitting in a chair, and contemplating the mask before putting it on. In a later exercise, the masked student chose one movement or physical attitude that would read clearly. One such student portrayed listening by intently staring at a fixed point.[46] As students grew more comfortable and skilled, exercises incorporated movement, progressing to brief scenarios, at times, individual, at others, paired. Descriptions read like nascent Marcel Marceau mime pieces.

Copeau's authoritarian character notwithstanding, the School was creating conditions that would ultimately generate collective creation practice. This was due in part to Copeau's unwillingness and—given his responsibilities at the theatre—inability to commit himself to teaching, preferring to leave the day-to-day practice to his trusted and fervent disciple Suzanne Bing. Bing's pedagogical approach, influenced by her Montessori experience, emphasized creativity, spontaneity, choice, and independence, within limits.

As in the "auto-cours" of Lecoq training,[47] the Vieux Colombier students constructed their improvisations together and criticized one another's work, deriving confidence and developing their imaginations from the practice. Spoken improvisation or character study, taken concurrently, had parallel elements. Paradoxically, its earliest exercises were silent—the emphasis being on clarity of purpose, movement, and behavior. Exercises were performed singly, paired, or in groups. As in all their classes, sincerity and truth were considered essential. But it was always theatrical truth they sought, never naturalistic. Students adopted their characters from plays—especially Molière's—or literature, but they took them in a personal direction. Exercises were created to aid them in defining these characters.[48] Bit by bit, vocalization was added. In the first stage, the students used an invented language—called "grummelotage"—made up of cries, murmurs, and chanting to express the emotion of the moment. In the next phase, each student developed phrases for his or her character-in-progress and began to interact with other protocharacters. They brought improvisation to their study of Greek theatre as well, using mythology as their wellspring for characters. Arguably, these miniscenes were the beginning of collective creation. For their year-end performance, they developed *Psyché*,[49] an eight-page scenario that they acted, danced, and sang, which from today's vantage point looks (and reads) like a full-blown collective creation.

Termination of the Vieux-Colombier Theatre

At the end of the 1923–24 season, Copeau closed his theatre. Multiple factors, personal and professional, influenced his decision. He experienced the first symptoms of the arteriosclerosis that would be responsible for his death in 1949.[50] He underwent a religious crisis that led to a fervent embrace of Catholicism and complete rejection of contemporary social values. On the professional side, Copeau had successes, but also failures, and grave disappointments. The Vieux-Colombier's limited seating capacity nullified the successes, but Copeau refused to move to a larger house for fear of becoming commercial. Real competition emerged when Charles Dullin created his own troupe in 1921 and Jouvet in 1922. Jules Romains abandoned Copeau when the latter rebuffed his *Monsieur le Trouhadec*, which Jouvet promptly accepted. During the 1923–24 season Copeau produced his autobiographical play *La Maison natale* [*The House Where I Was Born*], twenty years in the writing—a flop. Most critics judged it an outdated play that Copeau would have rejected had another dramatist submitted it.[51] His hopes for the future then resided in the students, due to present their version of the Noh play *Kantan*, directed by Suzanne Bing. The audience of intimates at the dress rehearsal were, except for Gide, stirred by its beauty. Unfortunately, the showing for a larger audience at the Vieux-Colombier Theatre was cancelled owing to an accident to the leading actor, Aman Maistre.

Morteuil

Copeau turned his back on Paris to create a brotherhood of theatre practitioners in Burgundy with his enthusiastic adherents. A motley group, bound together by a belief in Copeau and, in some cases, family ties, it was composed of 11 students; teachers Suzanne Bing and Georges Chennevière; actors Jean Villard, Auguste Boverio, and François Vibert; technician Alexandre Janvier; Michel Saint-Denis, his sister Suzanne, and her husband Aman Maistre; and Léon Chancerel. (A number of members brought spouses and children, bringing the total to 35.) Since they were to live communally, Copeau leased a farmhouse because of its large size and low rent.[52] Ironically misnamed the Château de Morteuil, it was dilapidated, filthy, ill heated, and situated close by a marsh.

The log or *journal de bord*, kept first by Léon Chancerel and then by Suzanne Bing, though sparse, is the most detailed source of their activities from 1924 to 1929. By the end of September 1924, almost everyone had settled in. On October 4, for reasons unknown, Copeau left the community for Paris, where he spent a month. Facets of the students' lives resembled a theatrical fête; improvisations, songs, and masquerades were woven into daily existence.[53] Birthday and holiday celebrations became even more theatrical, frequently making use of improvisations or characters in development. Upon Copeau's return, he laid down a rigorous schedule and a strict, almost monastic rule. Under the sway of his recent religious conversion, he told the community that the "essential condition [was] to have a religion."[54] It is unclear from the notes taken by the members if Copeau was

referring to Christianity or the theatre or conflating the two. There was unquestionably an aesthetic side to his ambitions for the community but also a quality of monasticism. Inspired by the ancient Greeks and commedia dell'arte, he intended to mold the actors into a unified collective, "the chorus," which undermined the notion of individualism and glorified the potential of group work. For today's reader, Copeau's vision of community conjures up a cult.

After instructing the group that their communal life would be "hard, poor, and nomadic,"[55] he divided duties among them: Saint-Denis, in charge of general order, and Marie-Hélène, in charge of the student group, who would live an almost cloistered existence. Both would act as intermediaries between the *Patron* and the community. Cooking and housekeeping were the responsibility of everyone, excepting Copeau, who spent considerable time in his room writing, meditating, and worrying about financing the project. Copeau was responsible even for the small monthly allowance group members received. He had only 3,000 francs,[56] with little chance of raising more, having left his supporters in Paris. The community was unaware of the gravity of the financial situation.

Classes soon started up again, but, with fewer instructors, former students took over courses or, as before, explored independently in solo and group work. In Burgundy, the division between professional actors and students disappeared. Everyone—again with the exception of Copeau—participated in the classes, which generated new work. Jean Dorcy taught gymnastics; Marie-Hélène Copeau, Madeleine Gautier, and Clara Stoessel researched and rehearsed different modes of pantomime.[57] Newer students worked with Suzanne Bing on diction and theatre games. Georges Chennevière continued his course on medieval French and history, using texts from the Middle Ages. Since Molière would be a focus of their study, Suzanne Bing, François Vibert, and Jean Villard gave nightly readings of his plays. Classes competed with rehearsals for time. Throughout December, weekends were given over to performing Molière farces, directed by Copeau, in neighboring villages and towns.

Copeau was often absent giving public readings, which, however, were insufficient to pay the group's expenses. He placed his hopes in a group of wealthy industrialists in Lille, longtime admirers of the Vieux-Colombier's work. Given the size of the potential contribution—300,000 francs[58]—Copeau's actions seem rash and foolhardy. He hastily put together an evening of plays: *L'Objet ou le contretemps* [*The Object or the Mishap*] and *L'Impôt* [*The Tax*], which he wrote, and a prologue, *Les Fâcheux* [*Irritating People*], authored by Léon Chancerel.[59] All three represented the group's commedia research. As such, they were meant to make the group's case to the funders. Rehearsals began as the plays were completed— *L'Objet* on December 11 and *L'Impôt* on January 4. No rehearsal records exist for Chancerel's piece.

The production in Lille on January 25, 1925, was a catastrophe. *L'Objet ou le Contretemps*, a comédie-ballet of "limited interest,"[60] lived up to its name when Auguste Boverio collapsed onstage—certainly a mishap. *L'Impôt*, a plea for money disguised as a comedy, repelled and bewildered its target audience. The industrialists had expected a production of the quality that they were accustomed to at the Vieux-Colombier Theatre. With no funding in sight, Copeau abandoned Morteuil

several weeks later. On February 18, he sent Saint-Denis a letter instructing him to dissolve the company, adding that Michel should perform this painful task as if he were the sole leader. Saint-Denis would take him at his word.

Most of the community departed distraught. A core group including Michel Saint-Denis, Jean Villard, Auguste Boverio, Aman Maistre, Léon Chancerel, and Suzanne Bing chose to stay. In the heat of the moment, they made a joint decision to form a troupe they called the Copiaus—"Copeau's children" in the local dialect. Saint-Denis was elected director because of his strong personality, managerial skills, and experience running rehearsals during Copeau's absences. To enlarge the troupe, Marie-Hélène Copeau and her soon-to-be husband Jean Dasté were recalled, as was Madeleine Gautier. Marguerite Cavadaski, a former Vieux-Colombier student, was invited to join. Never an official member, Chancerel participated for several months. Suzanne Maistre also worked in the troupe in various capacities. They all shared the belief that the comédie nouvelle and the fixed characters they had been exploring would be pivotal for the theatre of the future. And because it was a form of popular entertainment, they were convinced that they would find audiences in the local villages and be able to subsist on the proceeds. Immediate monetary problems were temporarily alleviated when Jean Villard borrowed money from Swiss friends. Copeau, freed from his economic burden, moved back to Burgundy, ostensibly to write.

The Copiaus returned to developing their archetypal, half-masked characters for the comédie nouvelle, the most interesting area of the work to the men in the company. Dasté, Villard, Maistre, and Chancerel each created one, but only Saint-Denis succeeded in inventing two usable characters. The first was "Jean Bourguignon," a wine-growing peasant, designed to foster identification in the local audiences. The second, "Oscar Knie," more complex and universal, took longer to emerge. Villard's "Gilles" and Maistre's "Julien"—contemporary versions of the commedia servants—took the names and elements of the characters into their second career as a singing duo.[61] Chancerel brought life to "Sébastien," a commedia-like pedant who in today's world still is recognizable as the "absent-minded professor." The commedia's miserly and elderly Pantalone infused Sébastien as well. In a long coat and yellow mask with a pointed nose and spectacles (to match his own),[62] Chancerel drew on his personal extremes of mood and volubility to create this double-faceted character, who continued to evolve long after his leaving the Copiaus.

Neither Saint-Denis nor Chancerel had been students at the school, yet both were successful with commedia types, while none of the women—even strong actresses like Marie-Hélène Copeau—developed an archetypal comedic character. Jean Dasté later hypothesized that the improviser enters "a kind of delirium which demands great strength, perhaps surpassing women's physical limitations."[63] More likely, contributing factors were the lack of female comic role models in popular entertainment, the sexism that permeated the Copiaus—as seen in Dasté's remark—and/or the fact that the women were so busy fabricating costumes and props that they lacked the time.[64]

The new regime with Saint-Denis as director was more a company of equals. With growing confidence, Saint-Denis began developing scenarios. He wrote a

Figure 4.3 Michel Saint-Denis as Oscar Knie, His Masked Contemporary "Commedia" Character

prologue titled *Jean Bourguignon et les Copiaus* for their upcoming production to introduce the young company to their public. Excited about their first independent show, they planned to present a series of short, comic, partially improvised pieces, interspersed with poetry and songs, as well as the medieval farce *La Sottise de Gilles* [*Gilles's Folly*]. In his element, Chancerel wrote two scenarios for which Villard composed the music.

Shortly after rehearsals began in March, Copeau made his presence felt. In mid-March, when the production fell a half-hour short, Copeau wrote a one-act play *Le Veuf* [*The Widower*], based on the grotesque suicide of a local resident. Essentially a monodrama for Copeau, Suzanne Bing and Michel Saint-Denis would each play a bit part. On April 17, the *journal de bord* tersely notes, "The *Patron* is attending rehearsals more frequently,"[65] which undoubtedly discomfited Saint-Denis. Two weeks before the May 17 premiere in Demigny, the rest of the Copiaus saw *Le Veuf* in rehearsal for the first time. The actors were appalled by the old-fashioned

naturalistic script and Copeau's hammy performance,[66] both out of tune with the joyful, theatricalist performance they were preparing. The audience reacted similarly. *Le Veuf* was replaced by *Mirandoline*, a one-act adaptation by Copeau of Carlo Goldoni's *La Locandiera*.

Notwithstanding his failure with *Le Veuf*, on June 8, Copeau, again asserting his need for control, met with the company and insisted that he reassume the direction. When the actors protested, he threatened to take back his daughter, Madeleine Gautier, and the materials he had loaned them for the company. He also cautioned Chancerel to restrain himself before expressing his erratic emotions. Swallowing his pride, Chancerel pleaded poetic sensitivity. The loss of their independence created resentment in the company. Saint-Denis was dismayed by losing his directorial position while retaining his administrative responsibilities. Years later he described the fraught atmosphere: "There was a state of tension between Copeau and the group of students who had become the Copiaus. It was never an open regime."[67] Tension also permeated the actors' relationships with one another; factions formed.

On July 2, Chancerel announced his departure. His public humiliation by Copeau may have caused him to rethink his future. Moreover, as Chancerel confided to his diary, Copeau seemed incapable of carrying out the renewal of the theatre. "When I am with the *Patron*, I no longer have the impression of being with a leader, but with an old tired uncle, whom I love and once admired."[68] And although he played a bigger role in Morteuil than he had at the Vieux-Colombier, he was not a full-fledged contributor. On his side, Copeau may have felt threatened by Chancerel, who from time to time criticized his decisions and writing, although privately. And if, as scholars John Rudlin and Maryline Romain suggest,[69] Chancerel planned to set up an experimental theatre center in Pernand-Vergelesses—taking with him Boverio and Villard—Copeau would have driven him out, as he had Dullin and Jouvet. We do know that Chancerel intended to purchase a house in Pernand-Vergelesses, and that Boverio left the Copiaus at the end of July.

After the initial takeover, Copeau, as Chancerel noted, led only intermittently, thus inadvertently boosting the prominence of Saint-Denis and Villard. Freed up to an extent, the actors created their own works. One such example was *La Célébration du vin et de la vigne et des vignerons [Celebration of Wine and Vine and Winegrowers]* in November 1925, which showcased their mime, gymnastic, and musical skills. Although partially scripted—Copeau, keeping his hand in, literally, wrote some of the text and Saint-Denis contributed poems—most of the production grew out of Saint-Denis and Villard's rudimentary anthropological research, a forerunner, although very different in style, to documentary theatre of the late twentieth century. The two men interviewed winegrowers for their stories and observed them at work, later incorporating their chores into the production in mimes, developed together with the performers. The finished production was closer to a "folkloric entertainment"[70] than a play. It was, the *journal de bord* reported, their "first total creation"[71]

Pernand-Vergelesses

In December, the Copiaus relocated to the sunny hills of Pernand-Vergelesses, a village (population one hundred) six kilometers away from the small city of Beaune. Communal living arrangements ceased, releasing the actors from their interminable domestic chores. Copeau bought the very house that Chancerel had considered; Suzanne Bing rented a house close by, as did Saint-Denis and his family. Other company members rented rooms in the area. Copeau acquired an abandoned *cuverie* (a building for aging wine) that the Copiaus renovated for classes and rehearsals. Two students, the first of several, joined the group. Saint-Denis taught improvisation and mask modeling; Marie-Hélène Copeau, mime; Dasté, mask; and Villard, singing. Sets, costumes, and masks were company made. In preparation for new works, they improvised topics, singly and in groups. Their interest was large and universal themes that could be represented through mime, sound, rhythm, and music. Copeau occasionally suggested themes, but more often the Copiaus devised them.

Their first Pernand creation, however, was scripted by Copeau. *L'Illusion* was inspired by Pierre Corneille's seventeenth-century *L'Illusion comique*, Fernando de Rojas's medieval *La Celestina*, and the Copiaus. The characters drew on their personalities and particular skills. As in the earlier Copiaus-generated work, the production was an entertainment or theatre game (*jeu*), written around themes rather than a story. Villard composed the music, Marie-Hélène Copeau designed the costumes; the actors created the masks and choreographed the mimed and dance sections. The production was an enormous success, not only in the villages of Burgundy, but in cities like Lyon, Lausanne, and Geneva, where it toured during the fall of 1926. Even the perennially dissatisfied Copeau was pleased.

Unable to capitalize on this achievement and in need of money, Copeau left for New York to mount *The Brothers Karamazov* for the Theatre Guild, after which he gave a series of remunerative readings and lectures in the city and its environs. When he returned to Europe, he toured Switzerland, France, England, Denmark, and Belgium. Isolated in Pernand, the Copiaus felt at loose ends. Should they develop a project or wait for Copeau? Copeau's letter instructing them to "redouble [their] efforts"[72] encouraged the actors to develop two performance pieces, *Le Printemps* [*Spring*] and *La Guerre* [*War*], which they spent five months rehearsing. Even the titles typify the difference between Copeau's approach to creation and the Copiaus'. Copeau's source was usually literary; the Copiaus', their thematic improvisations. *Le Printemps* was "a living fresco"[73] of the coming of spring; *La Guerre* an allegory of war.

Upon Copeau's return to Pernand, the now-familiar pattern reemerged: imposition of control, followed by withdrawal. The Copiaus continued to tour. No longer adoring disciples, however, the actors dreamed of striking out on their own. Working autonomously, they composed their most complex work to date: *La Danse de la ville et des champs* [*The Dance of the City and the Fields*], an elaboration of *Printemps*. The new version had a deliberately naïve plot that contrasted city and country values. Copeau was politely barred from rehearsals, directed by Saint-Denis and Villard. Like *L'Illusion*, *La Danse* brought together mime, mask,

dance, choral speech, improvisation, song, and music. Saint-Denis's masked character Oscar Knie had a prominent role, as did Dasté's César. The play premiered to cheers and laughter on March 4, 1928, in a crowded hotel ballroom in the small town of Meursault.[74] Léon Chancerel attended and later described the "perfect theatrical communion between the stage and auditorium," achieved through the Copiaus' style "at once informal and noble."[75] Copeau saw the production for the first time on opening night but reserved his comments for the next day. After criticizing them severely, Copeau left the room, hurling his final condemnation at them: "Dust!"[76]

The Copiaus soldiered on creating new pieces and touring in France (but never Paris) and abroad, gaining praise and fans for their theatricalist productions, so different from anything their audiences had seen. Saint-Denis and Villard, now responsible for the texts, grew dissatisfied with their efforts. Attempts to find a professional playwright willing to collaborate with them were fruitless. In May 1929, Copeau disbanded the Copiaus without prior warning. The *journal de bord* offers no explanation; rumors claimed that Copeau was soliciting the Comédie-Française for the artistic directorship.[77] If so, it came to naught.

Michel Saint-Denis and the Compagnie des Quinze

One year later, the Copiaus reunited in Paris under the direction of Michel Saint-Denis as the Compagnie des Quinze. It appeared that the company now had the autonomy they had craved as the Copiaus. Conditions were propitious. In addition to the 15 actors, including Saint-Denis, the company had a talented designer, André Barsacq; a backer, Marcelle Gompel; and, most important, a playwright. André Obey had learned about the Copiaus through Copeau. He tracked them down in Lyon, saw their *L'Illusion*, and was enchanted. He viewed the Copiaus as the ideal instruments to explore his ideas; Saint-Denis saw Obey as the means to fulfill his ambition of creating a professional troupe. Obey agreed to become the company playwright.

As a newcomer to an ensemble that had worked together for almost ten years, Obey had a lot to learn. But he quickly adjusted to their mode of work—collective creation, although the term had not yet entered the language—and functioned as a collaborator. In theory, Saint-Denis and the company proposed topics; the actors explored them physically and vocally, while Obey began creating appropriate text. Although Saint-Denis worked with the actors throughout, he did not block until the text was complete. However, this strict schema was not always adhered to; contributions sometimes overlapped. Copeau's daughter Marie-Hélène, newly married to Jean Dasté, designed costumes and worked with her husband Jean and Madeleine Gautier creating masks. (Only rarely was a character unmasked.) The Quinze rehearsed in an elaborate studio, complete with a replica of the Vieux-Colombier's stage, paid for by Marcelle Gompel. Although the Quinze expected to tour, they envisaged the Vieux-Colombier as their home base.[78] Barsacq remodeled it according to their aesthetic, more radical than Copeau's.

In February 1931, the Quinze premiered with *Noé* [*Noah*], followed later by *Le Viol de Lucrèce* [*The Rape of Lucretia*], two of the seven plays Obey would write with and for them over the next four years. A number of Obey's works for the Quinze were developments of the Copiaus' unproduced improvisations in more polished form. *Noé*'s roots were in the medieval mystery play, long a company interest; *Lucrèce*, an adaptation of Shakespeare's poem, was the first Shakespeare the actors had attempted. *Noé* made use of their farcical skills; *Lucrèce*, their poetic skills. *Lucrèce* was remarkable for its staging, which combined stylistic elements of medieval theatre, Greek tragedy, and the Noh. Like all of Obey's plays, they were presentational in style.

Reaction to the Quinze was mixed; their theatricalist approach alienated various Parisian newspaper reviewers, while others warmed to their freshness and sincerity. For Philippe L'Amour, writing on the state of French theatre, they represented a theatrical renaissance. The avant-garde artistic community supported them; writer Henri Ghéon offered to collaborate with them. Audience response tended to be tepid, however. Perhaps most difficult for the Quinze, who believed that they were taking Copeau's work to another level, was the perception that the troupe still belonged to the *Patron*. This perception was fed by Jacques Copeau's talk at the Quinze's premiere. Although the company had asked him to introduce their production in order to garner publicity, his presence at the Vieux-Colombier and his role as speaker undermined the Quinze's independence.

On their first tour, their reception was very different, particularly in London, where they triumphed. Tickets sold out, reviewers raved, and rising theatrical practitioners filled their dressing rooms every night. The arrival of the Quinze coincided with a search for an alternative to the stuck-in-a-rut London theatre. Directors and actors believed they had found in it in the Quinze's *Noé* and *Lucrèce* with their emphasis on movement, mask, song, and mime. Theatre professionals sought out Saint-Denis for his advice. The Quinze would return to London several times.

But by 1932, the Quinze's situation in Paris had deteriorated. They lost their Vieux-Colombier venue; the Depression affected the box office and Marcelle Gompelle's pocketbook; and there were power struggles within the company. In addition, almost nonstop touring exhausted the troupe, whose members began to fall away. Satisfactory replacements were hard to come by given their very different training. Although the Quinze had an acting program, its inexperienced students were suited only for ensemble work. André Obey, although prolific, was unable to furnish enough scripts, necessitating a search for other authors. Saint-Denis never found another writer whose ideas and style were as close a fit, nor did he consider staging traditionally authored plays.

Nonetheless, the Quinze kept going until 1935 when Saint-Denis left the depleted company in Aix-en-Provence and went to London to raise money to sustain it. Uninterested in supporting a foreign company, prospective investors persuaded Saint-Denis to found a school in London and teach his approach to the next generation of practitioners. Saint-Denis made England his home over the next 16 years and underwent an aesthetic change. Professional collective creations were relegated to his past. In his late thirties, Saint-Denis began to explore the classical repertory and stage the occasional new drama fully written

by a contemporary playwright. He became a prominent director, sought out by London's leading actors—including John Gielgud, Laurence Olivier, and Peggy Ashcroft—and renowned for productions such as *Oedipus Rex* and *Three Sisters*. Even more important for the British theatre's future were his two innovative drama schools, based in part on the Vieux-Colombier model: the London Theatre Studio (1936–39) and the Old Vic School (1947–52).[79] His dual and sometimes competing objectives were to reform the theatre and to train professional practitioners. Unlike Copeau, he did not appear to believe that theatre could be reformed when divorced from its professional aspect.

Yet collective creation, an outgrowth of the improvisation courses that formed much of the foundation of the acting training, continued to play a part in Saint-Denis's professional life in the form of an acting class in both these schools. Pieces, devised by students under the supervision of the instructor, were presented to audiences at the end of each term, thus keeping collective creation alive for his students and a limited public. Many of Saint-Denis's former students became drama teachers and, through using his methods and curriculum, exposed collective creation to further generations of actors.

Léon Chancerel and the Comédiens Routiers

Upon leaving Burgundy in 1925, Léon Chancerel returned to Paris without a plan or a network of colleagues. He bitterly regretted the rupture with Copeau and tried unsuccessfully to reingratiate himself into the *Patron*'s good graces. Over the next four years, he moved from project to project—acting, writing, assisting Louis Jouvet, publishing—none fully satisfying. Having served his theatrical apprenticeship, his goal was to devote himself to transmitting and extending Copeau's teachings. During this period, his ideas on theatre broadened or perhaps narrowed, depending on your point of view. Always repulsed by the materialism and industrialism of twentieth-century France[80] and its concomitant commercial theatre, he became attracted to both amateurism and the potential use of theatre as a tool of social welfare.

How to proceed was an open question for Chancerel until his 1929 encounter with Paul Doncoeur. Doncoeur, a militant Jesuit priest distressed by France's new secularism,[81] had founded the Catholic Routiers (a senior branch of the French Boy Scouts) with the intention of instilling into them a profound Christian belief through which they would attain "human glory."[82] Given that part of the Routiers' service was providing an example and guidance to younger scouts, they would prove useful as proselytizers. Doncoeur's principal mission was the training of an elite to elevate France to its prerevolutionary greatness. His mystical, rigid, religious, and goal-oriented beliefs answered a need in Chancerel. Soon after their meeting, Doncoeur requested Chancerel direct a Nativity play, using Routiers as actors. The production, which took place in a barn in the Marne Valley, satisfied Chancerel's romanticism and sense of social duty. The program was followed by charitable gifts to the poor. Chancerel's diary records his delight: "Complete success," "emotional evening," and, most importantly for Chancerel's future, "possibility of improvisation."[83] The Routier's youth, discipline, communitarian ethic,

healthy outdoor lifestyle, even naiveté—all reminiscent of the Copiaus—held enormous appeal for him.

Indeed, the Routiers would serve a function for Chancerel similar to the Copiaus' for Copeau. But younger, less experienced, and focused, the Routiers were more tractable, at least at the beginning. Early in 1930, Chancerel founded a drama center, le Centre d'Études et de Représentation Théâtrales Scoutes (CERTS),[84] whose long-term function was to renew all aspects of French theatre, including the public's taste.[85] More immediately, the center concerned itself with education, dissemination, and creation. (To deepen the connection between theatre and scouting, Chancerel introduced a theatre merit badge.) The center offered two actor-training sections: the first for scouts with an interest in the theatre, the second—the focus of Chancerel's activity—the Comédiens Routiers (1930–39).

The company of actors—led by Chancerel, who taught, directed, acted with, and wrote for them—was remarkably talented and deeply affected by their experience with the Comédiens Routiers.[86] Several, like Olivier Hussenot and Jean-Paul Grenier, would go on to form professional companies as actor-managers. Still others, like Hubert Gignoux and Maurice Jacquemont, would be leaders in the decentralization of French theatre following World War II. (Suzanne Bing's son Bernard passed briefly through their ranks.)

The Comédiens Routiers were tightly linked to Catholic activism and social service, also a scout mandate. They performed in hospitals, churches, nursing homes, the French equivalent of settlement houses, and schools. Their religion-inflected repertory was a proselytizing tool: Nativities at Christmas, Passion Plays at Easter, and, during the year, Catholic-themed plays presented at religious pilgrimages, inspired in part by Chancerel's interest in the Middle Ages. The anti-Semitic Le Juif errant [The Wandering Jew], in which Chancerel played the leading role, is an example.

However, given that Chancerel's special interest was commedia dell'arte, secular comedy shared equal emphasis. Chancerel, frustrated by what he saw as Copeau's failure to pursue the archetypal characters of the comédie nouvelle, took on the task. His training revolved around improvisation, as had the Copiaus'. Realizing the need for a more complete theatrical education in order to discover modern equivalents of Pantalone, il Dottore, and Arlecchino, in 1932 he engaged Jean Dasté for three years to teach mask and movement. To an extent, Chancerel succeeded through combining farce and fairy tale. He formed a branch of the Comédiens Routiers, the Théâtre de l'Oncle Sébastien (1934–38), which created five productions to prove his theory. Since the plays were original fairy tales directed at children, the characters were not the representative contemporary types that Copeau and Chancerel had envisaged. To encourage audience recognition, names frequently illustrated character traits. They included Chancerel's "Uncle Sébastien," the principal role; his sidekicks were Sébastien's nephews "Pouique the Glutton," "Lududu," and "Pedro the Music Maker," played respectively by Jean-Pierre Grenier, Olivier Hussenot, and Hubert Gignoux.[87] A fifth character, "Sylvestre the Saltimbanque,"[88] a magician, came to the rescue when adventures went awry. "Piaf the Enchanted Horse" rounded out the group. Vaguely reminiscent of an all-male Peter Pan and his band of followers, these characters also lived in an idealized countryside untainted by the modern world.

Were Chancerel's works collective creations? Supporting documentation is tenuous; Chancerel's biographer Maryline Romain claims they were, but does not elaborate.[89] Yet I would posit that despite Chancerel's rigid and dictatorial personality, collective creation was part of the work mode of the Comédiens Routiers. The Vieux-Colombier, its school, and most especially the Copiaus were the model for Chancerel. It was through working imaginatively, improvisationally, and collectively with the Copiaus that he created his character of Sébastien. Their goals were his—their rehearsal methods known and approved by him. In his teaching, he used their theatre games, as a glance at his acting manuals proves. His productions, made up of a series of choral recitations, short scenes, mimes, songs, and other musical numbers, resembled theirs. Like Copeau, Chancerel was a writer whose ambitions outweighed his talents. And again like Copeau, who wrote plays for the Copiaus, Chancerel wrote plays for his troupe. But he may have deviated slightly from the Copeau paradigm. As we have seen, it was the ad-libbing comic that aroused Copeau's interest in the possibilities of improvisation. Chancerel took the lesson to heart, but perhaps not in the way Copeau meant it. Uncle Sébastien's theatre always left considerable space for improvisational dialogue during the performance, following the spirit and the letter of commedia.[90] The Copiaus, on the other hand, were a collective who considered themselves full collaborators in their productions, but collaborators who needed a writer to shape the material.

In time, the modern world became more attractive to the actors of the Comédiens Routiers. As had the Copiaus before them, they began to feel the desire for independence, a professional career, and personal recognition—this last, apostasy for Chancerel, whose idea of the theatrical collective resided in the anonymous societies of medieval artists and craftsmen. The Comédiens Routiers ended in 1939. After they left Chancerel, none of the Comédiens Routiers manifested the Copiaus' continued interest in collective creation, presumably because, unlike the Copiaus, they had not been authors of its development but rather the means to fulfill another's vision.

Conclusion

In this chapter, I have traced the reemergence of collective creation in the work of Copeau and the insufficiently acknowledged Suzanne Bing and its extension in the theatres of Michel Saint-Denis and Léon Chancerel. I have argued that both Michel Saint-Denis and Léon Chancerel viewed themselves as Copeau's heirs, the bearers of his ideals and methods. Each carried out his self-appointed task, each in his own way and without reference to the other.[91] But how successful were they?

Saint-Denis's Compagnie des Quinze would seem to be the realization of collective creation as Copeau (and Suzanne Bing) envisaged it: an ensemble of actors working together with (and under) an author and director—a hierarchical collaboration. The fact that Suzanne Bing was a participant in the troupe's early years attests to its authenticity. Saint-Denis's schools carried forward the curriculum of the Vieux-Colombier, with amendments such as the emphasis on vocal training. His schools, which imparted an idealism to their students but one more

grounded in reality than Copeau's mysticism, reflected Saint-Denis's more prag-matic character.

While Copeau shared Chancerel's fervent Catholicism, he did not bring it directly into his pedagogy, nor did he explore religious theatre until after the dissolution of the Copiaus. In 1934, Copeau staged *Santa Uliva*, a medieval mystery play, and in 1935, *Savanarola*, a mystical drama based on the life of the religious zealot. Both were akin to the outdoor mass spectacles of the era, both performed in Florence during Benito Mussolini's fascist reign. In 1943, Copeau directed another Catholic work, *Le Miracle du pain doré* [*The Miracle of the Golden Bread*], which he refash-ioned from a fourteenth-century play, giving himself the role of the *meneur de jeu*, a character roughly analogous to the Chorus in Shakespeare's *Henry V*. This produc-tion, given for the five hundredth anniversary of the Hôtel-Dieu in Beaune (not far from Pernand-Vergelesses), was a source of satisfaction for the normally hypercriti-cal Copeau. A photo of the event reveals numerous Nazi officers in the audience.

Although Copeau regarded himself as "apolitical,"[92] these productions suggest a possible sympathy with fascism. More suspect was Copeau's adherence to the Vichy "racial" policies during his short tenure as Administrator of the Comédie-Française (May 1940–March 1941). Once in charge he dismissed Jewish actors and staff, evi-dently not because of personal anti-Semitism but because the Comédie-Française would not be allowed to continue its work otherwise. When in later years, Copeau's diary became public, it exhibited his concern for the persecuted Jews while, at the same time, revealing where his values lay—that is, with the theatre.

Chancerel's political ideology lay further to the right than Copeau's. Whereas Copeau wanted to build a new theatre for society, Chancerel's interest was in using the theatre to create a society based on service, religion, obedience to authority, and high culture.[93] We recognize, at least in the first three, the values of the Boy Scouts, which were also the values of the Vichy Government. (I am not arguing that the Boy Scouts are fascistic, but simply pointing out a confluence of ideals.) That Chancerel's beliefs were in accord with fascist policies is borne out by the Vichy production of his version of *Antigone* in 1941.[94] Further evidence is provided by his pro-Vichy children's novel, *Les sept leçons de Lududu* [*Lududu's Seven Lessons*], which upholds the Vichy government motto—"work, family, country"—that had replaced the French Republic's values of "freedom, brotherhood, equality."[95]

Although Copeau, Chancerel, and, to a lesser extent, Saint-Denis influenced the French theatre and theatre training for years to come, collective creation only came to the fore once again in France in the 1960s, influenced in part by The Living Theatre. A more French version was instituted at about the same time by Ariane Mnouchkine, who became a follower of Copeau through his writings. Jacques Lecoq, a disciple once removed, was responsible through his teaching for the emergence of numerous collective creation troupes, particularly in the Anglo-phone world.

Bibliography

Added, Serge. "Jacques Copeau and 'Popular Theatre' in Vichy, France." In *Fascism and Theatre: Comparative Studies on the Aesthetics and Politics of Performance in Europe, 1925–1945*, edited by Günter Berghaus, 247–259. Providence: Berghan Books, 1996.

Attinger, Gustave. *L'Esprit de la commedia dell'arte dans le théâtre français*. Paris: Librairie Théâtrale, 1950.

Baldwin, Jane. *Michel Saint-Denis and the Shaping of the Modern Actor*. Westport, CT: Greenwood Press, 2003.

Berghaus, Günter, ed., *Fascism and Theatre: Comparative Studies on the Aesthetics and Politics of Performance in Europe, 1925–1945*. Providence: Berghan Books, 1996.

Bing, Bernard. "À propos de Jacques Copeau." *Éducation et théâtre* 29 (June 1955): 289–254.

Chancerel, Léon, H. Charbonnier, and A.-M. Saussoy. "Les Copiaus" (typescript). *Jeux, Tréteaux, et Personnages* 1 (October 15, 1930): 13–17.

———. *Les Jeux dramatiques: Éléments d'une Méthode*. Juvisy: Éditions du Cerf, 1940.

Copeau, Jacques. *Copeau: Texts on Theatre*. Edited and translated by John Rudlin and Norman H. Paul. London: Routledge, 1990.

———. *L'École du Vieux-Colombier*. Paris: NRF, 1921.

———. "Un Essai de rénovation dramatique: le Théâtre du Vieux-Colombier." Translated by Richard Hiatt. *Educational Theatre Journal* 19, no. 4 (December 1967): 447–454.

———. *Registres III: Les Registres du Vieux Colombier I*. Edited by Marie-Hélène Dasté, Suzanne Maistre Saint-Denis, and Norman Paul. Paris: Gallimard, 1979.

———. *Registres IV: Les Registres du Vieux Colombier II: America*. Edited by Marie-Hélène Dasté, Suzanne Maistre Saint-Denis, and Norman Paul. Paris: Gallimard, 1984.

———. *Registres V: Les Registres du Vieux Colombier III: 1919–1924*. Edited by Marie-Hélène Dasté, Suzanne Maistre Saint-Denis, and Norman Paul. Paris: Gallimard, 1993.

———. *Registres VI: L'École du Vieux-Colombier*. Edited by Claude Sicard. Paris: Gallimard, 2000.

———. *Souvenirs du Vieux-Colombier*. Paris: Nouvelles Éditions Latines, 1931.

Dorcy, Jean. "The École du Vieux-Colombier." Undated typescript.

Gignoux, Hubert. *Histoire d'une famille théâtrale: Jacques Copeau, Léon Chancerel, Les Comédiens Routiers, La Décentralisation*. Lausanne: Éditions de l'Aire, 1984.

Gontard, Denis. "Entretien avec Michel Saint-Denis." In *La Décentralisation théâtrale en France 1895–1952*. Paris: Éditions SEDES, 1973.

———, ed. *Le journal de bord des Copiaus 1924–1929*. Paris: Seghers, 1974.

Hussenot, Olivier. *Ma vie publique en six tableaux*. Paris: Denoël, 1977.

Joubert, Marie-Agnès. *La Comédie-Française sous l'Occupation*. Paris: Talendier, 1998.

Kurtz, Maurice. *Biographie d'un théâtre*. Paris: Nagel, 1950.

Kusler, Barbara Anne. "Jacques Copeau's Theatre School: The École du Vieux-Colombier 1920–1929." PhD Dissertation, University of Wisconsin, 1974.

Laurent, Linda, and Andrée Tainsy. "Jane Bathori et le Théâtre du Vieux-Colombier 1917–1919." *Revue de Musicologie* 70, no. 2 (1984): 229–257.

Maistre, Suzanne. Interview with the author. March 15, 1996.

McBride, Henry. "Modern Art in the Theatre." *The Lotus Magazine* 10, no. 3 (March 1919): 130–133.

Page, Christiane. *Pratiques dans l'éducation en France au XXe siècle*. Arras: Artois Presses Université, 2009.

Patterson, Doug. "Two Productions by Copeau: *The Tricks of Scapin* and *Twelfth Night*." *The Drama Review* 28, no. 1 (Spring 1984): 37–51.

Paul, Norman. *Jacques Copeau: Apostle of the Theatre*. PhD Dissertation, New York University, 1961.

Romain, Maryline. *Léon Chancerel: Portrait d'un réformateur du théâtre français (1886–1975)*. Lausanne: L'Age d'Homme, 2005.

Rudlin, John. *Jacques Copeau*. Cambridge: Cambridge University Press, 1986.

Villard, Jean. "Léon Chancerel, le Vieux-Colombier et les Copiaus." *Revue d'histoire du théâtre* 20, no. 2 (1968): 152–62.

———. *Mon demi-siècle*. Lausanne: Payot, 1954.

Witt, Mary Ann Frese. *The Search for Modern Tragedy: Aesthetic Fascism in Italy and France*. Ithaca: Cornell University Press, 2001.

Notes

1. Unless otherwise indicated, all translations from the French are mine.
2. The first five volumes were edited by Copeau's daughter, Marie-Hélène Dasté, and niece, Suzanne Maistre Saint-Denis; the sixth, after their deaths, by Claude Sicard. A seventh volume, edited by Maria Inès Aliverti and Marco Consolini, is in preparation.
3. Jacques Copeau, "Un Essai de rénovation dramatique: Le Théâtre du Vieux-Colombier," 453. Hiatt mistranslated the title as "An Essay of Dramatic Renovation." *Essai* here means "attempt."
4. Ibid., 448.
5. Ibid., 451.
6. Copeau, quoted in Bernard Bing, "À propos de Jacques Copeau," 293–94.
7. In 1920, the stage was more radically redesigned, increasing its audience-actor relationship and nonrealistic aspects.
8. Copeau, "Un Essai de rénovation dramatique: Le Théâtre du Vieux-Colombier," 452.
9. Ibid., 453.
10. Jean Croué collaborated with Copeau on the script.
11. The first production was directed by Arsène Durec in 1911 at the Théâtre des Arts. The following season Copeau staged a revival.
12. Copeau's principal (and perhaps only) source at this period was Jacques Rouché's *L'Art théâtral moderne*, published in 1910.
13. Jacques Copeau, *Registres III*, 89.
14. Charles Dullin to Copeau, *Registres III*, 92–93.
15. Ibid., 91. Although the *Registres* specifically say one half-hour of exercise, numerous studies describe the class as an hour long, again without any citation.
16. Karl had played Dmitri in *The Brothers Karamazov*.
17. Copeau, *Registres III*, 91.
18. Copeau to André Suarès, *Registres III*, 91.
19. Maurice Kurtz, Biographie d'un théâtre.
20. John Rudlin, *Jacques Copeau*, 10.
21. To my knowledge, Claudel's play was first performed in English as *The Exchange* by the Échange Theatre Company in London in 2009, using a translation by David Furlong.
22. Copeau, *Registres III*, 208. In a letter to Régis Gignoux, summarizing the 1913–14 season, Copeau listed the productions, their dates, and number of performances. The two medieval plays are not mentioned. However, Norman Paul, in his dissertation, *Jacques Copeau: Apostle of the Theatre* (NYU, 1961), maintains that they opened, failed, and were removed from the repertory (169).
23. Paul Souday, *L'Éclair*, October 24, 1913, quoted in *Registres III*, 125.

24. Jacques Copeau, *Souvenirs du Vieux-Colombier*, 28.

25. Copeau, quoted in Doug Patterson, "Two Productions by Copeau," 49.

26. Copeau, *Registres III*, 278.

27. Over time, Copeau engaged former students of Jaques-Dalcroze as teachers. He found their work artificial, egocentric, and histrionic. See Jacques Copeau, *Copeau: Texts on Theatre*, 64.

28. Jacques Copeau, *L'École du Vieux-Colombier*, 34.

29. Ibid., 316.

30. Suzanne Bing's notes, quoted in Barbara Anne Kusler, "Jacques Copeau's Theatre School," 51–52.

31. Copeau, *Registres III*, 324.

32. Ibid., 329.

33. While waiting, Copeau went on a four-month lecture tour of the United States where he made valuable contacts.

34. Linda Laurent and Andrée Tainsy, "Jane Bathori et le Théâtre du Vieux Colombier 1917–1919," 233.

35. Jacques Copeau, *Registres VI*, 159.

36. Copeau, *L'École du Vieux-Colombier*, 36.

37. Ibid., 24–25.

38. Copeau, *Registres VI*, 257.

39. Jean Dorcy, "The École du Vieux-Colombier."

40. Maryline Romain, *Léon Chancerel*, 70.

41. Jean Villard, "Léon Chancerel, le Vieux-Colombier et les Copiaus," 154.

42. Romain, 370.

43. Ibid., 80.

44. Copeau, *Registres VI*, 232.

45. Ibid., 236.

46. Ibid., 301.

47. Jacques Lecoq came under the influence of Copeau's disciple, the actor and director Jean Dasté, in 1945. Dasté introduced Lecoq to mask work and other aspects of the Vieux-Colombier School training. Lecoq opened his own school in 1956.

48. Kusler, "Jacques Copeau's Theatre School," 119.

49. Copeau, *Registres VI*, 317–24.

50. Denis Gontard, "Entretien avec Michel Saint-Denis," 60.

51. Lucien Dubech, cited in Gontard, "Entretien avec Michel Saint-Denis," 61.

52. Several of the married couples rented houses in the neighborhood.

53. Denis Gontard, *Le journal de bord des Copiaus 1924–1929*, 43.

54. Ibid., 45.

55. Ibid.

56. Romain, 86. Three thousand francs in 1924 is roughly the equivalent of twenty-five hundred euros today.

57. Kusler, 175.

58. Gontard, *Le journal de bord des Copiaus 1924–1929*, 3.

59. Ibid., 57.

60. Ibid., 168.

61. Villard, "Léon Chancerel, le Vieux-Colombier et les Copiaus," 152.

62. Romain, 91.

63. Kusler, 195.

64. Maistre, Interview with the author.

65. Gontard, *Le journal de bord des Copiaus 1924–1929*, 73.

66. Ibid.

67. Quoted in Gontard, "Entretien avec Michel Saint-Denis," 71.

68. Quoted in Romain, 94.

69. Romain, 95; Rudlin, 88.

70. Gontard, *Le journal de bord des Copiaus 1924–1929*, 191.

71. Ibid., 93.

72. Unpublished letter from Copeau to Saint-Denis, July 22, 1927.

73. Villard, *Mon demi-siècle*, 136.

74. Chancerel, "Les Copiaus," 13–17.

75. Ibid.

76. Villard, *Mon demi-siècle*, 142.

77. Rudlin, 114.

78. After Copeau's departure, Jean Tedesco had taken over the Vieux-Colombier playhouse and turned it into an art cinema. The Compagnie des Quinze rented it from him by special arrangement when space was available.

79. In 1952, Saint-Denis established the École supérieure d'art dramatique in Strasbourg, France. In the 1960s, Saint-Denis cofounded the National Theatre School of Canada (1960) and the Juilliard Drama Division (1968). The latter two schools still make use of his curriculum.

80. Thanks to his marriage, Chancerel was independently wealthy.

81. In 1907, France secularized education, heretofore the province of the Church. However, the struggle between Church and State goes back to the French Revolution.

82. Romain, 133.

83. Hubert Gignoux, *Histoire d'une famille théâtrale: Jacques Copeau, Léon Chancerel, Les Comédiens Routiers, La Décentralisation*, 133.

84. The name was later changed to the Centre d'études et de représentations dramatiques (CERD).

85. Romain, 146.

86. At first, the company was made up solely of males. Women were added on a temporary basis to play female characters such as the Virgin Mary.

87. Christiane Page, *Pratiques théâtrale dans l'éducation en France au XXe siècle*, 197.

88. A type of street performer.

89. Romain, 189.

90. Gustave Attinger, *L'Esprit de la commedia dell'arte dans le théâtre français*, 446.

91. Neither Saint-Denis nor Chancerel mention the other man's work in their writings, at least as far as I could ascertain.

92. Serge Added, "Jacques Copeau and 'Popular Theatre' in Vichy, France," 254.

93. Page, 148.

94. Mary Anne Frese Witt, *The Search for Modern Tragedy*, 219.

95. Saint-Denis spent the war in London as the BBC's voice of free France.

5

Collective Creation in Documentary Theatre

Attilio Favorini

Introduction: Issues of Taxonomy

To judge from the earliest evidence, it has frequently taken a village to nurture and cultivate documentary theatre and its forebears. From conception through production, the documentary mode has attracted—even required—collective effort, frequently to the extent that no single "author" is formally credited or acknowledged, even if a dominant figure (often the director) does emerge in accounts and memoirs. As over the course of the twentieth century the documentary mode initially crossed European borders and channels and then oceans, the penchant for coauthorships, collaborations, and other forms of collective creation went with it. Even today, one of the most frequently performed plays in American collegiate and regional theatres, the documentary *Laramie Project*, is prominently touted as a collective creation.

Collective creation shares with the documentary mode an extensive and diverse variety of realizations. While it is considerably beyond the scope of this article to offer a comprehensive taxonomy, one can employ certain coordinates to locate a given example of the documentary mode on an imagined grid of collective creation. A by no means exhaustive list of such coordinates might include structural discipline (from raw and piecemeal to crafted and managed); top-down or bottom-up momentum; leadership accommodation (from absent through deputized or elected to autocrats, gurus, or even political dictators); homogeneous or heterogeneous collectives; modes of attribution (anonymous to single authored); political point of reference (identity, in-group, monocultural/intercultural, urban/rural); relational positioning (vis à vis the writer, the group, the self); emotional dynamics; discipline- or studio- or training-related; source of dialogue (improvised, found, transcribed and transformed, playwright sourced); amateur/professional; derived/devised; geopolitical focus (site specific to internationally touring); inclusiveness (of ensemble, audience, community); and aesthetic ranking (text/plot privileged or body/spectacle privileged).

Within this infinite variety, continuities are nonetheless evident. Large-scale, reality-driven representations, from early Soviet mass spectacles to contemporary examples of Anne Jellicoe's quasi-documentary Community Play movement (1987) incorporate both a top-down organizational discipline and a bottom-up, broad-based creative participant team. Smaller forms produced by troupes working over an extended time as collectives, from Blue Blouse reviews to Theatre Workshop's *Oh What a Lovely War*, are drawn to commedia and clown techniques, often coarsely juxtaposed with compendia of factual data. Living Newspapers, throughout their heyday from the 1920s through the early 1950s, characteristically relied on research teams of writers, revisers, and editors to compose text-privileged productions, which nevertheless were irregularly attributed in playbills and other publications. The exclusive reliance on found dialogue, as practiced in the documentaries of Peter Cheeseman and his followers, conveys at the very least the impression of a collectivity extending to an audience. Here, the community participates not only as observers but, through their representatives whose words constitute the dialogue, as collective creators by virtue of a shared experience. The more focused the documentary is on specific issues like Apartheid or Bloody Sunday, the more porous the barrier between spectator, actor, and writer/spokesperson—a value early embraced by the Soviet Proletkult.[1] The reader will note other continuities and recurrent themes in what follows.

The confluence of collective creation and the documentary mode was sustained by many complex cultural forces, not the least of which was the study of collective memory initiated in 1925 by the Swiss sociologist Maurice Halbwachs, along with the rise of object relations psychology, which reckons the formative impact of family groupings on personhood. The embrace of communitarian values by the youth of the 1960s and the motivation to give voice to the voiceless found their natural convergence in the collectively created documentary. But these and other broader cultural issues will have to be addressed in another study.

Documentary Origins

Whether one considers the Russian mass spectacles of the earliest Soviet era to be proto- or pseudodocumentaries, they were at least commemorative and reality driven. As Frantisek Deák long ago established, they also characteristically featured collective authorship of both script and mise en scène.[2] Neither Deák nor any of the other standard sources[3] on Soviet spectacles include playwrights' names in their accounts of the most famous productions: *The Mystery of Freed Labor*, *The Blockade of Russia*, *In Favor of a World Commune*, and *The Storming of the Winter Palace* (all 1920). They do, however, record that the complexity of the spectacles regularly required multiple directors—for example, five for *In Favor of a World Commune* and six for *The Storming of the Winter Palace*, under the general direction of Nikolai Evreinov.[4] There was one "foreman" (stage manager) for every ten of the eight thousand participants in *Winter Palace*![5]

Everywhere in evidence in protodocumentaries, boosting their immediate acceptance and popular appeal, is the satirical-grotesque idiom that remained

central to Soviet aesthetics until the triumph of Socialist Realism. The format of short, satirical pieces patched together in review fashion likewise encouraged a "many hands make light work" ethic. The "Living Newspaper" idea originated at TEREVSAT (Theatre of Revolutionary Satire), which parodied the news in a way that would not be unrecognized by Jon Stewart and Stephen Colbert. So, too, the outdoor spectacles: *Winter Palace* had scenes of bloated capitalists carrying huge bags of money marked "$50,000" along with bevies of fancy-dressed women in feathered hats.[6] Adding to their popularity were the spectacular elements, ranging in the various productions from cannon fire to naval battles reminiscent of the *naumachia* of Ancient Rome and the Renaissance. The broad, vivid, monumental outdoor productions validated what was taken to be proletarian taste.

Proletkult theoretician Platon Kerzhentsev claimed that the documentary-leaning spectacles had the further advantage of being able to effect "the disappearance of the boundaries . . . between life and art, spectator and artist."[7] Kerzhentsev understood that theatre embodied the collectivism at the heart of Soviet values. The theatrical collectivism he promoted envisioned all the people of a neighborhood participating in a theatrical production (he had seen community pageants in the United States and England) and endorsed a collectivist ideal in which participants shared all aspects of theatre work—from actors sewing costumes to ticket-takers choosing plays.[8] Kerzhentshev's ideas influenced the MastKomDram (Workshop of Communist Drama), some of whose projects were documentary-like, coauthored, and overseen by a committee comprising an actor, a director, a writer, and a designer, critic, or musician. These teams, often composed of enthusiastic amateurs, almost intentionally produced no masterpieces.[9] Kerhzentshev's ideas are also evident in the coauthored spectacle *The Crushing Defeat of the Trade Delegation from the USSR in Berlin* (1924), in which the audience became, as needed, German workers or Soviet demonstrators; the enthusiasm of the amateurs was barely contained.[10]

By contrast, professionalism, both journalistic and theatrical, gave birth to the first Blue Blouse agitprop troupe (1923), a Living Newspaper project of the Moscow Institute of Journalism and the Moscow Trades Council.[11] The responsiveness of the form to contemporary events virtually enforced a situation in which necessarily collective improvisation was common and in which a team of "factographers" was employed to collect current, official proclamations and newspaper texts and to draw material from among the mundanities of everyday life.[12] Furthermore, the variety show nature of the productions—which involved a "parade" of headlines, intricate dance and choreography inspired by Meyerhold and Nikolai Foregger, song, skits, pantomimes, masks, and puppetry—mitigated against individual-dominated work. Living Newspaper "articles" (i.e., scenes) sometimes had a single author—for example, Mayakovsky or Tretyakov—but whole texts were normally treated as "carcasses" or "frameworks" (scenarios, really) subject to update and renewal by subsequent authors/editors.[13]

Collective creation persisted as the original Blue Blouse troupe spawned copies both amateur and professional, domestic and foreign. Because the members of the troupe introduced themselves to the audience, programs were generally

unnecessary,[14] reinforcing the impression that all had worked together in creating the show. As a Blue Blouse "signature tune" put it,

> We are only cogs
> In the great soldering together
> Of one working family.[15]

Similarly, the 1924–26 repertoire printed[16] in the *Blue Blouse* journal has hundreds of titles but not a single author's name. The ethos of the troupes was perhaps never more succinctly summed up than in a 1928 article in *Blue Blouse*: "*The new forms were born in mass work.*"[17] The theoretician A. Lubimov put it even more directly: the Blue Blouse troupe was "a collective."[18]

The late 1920s spawned the political dispute over small forms (Blue Blouse) versus large forms (big professional productions). In the dispute, the Blue Blouse faction emphasized "the local character of its material."[19] Stalinism, however, looked for art that was less dynamic and diverse (and therefore more easily controllable) and more directly associated with the Communist Party. Even more important, Stalinists wanted art that was affirmative and unifying; the critical, satirical Blue Blouse productions just didn't suit this aesthetic.[20] By the time of the First All-Union Congress of Soviet Writers (1934), the "big forms" had triumphed, and with them came the renewed embrace of the master writer or director, inheritors of the mainstream Russian tradition. Collective creation took an extended holiday.

Piscator's Experiments with Collective Creation

Contemporary with the rise and demise of documentary theatre in Soviet Russia, Erwin Piscator and his colleagues were developing their own fact-driven drama in Germany. Collective creation of various degrees was part of his program from the outset. When he took a pause from his relentless production schedule to write up his theories, Piscator acknowledged in the Preface to *Political Theatre* (1929), "This book is the product of a collective effort," mentioning Felix Gasbarra and Leo Lania, in particular.[21]

From the outset, Piscator's peripatetic Proletarian Theatre "replaced the capitalist hierarchy with a collective approach. The directing team, actors, writers, designers and the technical as well as the administrative staff were bound together by their common interest in the work."[22] Typical of its early efforts was the pro-Soviet *Russian Day* (1920), commissioned by the Proletarian Theatre from a Hungarian playwright Lajos Barta, whose work was then refined and rewritten by the Proletarian Theatre's collective as the theatre's opening production.[23] As in Soviet theatre, Piscator worked both with small and big forms. He cites the 1924 *Red Riot Revue*, short scenes interspersed with music and projections "crudely assembled" by himself and Gasbarra,[24] as being important in securing the order from the German Communist Party to create *In Spite of Everything* (1925), the first play to which the term *documentary* was applied—by Bertolt Brecht, no less.[25] Of the documentary drama's creation, Piscator wrote,"The show was a collective

effort. The separate tasks of writer, director, music director, designer and actor constantly overlapped . . . And the script itself emerged gradually as the director worked with the group. Different scenes were put together in different parts of the theater, sometimes even before a definitive script had been worked out."[26] "The dress rehearsal was utter chaos . . . Gasbarra kept popping up with new scenes (until I put him in charge of the projectors)."[27]

Even after abandoning strict documentary, Piscator encouraged the formation of a dramaturgic collective at the Piscator-Bühne. This group, which included Brecht and Ernst Toller, functioned loosely to come up with ideas, rather than tightly as a writing team. Piscator was initially not happy with the results,[28] until the triumphant production of *The Good Soldier Schwejk* (1928), whose complicated germination included an adaptation of the Jaroslav Hasek novel by the coauthors Max Brod and Hans Reimann that was then readapted by a team composed of Piscator, Brecht, Gasbarra, and Lania, along with the designer Traugott Müller, the stage manager Otto Richler, and Georg Grosz, who created an animated cartoon for the show.[29] Dramaturgy itself was absorbed into stage mechanics and acting structures, effectively according the technical director coauthorial status. The technical and logistical complexities of Piscator's productions, which necessitated constant reordering of scenes and radical changes "up to and beyond the dress rehearsal," led to a general de-emphasis on the author's dialogue, which for Piscator squared with Socialist principles.[30]

After decades of exile in Europe and the United States, Piscator became prominently associated with the revival of the documentary movement in Germany in the 1960s, directing the most controversial plays of Rolf Hochhuth, Heinar Kipphardt, and Peter Weiss. Collective creation played no part in the aesthetic. As Thomas Irmer has recently asserted, these old-style political documentaries were a dead issue by the 1970s.[31] Interestingly enough, though, the new German documentary style that rose in the 1990s abandoned the broadly political for the personal, and the past for the present; it was for the most part auteur dominated, as the older style had become. A notable exception, hearkening back to documentary's collective-creation roots, is the group Rimini-Protokoll, which produces neighborhood walkthrough events, examining the "political in the quotidian" of the present.[32]

The English Documentary

At just about the time that team-written, Blue Blouse–inspired Living Newspapers were disappearing from the Soviet Union and Germany, they sprouted in England and the United States. Though the British Workers' Theatre Movement had produced some agitprop pieces in the 1920s, it was in the mid-1930s that the Unity Theatre and the Theatre Union began regularly producing Living Newspapers with a distinctive documentary tendency.[33]

Unity Theatre produced *Busmen* (1938) on the first anniversary of the Coronation bus strike; it was written by a group of ten, including two of the strike leaders, who monitored the accuracy of the dialogue and offered transcripts of hearings

and minutes of meetings.[34] In September 1938, a writing team was hurriedly thrown together to create *Crisis*, produced as a script-in-hand performance on the day Chamberlain flew to Munich for the Czechoslovak appeasement.[35] Such practices continued after World War II. Though Eric Paice and Roger Woddis were credited with the authorship of *World on Edge* (1956), dealing with the Suez Crisis and the Hungarian Revolution, the script was another collective creation, partly the result of material solicited in press advertisements. There was considerable contention among the writing team over how much unfavorable information to include on the Communists' ruthless behavior in Hungary, but the show played to sold-out houses every night.[36] Unity continued to produce documentaries well into the 1970s.

Though Joan Littlewood is most commonly associated with Theatre Workshop, her colleague and sometime nemesis Ewan MacColl is arguably the key figure whose passion for fact-driven, social-action theatre stiffened the spine of the theatre companies that ultimately formed into the group credited with creating *Oh What a Lovely War*. Company member Howard Goorney recounts MacColl's key role in forming the union-backing Red Megaphones (1931) and Theatre Union (1936); he notes that both MacColl and Littlewood were expelled from the Communist Party in 1935 for not accepting Socialist Realism; and he quotes the 1945 Manifesto of Theatre Workshop, which pledges the creation of a theatre "as swift moving and plastic as the cinema, by applying the recent technical advances in light and sound, and introducing music and the 'dance theatre' style of production."[37] (One cannot help noticing that, compared with earlier manifestoes, this one addresses aesthetics more than socialism—a shift that ultimately became the cause of MacColl's alienation from the company.)

The Theatre Workshop early on produced a documentary-like piece or two (e.g., *Uranium 235*—1946) and embraced both the challenges and rewards of teamwork. For some playwrights, such as Wolf Mankovitz and Frank Norman, Littlewood was too free in using the ensemble to rewrite scenes.[38] But the practices surely contributed to the company's rise in the 1950s and early 1960s with a heady mix of edgy contemporary pieces like *Quare Fellow* and *Taste of Honey*, along with the classics. At different times, both MacColl and Littlewood left the company on the grounds that it had abandoned its founding working class ideals, but Littlewood returned to become the "editor-in-chief" of the complexly created *Oh What a Lovely War* (1963). Derek Paget has meticulously documented the fashioning of the play from the tape of a Charles Chilton radio show featuring World War I songs; cullings from new history books on the war, notably Barbara Tuchman's *August 1914*; improvisations based on the library research of the company's actors; and scenes written by company general manager Gerry Raffles and an actor/writer committee whose self-styled job description was "to knock out a bit of a shape" for the show—all overseen by Littlewood.[39]

The credits in the 1980 publication of the script attempt to capture the density of the collective creation:

Joan Littlewood's Musical Entertainment

Oh What a Lovely War
by
Theatre Workshop
Charles Chilton, Gerry Raffles
And Members of the Original Cast

Title suggested by
TED ALLEN

Military Advisor
RAYMOND FLETCHER

Revised and restored to the original version by
Joan Littlewood

The complicated credits also reflect lawsuits brought years earlier by various participants. No wonder that the enterprise ended up, in Paget's words, as a "montage-of-a-montage" and a "palimpsest"[40] reflecting its creators' predilections, passions, and politics: commedia dell'arte, agitprop, documentary, cartoon, grotesque satire reminiscent of the Soviet mode, and, according to some, nostalgic indulgence in spite of itself. There was great debate over whether the entire production was compromised when it moved from the Stratford East home of Theatre Workshop to the West End.

The collective creativity manifest in the performance was a powerful metonymy for the collectivism of a society that had marshaled its energies in support of the war effort.[41] This feature was only enriched and intensified by Littlewood's relentlessly physical directing style; the texture of the ensemble performance was more manifest and effective than the linear progression of the text.[42] The distribution of authorship and the textual additions and subtractions link the company's work to the oral tradition of ancient rhapsodes, who added to and altered texts for popular consumption over hundreds of years, thus preserving the multivocality inherited and valued by documentary theatre.

On the occasion of Littlewood's first departure from the company in 1961, she made a strong case for collaboration in her farewell, insisting that "you too know how the theatre must function if it is to reflect the genius of a people, in a complex day and age. Only a company of artists can do this."[43] The success of *Oh What a Lovely War* only reinforced both an impetus toward the formation of regional companies and the development of reality-driven theatre, such as John McGrath and Theatre 7:84's *The Cheviot, the Stag and the Black, Black Oil*—a documentary on the exploitation of Scottish yeomen that toured Scotland for a year (1973). But the most committed disciple of Littlewood's blend of documentary, song, and collective creation was the late Peter Cheeseman, who returned inspired from a performance of *Lovely War* to his Victoria Theatre in Stoke-on-Trent, where he would produce musical documentaries for the next thirty years.[44]

The Stoke documentaries from the mid-1960s through the mid-1990s are more strictly reliant on primary source material (written and oral) than was *Lovely War*, and they are all site-specific to Staffordshire. Whenever possible, the company's actors living in the region conducted historical research, and actors portraying living individuals always met with them and often carried out the oral history recording that became verbatim dialogue. The collective creation that governs how disparate sources take shape is not just an aesthetic technique or a political principle for Cheeseman; it is a principle of historiography, for it "tends to preserve the contradiction of viewpoint inherent in every historical event" and "ensures that a multiplicity of voices are heard."[45] Cheeseman's acknowledgment of "contradiction" dispels any naïve aspirations to objectivity and also precludes him from claiming sole authorship, because "[y]ou can't write a documentary—it's a contradiction in terms. You can only edit documentary material."[46]

In the Introduction to *The Knotty* (premiered 1966, published 1970), Cheeseman describes the creative process in the company's early years as originating from ideas and documents generated by a research committee of company members; a "resident dramatist, who operates under the strict discipline of not being permitted to write any of the show himself";[47] and Cheeseman himself as director. The script is created scene by scene in rehearsal, with company members responsible for carving primary source materials into playable units. A production secretary recorded the first workable version of each scene. Beginning what was at most a five-week rehearsal period without a complete script was regularly a frightening experience for the company, but it reinforced each member's responsibility for the creative whole. Cheeseman's own responsibility as director in these circumstances must have been massive, though it goes undocumented by him.

Cheeseman's credits in playbills for the documentaries are a varied lot. *Miner Dig the Coal* (1981) was "researched and compiled by Caroline Jay and Peter Cheeseman." Peter Terson was the resident dramatist on *The Knotty*, but you wouldn't know it from Cheeseman's Introduction, which mentions no author. *Plain Jos* (1980) has the following credits: "[A] musical documentary in the tradition of the Victoria Theatre, Stoke-on-Trent compiled from the letters and other papers of Josiah Wedgwood and his companions by Joyce Cheeseman . . . with additional research material from the workers of Josiah Wedgwood and Sons, Ltd collected by Caroline Jay, Jules Wright and Richard Addison[,] the text and action of the documentary staged and directed by Peter Cheeseman, Jules Wright, John Kirkpatrick and Diana Kyle."

Cheeseman's reluctance to take authorial credit stems from no false modesty; rather, it is compatible with his unstinting effort "to bridge the cultural gap which separates the artist from the majority of the community"[48]—an effort epitomized in region-specific documentaries, in which community members saw the texture of the their lives represented, often in their very own words spoken in the deep Midlands accent Cheeseman insisted that his actors master.

Post-Cheeseman documentaries demonstrate the "broken tradition" of documentary theatre: "Practitioners almost always have to learn again techniques that seldom get passed on directly."[49] While revivals and restorations of Victoria documentaries were still on the boards at Stoke, documentary form was seemingly

reinvented in the "tribunal plays" of the Tricycle Theatre, beginning with *Half the Picture* (1994) and deploying the verbatim techniques long cultivated by Cheeseman and his predecessors.

Most of the English documentaries that have broken through into the mainstream have abandoned collective creation, however. David Hare wrote his "verbatim plays" *The Permanent Way* (2003) and *Stuff Happens* (2004) alone. Many of the Tricycle plays are written by Richard Norton-Taylor or other individual writers (*Guantanamo* was by the team of Victoria Brittain and Gillian Slovo), and the National Theatre of Scotland's international hit *Black Watch* is Gregory Burke's. Winning far less attention were a series of plays focusing on immigration and asylum seeking, using verbatim techniques and relying on a creative team of writer-researchers. These include Banner Theatre's *Migrant Voices* (2002) and *Wild Geese* (2004), and *I've got something to show you* (2005) at the University of Manchester.

Collaboration and Collective Creation in the American Documentary Play

Hallie Flanagan and Joseph Losey, both closely associated with the rise of documentary theatre in America, had visited Soviet Russia in the 1920s and brought back with them the trend for collectively created, reality-driven work. Though the Workers' Laboratory Theatre had produced "Living Newspapers" on the Soviet model prior to the Federal Theater Project (FTP),[50] it was the government-funded series beginning with *Ethiopia* (1936; censored and prevented from public performance) and ending with *Spirochete* (1938) that genuinely captured America's dramatic imagination. Several of the FTP Living Newspapers were either adapted to local conditions when produced outside of New York (notably *One-Third of a Nation*—1938) or revised during the run, as was *Triple-A Plowed Under* (1936), with up-to-date facts and issues relevant to the Agricultural Adjustment Administration. As with the Russian models, all of this revision only served to emphasize the collaborative nature of the projects.

The Living Newspaper Division at its high point employed 65 people, but early experiments in collective writing led to the emergence of Arthur Arent as chief author and/or editor-in-chief,[51] though authorial credits for the Living Newspapers were not always consistent. But Arent appears to be the one responsible for editing the material gathered by staff writers into a drama.[52] In the Appendix to Flanagan's *Arena* listing FTP productions, Arent is credited with the authorship of *One-Third of a Nation* and *Power*, but not *Triple-A Plowed Under*, though the original Works Progress Administration–published script says, "Written by the Editorial Staff of the Living Newspaper Under the Supervision of Arthur Arent."[53] Some of Flanagan's entries list single authors unambiguously (e.g., Arnold Sundgaard for *Spirochete*), while others mention just "Living Newspaper Staff" (*Injunction Granted* and *Triple-A Plowed Under*).[54] Perhaps Arthur Miller, a member of the playwriting division, summed up the creative collaboration on Living Newspapers most succinctly: "No one writer ever wrote them. They were really written by group, the way movies were written. It's precisely the same situation. They had an

editor-producer, Arthur Arent, and they had different writers working on different scenes. It was a big collaborative thing."[55]

The year 1963, which saw productions of the pseudodocumentary *The Deputy* in Germany and *Oh What a Lovely War* in England (sparking renewed interest in documentary in those countries), also brought historian Martin Duberman's *In White America: A Documentary Play* to off-Broadway in New York. Since then, many American stages (particularly beyond Broadway) have seen successful, single-author documentaries regularly, while Broadway had to wait until Emily Mann's Tony-winning *Having Our Say* (1995) for its first documentary "hit." Despite occasional "off-the-radar" experiments such as Spiderwoman Theater's *Power Plays* (1973) and the Bloomsburg (PA) Theatre Ensemble's *Letters to the Editor* (1996), collective creation had parted once again from the American documentary mode—until the work of Moisés Kaufman.[56]

In the Introduction to *The Laramie Project*, Moisés Kaufman unwittingly provides a perfect example of the "broken tradition" of documentary when he presents his concept of a "performance writer" in charge of specific moments in the script as if it were a new idea.[57] As we have seen, "performance writers" required to do a sort of homework outside the workshop experience have periodically dominated the documentary mode from its origins. As well, Kaufman's conceptualizing a "horizontal" theatre placing nontextual elements on equal footing with text is as "new" as the Blue Blouse movement.[58] Similarly, the "central formal device"—namely, to confront spectators with conflicting documentary sources— for Kaufman's earlier documentary *Gross Indecency*, "spontaneously created during one of the collective development workshops,"[59] has been a staple of Emily Mann's documentary technique for decades.

Though Tectonic Theater Project is not a theatre collective, *The Laramie Project* took two years to develop, thereby demanding a substantial commitment from the company. Actors interviewed Laramites and presented initial impressions in "moment" form to company members. Cheeseman described a similar process for his work on *The Knotty* in 1966. Kaufman's "hunch"[60] to tell the story of the town rather than Matthew Shepard's murder is similar, again, to Emily Mann's choice to offer a panoramic view of San Franciscan social relations rather than merely to cover the trial of Dan White in *Execution of Justice*. At a certain point, it is Kaufman who decides when a workshop is able to metamorphose into a rehearsal, and the conventional realities of commercial theatre kick in. While there is no question that *The Laramie Project* makes sophisticated use of Kaufman's methods, such methods have been features of collaboratively created documentaries for almost the past hundred years.

Collectives, Cooptation, Colonialism, and Community

In high contrast to United States documentary practices, in Canada "collective creation was the most common means of creating documentary theatre, and documentary plays were usually created collectively."[61] Alan Filewod links this phenomenon to a repudiation of colonial methods of making theatre. While the six

representative plays and theatres he considers are, to a greater or lesser degree, connected to the European tradition via Canadians who worked with the likes of Littlewood and Roger Planchon, as well as by a visit of Peter Cheeseman to Canada in 1972, Canadian documentaries "enabled actors and directors to locate and test the raw material out of which playwrights could begin to fashion a national drama."[62]

As Filewod is so thoroughly focused on collective creation of the documentaries he covers (roughly, from 1972 to 1982), for me to recapitulate that history would be largely reductive. The plays he considers range from the highly regional (Globe Theatre's *No. 1 Hard* and 25th Street Theatre's *Paper Wheat* are about the Saskatchewan grain industry) to interactive documentaries designed to tour to penal institutions (Catalyst's *It's About Time*). Theatre Passe Muraille's *The Farm Show* and Mummers Troupe's *Buchans: A Mining Town* demanded extensive personal involvement by the actors in folklore research and oral history. Some theatres had strong, long-term, Cheeseman-like leaders (Paul Thompson at Passe Muraille; George Luscombe at Toronto Workshop Productions), while others veered closer to collectives (Catalyst). Filewod generalizes that Canadian documentary of the period tended to be indigenous and community affirming, rather than ideological. By the time Filewod finished the book in 1987, however, all the theatres except Catalyst had largely abandoned collective creation, the documentary mode, or both.[63]

In Australia, collaboratively created docudramas about atom bomb testing and the consequent removal of native peoples were written in native and English languages and deployed traditional storytelling techniques along with new media in a collaborative project involving aboriginals and Anglo-Australians. *The Career Highlights of the Mamu* (2002) was written by native playwright and professional actor Trevor Jamieson, working with other collaborators, and produced by Black Swan Theatre for the Adelaide Festival, which incorporated 17 of Jamieson's family members and other elders into the show, performing traditional dances and stories. Indigenous actors spoke in their first languages, which were translated in subtitles onstage. The documentary focuses on the migration of the playwright's family, which fled the nuclear tests. The main story is one of racial violence, drunkenness, and infidelity caused by the disruption of the family. In Jamieson's *Ngapartji Ngapartji* (produced for the Melbourne International Arts Festival, 2005), interwoven with a continuation of Jamieson's story are personal accounts of a Hiroshima survivor and an Afghan refugee.

These interpolations, Maryrose Casey argues, stereotyped the testimony of indigenous people into white narratives of oppression and reconciliation and undermined the ownership held by the native actors of *Mamu*. Important to indigenous peoples is acknowledgment of the jurisdiction of the land at every performance and the conformity of performances with the "Law" of how and when and where certain stories may be told. By this criterion, according to Casey,[64] *Mamu* was superior to its successor *Ngapartji Ngapartji* in that the elders' participation assured that the play would go beyond a testimony of oppression to a story of origins.

The experience of verbatim theatre in South Africa suggests that personal and state narratives must sometimes be pitted against each other in documentaries that are a response to a failure of journalism. When documentary enters the debates

over human rights and terrorism, the issue of the relationship of authenticity to theatrical efficacy begs to be examined—especially in an African cultural context, where conventional evidence of empirical truth is not as valorized as in the West. In Africa, the shape of the telling in itself bears significance and efficacy.[65]

In 1997, two plays of remarkably different character deployed documentary techniques to deal with the aftermath of Apartheid. Under the auspices of the Truth and Reconciliation Commission (TRC), *The Story I Am about to Tell* was verbatim-based—indeed, the "actors" were the real people who testified, though now enacting their roles in a fictionalized context—evading (Hutchison argues) both too much distancing and too much reality.[66] In the same year, *Ubu and the Truth Commission* by Jane Taylor in collaboration with the Handspring Puppet Company used the Jarry play *Ubu Roi* to frame testimony at the TRC. Two live actors, playing "Ma and Pa Ubu," are testified to by wooden puppets speaking the actual TRC testimony. Rear projections provided further distancing and linking to real events. Here again the idea is to balance distancing, so as to make the telling bearable, with a reality-driven context that brings home the real suffering. Hutchison argues that critical distance and compassion both survive.[67]

The events of "Bloody Sunday" (January 30, 1972), in which 13 Irish civilians were killed by British soldiers during a peace march, have been the subject of numerous documentaries and pseudodocumentaries. The great volume of documentary material—millions of words, hundreds of tapes—places special burdens on the documentarian, as does the passionate investment of the opposing sides (Irish victims, British perpetrators). Here, following Carole-Anne Upton,[68] I want to mention only a couple of Derry-based productions, which, though single authored, involved the community in particularly satisfying ways.

Largely unknown beyond the local community, Fintan Brady directed *Heroes with Their Hands in the Air* (2007), a verbatim piece adapted by him from a book of transcribed interviews with families of the victims. Upton reports, "The cast of mostly local actors worked closely with the individuals they were portraying and achieved a high degree of ownership of the piece among the community."[69] Clearly, the indispensable multivocality of the original sources was powerfully endorsed and magnified. David Duggan's *Scenes from an Enquiry* (2002, published 2008) incorporated recordings made on Bloody Sunday, and "among the cast of three were two relatives of victims."[70] One of the "Witness" characters beautifully sums up the challenge and responsibility of the documentarian to balance off the cold factuality of the written document against the living voice of memory: "I read all the books. I read all the articles . . . I have a shelf in the back room . . . I put me own books there . . . Videos, too. Docu-dramas . . . A shelf full . . . There's memory and knowledge. I have both. Books are a scaffolding. I'm trying to be fair. I read. I climbed. I looked down. I remembered."[71]

Conclusion

Balancing disinterested factual knowledge and passionate memory has been the challenge of the documentary "performance writers" ever since Piscator integrated

vocal recordings of the real historical characters with the written documents of *In Spite of Everything*. While the inventive variety and unruliness of the documentary has been obscured by its definitional association with a handful of positivist German documentaries and pseudodocumentaries in the early 1960s, collective creation both deconstructs that restrictive model and adds its own companionable vitality to the form.

My selective history of the diverse encounters between collective creation and documentary theatre suggests that their confluence has no single cause. By creating their own work, amateur and hard-pressed professional theatres could reap economic benefits from saving on royalties and a playwright's commission. Another clear benefit was the ability to take advantage of a company's specific strengths and to establish company solidarity with made-to-order material. Many practitioners celebrate the benefit to actor training derived from participating fundamentally in the making of scenes from found and researched material. The association of collective creation with collectivism and left-wing causes suggests a political motivation for the confluence of comradely work and the alternative journalism of the Living Newspaper. The spectacle of an acting company working as a tight unit from script creation through performance is metonymic of a working society, and it also yields the advantage of grouping the theatre company with other essential service providers in the community. Finally, collective creation preserves the often contradictory multivocality inherent in historic event, content to offer reasonable truths rather than an author/itative truth.

Bibliography

Arent, Arthur. "The Techniques of the Living Newspaper." *Theatre Quarterly* 1, no. 4 (October–December 1971): 57–59.

Brown, Rich. "Moisés Kaufman: The Copulation of Form and Content." *Theatre Topics* 15, no. 1 (March 2005): 51–67.

Casey, Maryrose. "*Ngapartji Ngapartji*: Telling Aboriginal Australian Stories." In *Get Real: Documentary Theatre Past and Present*, edited by Alison Forsyth and Chris Megson, 122–139. London: Palgrave Macmillan, 2009.

Chambers, Colin. *The Story of Unity Theatre*. London: Lawrence and Wishart, 1989.

Cheeseman, Peter. *The Knotty*. London: Methuen, 1970.

Deák, Frantisek. "Russian Mass Spectacles." *The Drama Review* 19, no. 2 (June 1975): 7–22.

Elvgren, Gillette, and Attilio Favorini. *Steel/City*. Pittsburgh: University of Pittsburgh Press, 1992.

Filewod, Alan. *Collective Encounters: Documentary Theatre in English Canada*. Toronto: University of Toronto Press, 1987.

Flanagan, Hallie. *Arena*. New York: Duell, Sloan and Pearce, 1940.

Golub, Spencer. *Evreinov: The Theatre of Paradox and Transformation*. Ann Arbor, MI: UMI Research Press, 1984.

Goorney, Howard. *The Theatre Workshop Story*. London: Eyre Methuen, 1981.

Hutchison, Yvette. "Verbatim Theatre in South Africa: 'Living History in a Person's Performance.'" In *Get Real: Documentary Theatre Past and Present*, edited by Alison Forsyth and Chris Megson, 209–223. London: Palgrave Macmillan, 2009.

Innes, C. D. *Erwin Piscator's Political Theatre: The Development of Modern German Drama.* Cambridge: Cambridge University Press, 1972.

Irmer, Thomas. "A Search for New Realities: Documentary Theatre in Germany." *TDR* 50 (Fall 2006): 16–28.

Jeffers, Alison. "Looking for Esrafil: Witnessing 'Refugitive' Bodies in *I've got something to show you.*" In *Get Real: Documentary Theatre Past and Present,* edited by Alison Forsyth and Chris Megson, 91–106. London: Palgrave Macmillan, 2009.

Leach, Robert. *Revolutionary Theatre.* London: Routledge, 1994.

Mally, Lynn. *The Americanization of the Soviet Living Newspaper.* Pittsburgh: The Carl Beck Papers in Russian and East European Studies, Number 1903, 2008.

McDermott, Douglas. "The Workers Laboratory Theatre: Archetype and Example." In *Theatre for Working Class Audiences, 1830–1980,* edited by Bruce McConachie and Daniel Friedman, 121–142. Westport, CT: Greenwood Press, 1985.

Paget, Derek. "The Broken Tradition of Documentary Theatre and Its Continued Power of Endurance." In *Get Real: Documentary Theatre Past and Present,* edited by Alison Forsyth and Chris Megson, 224–238. London: Palgrave Macmillan, 2009.

———. "*Oh What a Lovely War;* The Texts and Their Contexts." *New Theatre Quarterly* 6, no. 23 (August 1990): 244–260.

Piscator, Erwin. *The Political Theatre.* Translated by Hugh Rorrison. New York: Avon Books, 1978.

Elmer Rice. *The Living Theatre.* New York: Harper and Brothers, 1959.

———. *Minority Report.* New York: Simon and Schuster, 1963.

Rudnitsky, Konstantin. *Russian and Soviet Theatre Tradition and the Avant-Garde.* London: Thames and Hudson, 1988.

Russell, Robert. *Russian Drama of the Revolutionary Period.* Totowa, NJ: Barnes and Noble, 1988.

Schwartz, Bonnie Nelson, and the Educational Film Center. *Voices from the Federal Theatre.* Madison: University of Wisconsin Press, 2003.

Stourac, Richard, and Kathleen McCreery. *Theatre Was a Weapon: Workers' Theatre in the Soviet Union, Germany and Britain, 1917–1934.* London: Routledge and Kegan Paul, 1986.

Theatre Workshop et al. *Oh What a Lovely War.* London: Methuen Publishing, 1980.

Upton, Carole-Anne. "The Performance of Truth and Justice in Northern Ireland: The Case of Bloody Sunday." In *Get Real: Documentary Theatre Past and Present,* edited by Alison Forsyth and Chris Megson, 179–194. London: Palgrave Macmillan, 2009.

Von Geldern, James. *Bolshevik Festivals, 1917–1920.* Berkeley: University of California Press, 1993.

Willett, John. *The Theatre of Erwin Piscator: Half a Century of Politics in the Theatre.* London: Methuen, 1978.

Notes

1. The Proletkult (short for Proletarskaya Kultura) was founded in 1917 as an independent organization to promote distinctively proletarian art.
2. Frantisek Deák, "Russian Mass Spectacles," 7.
3. Robert Leach, *Revolutionary Theatre;* James Von Geldern, *Bolshevik Festivals, 1917–1920;* Konstantin Rudnitsky, *Russian and Soviet Theatre Tradition and the Avant-Garde.*
4. Spencer Golub, *Evreinov,* 198.
5. Ibid., 197.

6. Orbit has distributed a newsreel of parts of the rehearsal for *Winter Palace*. I am grateful to my graduate student, Robert Crane, who brought a copy back from Russia.

7. Robert Russell, *Russian Drama of the Revolutionary Period*, 34.

8. Robert Leach, *Revolutionary Theatre*, 24.

9. Ibid., 91–92.

10. Ibid., 168.

11. Ibid.; and Lynn Mally, *The Americanization of the Soviet Living Newspaper*, 5

12. Mally, 7.

13. Ibid.; Leach, 84; and Richard Stourac and Kathleen McCreery, *Theatre Was a Weapon*, 46.

14. Stourac and McCreery, 30.

15. Leach, 169.

16. Reprinted as Appendix 1 in Stourac and McCreery.

17. Quoted in Stourac and McCreery, 45, italics in original.

18. Ibid., 51–53.

19. Ibid., 62.

20. Ibid., 63–64.

21. Erwin Piscator, *The Political Theatre*, x.

22. Stourac and McCreery, 94.

23. Piscator, 48.

24. Ibid., 82

25. John Willett, *The Theatre of Erwin Piscator*, 186.

26. Piscator, 92.

27. Ibid., 96.

28. Ibid., 196.

29. Ibid., 255.

30. C. D. Innes, *Erwin Piscator's Political Theatre: The Development of Modern German Drama*, 80.

31. Thomas Irmer, "A Search for New Realities," 19.

32. Ibid., 26.

33. Key members of these theatres ultimately founded Theatre Workshop.

34. Colin Chambers, *The Story of Unity Theatre*, 142.

35. Ibid., 162

36. Ibid., 340–45.

37. Howard Goorney, *The Theatre Workshop Story*, 42.

38. Ibid., 113.

39. Derek Paget, "*Oh What a Lovely War*; The Texts and Their Contexts," 248.

40. Ibid., 250.

41. Ibid., 245.

42. Ibid., 252

43. Goorney, 185.

44. As I have written thrice previously about Cheeseman, this account of his work will be briefer than his legacy of collectively-created documentaries deserves.

45. Peter Cheeseman, *The Knotty*, xiv–xv.

46. 1974 interview with Elvgren cited in Gillette Elvgren and Attilio Favorini, *Steel/City*, xvii.

47. Cheeseman, xiii.

48. Ibid., x.

49. Paget in Alison Forsythe and Chris Megson, *Get Real*, 224

50. See Douglas McDermott in Bruce McConachie and Daniel Friedman, *Theatre for Working Class Audiences, 1830–1980.*
51. Mally, 17.
52. Arthur Arent, "The Techniques of the Living Newspaper."
53. Hallie Flanagan, *Arena*, 390; and http://dspace.wrlc.org/doc/bistream/2041/60703/TripleAPlowedUnderdisplay.
54. Flanagan, 390.
55. Bonnie Nelson Schwartz, *Voices from the Federal Theatre*, 140.
56. Kaufman is a Venezuelan, trained both in his home country and at NYU.
57. Rich Brown, "Moisés Kaufman," 51.
58. Ibid., 54.
59. Ibid., 55.
60. Ibid., 58.
61. Alan Filewod, *Collective Encounters*, viii.
62. Ibid., 23.
63. There is little evidence in the *"Ethnic," Multicultural and Intercultural Theatre* volume of the *Critical Perspectives on Canadian Theatre in English* series that the torch of collectively-created documentary has been picked up in Canada today. I would be surprised, however, if Canadian indigenous peoples, like their counterparts in Australia, South Africa, or Northern Ireland, were not hybridizing the documentary form with native or local practices.
64. Maryrose Casey, *"Ngapartji Ngapartji,"* 136–37.
65. Yvette Hutchison, "Verbatim Theatre in South Africa," 211.
66. Ibid., 217.
67. Ibid., 219.
68. Carol-Anne Upton, "The Performance of Truth and Justice in Northern Ireland."
69. Ibid., 181–82.
70. Ibid., 182.
71. Quoted in ibid., 183.

Part II

Collective Creation's Second Wave

Preface to Part II: Crossroads and Confluence, 1945–1985

Scott Proudfit and Kathryn Mederos Syssoyeva

The aim of this chapter is to provide a context for the work that follows. Much has been written about the collectives of "the sixties" (in reality, a period spanning the 1950s into the 1980s); it is not our goal to retread that ground. Rather, we wish to explore certain salient themes chacterizing this period of theatrical experimentation. Predominant among them is the question of influence, or rather, of a complex network of influences—local, national, and international—and lineages—artistic "family trees" whose roots reach back into the prewar period—which shaped the collective practices of the sixties and beyond. Our focus will be primarily on the United States, viewed in the context of concurrent practice in Europe and Canada.

The revolutionary theatre of the 1960s, Judith Malina recently announced, began in the 1940s—1945, in her particular case, "behind the striped metal doors of the 12th Street building," which held the Dramatic Workshop of The New School for Social Research, "with Piscator there to guide the movement he had spawned along the wide path to revolution." In 1945 Judith Malina was Erwin Piscator's directing student; by 1947, she and Julian Beck had founded The Living Theatre. More than a decade and a half would elapse, however, before the company's first collective creation (*Mysteries and Smaller Pieces*, 1965). In the first years after the war, the "fervor of the '60s" was already brewing, but "we were not yet ready for revolutionary action . . . There was something towards which were were moving, though the time was not yet ripe. We were moving towards the spirit of '68, still 20 years ahead of us, just as the socialist revolutions of which Piscator spoke were 20 years behind us."[1]

The extraordinary proliferation of theatre practitioners, dancers, and artists practicing some method of collective creation in the sixties and seventies was possible precisely because the roots of that work stretched back deep in time. Starting in the late 1940s and continuing throughout the 1950s, the beginnings of this boom can be traced to the founding of companies that, like The Living Theatre, explored and attempted to define various methods of nonhierarchical theatre

practice—such as Joan Littlewood and Ewan MacColl's Theatre Workshop in Eng-
land; George Luscombe's Toronto Workshop Productions in Canada; the Compass
Players in Chicago; and the Merce Cunningham Dance Company at Black Moun-
tain College, North Carolina. Early signs of collective creation in the 1950s can
likewise be found in the theatrical debuts, collaborations, and training of artists
who fueled the subsequent spread of collective practices: Jacques Lecoq's work first
with Jean and Marie-Hélène Dasté in France, then with Amleto Sartori in Italy,
and his subsequent founding of the School of Mime and Theatre; Ronnie Davis's
training under Ètienne Decroux in Paris and his subsequent founding of the
R. G. Davis Mime Studio and Troupe in San Francisco; Jerzy Grotowski's directo-
rial debut and subsequent directorship of the Theatre of 13 Rows in Poland; Anna
Halprin's first presentation of choreographed rituals in California; Augusto Boal's
studies under John Gassner in New York and his return to Brazil to direct the
Arena Theatre. However, it is not until the early 1960s that the majority of theatre
collectives whose names have become synonymous with collective creation in sub-
sequent histories rose to prominence: The Open Theater, Judson Dance Theatre,
The Performance Group, the Bread and Puppet Theater, the San Francisco Mime
Troupe, Théâtre du Soleil, and Odin Teatret.

It should be noted that while this chapter (and the chapters that follow) privi-
lege theatre companies when tracing this history, we nonetheless repeatedly
reference the names of the directors of those companies, for, as a result of the
tendencies of historical writing, "great names" take on a synecdochal relationship
to entire theatrical movements, aesthetic perspectives, and methods. In the same
vein, the majority of the collectives mentioned in this chapter are those most his-
torically prominent. Space prohibits thorough acknowledgement of individuals
and groups who may not have enjoyed the longevity or critical recognition of col-
lectives such as The Living Theatre or practitioners such as Grotowski but none-
theless were vital contributors to the expansion of collective practices during the
1960s and 1970s.

Moreover, while the chapters in this section focus primarily on collective cre-
ation within theatre and dance companies, it must be acknowledged that within
this time period there was an increasing commitment to similarly collabora-
tive modes among artists (and between artists and audiences) in other types of
performance, particularly in the emerging international performance-art scene.
These parallel artistic tendencies undoubtedly influenced the theatre companies
under consideration in this collection. Certainly Allen Kaprow's "Happenings"
throughout the late 1950s, to take one prominent example, were a major influ-
ence on collectives such as The Living Theatre. Further, a number of performance-
art "partnerships"—from the living sculptures of British artists Gilbert and
George in the early 1970s to the longtime collaboration of Serbian artist Marina
Abramovic and West German Uwe Laysiepen, who first began working together
in 1976—parallel the partnerships of earlier committed collaborators in theatre
and dance such as Julian Beck and Judith Malina or Merce Cunningham and John
Cage. Indeed, the collaboration of pairs versus groups—the notion of the "group
of two"—is an area of collective creation studies that—while touched on in

this book, especially in the chapters of Laura Cull (Chapter 7), Michael Hunter (Chapter 8), and Scott Proudfit (Chapter 9)—deserves further exploration.[2]

Likewise, our focus on theatre is not meant to exclude the simultaneous exploration of collaboration in art movements not primarily committed to "performance." For example, Pop Art, as practiced by Andy Warhol at least, can also be considered a "democratic" movement that parallels the renewed commitment to collective practices in theatre and dance companies in the 1960s (much as Bauhaus collectivism paralleled theatrical collectivism in the 1920s and early 1930s). As Scott Proudfit notes in "Shared Space and Shared Pages: Collective Creation for Edward Albee and the Playwrights of The Open Theater," Chapter 9, Warhol was as much a part of the off-off-Broadway theatre scene of the early 1960s, which incubated the major New York City collectives that created nonhierarchically, as was Joseph Chaikin, Joe Cino, or Ellen Stewart. Warhol contended that art could be made by anyone. Moreover, he was committed to a variety of collaborative modes throughout most of his career. His concept of building "the Factory" in 1962 was to have a location where art could be mass-produced by a group (a return, in its way, to Renaissance collaborative models). In order to accomplish this mass production, Warhol spent a great deal of time getting his friends and family to work with him on projects, often for free. Projects such as "the Brillo boxes" were created in a production line at the Factory, a process that Warhol oversaw, in a kind of parallel to the stage director as facilitator. In addition, while in the press and subsequent histories Factory member Gerard Malanga, for instance, was referred to as Warhol's "assistant," this might primarily be because this label conforms to an art-world convention that the "master" artist employs assistants to help him complete his works. However, Malanga mass-producing silk screens side by side with Warhol, of (for example) Elizabeth Taylor, would seem to merit at least "collaborator" and perhaps "cocreator" status. After all, both men selected Taylor's image and labored to reproduce it.

Transmission, Transformation, and Influence: The Case of the United States

In the United States from the mid-1960s on, as new collaborative methods were devised, refined, or rediscovered, they often passed from company to company as a result of the movement of company members from group to group or the proximity and sharing of performance spaces. This was particularly true in Greenwich Village, where, for instance, in the early 1960s The Living Theatre shared a building with Merce Cunningham and John Cage, played host to Bread and Puppet and Judson Dance, and cast and later workshopped with Joseph Chaikin (future artistic director of The Open Theater). The result was that transmission and transformation of methods was possibly more intense during the 1960s than any previous decade.

Sometimes the transmission was adulatory: theatre artists, inspired by what they had experienced with one group, brought learned principles and practices to a new artistic, cultural, and/or geographic community. Thus, for instance, in Jorge A. Huerta's "Who's in Charge?: The Collective Nature of Early Chicano Theatre"

(Chapter 12), we find a young Luis Valdez working with the San Francisco Mime Troupe before returning to Southern California to found El Teatro Campesino. At other times, transmission was the result of new artistic impulses emerging within a group and taking form in an offshoot company. For instance, an interest in performance as biography and "being yourself" onstage during The Performance Group's rehearsal periods in the late 1960s inspired company members Elizabeth LeCompte and Spalding Gray to create Gray's autobiographical *Sakonnet Point* as the first "Wooster Group production" in 1975. And other times, the transformation of methods was the result of disaffection: a handful of members from a particular theatre company might set out to reinvestigate the premises and actions of group dynamics within a new collective. For instance, in 1974, Paul Zimet, Ellen Maddow, and Tina Shepard, all former company members of The Open Theater, founded the Talking Band while still working with Joseph Chaikin's Winter Project. Splits caused by disaffection were often driven by concerns about the gap between the rhetoric and practice of radical democracy within the theatre collective. Often, too, divergent perspectives deriving from differences in gender, race, and class led to the splintering of collectives; in the United States, we see this process repeated again and again. In 1975, for example, company cofounder Paul Boesing and all other male members of Minneapolis's At the Foot of the Mountain left the company, which had begun to identify itself as a theatre primarily interested in presenting women's experience. It is worth noting that Boesing had previously worked with The Open Theater prior to joining At the Foot of the Mountain. Victoria Lewis explores such difference-based fracturings of the group ideal in Chapter 11, "From Mao to the Feeling Circle: The Limits and Endurance of Collective Creation."

Often, too, these rifts within collectives, many of which led to a further dispersion of methods, were caused by the complex network of influence and tradition beneath the surface of the new. Despite the pronounced shift toward a countercultural ethos reflective of the decade, the collectives of the sixties could hardly be said to have emerged *ex nihilo*. The Living Theatre, as discussed previously, had roots in the practices and politics of Erwin Piscator (who had been Living Theatre coleader Judith Malina's mentor) and Bertolt Brecht (whose *Mann Ist Mann* the company had presented in 1962 with Joe Chaikin in the lead). The company also briefly investigated the work of Vsevolod Meyerhold, attempting to reconstruct biomechanical etudes. At the same time, coleader Julian Beck's early career as a painter in New York City put him in contact (and sometimes in collaboration) with fellow artists such as Jasper Johns and Robert Rauschenberg, not to mention Allan Kaprow, choreographers Merce Cunningham and James Waring, as well as composer John Cage. Many of this eclectic group had likewise, throughout the 1950s, collaborated among themselves in different ways at North Carolina's Black Mountain College. Even the Provincetown Players' generation had a tenuous influence on The Living Theatre's organization; Julian Beck had early on sought the advice of Alfred Kreymborg and Robert Edmund Jones on the best ways to administer and organize his newly formed company. There is a sense, then, in which The Living Theatre, like a number of similar theatre companies creating collectively in the 1960s (and like the cultural and political movements of the sixties generally),

seems to have absorbed into itself a wealth of experimental forms and radical impulses drawn from the first decades of the century.

More specific influences on collective practices in the United States in the 1960s, such as the embrace of improvisation and chance as guides in the devising process, can likewise be traced back to the practices of earlier theatre companies and can suggest reasons behind the organizational ruptures and the dispersal of methods so common during this later period. In challenging traditional authorities within the process of theatrical production, 1960s collectives turned to improvisation as a means of creating nonhierarchically and also to the emancipative possibilities of "chance." In this aspect, Cage's work at Black Mountain in the late 1950s, particularly, can be seen as influential on methods of collective creation in the 1960s—not only with The Living Theatre, with which he directly collaborated, but also with those collectives within The Living Theatre's geographical/artistic orbit. (Michael Hunter's "Something Queer at the Heart of It: Collaboration between John Cage and Merce Cunningham," Chapter 8, examines Cage and Cunningham's long artistic relationship and considers how these artists' position as sexual minority subjects in midcentury America might have contributed to the shape of their collaborative arrangement.) However, it is Viola Spolin's transformation of diverse improvisational modes, current and historical, into a coherent system of practice that arguably had the greatest influence on 1960s collectives in the United States. The theatre game practices of Spolin, so profoundly influential for collectives such as The Living Theatre, The Open Theater, and The Performance Group, in turn had roots in the urban social reform movements of the 1920s in institutions such as Chicago's Hull House, where, from 1924 to 1926, Spolin developed her methods of play, working with inner city children under the tutelage of Neva Boyd. Spolin's work with immigrant populations, which she would continue under the auspices of the Works Progress Administration from 1939 to 1941, spurred her toward the development of a system of theatre games that she hoped might transcend barriers of language and culture. Such methods proved particularly well suited to alternative theatre practice in a cultural climate oscillating between identity politics and an ideal of unity.

The circulation of certain inspirational texts during this period was as pervasive as the circulation of the ideas of such figures as Cage and Spolin. Antonin Artaud's *The Theatre and Its Double* was widely read and referred to by practitioners from Brook to Grotowski to Chaikin. Julian Beck went so far as to identify Artaud as The Living Theatre's "ghostly mentor."[3] For many collectives, we might posit, too, the "ghostly mentor" of John Dewey and the Progressive Education movement, which played such a formative role in the development of the American Worker's Theatre Movement and the emergence of Black Mountain College, later home to Cage and his collaborators.

In the interplay of Artaud's texts and Spolin's exercises, we can locate the roots of philosophical and aesthetic contradictions that would lead to the disruptions and organizational splintering typical of many 1960s theatre collectives. For a company such as The Living Theatre, if Artaud provided an aesthetic vision, Spolin provided the human vision—and a method. Spolin's program, received by The Living Theatre largely secondhand through their workshops with the

Spolin-trained Chaikin, emphasized that every member of the theatre company must share equally in the artistic process. Spolin envisioned teachers as guides and directors as facilitators. Such a vision is in direct contradiction to the type of organizational structure suggested in Artaud's *The Theatre and Its Double*—a structure built around a single auteur's artistic vision. Therefore, for companies such as The Living Theatre, a profound tension—inherent as much in the model as in the dynamics of the group that put that model into practice—between the visionary as leader (Artaud) and the vision of the leaderless ensemble (Spolin) inevitably led to tensions and confusion in the creative process. Beck and Malina's fluctuation between demanding that the company lead itself and accepting (their own) centralized personal authority at key moments in the collective's organizational life testifies to this underlying paradox.

Nor is the gendering of the Spolin-Artaud equation purely coincidental. Women have played a central role in the history of collective creation, and while some have risen to great prominence, many, often as a result of their commitment to group identity, have remained in the historical shadows (a theme taken up by Victoria Lewis in Chapter 11, "From Mao to the Feeling Circle: The Limits and Endurance of Collective Creation"). The central role of women in collective creation remains underhistoricized; a list of prominent names alone lays out an exciting path for further scholarship: directors such as Ariane Mnouchkine, Judith Malina, Joan Littlewood, Elizabeth LeComte, Tina Landau, Anne Bogart, and JoAnne Akalaitis; companies such as WOW Cafe Theatre, At the Foot of the Mountain, Spiderwoman Theater, Guerilla Girls, Omaha Magic Theatre, and Split Britches; choreographers such as Anna Halprin, Yvonne Rainer, Aileen Passloff, Trisha Brown, and Mary Overlie; playwrights such as Caryl Churchill, Deb Margolin, Muriel Miguel, and Megan Terry; teachers such as Spolin and the little-known Suzanne Bing, who imported the children's theatre games model from the American progressive education movement into her work with Jacques Copeau in the 1920s—with profound consequences for the future Copiaus.

Transnational Lineages

Suzanne Bing's importation of American progressive education models into the development of French mime reveals the extent to which the evolution of collective creation in the 1960s and later is a study in panhistoric, transnational influence. By *transnational*, we are acknowledging that to trace a history of collective creation it is necessary to recognize that collaboration practices are rarely developed within a single country over an extended period of time without significant cultural exchanges among artists across national boundaries. Using this term *transnational*, however, we do not wish to suggest that the study of collective creation requires a philosophical commitment to challenging "the significance of the modern nation state as a political, economic, and cultural unit," as, for example, Paul Gilroy insists in *The Black Atlantic*.[4] Nor do we mean to imply that a philosophical commitment to transnationalism, as such, is intrinsic to collective creation—though, no doubt, readers may sense such a commitment at work in

some of the companies we discuss, as well as others not included here. It is a theme offering yet another fruitful line of inquiry.

Put more romantically, we might speak of a vast theatrical family of collective creators extending across generations and continents. To take just one branch by way of example, consider Copeau and the Copiaus. In "From the Cotes d'Or to the Golden Hills of California," Jane Baldwin has traced a direct line of influence from the Copiaus to the present-day Dell'Arte Company in Blue Lake, California. In the late 1930s, Italian-born Carlo Mazzone-Clementi (who would cofound the Dell'Arte Company in the 1970s) left Italy to study mask and physical acting with "'the master teachers of Commedia in France'": former Copiaus Jean Dasté, Jean Dorcy, Etienne Decroux, and Decroux disciple Jean-Louis Barrault— for "although Italy was the birthplace of commedia, by the late 1920s and 1930s, Paris had superseded it as the experimental center of training in commedia."[5] Subsequently, Mazzone-Clementi worked professionally with Jacques Lecoq—like Mazzone-Clementi, a member of the "second generation" in the Copiaus family tree. Lecoq had been introduced to commedia and mask by Jean Dasté and performed with Dasté's company, La Comédie du Grenoble, where he was put in charge of the school's physical training and appeared in two productions directed by Marie-Hélène Dasté: L'Exode, a masked mime, and a Noh play involving mime and "grumelotage," the dramatic nonsense language originally developed by the Copiaus in Burgundy.[6] In 1948, Lecoq left for Italy to teach at the University of Padua. There he staged his first pantomimes and investigated Italian commedia, researching mask with sculptor Amleto Sartori and working with Giorgio Strehler and Paolo Grassi to found the Piccolo Teatro school in Milan. Mazzone-Clementi accompanied Lecoq, serving as his assistant for the next eight years. Mazzone-Clementi, in turn, "revivified [the Copiaus'] dreams when he came to Humboldt County in the Golden Hills of Northern California in 1974 with Jane Hill (then his wife) to set up what would eventually become the Dell'Arte Company."[7]

R. G. Davis, too, holds a place on the sprawling Franco-Italian family tree. Not only did Davis train with Decroux in France in 1957 before returning to the United States to found the R. G. Davis Mime Troupe (subsequently the San Francisco Mime Troupe) in 1959, but it was Mazzone-Clementi who first introduced the Troupe to commedia dell'arte in early rehearsals of The Dowry, the company's first commedia show (1962). Indeed, the Troupe reproduced Mazzone-Clementi's eight leather masks (originally created made by Amleto Sartori), which they used in all subsequent commedia productions over the next seven or so years. The long reach of the Franco-Italian commedia influence is further evident in the fact that Lee Breuer and Ruth Maleczech, future artistic directors of Mabou Mines, were members of the San Francisco Mime Troupe at that time; Maleczech was a lead in The Dowry.

The appropriation and transformation of forms and methods across cultural lines, implicit in the tale of Mazzone-Clementi, is largely a byproduct of creative curiosity and a peripatetic artistic life; in other instances, intercultural confluence has been far more deliberate. Many theatre makers in the 1960s embraced cultural exchanges across national boundaries as an attempt to transcend culture altogether. Jerzy Grotowski, for example, whose first trip to Asia in 1956 cemented

his interest in cross-cultural exchange, ceased directing theatre productions in the late 1960s and began devising "paratheatrical experiments" between members of his own Polish Laboratory Theatre and artists from other nations. This work led to his "Objective Drama" project at the University of California-Irvine in the early 1980s, where Grotowski worked with, among others, artists from Bali, Colombia, Haiti, and India. The goal of this project was "to find specific elements of performance that transcended the particular cultures in which they were embedded."[8]

One of Grotowski's assistants in the 1960s, Eugenio Barba, pursued similar intercultural exchanges (with Asian and Indian dancers in particular), likewise searching for universals in performance that transcend culture. Since the late 1970s, Barba, at Odin Teatret and at the International School of Theatre Anthropology, has focused his work on answering a specific question: "Where does a performer's 'energy' and/or 'presence' come from?"[9] Barba, like Grotowski, is not interested in the finished products of actor training—productions—but rather in discovering the principles beneath the ways in which performers, regardless of era or culture, "train and display their bodies."[10]

Similarly, in 1970, British director Peter Brook founded the International Centre for Theatre Research in Paris, the goal of which was to identify and express a "universal art" of performance that transcends national boundaries. Unlike Grotowski and Barba, however, Brook's research goal has always been theatrical production. His work in the 1970s at the International Center for Theatre Research culminated in Brook's 1985 production of the *Mahabarata*, which featured actors from 19 nations. Also unlike Grotowski and Barba, Brook's "transcultural" productions of the 1980s often relied, as critic Marvin Carlson noted, on "a layering on of cultures rather than a transcendence of them."[11] If Grotowski and Barba seek transcendent universals by stripping performance down to its basic elements, Brook seeks them by building up common practices from multiple cultures and highlighting what overlaps in expansive theatre pieces.

The transnational character of collective creation in this period is evident also in a sudden commitment to certain practices occurring seemingly simultaneously in distant countries. Such moments of "coincidence" are attributable less to some sort of global "zeitgeist" than to the international training of, and international touring and teaching by, collectives and collectives' members. In 1965, for example, Augusto Boal, while creating *Arena Conta Zumbi* at the Arena Theatre in Brazil, commits his company to breaking the "actor/character correspondence, achieved by having all the actors play all the characters."[12] At the same time in France, The Living Theatre "in exile" makes that same commitment in rehearsals for *Frankenstein* (though the goal is never achieved). Three years later, Richard Schechner and The Performance Group likewise attempt this type of role sharing while creating *Dionysus in '69*. While this specific way of breaking the "actor/character" correspondence may seem strangely similar, the impulse to challenge the actor's "ownership" of his or her character is traceable to the influence of Brecht on all three companies. The Living Theatre's Brechtian heritage has been mentioned earlier. Schechner's interest in Brecht in this period is well documented, culminating in 1975 with The Performance Group's production of *Mother Courage and Her Children*. Boal's

encounter with Brecht is perhaps most prominent in the early 1950s while study-
ing playwriting with John Gassner in New York City.

Much can be said about the place of Ariane Mnouchkine and Théâtre du
Soleil within intersecting lineages. Theatre scholar Thomas J. Donahue argues
that Mnouchkine and company continued the project of Jacques Copeau in their
attempt to "create a new popular theater by using performance elements that
transcend the language based traditional theatre in France."[13] Like the Copiaus in
Burgundy, "the young actors" of Théâtre du Soleil, "most of whom lacked formal
training in the theater when they began, emphasized physical expression, impro-
visation, mime, the mask and mummery—elements of the traditional popular
theatre."[14] All of this would seem to place Théâtre du Soleil solidly on the path
of Franco-Italian popular theatre and frame Mnouchkine as a third-generation
descendant of Romain Rolland, heeding his call for a modern people's theatre.
But the company's predominantly Marxist political stance, especially its early
efforts to work with and among the striking French factory workers of 1968, is a
prime example of the postwar reemergence of the impulses that drove the British
and American Workers' Theatre Movements and German and Russian agitprop.
In Chapter 10, "Against Efficiency: The Production Time of Collective Creation,"
David Calder explores the Marxist underpinnings of Théâtre du Soleil's practices,
arguing that "[t]he resurgence of collective creation in France during the 1960s
and 1970s must be understood alongside challenges to the relations of industrial
production in French factories." At the same time, Théâtre du Soleil has long been
at play in an exploration of intercultural aesthetics in a tradition akin to that of
Peter Brook's International Centre for Theatre Research.

Looking Inward

Despite the transnational impulses that characterize many theatre companies
and artists practicing collective creation in the sixties and seventies, nationalist
impulses may also be found underlying the collaborative practices of this period
(at times coexistent with transnational influence and exchange). In Canada, for
example, collective practices allowed companies to make work reflecting their
"own people." As Alan Filewod notes in *Collective Encounters: Documentary The-
atre in English Canada*, "[T]o the emerging, fiercely nationalistic generation of the
1960s, the regional theatres exemplified what came to be criticized as a colonial
dependence on Britain."[15] The "search for cultural identity in community experi-
ence found an ideal expression in collective creation," Filewod argues.[16] This was
no less true for Quebec—a theme taken up by Jean-Marc Larrue in Chapter 13,
"Collective Creation in Quebec: Function and Impact." Even The Living Theatre—
which not only produced plays by a number of European playwrights early in its
organizational life but also ultimately considered its members "global citizens" as
the company started touring its productions internationally in the late 1960s—
was founded with the mission of producing "native" playwrights. As late as 1965,
Julian Beck was still specifically committed to producing US "poet-playwrights,"
who, Beck argued, could break through language to touch "life" better than their

European ancestors.[17] As Beck recalled in his preface to Jack Gelber's *The Brig*, "Storming the Barricades": "Our first statement said something about encouraging the poets to write for the theatre by providing them with a stage where their plays could be produced."[18]

Not only were many prominent theatre collectives looking inward toward the concerns of national identity, but many were simultaneously committed to looking inward within the group itself, reforming their own organizational structures in the hopes that they might serve as models to society at large and struggling to come to terms with the gap between egalitarian politics in theory and in lived practice. The very act of practicing alternative models of group interaction— interpersonal, political, and economic—was viewed as civic action, a form of society building: what political groups now might term "being the change you want to see." Many practitioners considered collective creation both a "new" way of making theatre and a political stance.

Audience Involvement

Collectives such as The Living Theatre considered each of their productions a tool for social mobilization as well as a way to theatricalize their company's politics. Therefore it makes sense that as the company evolved during the 1960s, its creative methods became increasingly nonhierarchical (in intent, if not always in practice), as productions were more closely aligned with the politics of the collective's members. Beck and Malina saw their work as part of a global movement of political activism. The Living Theatre hoped that a production such as Brown's *The Brig* might not only "tear down the walls" between the company and its audiences but might also inspire patrons to tear down the walls of the rules of expression in daily life. Performances of The Living Theatre's *Paradise Now* were considered by company members a map for "permanent revolution":[19] an opportunity for audiences to organize themselves into cells in preparation for worldwide social upheaval.

For theatre companies such as The Living Theatre, The Performance Group, and The Open Theater, political activism was often about involving audiences more deeply in productions and even in the creative process. The desire to bring "the people" onstage was behind the documentary theatre movement in Canada and the rediscovery of commedia on the West Coast at such companies as the San Francisco Mime Troupe and the Dell'Arte Company. Devising "people's theatre" meant erasing the modern separation between audience and performer. Even at Open Theater performances, where audiences were only reluctantly allowed in because company members felt their explorations should remain "workshops" for the eyes of the professionals only, there was a stated commitment to reexamine the artist as an active "guide" toward enlightenment for members of the larger society. As Jean-Claude van Itallie wrote of *The Serpent*, his 1968 collaboration with The Open Theater, he and the company hoped to bring people together "in a community ceremony where the actors are in some sense priests or celebrants, and the audience is drawn to participate with the actors in a kind of eucharist."[20]

Despite this commitment to more deeply involving audiences, critics such as Mark Weinberg in his book *Challenging the Hierarchy* have claimed that in the 1960s "the connection between theatre makers and the broader society was tenuous as best" and that "the theatre revolt . . . was more self-reflexive and more concerned with theatre makers and their art, their politics, with their relationship to themselves than their audiences."[21] According to Weinberg, in the 1960s even the most seemingly politically active company members of collectives such as The Living Theatre were often first and foremost concerned with their own personal journey to enlightenment. Certainly members of collectives such as The Open Theater used collaborative practices at least in part as a mode of self-exploration, in line with Grotowski's paratheatrical events of the same period. The search for personal liberation, autonomy, and authenticity was an impetus for creative exploration. This search was one of the impulses that led many collectives to embrace "Eastern" influences—Yoga, Tai Chi, the I-Ching—in an effort to "reconnect" body and mind.

Struggles with Authority

Nonetheless, collective creation in the late 1960s in particular was also "a political response to the hierarchical structures of established theatre in the first half of the century," as Emma Govan, Helen Nicholson, and Katie Normington note in *Making a Performance: Devising Histories and Contemporary Practices*.[22] Collectives questioned not only the hegemony of society at large but also the hegemonic structures of their own theatrical tradition. The gradual embrace of nonhierarchical creative practices in a company such as The Living Theatre can be understood as a series of challenges to the traditional authorities within theatre's creative process. One by one, companies such as The Living Theatre questioned (and rejected) the role of the producer, the playwright, and the director. In doing so they replaced the contribution of these authority figures with collective labor and creativity. As a number of papers in this collection attest, the director was the hardest authority by far to throw off—and rarely was this emancipation achieved. Chapter 7, Laura Cull's "Collective Creation as a Theatre of Immanence: Deleuze and The Living Theatre," examines the philosophical underpinnings of these common emancipative goals. Focusing on The Living Theatre and more recent work of Goat Island, Cull argues that collective creation may be viewed "as a process that generates a self-differing performance irreducible either to the identity of any one authorial subject, director, or transcendent theme." Nevertheless, collaborative practices are not "opposed to working alone" but rather "to any practice structured by a transcendent authority that is positioned 'outside' the creative process."

An illustrative example of the tensions within 1960s theatre collectives, between central artistic authorities and democratic processes of creation, is the Bread and Puppet Theater. This organization's development and various incarnations in the 1960s is both particular to the company but also representative of a number of "Lower East Side" theatres committed to collective creation. As James Harding and Cindy Rosenthal note in *Restaging the Sixties: Radical Theaters and Their Legacies*,[23]

Peter Schumann's role of artistic director of Bread and Puppet was so central to the identity of the company that critics have had a difficult time defining exactly when in the early 1960s a "collective" came into existence separate from the series of collaborations Schumann was having with sculptors, dancers, puppeteers, and musicians at the beginning of the decade at venues such as the Judson Memorial Church. Tellingly, while The Open Theater avoided describing itself as "Joe Chaikin's Open Theater," and The Living Theatre never advertised itself as "Beck and Malina's Living Theatre," Bread and Puppet (like R. G. Davis's San Francisco Mime Troupe) was in its early years called Peter Schumann's Bread and Puppet Theater. Schumann's moniker fell away from Bread and Puppet's identification in the mid-1960s as the company expanded and creative processes within the group separated from Schumann's constant guidance. Following a European tour in 1969, however, Schumann felt the company had become too large and too diffuse. Breaking up the company into smaller units (a division also made by The Living Theatre in 1970), Schumann and only two other members of the Bread and Puppet relocated from Manhattan to Goddard College in Vermont. There, Schumann's identity and influence was reestablished as central to the Bread and Puppet Theater. Indeed, the other two divisions of the Bread and Puppet eventually faded away, and the company by the mid-1970s was understood to operate solely out of its Vermont location.

While Schumann's retreat to Goddard College in 1970 reflects the fact that theatre collectives in this period were constantly negotiating, assessing, and reassessing their commitment to nonhierarchical practices and the importance of artistic "visionaries," the economic influences on Schumann's decision must also be acknowledged. After all, the concerns of supporting a fifty-member Bread and Puppet Theater were very different from the concerns of supporting a three-member Bread and Puppet Theater. Indeed, in general, the role of funding (or the lack of funding) cannot be ignored when examining the proliferation of nonhierarchical creative practices internationally in the 1960s and 1970s. As Alex Mermikides and Jackie Smart describe in *Devising in Process*, "[G]overnment subsidy of the arts (whether through the Arts Council or the dole) allowed a flourishing of left-wing, activist companies" in Great Britain during the 1960s and well into the 1970s.[24] Many of these activist companies created collectively. In *Collective Encounters*, Filewod similarly notes that the documentary theatre movement of 1960s Canada, which grew hand in hand with the arrival of collaborative methods in Canada, was due in part to the "large scale injection of government funding into the arts."[25] In the United States, on the other hand, companies creating collectively in the 1960s often found themselves penalized by, as opposed to encouraged by, government agencies. A series of collectives faced IRS audits. No incident was more dramatic than the 1965 riots following the IRS closure of The Living Theatre during its production of *The Brig*. These riots led to Malina and Beck's incarceration and were ultimately the impetus for The Living Theatre's leaders to move the company to Europe once they were released.

Continuities

Any endpoint for this second wave of collective creation, which crested in the 1960s and the early 1970s, is largely an arbitrary designation. While it seems as if collective creation is less common or at least less visible as a practice in the late 1970s and early 1980s, The Performance Group was actually the only major theatre company involved in nonhierarchical creative practices that officially disbanded during this period. Other companies, such as The Living Theatre, the San Francisco Mime Troupe, and Théâtre du Soleil, continued to create collectively throughout this period, albeit with changing personnel and sometimes different methods and organizational homes. Still other companies, such as The Open Theater, had disbanded beforehand—in the early 1970s. If an ending to the second wave can be identified, it is perhaps better sought in the beginnings of a third wave: the proliferation of new theatre companies founded in the late 1970s and early 1980s and practicing collective creation in different though related ways to the collectives of earlier periods. These companies included Spiderwoman Theater, Bloomsburg Theatre Ensemble, the Traveling Jewish Theatre, Pregones Theater, Touchstone Theatre, the Actors' Gang, and Théâtre de la Complicité, all of which began operation between 1976 and 1983. This third wave of collective creation, which arguably extends to current companies and practices, is the subject of the companion to this collection, *Collective Creation in Contemporary Performance* (Palgrave Macmillan, 2013)

If the notion of an endpoint is an arbitrary academic construct, our date, 1985, is not—for that year brought the death of Julian Beck. However, in the same way that the end of the second wave of collective creation is not truly an end because the practices and often the organizations continue on, so, too, does Beck live on—in Judith Malina's continuation of their collaborative work. The Living Theatre, like collective creation, continues its "ongoing epic."[26]

Bibliography

Babbage, Francis. *Augusto Boal*. New York: Routledge, 2004.

Baldwin, Jane. "Collective Creation's Migration from the Cotes d'Or to the Golden Hills of California: The Copiaus / Quinze and the Dell'Arte Company." In *Vies et morts de la création collective / The Lives and Deaths of Collective Creation*, edited by Jane Baldwin, Jean-Marc Larrue, and Christiane Page. Sherborn, MA: Vox Theatri, 2008.

Beck, Julian. "Storming the Barricades." Preface to *The Brig*, by Kenneth H. Brown. New York: Hill and Wang, 1965.

Carlson, Marvin. "Brook and Mnouchkine: Passages to India?" In *The Intercultural Performance Reader*, edited by Patrice Pavis, 79–92. London: Routledge, 1996.

Donahue, Thomas J. "Mnouchkine, Vilar and Copeau: Popular Theater and Paradox Author." *Modern Language Studies* 21, no. 4 (Autumn 1991): 31–42.

Filewod, Alan. *Collective Encounters: Documentary Theatre in English Canada*. Toronto: University of Toronto Press, 1987.

Gilroy, Paul. "From *The Black Atlantic: Modernity and Double Consciousness*." In *The Norton Anthology of Theory and Criticism*, edited by Vincent B. Leitch, William E. Cain, Laurie

A. Finke, Barbara E. Johnson, John McGowan, T. Denean Sharpley-Whiting, and Jeffrey J. Williams, 2556–75. New York: W. W. Norton, 2010.

Harding, James, and Cindy Rosenthal, eds. *Restaging the Sixties: Radical Theaters and Their Legacies*. Ann Arbor: University of Michigan Press, 2006.

Malina, Judith. *The Piscator Notebook*. New York: Routledge, 2012.

Mermikides, Alex, and Jackie Smart, eds. *Devising in Process*. New York: Palgrave Macmillan, 2010.

Schechner, Richard. *Performance Studies: An Introduction*. London: Routledge, 2002.

van Itallie, Jean-Claude. *The Serpent*. New York: Atheneum, 1969.

Weinberg, Mark S. *Challenging the Hierarchy: Collective Theatre in the United States*. Westport, CT: Greenwood Press, 1992.

Notes

1. Judith Malina, *The Piscator Notebook*, 29.
2. If memory serves me correctly, Andre Gregory used this phrase in the early 1980s during an informal talk with students at NYU to describe his collaboration with Wallace Shawn (K. M. S.).
3. Julian Beck, "Storming the Barricades," 24.
4. Paul Gilroy, "From *The Black Atlantic: Modernity and Double Consciousness*," 2561.
5. Jane Baldwin, "Collective Creation's Migration from the Cotes d'Or to the Golden Hills of California: The Copiaus / Quinze and the Dell'Arte Company," 41.
6. Ibid., 42.
7. Ibid.
8. Richard Schechner, *Performance Studies: An Introduction*, 244.
9. Ibid., 246.
10. Ibid.
11. Marvin Carlson, "Brook and Mnouchkine: Passages to India?" 89.
12. Francis Babbage, *Augusto Boal*, 13.
13. Thomas J. Donahue, "Mnouchkine, Vilar and Copeau: Popular Theater and Paradox Author," 31.
14. Ibid.
15. Alan Filewod, *Collective Encounters: Documentary Theatre in English Canada*, viii.
16. Ibid., 22.
17. Ibid., 7.
18. Julian Beck, "Storming the Barricades," 6.
19. While Beck and Malina probably encountered the idea of "permanent revolution" through writing by and about Trotsky, their use of the term in *Paradise Now* is as much about a personal, internal revolution as it is a social revolution.
20. Jean-Claude van Itallie, *The Serpent*, ix.
21. Mark S. Weinberg, *Challenging the Hierarchy: Collective Theatre in the United States*, 43.
22. Emma Govan, Helen Nicholson, and Katie Normington, *Making a Performance: Devising Histories and Contemporary Practices*, 47.
23. James Harding and Cindy Rosenthal, *Restaging the Sixties: Radical Theaters and Their Legacies*, 353.
24. Alex Mermikides and Jackie Smart, *Devising in Process*, 11.
25. Filewod, vii.
26. Malina, 121.

Collective Creation as a Theatre of Immanence

Deleuze and The Living Theatre

Laura Cull

In this chapter I want to focus on the philosophical implications of collective creation with respect to the work of the US company The Living Theatre (1947–) and in relation to the philosophy of Gilles Deleuze (1925–95). That is, this chapter starts from the premise that what is at stake in collective creation is ontological, as well as ethical and political, and suggests that we might be well equipped to understand the ethical and political dimensions of this instance of collective creation from a philosophical point of view. In particular, I want to examine the productivity of addressing the specificity of collective creation as a method of organizing the process of performance making, in the light of the conceptual dyad of immanence/transcendence that is at the heart of Deleuze's thought. Then, having argued that both immanence and transcendence are best understood as tendencies rather than mutually exclusive qualities, I draw from some additional examples—including Jerzy Grotowski and the contemporary performance company Goat Island—to explore collective creation as a mode of performance practice that is defined not simply in terms of a rejection of the (transcendent) figures of "the director" and "the author" but as a practice that constitutes an immanent rethinking of both directing and authorship. Or, framed differently, I want to try to articulate the complex philosophical, ethical, and political relationship between collective creation and its "others" (i.e., directed and/or scripted theatre).

Bearing these aims in mind, and as I hope will become clearer as I go on, I do not mean to use philosophy to retrospectively valorize any and all practices that have referred to themselves or been referred to as "collective creation." Rather, I hope to generate an alternative, philosophical definition (as distinct from a historical or technical definition) of collective creation that might allow us to approach various historical and contemporary performance practices differently. In this way, I mean to take up Bruce Barton's spirited call to allow definitions of collective

creation—and the correlative connections those definitions establish between collective creation and the related concepts of "collaboration" and "devising"—to "become open sites for multiplicity, for . . . contestation, and . . . for *creation*."[1] Indeed, this call resonates with Deleuze's own definition of philosophy as the creation of concepts and his argument that we must judge theories on their functionality or usefulness in practice: "[T]reat my book as a pair of glasses directed to the outside; if they don't suit you, find another pair."[2] Likewise, rather than become embroiled in debates whether or not specific practices or performances count as collective creation, I wonder if we are better served by allowing the conjunction of practice and concept to be mutually transformative and mutually questioning.

What Is Collective Creation? A Deleuzian Approach

In Deleuze's processual philosophy, which has been not only the primary influence on my recent thought but a key resource for Goat Island founding member Matthew Goulish, both concepts of collectivity and creativity, of the multiplicity of the group (rather than the sovereignty of the individual) and the radical difference of creation (rather than the sameness of reproduction), feature very strongly. For instance, we might wish to note in passing that Deleuze wrote several of his works in collaboration with the activist and analyst Félix Guattari—and that Guattari also devoted much of his independent work to the analysis of groups in both psychoanalytic and political context. In this next section, though, I will outline three of the key concepts related to collectivity and creativity that appear in Deleuze's work: difference, immanence (and its relationship to Deleuze's critique of hylomorphism), and judgment (and its relationship to his critique of "the subject").

So first, "difference." Most critically perhaps, the notion of creativity lies at the heart of the fundamental ontological premise that Deleuze's philosophy espouses—namely, that the world is just a collection of interacting processes of perpetual creation. In this context, creation means the production of novelty or qualitative (rather than quantitative) "difference," and Deleuze's goal (like that of his contemporary, Jacques Derrida) is to liberate difference from its historical construction as a derivative of identity—for instance, as that which we can think of, merely, in terms of the difference between two things. Rather, Deleuze wants to show "how it is in fact the movement of difference [or creation] itself that produces the apparent stability of the world of fixed identities (of substances and essences)."[3] In turn, Deleuze argues that we need to develop a mode of thinking adequate to this primary creativity by going "beyond the form of identity, in relation to both the object seen and the seeing subject."[4] One suggestion that I hope to develop here is that the performative practice of collective creation might be one form that this thinking might take. Collective creation is a mode of thinking adequate to the primacy of difference.

A second key concept in Deleuze's elaboration of his philosophy (and, as we shall see, ethics) of creation is the notion of "immanence" as distinct from "transcendence." To simplify, we might suggest that, in Deleuze's thought, these two terms name contrasting modes of relation to the primary process of creation or

differentiation described before. From the point of view of immanence (which Deleuze professes to hold), there is nothing "outside" this process: no creator, for instance, on whom creativity is dependent or by whom creativity is controlled from some external (authoritative and authorial) position. In contrast, an extreme transcendent perspective would posit a "two worlds view" in which it is possible for some being—whether in the form of a transcendent God or Subject—to occupy a realm outside the material world. These two realms may participate in or interact with one another, but they are nevertheless distinct and usually understood as being of differing value: the long-standing mind-matter distinction being a case in point. As Todd May explains, philosophies of transcendence are committed both to dualism—the idea of Being as composed of two, interactive types of substance such as "mind" and "matter"—and to the idea of the primacy of one of these ontological substances over the other.[5]

Deleuze's immanence expresses itself in a number of ways throughout his oeuvre. One manifestation occurs in Deleuze's location of the powers of transformation, differentiation, or creation in the realm of matter itself and his parallel critique of "hylomorphism": "the doctrine that production is the result of an . . . imposition of a transcendent form on a chaotic and/or passive matter."[6] In contrast, in line with writing in the field of emergence, Deleuze's thought "emphasizes the self-organizing properties of "matter-energy."[7] This self-organizing, creative aspect of matter, including the matter of the performing body, is conceived by Deleuze as the difference or "line of variation" running through all actual things. From this perspective, production is always a matter of collaboration. For instance, in carpentry, Deleuze and Guattari argue, "It is a question of surrendering to the wood, then following where it leads by connecting operations to a materiality instead of imposing a form upon a matter . . . We will therefore define the artisan as one who is determined in such a way as to follow a flow of matter . . . To follow the flow of matter is to itinerate, to ambulate. It is intuition in action."[8]

For Deleuze, though, transcendent thinking not only gets life "wrong" from an ontological perspective; it is also ethically "wrong" insofar as it provides the metaphysical structure necessary for the restrictive organization of creative processes by "judgment"—the third concept I want to introduce. For instance, in works such as "To Have Done with Judgment"—a late essay on Artaud—Deleuze critiques transcendent judgment as that which brings only pre-existing criteria to bear on that with which it is concerned and, as such, oppresses creativity and stultifies the production of the new. Judgment, Deleuze argues, can "neither apprehend what is new in an existing being, nor even sense the creation of a mode of existence . . . Judgement prevents the emergence of any new mode of existence."[9]

This judgment, for Deleuze, can take many forms, including the overbearing concept of the individual or sovereign subject, which he frames as a secondary organization imposed on the primacy of relationality. Deleuze argues that the process of subjectification attaches itself to consciousness and secures us to "a dominant reality," operating like a utilitarian logic or transcendental point of view that passes moral judgment on any differences between how we live and "the subject" as a representational category: "You will be a subject, nailed down as one . . . otherwise you're just a tramp."[10] Whereas the notion of the subject imposes strict

distinctions between self and other, subject and object, Deleuze and Guattari's thought proliferates a range of concepts that posit relationality and intersecting processes of transformation as more primary than any such fixed categories. We are not subjects; we are "desiring machines" plugging in to one another, they suggest;[11] not a self, but an "assemblage": "a set of speeds and slownesses between unformed particles, a set of nonsubjectified affects."[12]

Collective Creation as Immanent Production

Let us move on now from looking at Deleuze's thought in isolation to looking at it alongside the work of The Living Theatre, who actively appropriated the label *collective creation* for a number of their works made during the 1960s.[13] In *Utopia Limited*, Marianne DeKoven argues that The Living Theatre used the term *collective creation*—in relation to their best-known work, *Paradise Now* (1968)—because they wanted to connote a repudiation of "all traditional theatrical structures that establish hierarchies of separated functions and entities: play, playwright, producer, director, actors, crew, performance."[14] On first inspection, there would seem to be a resonance between these theatrical ideas and Deleuze's philosophy of immanence—for instance, in the shared concern to dissolve boundaries and unsettle the value judgments that derive from them. Correlatively, just as the transcendent, mind-matter hierarchy persists in some branches of contemporary philosophy, we might also note its influence on the relative status that tends to be accorded to crew and playwright in some contemporary theatres. Alternatively, we might also note a relation between the two-worlds view of transcendence and Theodor Shank's characterization of pre-1960s "traditional theatre" in terms of a "two-process method" that involves "a playwright writing a script in isolation and other artists staging it"[15]—where the latter process of creation is subordinated to or understood to be derivative of the former.

Likewise, the hylomorphic perspective that Deleuze critiques might initially seem to have its theatrical parallel in the pursuit of directorial control over seemingly uncontrollable performing bodies that tends to be associated with practitioners such as Edward Gordon Craig and Samuel Beckett. In turn, collective creation might be broadly identified with immanence and the dictatorship of the director (or the author or text as sources of truth and authority beyond the performance) with transcendence. These links between collective creation and Deleuze's philosophy of immanence are partially expounded in a recent essay by Deleuzian scholar Eugene Holland, who aims to explore the value of the conceptual difference between immanence and transcendence for analyzing distinctions between modes of creative practice, in his case between classical symphony performance and jazz. Holland argues that "[t]he classical symphony orchestra requires a transcendent instance of command in the figure of the conductor to guarantee coordination, whereas coordination arises more spontaneously and in a manner immanent to the group activity in jazz. Classical music entails a social division of labour whereby some merely execute what others (composers and conductors) conceive and command."[16]

Clearly, the immanent pole is also accorded greater political value here, insofar as it breaks with some of the traditional hierarchies that might block equality of access to creativity. Classical music is less democratic than jazz, Holland seems to suggest, because it assigns creative labor only to the elite few. But is creativity really only on the side of composers and conductors in an actual orchestra? Is it appropriate to frame the performances of individual orchestral musicians as the mere execution of others' commands?

Holland goes on to link the immanent mode of organization with Deleuze and Guattari's concept of "nomadism," contending that nomadism "designates forms of activity where the modes and principles of social organisation are immanent to the activity itself, not imposed by a transcendent instance from above; where itinerant following and group creation prevail over the issuing and obeying of commands."[17]

Here, Holland's article emphasizes the social nature of cultural activities—the way in which activities like jazz or theatre "induce a certain division of labour" or style of social organization that contributes to the wider organization of the social field.[18] In this sense, it is not just that theatre can function as a macrocosm of the social in the event of performance. Rather, theatre can be understood to have a sociopolitical dimension in terms of the style of organization manifested in its creative process. Likewise, as Shank discusses in his key article on collective creation, the "new theatre organizations" of the 1960s and 1970s, like The Living Theatre, can be seen as reflections of other countercultural visions "of the alternative society."[19]

Were we to translate Holland's schema to examples of theatre rather than music, then the immanent collective creations of groups like The Living Theatre could be straightforwardly contrasted with transcendent directors' theatre.[20] By eliminating top-down processes of authorship and direction during the making of works such as *Mysteries and Smaller Pieces* (1964), but also the infamous *Paradise Now* (1968), the company allows order to emerge from the bottom up (providing a theatrical illustration of the modes of organization discussed in complexity theory). Rather than allowing an individual to coordinate and command the process of creating a performance from the "outside," The Living Theatre engaged in lengthy group discussions as the primary method for generating, developing, and organizing new performance material. But can specific practices really be so simply turned into illustrative examples? Likewise, does this dualist parallel do justice to Deleuze's understanding of the relationship between immanence and transcendence?

Deleuze and Guattari repeatedly insist that, although there is an externality of relation between the immanent and transcendent (or nomad/royal, nomadic/sedentrist) *in principle*, there is always a mixture of the two forces in experience. That is, we can find the transcendent as well as the immanent in jazz, just as we can find the immanent in classical music—neither is a pure instance of one force or the other. On the one hand, we might also note the resistance of one tendency to the other—for instance, in terms of the inability of even the most overbearing director to fully manipulate the complex material processes involved in theatre (including spectatorship) to comply with his or her own singular intention. On the other hand, is it not also that—no matter how fully a company might

embrace the idea that they cannot, and do not want to, occupy a God's-eye view outside their creative process—they must inevitably arrive at a point in that process where they must at least *stage* an occupation of such a position in order to edit and organize their material, arrive at a "finished" work, and perform the "same" show more than once? As such, I want to suggest that we treat collective creation as the extreme pole of a tendency rather than as a discrete category of practice (see Figure 7.1). From this perspective, rather than accepting or rejecting specific companies or works from the category of collective creation, we would do better to acknowledge that all our examples will exhibit a mixture of both tendencies in varying degrees, with practitioners like Beckett and Gordon Craig—notorious for the control they sought to extend over their actors—occupying a position close to one extreme pole, and my own chosen examples located at a point closer to the other, tending toward collective creation. In turn, we might now rethink how this diagram of tendencies might overlap with the continuum of immanence/transcendence.

Despite the frequent affirmations of collective creation in the writings of The Living Theatre, it has been suggested that Julian Beck and Judith Malina played a perpetually central role in the composition of works, albeit against their best intentions. That is, we might say that despite The Living Theatre's attempts to create collectively, to genuinely collaborate in the absence of the judgment of a director, traces of transcendence remained. For example, although Beck describes *Frankenstein* (1965) as a collective creation in an interview with Pierre Biner, he also acknowledges that during "the last five or six weeks" before its performance in Venice, he and Malina broke off from the rest of the company to work on the piece's overall structure. "It was no longer possible to have twenty-five directors on stage. The pieces of the puzzle had to be assembled. Judith and I were holed up in the hotel room."[21]

Beck goes on to say that the same situation occurred before *Paradise Now*, and many commentators have since argued that the company's operations were less decentralized than they were claimed to be. Robert K. Sarlós, for example, argues that in the case of *Paradise*, Beck and Malina "ended up dominating and manipulating the anarchistic collective."[22] Similarly, in relation to the 1970s period when The Living Theatre split into four separate "cells," Gerald Rabkin argues that "the disappearance of the non-Beckian cells after the 1970 declaration" exactly confirms the unequal importance of Beck and Malina in relation to the other company members.[23] Even a sympathetic commentator like Paul Ryder Ryan made similar remarks in relation to the rehearsals for the play cycle *The Legacy of Cain*, inviting us to consider the pragmatics of immanence as collective creation: "While in theory Malina and Beck have tried to stay in the background and let the

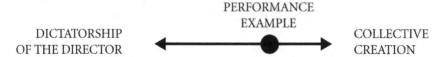

PERFORMANCE
EXAMPLE

DICTATORSHIP
OF THE DIRECTOR

COLLECTIVE
CREATION

Figure 7.1 A Continuum Model of Collective Creation

collective assume the directing leadership, in practice they find themselves guiding the rehearsals a great deal, mainly because they have more experience than other members of the group."[24]

Likewise, we know that Beck and Malina's contemporary Jerzy Grotowski remained suspicious of the emancipatory claims made by some proponents of collective creation. For instance, in his 1972 text "Holiday [Swieto] The day that is holy," Grotowski argues,

> [T]he idea of a group as a collective person must have been a reaction to the dictator-ship of the director, i.e., someone who dictates to others what they are to do, despoil-ing them of themselves. Hence the idea of "collective creation." However, "collective creation" is nothing but a collective director; that is to say, dictatorship exercised by the group. And there is no essential difference whether an actor cannot reveal himself—as he is—through the fault of the director, or the group director. For if the group directs, it interferes with the work of every one of its members, in a barren, fruitless way—it oscillates between caprices, chance and compromise of different tendencies and results in half-measures.[25]

Grotowski's position should not be read as one that rejects collective creation; rather, his writings and statements are full of interrogations of the relationship between creativity and control, in ways that are extremely useful for the consider-ation of collective creation. In an earlier interview, Grotowski used the term *collective creation* to describe the nature of theatre, but by this he meant that the theatre is a site in which "we are controlled by many people and working during hours that are imposed on us." For Grotowski, one of the fundamental questions for the actor is "how to create while one is controlled by others, how to create without the security of creation, how to find a security which is inevitable if we want to express ourselves."[26]

But need we necessarily see this returning need for direction as some kind of fail-ing in terms of an overall attempt to construct a theatre of immanence rather than transcendence? Above all, Patrice Pavis suggests, collective creation positions itself as an alternative to "the 'tyranny' of the playwright and his/her text and the direc-tor, who have tended so far to monopolize the power and to make all aesthetic and ideological decisions."[27] However, beyond this oppositional mode of thinking, the continuum or tendencies model I am trying to develop would frame neither collec-tive creation and direction nor immanence and transcendence as mutually exclusive.

In its purest form, the immanent tendency would correspond to a theatre that is independent of anything outside itself; entirely self-organizing rather than appeal-ing to the authority of a text, author, or director; and also perhaps not measuring the value of the worlds it creates in relation to an external reality. But no such theatre exists; rather, as we've already noted, actual theatres are always a mixture of both immanent and transcendent tendencies, and because *theatres are processes*, the balance of this mixture is always changing. Theatre has a tendency to imma-nence, which we might suggest can be nurtured by means of collective creation (among other means), but it also has a tendency to transcendence that manifests itself in the exertion of authorial control and in the notion of "truth to the text" (among other theatrical phenomena, such as the frequent reference made to the

notion of the director as offering an "outside eye" on a performance). Director's theatre differs from collective creation, as does solo work from collaboration, in degree rather than kind.

We might argue that what matters is the approach to directing taken by a given individual, which can vary from one of dictatorship to one of creative facilitator. The approach of Goat Island's director, Lin Hixson, very much tends toward the latter. For example, Hixson's direction of the other members of Goat Island often involved the provision of "directives" or starting points. As Hixson describes, "Our process could be described as a series of directives and responses . . . I produce a directive. The members of the group present responses to the directive—acts in return. In response to the responses, I produce more directives."[28]

While instructive, the directives are nevertheless articulated in a poetic form that leaves them open to multiple forms of response. "Create a shivering homage," Hixson instructs;[29] "construct a last performance in the form of a heavy foot that weighs 2 tons and remains in good condition." Clearly, to respond to such an instruction is not to execute a director's idea or command; there is no fixed and predetermined concept of what a "shivering homage" might look like to which the performers' response must correspond. In the same way, for Hixson, the unpredictable nature of the performers' responses to her directives allows the final piece to remain surprising, strange, and complex rather than a representation of her own singular vision. Mutually responsive, there is no clear separation between directive as the creator and directive as the condition of the creativity of the response; the response creates the directive as much as the other way around, such that no traditional hierarchy of value might emerge to privilege the role of director over that of performers. Writing of collaboration, Hixson says,

> I can't even start with words to describe my experience . . . I can begin with a physical sensation; my head enlarging to six heads; my legs jumping up and down with twelve feet; my body restricted by five other bodies . . . For I visit places I never imagined. I would never buy Astroturf on my own. It would not occur to me to roll up in a curtain and spin out of it to start a play . . . Only I do create these events. I create them not with my singular self but with my multi-headed and many-armed self . . .[30]

Furthermore, though, we might note that Deleuze's own celebration of individual authors and directors—such as the Italian theatre director, Carmelo Bene—also troubles any easy superimposition of collective creation/immanence and direction/transcendence. For instance, in his 1979 essay "One Less Manifesto" (his only extended discussion of theatre), Deleuze explicitly embraces the idea of an authoritarian director, which forces us to question whether a top-down directorial approach is necessarily at odds with the project of immanent theatre. We might say then that collective creation *can* lead to relations of immanence, but that many things can be collective creation. Indeed, Deleuze goes as far as to argue, "It is of little consequence that the actor-author-director exerts influence and assumes an authoritarian manner, even a very authoritarian one."[31] Because of the "minoritarian" nature of the work that Bene is trying to make, Deleuze claims, "This would be the authority of perpetual variation in contrast to the power or despotism of

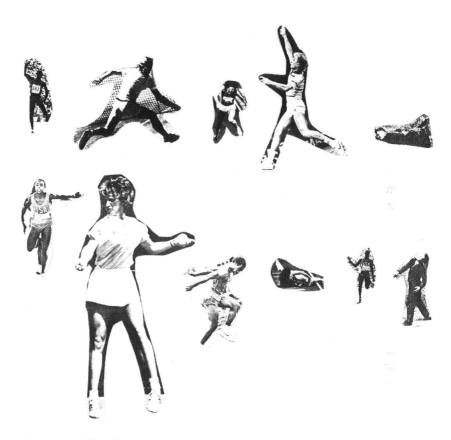

Figure 7.2 Collages by Lin Hixson

In April 1993, two months before the piece's premier in Hull, England, we concentrated on a dance/movement sequence for the first half of the piece. In this sequence, which Lin placed after the Breathing section of the very beginning, and before the Medical section, we wore the white doctors' coats and performed at a slow, counter-rhythm to loud, extremely fast music by a band from Lansing, Michigan called The Crucifucks. Many of the movement ideas had accrued around Tim's Butoh Bush dance. Various images generated the moves, including pictures of drawings of dancers, actors, athletes, and kama sutra subjects. Sometimes one figure's upper body inspired an unusual movement, but the lower body seemed vague and generalized, or vice versa. In rehearsals, we began to fold the pictures and paperclip the mismatched halves together. Lin started to cut out the photocopied figures, rematch the body halves or parts, and create collaged figures for us to interpret, particularly to give the sequence more leaps and falls. An office supply store had drawn her name out of a box, and she had won a home Xerox copier and 100 reams of paper, which tremendously speeded up the collage process.

Figure 7.3 *Hankbook* by Goat Island
From *Process Text in 22 Parts* by Matthew Goulish.

the invariant. This would be the authority, the autonomy of the stammerer who has acquired the right to stammer in contrast to the 'well-spoken' majority."[32]

The political function of the "minor" theatre, as Deleuze sets it up, is to awaken a "minority-consciousness" in its audience or to enlist the audience in a "becoming-minority" by putting all the elements of theatrical representation—character, gesture, enunciation—into variation by emphasizing the self-difference or self-creating nature of all theatre's materials. If a dominant director is needed to construct such a theatre, then so be it, Deleuze seems to imply; whatever way works.

From this perspective, Deleuze might be seen as prioritizing ends over means in a problematic way; the authoritarian actor-author-director's methods are justified on account of the disruptive and emancipatory effects that the product of such methods are said to have on the audience. But surely, there must be ways to reconcile the pursuit of relations of immanence in both process and performance—where the experiences of all those involved (performers, directors, designers, audiences, etc.) are given equal value. Alternatively though, we could interpret Deleuze's remarks as emphasizing the importance of producing some kind of "work" or creation in order to share or transmit the experience of immanence to others. As Leonard Lawlor has discussed in relation to writing, a work is required to aid the future self-transformation or "becoming" of others: "[B]y writing the becoming down one 'conserves' the formulas that will allow others to become and cross thresholds."[33] That is, whereas "One Manifesto Less" seems to prioritize the transformation of the audience over the experience of those subject to the authority of a director, elsewhere Deleuze invokes a model of contagion, where the work becomes a kind of infectious document of its own processes of production—not "naturally" or automatically, but through a careful and difficult procedure of conservation.

In turn, just as we've seen how Hixson exemplifies that there are immanent approaches to directing, Goat Island has also developed immanent approaches to authorship and script. No doubt, the power of collaborative practice to release performance from representing the individual author is affirmed by the company; for instance, while attempting to explain the work of Goat Island and its value for the performers who make it, Matthew Goulish isolates the notion of "escape," among other concepts, as an important idea for the company: "Escape from ourselves, from the limited perspective of the individual ego . . . Who we were, when we met, how we proceeded, what we produced, all seem products of the togetherness, the conjunction . . . Escaping our individual limitations was certainly one of our goals—and not only limitations of identity, but also of thought, imagination, history and progress."[34]

However, such an affirmation of collective authorship is not based on any metaphysically naïve notion of the individual author as a unified subject; the embrace of creating together is not fuelled by a rejection of the individual, creative self as self-same. Patrice Pavis has argued that "[t]he cause of the current crisis in collective creation is not only a return to the playwright, the text and the establishment after the collective euphoria of 1968. It is also attributable to the fact that the individual artistic subject is never unified and autonomous in any case."[35]

In other words, he suggests that collective creation lost its sense of purpose when practitioners "realized" that the individual was always already split. In contrast, we might argue that collaboration or collective creation was never opposed to working alone per se, but to any practice structured by a transcendent authority that is positioned "outside" the creative process—including the notion of the subject. Indeed, within the previous passage, Goulish quotes from the famous opening sentence of *A Thousand Plateaus*, in which Deleuze recalls his and Guattari's first collaboration: "The two of us wrote *Anti-Oedipus* together. Since each of us was several, there was already quite a crowd."[36] Individual presence is always already differentiated for Deleuze and Goulish because of what they conceive as the material, vital difference that runs through all bodies.[37] It is precisely because the "the individual is also a group" that Deleuze argues that the self or subject is "one more thing we ought to dissolve, under the combined assault of political and analytical" (and we might add theatrical) forces.[38] It is not that we want to reify collective creation as *the* immanent theatrical mode par excellence, but no doubt—equally— there are forms of individual practice that reinforce the idea of the unified, artistic subject, while collective creation practices like The Living Theatre's and Goat Island's invite their members to explore their difference from themselves as well as from one another. Collective creation is one way to directly experience ourselves *as* relation. Indeed, Deleuze's ontology suggests that this self-difference is what we all have in common (both with one another and with inhuman others), in a manner that suggests a new basis for collective action (and a new understanding of what counts as "political theatre") beyond the politics of identity.

Figure 7.4 Goat Island: The Last Film. Mark Jeffery, Litó Walkey, Karen Christopher, Matthew Goulish, Bryan Saner, Lucy Cash, and Lin Hixson
©2009 John Sisson

To conclude, this chapter has proposed that there is no such thing as *pure* dictatorship of the director nor *pure* collective creation, just as there is no such thing as pure immanence or pure transcendence in experience. But further, and following from these examples, we might suggest that just because an organization has a named director, or a performance a named author, does not mean that immanent, collective creation is not going on, and therefore, equally, just because an organization does not have a named director does not mean that instances of transcendent organization are not going on behind the scenes. As such, we have also suggested that it is not so much individual artistic practice that collective creation departs from—given that the individual is also a group[39]—so much as from notions of "the subject" that bear down on and delimit both kinds of creative process. A philosophical approach, then, insists that we acknowledge that collective creation cannot guarantee immanence or desubjectified experience; it is only one means among others and a means that differs from those others in degree rather than kind. But hopefully, such an approach can also fruitfully work alongside more historically or politically focused approaches, bringing to light the connections between theatrical practices that embrace collective creation and philosophies such as Deleuze's that call on us to live in ways that affirm the fundamental creativity of the world.

Bibliography

Barton, Bruce, ed. *Critical Perspectives on Canadian Theatre in English*, Volume 12: *Collective Creation, Collaboration and Devising*. Toronto: Playwrights Canada Press, 2008.

Beck, Julian. *The Life of the Theatre: The Relation of the Artist to the Struggle of the People*. San Francisco: City Lights Books, 1972.

Biner, Pierre. *The Living Theatre*. New York: Horizon Press, 1972.

Bloom, Alexander. *Long Time Gone: Sixties America Now and Then*. Oxford: Oxford University Press, 2001.

Cull, Laura. "Performing Presence, Affirming Difference: Deleuze and the Minor Theatres of Georges Lavaudant and Carmelo Bene." In *Contemporary French Theatre and Performance*, edited by Clare Finburgh and Carl Lavery, 99–110. New York: Palgrave Macmillan, 2011.

DeKoven, Marianne. *Utopia Limited: The Sixties and the Emergence of the Postmodern*. Durham, NC: Duke UP, 2004.

Deleuze, Gilles. *Desert Islands and Other Texts 1953–1974*. Edited by David Lapoujade. Translated by Mike Taormina. Los Angeles: Semiotext(e), 2004.

———. *Difference and Repetition*. Translated by Paul Patton. London: Athlone Press, 1994.

———. *Essays Critical and Clinical*. Translated by Daniel W. Smith and Michael A. Greco. London: Verso, 1998.

———. "One Less Manifesto." In *Mimesis, Masochism and Mime: The Politics of Theatricality in Contemporary French Thought*, edited by Timothy Murray, translated by Timothy Murray and Eliane dal Molin, 239–258. Michigan: University of Michigan Press, 1997.

Deleuze, Gilles, and Michel Foucault. "Intellectuals and Power: A Conversation between Michel Foucault and Gilles Deleuze." Libcom.org, September 9, 2006 [1972], accessed October 17, 2010. http://libcom.org/library/intellectuals-power-a-conversation-between-michel-foucault-and-gilles-deleuze.

Deleuze, Gilles, and Felix Guattari. *Anti-Oedipus: Capitalism and Schizophrenia*. Translated by Robert Hurley, et al. London: Athlone Press, 1984.

———. *A Thousand Plateaus: Capitalism and Schizophrenia*. London: Continuum International, 2004.

Goat Island. "Part 1—Reflections on the Process: Goat Island's When Will the September Roses Bloom? Last Night Was Only a Comedy." *Frakcija* 32 (2006).

Goulish, Matthew. *39 Microlectures: In Proximity of Performance*. London: Routledge, 2000.

Holland, Eugene. "Nomad Citizenship and Global Democracy." In *Deleuze and the Social*, edited by Martin Fuglsang and Bent Meier Sørensen, 191–206. Edinburgh: Edinburgh University Press, 2006.

Lawlor, Leonard. "Auto-Affection and Becoming: Following the Rats." Paper delivered at the International Association for Environmental Philosophy, Twelfth Annual Meeting, Pittsburgh, Pennsylvania, October 18–20, 2008.

Living Theatre, The. "'Paradise Now': Notes." *The Drama Review* 13, no. 3 (Spring, 1969): 90–107.

Marks, John, ed. *Deleuze and Science*. Edinburgh: Edinburgh University Press, 2006.

Martin, Bradford D. *The Theater Is in the Street: Politics and Performance in Sixties America*. Massachusetts: University of Massachusetts Press, 2004.

May, Todd. *Gilles Deleuze: An Introduction*. Cambridge: Cambridge University Press, 2005.

Pavis, Patrice. *Dictionary of the Theatre: Terms, Concepts, and Analysis*. Translated by Christine Shantz. Toronto: University of Toronto Press, 1998.

Protevi, John. *A Dictionary of Continental Philosophy*. Edinburgh: Edinburgh University Press, 2005.

———. *Political Physics: Deleuze, Derrida and the Body Politic*. London: Athlone Press, 2001.

Rabkin, Gerald. "The Return of The Living Theatre: Paradise Lost." *Performing Arts Journal* 8, no. 2 (1984): 7–20.

Ryan, Paul R. "The Living Theatre's 'Money Tower.'" *The Drama Review* 18, no. 2 (1974): 9–19.

Sarlós, Robert K. *Jig Cook and the Provincetown Players: Theatre in Ferment*. Massachusetts: University of Massachusetts Press, 1982.

Schechner, Richard, and Lisa Wolford, eds. *The Grotowski Sourcebook*. New York: Routledge, 2001.

Shank, Theodore. *Beyond the Boundaries: American Alternative Theatre*. Ann Arbor, MI: University of Michigan Press, 2002.

———. "Collective Creation." *The Drama Review* 16, no. 2 (June 1972): 3–31.

Notes

1. Bruce Barton, *Collective Creation, Collaboration and Devising*, ix, original emphasis.
2. Gilles Deleuze, "Intellectuals and Power: A Conversation between Michel Foucault and Gilles Deleuze."
3. de Beistegui in John Protevi, *A Dictionary of Continental Philosophy*, 151.
4. Deleuze, *Difference and Repetition*, 82.
5. Todd May, *Gilles Deleuze: An Introduction*, 28–29.
6. John Protevi, *Political Physics*, 8.
7. John Marks, *Deleuze and Science*, 4.
8. Deleuze and Guattari, *A Thousand Plateaus*, 451–52.
9. Deleuze, *Essays Critical and Clinical*, 135.
10. Gilles Deleuze and Felix Guattari, *A Thousand Plateaus*, 177.

11. Gilles Deleuze and Felix Guattari, *Anti-Oedipus*, 2.

12. Deleuze and Guattari, *A Thousand Plateaus*, 289.

13. Although clearly influenced by the wider context of May '68 in many ways, The Living Theatre had already begun to create collectively prior to the strikes and the emergence of collective creation in French companies such as Théâtre du Soleil and Le Folidrome. Appropriately, Beck and Malina claim that The Living Theatre found themselves working on a collective creation almost by accident in 1964 in the development of *Mysteries and Smaller Pieces*, the first original production undertaken in their "exile" period. According to Beck, "Mysteries had no director"—a shift in the nature of the company's creative process that he presents as accidental—as something that happened to the company without them knowing or planning it (Julian Beck, *The Life of the Theatre*). However, though collective creation might have happened to The Living Theatre unintentionally, by 1969 Beck was arguing that "the real work of the director in the modern theatre is to eliminate himself" (Beck in Theodore Shank, *Beyond the Boundaries*, 36). Whereas in previous productions the company had tended to use an authored script as the basis for performance (e.g., in their staging of *Many Loves* by William Carlos Williams in 1959), *Mysteries* was conceived as an opportunity for all company members to engage in the process of creative production, beyond the form of improvisation. Primarily, this participation took the form of lengthy, multiple discussions that The Living Theatre refer to as their "rehearsals." In turn, published notes concerning *Paradise Now* document only the first five of one hundred general discussions in which all company members participated. According to Beck, discussions such as these became "an integral part" of the company's "working method, and were the source material out of which *Mysteries, Frankenstein, Paradise Now*, and the mise en scène for *Antigone* were created" (The Living Theatre, "'Paradise Now': Notes," 90).

14. Marianne DeKoven, *Utopia Limited*, 144.

15. Theodore Shank, "Collective Creation," 4.

16. Eugene Holland, "Nomad Citizenship and Global Democracy," 195.

17. Ibid., 195.

18. Ibid., 195.

19. Ibid., 195. Specifically, Shank suggests, the new theatres shaped themselves as alternatives to a mainstream theatre that was as competitive and specialized as mainstream society. Such theatres had a strict division of labor in which actor, director, and playwright all play distinct roles. From this perspective The Living Theatre's processes of collective creation could be seen to suggest a "social ideal" of bottom-up rather than top-down organization and the integration of difference into group production. Indeed, Rabkin suggests that this might be the best way to understand *Paradise Now* and the transformation of The Living Theatre as a company during "the exile period": "It was no longer a theatre in the formal sense; it was a tribe, a commune. The new performers on stage . . . were not primarily artists sharing in a collective effort, but members of a family cultivating alternative modes of living. And . . . why not? The violent, polarized society we lived in then demanded new strategies" (Gerald Rabkin, "The Return of The Living Theatre: Paradise Lost," 13).

20. To be fair to Holland, it is important to note that he does acknowledge that his clean separation of transcendent and immanent modes of organization is a "heuristic distinction" specifically designed to aid our understanding of how these modes operate, not a precise analysis of how classical music and jazz might actually operate in practice. Nevertheless, I remain unconvinced that such "heuristic distinctions" do not in fact do more harm than good in terms of helping us to think through how to relate theory and practice, philosophy and performance.

21. Beck in Pierre Biner, *The Living Theatre*, 160.
22. Robert K. Sarlós, *Jig Cook and the Provincetown Players*, 167.
23. Rabkin, 18. As Rabkin recounts, when "[m]ysteries was performed for the last time in Berlin in January 1970, a declaration was issued announcing that the theatre was dividing into four cells to be located in four different countries, from Britain to India" (Rabkin, 14).
24. Paul R. Ryan, "The Living Theatre's 'Money Tower,'" 18. In interviews with Biner, Beck also acknowledges that he and Malina control the casting for every production (Biner, 165).
25. Grotowski in Richard Schechner and Lisa Wolford, *The Grotowski Sourcebook*, 224.
26. Ibid., 41.
27. Patrice Pavis, *Dictionary of the Theatre*, 62.
28. Hixson in Goat Island, "Part 1—Reflections on the Process."
29. Hixson in Matthew Goulish, *39 Microlectures*, 10.
30. Goat Island, "Our Simplest Gestures: 6 Short Lectures by Goat Island," unpublished source courtesy of the company.
31. Gilles Deleuze, "One Less Manifesto," 54.
32. Ibid., 54. In "One Less Manifesto," Deleuze defines a "minor" theatre as one that places all the different elements of theatre—its language, gestures, costumes, and props—in perpetual variation, through a process of "subtraction" or "amputation" (239). Whereas in much dramatic theatre the tendency is to submit the speeds and slownesses of performance to the organizational forms of plot and dialogue and to emphasize characters over transformative becomings that sweep them away, a minor theatre seeks to affirm the primacy of perpetual variation over the fixed representation of subjects, objects, and a coherent fictional world. As I've discussed elsewhere, it is also important to note that there are no *essentially* major or minor theatres for Deleuze, but rather different *usages* of theatre and its elements that we can call major and minor (Clare Finburgh and Carl Lavery, *Contemporary French Theatre and Performance*).
33. Leonard Lawlor, "Auto-Affection and Becoming."
34. Goulish, 15.
35. Pavis, 63.
36. Deleuze and Guattari, *A Thousand Plateaus*, 3.
37. In contrast, we might suggest that for Pavis it is the penetration of representation that differentiates the subject.
38. Gilles Deleuze, *Desert Islands and Other Texts*, 193.
39. Ibid., 193.

8

Something Queer at the Heart of It

Collaboration between John Cage and Merce Cunningham

Michael Hunter

Beginning Together

In the summer of 1953, John Cage and Merce Cunningham participated (for the second time) in the summer session at Black Mountain College in North Carolina.[1] Having recently become interested in the writings of Antonin Artaud, as well as having made the acquaintance of Julian Beck and Judith Malina of The Living Theatre, Cage was pushing his ideas about sound and music in the direction of theatre, albeit in radically decentered forms. Together with Cunningham, Robert Rauschenberg, the poets Charles Olson (then director of Black Mountain) and M. C. Richards, and his frequent musical collaborator David Tudor, Cage presented what countless scholars and practitioners have come to identify as the first Happening, if not in name then in spirit; lasting roughly 45 minutes, the piece featured the simultaneous actions of Cage, Richards, and Olson standing on ladders and reading lectures and poetry, Tudor playing the piano, and Cunningham and his dancers moving throughout the space, above which hung Rauschenberg's white paintings. Cage himself explained that the lesson he took from Artaud was that theatre didn't need text, and if it did contain text, "that it needn't determine the other actions, that sounds, that activities, and so forth, could all be free rather than tied together; so that rather than the dance expressing the music or the music expressing the dance, that the two could go together independently, neither one controlling the other."[2]

Cage's comments seem almost banal from a twenty-first-century perspective: much of what has fallen under the umbrella term of "performance" since the 1950s—not to mention a good deal of what we still call theatre—has contained at least some of the features Cage finds in Artaud's text. What the Black Mountain

Happening represented for many artists and scholars who saw or heard about it, however, was a new possibility of what would constitute a performance event: individual performers, working with different media, could "collaborate" by sharing a structure of space and time, without attempting to fuse into a cohesive whole.

In a 1985 conversation, David Shapiro asked Cage about the piece at Black Mountain, specifically in relation to the issue of collaboration:

> *Shapiro*: So collaboration also involved simultaneity?
> *Cage*: That's all it really means to me.
> *Shapiro*: Two things happening at the same time.
> *Cage*: That is their relationship.[3]

A little later in the discussion, Cage elaborated: "[A]ctually if you're collaborating, it has only been agreed that you're collaborating. Because when you actually do the work you're not collaborating at all. You're simply doing the work."[4]

One might characterize the long-term working relationship between Cage and Cunningham in precisely this way: agreeing to collaborate, but doing the work separately. Almost ten years before the performance at Black Mountain, on April 5, 1944, the two men had presented their first concert of dance and music together at the Humphrey-Weidman Studio Theatre in New York. The evening-length bill featured six solos by Cunningham, for which Cage composed the music, as well as three additional pieces of music by Cage. In 1968, Cunningham wrote, "I date my beginning from this concert."[5]

As with much of the two men's commentary on their own work, the precision of Cunningham's language here is revealing: he does not date *their* beginning from this concert; rather, he locates his own individual artistic genesis within the structure of a collaborative relationship that would prove to be an almost inexhaustible source of creative energy for both men, as well as for many of those who came into contact with them, for more than fifty years.[6] Within the framework of that relationship, each artist maintained his separate aesthetic trajectory, continuing to push through and against the fundamental formal questions and material constraints of his own medium (dance and music, respectively). As collaborators, what Cage and Cunningham sought to create and develop was a set of structures that would allow them to work together, but in a nonhierarchical relation, such that music and dance would remain "separate identities which could in a sense coexist."[7] What they sought in this collaboration was "simply being together in the same place and the same time, and leaving space around each art."[8] In many ways, this aspect of Cage and Cunningham's work together, and with their extended network of collaborators, constitutes their most important legacy for the experimental performance practices of the latter half of the twentieth century. Certainly Allan Kaprow's development of the Happenings and Events of the 1950s and 1960s is directly indebted to Cage's influence as his teacher at The New School for Social Research, as were the Fluxus experiments of George Brecht, Dick Higgins, and Al Hansen, all of whom participated in Cage's Experimental Composition class at the New School in 1956–57.[9]

Roger Copeland has argued that the fundamental principle guiding Cunningham and Cage's collaborative process—both with each other and with other artists—is collage: "Unlike the Gesamtkunstwerk, which exemplifies a hunger for wholeness, collage appeals to an age that has come to distrust claims of closure, 'unity,' and fixed boundaries."[10] Copeland evokes the term "polyvocality" to describe the fact that "the component parts of any successful collage speak with separate, often disunified voices."[11] In the context of a volume dedicated to collective creation, Cage and Cunningham's model of polyvocal collaboration is simultaneously central and marginal to the frameworks in which collaborative work is generally discussed. Their process of preparing and performing the work's component parts separately deliberately refuses the processes of discussion and planning that would place these parts in an intentional relation to each other; it is both rare and accidental that their work together produces the kind of unity, cohesion, or harmony that the terms *collaborative* and *collective* suggest. In the duration of their life and work together over many decades, however, their model of working together engages profoundly with these terms, illuminating the ways in which our notions of collaborative work have been shaped by larger cultural frameworks such as heterosexual marriage, the family, and the corporate team—each of which presumes that two or more individuals come together to produce something more unified, durable, and future oriented than they would be able to achieve alone. Cunningham and Cage, by contrast, spent five decades cultivating what Copeland has called a "shared sensibility," by finding new and unexpected modes of relation between individual components (including people) that share space and time, without either fusion or transcendence.

The model that structured Cage and Cunningham's collaborative process was based primarily on three principles: the separation of composition, so that collaborators often encountered one another's contribution for the first time during a performance (and because of which Cunningham often choreographed to silence); time, rather than beats and measures, as the fundamental unit of compositional structure; and chance (or aleatory) procedures, which provided structural elements that were not based on the collaborators' preferences or subjectivities. These principles guided their work in varying proportions over the course of their collaborative career, and generally when others were brought into the process of creation, such as the painters Robert Rauschenburg and Jasper Johns, their contributions would also be produced separately and ultimately shaped by the aleatory processes that gave form to the performances as a whole. With rare exceptions, Cage and Cunningham refrained from discussing the separate parts at any point during the composition process and also generally refused to reject or edit any collaborator's contribution.

Silent Together

In the conversation with Shapiro, Cage discussed the central role of collaboration in his career in characteristically paradoxical language:

> *Shapiro*: . . . on the one hand you are regarded as a sort of divinity of inclusiveness in collaboration, but on the other hand . . .

Cage: I refuse collaboration.
Shapiro: Yes.
Cage: I refuse collaboration in the sense of two people discussing something in order
 to arrive, so to speak, at a democratic work of art.[12]

Cage's "refusal" of collaboration *as discussion* echoes his sustained commitment
to *silence*, which found its most (in)famous manifestation in 1952's "silent con-
cert" 4'33"; for Cage, "silence" represents not so much a genuine acoustic void as
the revelation of sonic material that has not been culturally designated as worthy
of attention. In a structure of time designated as "silent"—which is to say free of
culturally legitimated sounds—*all* manner of sounds *and noises* can be heard (or
included), many of which are conventionally regarded as annoying, intrusive, or
too "small" to warrant directed audition.

As numerous critics—including Copeland, Jonathan Katz, and Carolyn A.
Jones—have argued, Cage's version of silence is composed of strategies and tech-
niques for transforming perception, limiting the reach of the ego, and resisting
certain forms of discursive power. Throughout his life and work, he attempted
to elaborate and sustain a complex position of productivity from which he could
challenge discursive formations that threaten to reify, manage, and limit individual
subjectivities. Often, Cage tried to find ways to remain silent, opaque, or unstable
within the frameworks of dominant discursive power without relinquishing *pres-
ence*. This is perhaps best exemplified in the opening of his paradoxical "Lecture
on Nothing" (1950): "I am here/and there is nothing to say."[13] Being present with-
out having anything to say proposes a *listening*, rather than a *speaking*, subject,
and if that subject happens to begin to speak, it will not be because he has anything
particular to *express*.

"Lecture on Nothing" was infused with Cage's interest in Zen spirituality, which
he famously reworked to support his own idiosyncratic philosophical and aes-
thetic priorities. For Cage, one of the lessons of Zen for his aesthetic practice was
an avoidance of expressing his "likes and dislikes," which I take as shorthand for
the kinds of preferences that help to constitute an *identity* within a culture domi-
nated by notions of consumption and choice. Silence, combined with structural
frameworks resulting from both predetermined durations of time and chance
procedures, offered rich possibilities for exploring discursive operations (both lin-
guistic and acoustic) that would avoid expressions of a "self" behind, or beneath,
that operation.[14]

Cunningham's work, especially in its early stages, represented a crucial turning
point in a number of aspects of dance, including many that were linked to Cage's
work: the division of dance and music in the compositional process; the use of
chance procedures; and the emphasis on time, rather than beats, to structure the
dance. He also strove to eliminate both emotional expressivity and dramatic char-
acter in the dancer's work, to emphasize movement and extension of the dancer's
torso, and to rethink the conventional orientation of the stage space toward the
spectator (so that, for the dancer, any number of directions might represent the
"front.") While these last features of Cunningham's work were fueled by his own
independent struggle with the traditions, constraints, and possibilities inherent

in dance, they served in concert with Cage's aesthetic concerns to produce a radical assault on the notion (shared by both ballet and earlier modern dance) of the *dance concert* as an artistic form that brought music and dance together, generally in a hierarchical relation (where music supports the dance), to express emotional and/or narrative content for—and toward—an audience of spectators. Among the numerous influential effects of this collaboration, the role of the spectator was transformed from one who has an experience "done to" her to one who must work to create her own meaning from the various discrete acoustic and visual materials simultaneously occupying the performance space, without recourse to predetermined structures of thematic, narrative, or even conceptual relation.

Living Together

For reasons that are understandable given the historical moment in which their work was being developed, Cage's and Cunningham's aesthetics have rarely been considered to have any relation to their sexuality.[15] More than fifty years on, that verdict is worth an honest reassessment. One might begin—as Jonathan Katz has done in his insightful work on Cage—by proposing connections between the forms of silence that Cage and Cunningham imposed on their work and the larger silence that American culture enforced on homosexuals, particularly during the period of the Cold War. Much has been made of the fact that Cage and Cunningham remained publicly incommunicative about the sexual or intimate nature of their relationship and refrained from embracing the models of gay identity that became increasingly available in the wake of the gay liberation movements of the 1960s and 1970s.

One of the problems with trying to understand the role of queer sexuality in preliberation aesthetics is the ease with which these projects are relegated to a noteworthy but historically dated manifestation of *the closet*—that is, a fascinating complex of hidings and disclosures that we allegedly no longer need because we have discovered, and achieved, "gay pride." My sense is that this way of thinking about Cage and Cunningham's work, both separately and as collaborators, misses much of the point of their particular refusal of identity *in general*, regardless of the opportunities that liberation might afford for the individual life. What complicates this question is the way in which their particular forms of silence block inquiry into the relationship between the *development* of their aesthetic in the 1940s and 1950s and the pressures of a broader homophobic culture. Katz, for example, having suggested that Cage's "closeted gay identity compelled his infamous anti-expressionism," then goes on to ask, "Could it also be the case that Cage's anti-expressionistic convictions compelled his closetedness, that his belief in the utility of silence caused him to stifle or at least mute the public acknowledgement of his sexuality?"[16] While the philosophical value of both silence and the renunciation of the ego in both Cage's and Cunningham's work—as well as the various aesthetic corollaries that they developed to give form to those values—unquestionably exceeds merely the freedom to live openly as gay men in America, what is more difficult to know is the degree to which those strategies were formed

as responses to homophobia in the first place. Once gay liberation began to offer viable alternatives to the closet, Cage and Cunningham had already systematically (and for more than twenty years) developed a philosophical and aesthetic trajectory that could only be compromised by the adoption of clear identity positions, not to mention that they had lived as partners in the context of an openly homophobic culture for the same amount of time.

The critical silence surrounding Cage's and Cunningham's sexualities has made a certain kind of sense first and foremost as a gesture of tacit *respect* for their own preferred silences and complex evasions regarding the details of either their relationship or their sexual orientations. While their reasons for embracing such silence are certainly overdetermined, it has been a shared assumption that any kind of overt "queering" of their work would represent a fairly crude disturbance of a collaborative project that, in most of its manifestations, has been subtle, strategic, and—as a result—fragile in its general refusal to "express" anything at all, especially the libidinal profiles of its makers. As Cage has said, "personality is such a flimsy thing on which to build an art . . . and the ballet is not built on such an ephemeron, for, if it were, it would not at present thrive as it does."[17]

There are numerous ways in which we could begin to consider Cage's and Cunningham's respective aesthetic projects as somehow linked to their sexualities—which is not to say that their work can or should be reduced to a revelatory sexual secret that would explain or order it.[18] Cunningham's insistence on his dancers' orientations toward different points of focus, for example, proposes a critique of conventional directional logics that shape both the trajectory of the dancer's movement onstage and the spectator's privileged viewing of that movement. In his work, dancers and audience are denied familiar structures, long built into the history of concert dance, which would allow them to make sense of individual movements, and lines of movement, in relation to a whole. While it would be ridiculous to suggest that this trademark aspect of Cunningham's work is a direct response to or result of his sexuality, it might be profitable to consider how the particular traditions of both choreography and spectatorship that his work disrupts have themselves been formed within cultural frameworks that associate forward movement, arrival/completion, fragmentation/cohesion, and even "the front" with broader Western binaries of homo/heterosexuality.[19]

Despite the fact that there are numerous inroads for considering Cage and Cunningham's work in a "queer" light (particularly given the ways in which recent queer theory has expanded to encompass analyses and critiques of cohesive subjectivities, spatial and temporal formations, and phenomenology, to name a few), it remains true that their aesthetics do not *look* particularly queer or contain the aesthetic qualities we usually associate with that term (or with the work of marginal sexual subjects more generally). For one thing, although both men are interested in irony, there is nothing resembling the particular excessive and theatrical ironies of "Camp" in their work, in large part because Camp is built on a substructure of expressiveness. Neither is there an interest in the politics of identity *per se*, except to the extent that it is a political act to eschew identity. There is no mimetic relation to marginalized sexual subjects, or to the kinds of situations that such subjects tend to find themselves in, or even to sex itself: many of their collaborative

pieces are remarkable for their total lack of libidinal energy, suggesting instead the languid observation of pond life, fascinating for its variation rather than its agonism. Ultimately, their work reaches toward the abstract and the universal, rather than the minoritarian, although its version of universality fractures its audience into radically individuated spectators/auditors.

There is, however, a clear sense in which both Cage and Cunningham are profoundly interested in the aesthetic space as one in which almost limitless *variation* can appear without organizing itself according to pre-established rules or hierarchies. It is also clear that their work *together* expands the horizon of possible variation exponentially—this is the sense in which Copeland describes their collaborations as "polyvocal." In her important queer readings of Marcel Proust and Henry James, Eve Kosofsky Sedgwick suggests that the two writers both elaborated forms of what she calls "nonce taxonomy"—that is, improvisatory descriptions and categorization of "all the kinds it may take to make up a world." Sedgwick associates this version of taxonomy with *gossip*; as opposed to official discourses, which tend to reduce the diversity of human behavior to limited ranges, or even binaries, of types, gossip proliferates and maps out "the possibilities, dangers, and stimulations" of human social culture: "I take the precious, devalued arts of gossip, immemorially associated in European thought with servants, with effeminate and gay men, with all women, to have to do not even so much with the transmission of necessary news as with the refinement of the necessary skills for making, testing, and using unrationalized and provisional hypotheses about what *kinds of people* there are to be found in one's world."[20]

In their careful and systematic avoidance of the discourses of official Western thought that, in Sedgwick's terms, have the effect of "delegitimating our space for asking or thinking in detail about the multiple, unstable ways in which people may be like or different from each other,"[21] both Cage and Cunningham produce unique systems of taxonomy that embrace the possibility of and conditions for limitless variety. While Sedgwick emphasizes the counterofficial discourse of gossip as a *linguistic* register that allows for a fuller acknowledgement (and analysis) of human variety, Cage and Cunningham elaborate *extra*linguistic discursive forms to the same end. In Cunningham's work, that system focuses its energy on things the human body can, or might be able to, do. The resulting choreography often resembles a catalogue of demonstrations of gestures and movements separated from a larger, coherent "body," in a way that evokes the laboratory more than the traditional dance stage. Moving between high lyricism and pedestrian movement, Cunningham's work is a corporeal analogue to gossip with its refusal to obey the laws that separate proper and vulgar, serious and ridiculous, high and low, rational and superstitious. Likewise, as Cage's aesthetic developed in the 1950s, he increasingly came to regard his role as a composer in terms of creating structures that would facilitate the apprehension of all kinds of sounds on their own terms, rather than in relation to predetermined concepts and established meanings: "There are, demonstrably, sounds to be heard and forever, given ears to hear. Where these ears are in connection with a mind that has nothing to do, that mind is free to enter into the act of listening, hearing each sound just as it is, not as a phenomenon more or less approximating a preconception."[22]

Many of Cage's most important compositions, in fact, are structures that shape audition, creating conditions in which the listener might discover both sounds and qualities of sounds previously unknown. *Silence*, in this context, denotes a graveyard of acoustic phenomena that the Western ear has deemed unworthy of attentive audition; Cage systematically proposes new ways of attending again to that graveyard, with the goal of expanding and recalculating auditory perception itself.

No Government

In Chapter 11, Victoria Lewis has detailed the Maoist and feminist frameworks that shaped the group processes of companies such as the San Francisco Mime Troupe, the Family Circus Theatre, and Lilith. The examples she chooses represent important attempts in the history of US collective creation practices to resist individualization and hierarchical organization and to promote the collective. Her analysis draws careful attention to both the advantages and the limitations that resulted from the groups' extensive *discussions* about their creative and organizational processes, especially as regards the challenging project (as Lewis puts it) "of institutionalizing *communitas* and maintaining absolute equality amongst all participants."[23]

While I don't mean to suggest that Cage and Cunningham represent a *better* model than the companies Lewis describes, their collaborative practice does avoid the particular kinds of negotiations and conflicts in Lewis's account, which result from discussion. One might of course argue that a key difference between groups like Lilith or the Mime Troupe and Cunningham and Cage—besides the role of discussion in their creative process—has to do with the respective presence and absence of an explicit political agenda in their work.[24] In an interview with Jacqueline Lesschaeve in 1980, Cunningham recounted his difficulty addressing European audiences who assumed a connection between art and politics, and wanted to know his political position: "They kept asking, 'What are your politics?' Now I begin to understand. But what we represent is in a sense no government. We do represent a kind of individual behavior in relation to yourself doing what you do and allowing the other person to do whatever he does. As Christian Wolff once said, it does imply good faith between people."[25]

"No government" is a surprisingly direct statement of anarchic principles, suggesting a disavowal of institutions and discourses that calcify individual subjectivities into cultural identities, such that their relation to others is embedded in hierarchical frameworks. In other words, for Cage and Cunningham, "no government" means renouncing forms of communication and expression (including discussion) that are bound up with power; instead, they actively promote silence, *listening*, and a term that Cage opposes to communication: *conversation*. "I much prefer this notion of dialogue, or conversation, to the notion of communication. Communication presupposes that one has something, an object, to be communicated . . . Communicating is always imposing something: a discourse on objects, a truth, a feeling. While in conversation, nothing imposes itself."[26]

The ways in which Cage and Cunningham proposed to *listen* in their collaborative process—to each other, to outside collaborators, and to what is emerging in the work itself—echoes this resistance to language as a form of imposition. The refusal to discuss, to share plans, and to reject others' proposals, together with the use of chance methods and segments of time as organizational structures, helped to formalize a model of collaboration as listening and conversation rather than communication and expression. This model had profound influence on a generation of experimenters in the performing arts and arguably helped to shape many models of postmodern and postdramatic performance practice, especially in the United States.

Epilogue

To ask whether there is something queer at the heart of this collaborative model serves a number of purposes. The first is to expand the territory of what we regard as *queer aesthetics*: to examine work such as Cage and Cunningham's—with its abstract, impersonal, and universalist character—from *within* that category suggests new ways of thinking about what does, or doesn't, make art queer, and continually opening up this category offers also to expand possibilities for future queer art making. Second, these questions serve to promote what Sedgwick has quite simply called an "antihomophobic" project, in which marginalized sexual subjects and practices are reconsidered as productive of and central to the fabric of culture, both historically and in the contemporary field.

Finally, this project proposes that we think further about the relation between forms of desire and intimacy and the structures of working together through which collaborations are made. In many cases, collaborative models serve as experimental (and even utopian) bridges between human needs and desires, and the institutional structures that surround, support, and limit them. Seen as proposals for alternative ways of living, working, loving, and governing together, they have much to teach us about tangible ways of resisting, reinventing, and maximizing the discourses and institutions with and against which we are formed.

Bibliography

Butt, Gavin. *Between You and Me*. Durham: Duke University Press, 2005.

Cage, John. *Silence*. Middletown: Wesleyan University Press, 1961.

"Chance Conversations: An Interview with Merce Cunningham and John Cage." Walker Arts Center, 1981. http://walkerart.org/channel/1981/chance-conversations-an-interview-with -merce.

Copeland, Roger. *Merce Cunningham: The Modernizing of Modern Dance*. New York: Routledge, 2004.

Cunningham, Merce, and Jacqueline Lesschaeve. *The Dancer and the Dance*. New York: Marion Boyars, 1985.

Freud, Sigmund. *Three Essays on the Theory of Sexuality*. Translated by James Strachey. New York: Basic Books, 1975.

Jones, Caroline A. "John Cage and the Abstract Expressionist Ego." *Critical Inquiry* 19, no. 4 (Summer 1993): 628–65.

Katz, Jonathan. "John Cage's Queer Silence or How to Avoid Making Matters Worse." *Queer Cultural Center.* Accessed June 2009. http://www.queerculturalcenter.org/Pages/KatzPages/KatzWorse.html.

Kosofsky Sedgwick, Eve. *The Epistemology of the Closet.* Berkeley: University of California Press, 1990.

Kostelanetz, Richard. *Conversing with Cage,* Second Ed. New York: Routledge, 2003.

Shapiro, David, and John Cage, "On Collaboration in Art: A Conversation with David Shapiro." *RES: Anthropology and Aesthetics* 10 (Autumn, 1985): 103–116.

Vaughan, David. *Merce Cunningham: Fifty Years.* New York: Aperture, 1997.

Notes

1. Founded in 1933 by John Andrew Rice and his colleagues from Rollins College, Black Mountain fostered an experimental model of education to which interdisciplinarity and collaboration were fundamental. Hosting such notable faculty as Eric Bentley, Franz Kline, Robert Motherwell, and Robert Creeley during its 24 years of existence, Black Mountain was an essential contributing force to the American avant-garde and to the development of alternative education in the United States. The college closed its doors in 1957.

2. Richard Kostelanetz, *Conversing with Cage,* 110.

3. Davud Shapiro and John Cage, "On Collaboration in Art," 108.

4. Ibid.

5. David Vaughan, *Merce Cunningham,* 29.

6. Cage died in 1992, and Cunningham in 2009. After Cage's death, Cunningham continued to use the composer's works and methods in his own performance practice, in ways that continued to produce novel relationships between their aesthetics.

7. "Chance Conversations: An Interview with Merce Cunningham and John Cage."

8. Ibid.

9. An influential painter, "assemblagist," and later professor, Kaprow is considered by many to be the founder of American performance art. His Happenings and Environments in the 1950s and 1960s (and, later, Activities) developed from action painting, but they pushed the concept of the active artist to a more radical point, insisting that such activity could become a viable aesthetic object in itself. Kaprow's work was a direct influence on the experiments of the Fluxus group, who, among their wildly diverse aesthetic and performance activities, created "event scores"—short performance art scripts that could easily (and briefly) be executed by anyone. Both Kaprow and the members of Fluxis insisted on collaboration as an imperative aspect of their democratized, and reinvigorated, American avant-garde aesthetics.

10. Roger Copeland, *Merce Cunningham,* 167.

11. Ibid., 180.

12. Quoted in Copeland, 98.

13. John Cage, *Silence,* 109.

14. Carolyn A. Jones has read these Cagean modes of discourse as a critique of what she calls the "abstract expressionist ego"—that is, the "cultural construction of the artist as a masculine solitary, his artwork as a pure statement of individual genius and autonomous will" that characterized American modernist painters such as Pollock and de Kooning in the 1940s and 1950s. See Jones, "John Cage and the Abstract Expressionist Ego," 630.

15. Notable exceptions to this include the work of Jonathan Katz and Caroline A. Jones, who specifically deal with Cage's work as a queer or homosexual aesthetic. Roger Copeland has suggested that "attempts to draw a connection between [Cage and Cunningham's] sexual preferences and their artistic practices" are "woefully misguided." For a fascinating analysis of the pressures of homophobia on the art world in 1950s and 1960s New York, see Gavin Butt, *Between You and Me*.

16. Jonathan Katz, "John Cage's Queer Silence or How to Avoid Making Matters Worse," 12.

17. Copeland, 98.

18. It seems to me that the recent death of Cunningham, despite the deep loss that it produced, offers new possibilities for approaching this connection, making possible a consideration of the multiple ways in which the two men's work is "queer" in both some of its particular aesthetic features as well as its position in relation to the dominant forms of American cultural expression. This consideration might risk becoming less tactful, as regards the potential of betraying their own preferred silence on the matter, at the same time that it begins to contemplate, and respect, the complex reasons for that silence.

19. In but one exemplary account of this associative logic, Freud discussed the "perversions" (which include varieties of same-sex object-choice) as activities that compel subjects to "linger over the intermediate relations to the sexual object which should normally be traversed rapidly on the path towards the final sexual aim." (Sigmund Freud, *Three Essays on the Theory of Sexuality*, 16) For Freud, these pleasures are sufficiently compelling that culture must step in, in the form of encouragements and taboos, to keep subjects moving along swiftly towards their destination.

20. Eve Kosofsky Sedgwick, *The Epistemology of the Closet*, 23.

21. Ibid.

22. Cage, 23.

23. Chapter 11 in this volume.

24. One could also justifiably suggest that, given their status as queer white men, silence affords Cage and Cunningham access to domains of privilege in US culture that the members of, say, Lilith did not have.

25. Merce Cunningham and Jacqueline Lesschaeve, *The Dancer and the Dance*, 164.

26. Quoted in Katz, 9.

Shared Space and Shared Pages

Collective Creation for Edward Albee and the Playwrights of The Open Theater

Scott Proudfit

One way to understand the proliferation of collective creation in New York City's downtown arts scene in the mid- to late 1960s is to trace the idea of "shared space" through the aesthetic theories and philosophical texts that derived from (or were influential to) this particular cultural moment, as well as through the histories (of venues and creators) that have been written subsequently and the artistic products that have endured. Justifiably, this scene has often seemed too fractured and diverse to generalize across with any real confidence. Yet, while it is oversimplification to credit one area with so much, undeniably within a few short years the fecund atmosphere of lower Manhattan gave birth to postmodern dance, Pop Art, electroacoustic experimental music, and off-off-Broadway theatre.

As recent histories of this particular time and place have begun to recover and catalog the myriad artists, musicians, dancers, poets, theatre makers, coffeehouses, and performance venues that were blended together in this cultural milieu, defining and acknowledging differences has revealed that philosophical, aesthetic, and political gulfs divided even artists working in the same media a block away from one another. For example, while they may have been part of the same off-off-Broadway theatre scene, Sam Shepard was not Charles Ludlam was not Adrienne Kennedy. Likewise it is important to clarify how, for any of these playwrights, there were significant material differences between an Off-Broadway and an off-off-Broadway production of their work, and that quite different stereotypes and reputations accompanied either type of production. This process of differentiation is vital for an accurate history of people, ideas, and institutions. At the same time, "the join between things which are distinct and yet continuous" can sometimes get lost in this differentiation.[1] One way to preserve this join is to focus on the idea of "shared space" as it affected one small selection of seemingly very different theatre makers who were a part of the 1960s downtown New York scene (Edward Albee and the "Open Theater playwrights" Jean-Claude van Itallie and Megan Terry),

specifically as it affected their commitment to collaboration and their methods of composition.

In the United States, there was perhaps never as high a concentration of artists engaged in some type of collective creation as there was off-off-Broadway and Off-Broadway in the mid- to late 1960s. The majority of theatre companies most commonly associated with collective creation in the 1960s was active at this place and time: The Living Theatre, The Open Theater, The Performance Group, and the Bread and Puppet Theatre. Excepting The Performance Group, which made its home almost exclusively at the Performing Garage (33 Wooster Street), these companies were largely nomadic, moving from theatre space to theatre space. Their identities were not tied to a single venue. Justifiably, then, theatre histories that have dealt with this scene have typically focused on companies and not venues.[2] However, two recent books, David Crespy's *Off-Off-Broadway Explosion: How Provocative Playwrights of the 1960s Ignited a New American Theater* (2003) and Stephen J. Bottoms's *Playing Underground: A Critical History of the 1960s Off-Off-Broadway Movement* (2004), have turned their attention to the performance spaces that defined downtown New York in the 1960s and to the individuals who ran them: Joe Cino and Caffe Cino, Ellen Stewart and Café La Mama, Ralph Cook and Theatre Genesis, and Al Carmines and the Judson Poets' Theatre. In doing so, these histories have exposed the fertile soil out of which many 1960s US theatre collectives and individual theatre makers emerged, revealing useful continuities across seemingly separate aesthetic philosophies, political commitments, and media.

Crespy and Bottoms make it possible to see the close physical proximity these diverse artists had to one another within the Downtown arts scene, as well as the amount of time these artists spent together in hangouts, social spaces, and performance venues: the way, in other words, these artists shared space. Yet, while is it is important to note that on a single night in 1967 at Café La Mama the audience may have contained Albee, Richard Schechner, Joe Chaikin, Jean-Claude van Itallie, Robert Wilson, Jasper Johns, Leonard Bernstein, Meredith Monk, and Elizabeth Swados, it is as important to note the ways these audience members may have understood their roles as artists "sharing space" with other artists.

Taking Albee, Schechner, and van Itallie, for instance, despite their common interest in challenging the conventions of commercial theatre at the time, these three theatre makers may seem quite separate in their goals, interests, and attitudes. In the early 1960s, Schechner, as editor of *Tulane Drama Review*, steered his critics away from covering some of the future Open Theater playwrights' one-acts at Caffe Cino because they were not "professional" enough. *TDR*, in general, showed little interest in off-off-Broadway theatre in the early 1960s. Moreover Schechner argued that the only value of Albee's *Who's Afraid of Virginia Woolf?* was its ability "to titillate an impotent and homosexual theatre and audience," as expressed in a 1963 *TDR* editorial.[3] As Bottoms notes, Schechner and other leading theatre critics may have wanted to hold at a "manly arm's length" both the underground theatre of off-off-Broadway as well as Albee's Broadway successes because of the "queer spirit" these performances exhibited.[4] Despite these differences, there seems to be some significant common ground among these theatre makers (more definitive

than the general notion that all three were working on nontraditional theatre). By the mid-1960s, it is clear (in hindsight if not to the artists at the time) that Off-Broadway theatre gurus such as Schechner, off-off-Broadway playwrights such as Jean-Claude van Itallie (who was developing *The Serpent* at The Open Theater), and off-off-Broadway-playwright-turned-Broadway-playwright (and Off-Broadway producer) Edward Albee were all more alike than different in at least one aspect: their obsession with space and how space is shared.

All about Space

Once you look for it, the idea of "space," and how to share it, is everywhere in the mid- to late 1960s downtown New York arts scene. The first chapter of Schechner's book *Environmental Theater*, which attempts to systematize and explain The Performance Group's explorations in theatre since its founding in 1967, is titled appropriately "Space." As the chapter emphasizes, the idea of "space" underlies all The Performance Group's methods and interests. As Schechner writes, "The basic work of TPG is with space: finding it, relating to it, negotiating with it, articulating it."[5] Moreover Schechner defines environmental theatre design and environmental theatre performer training as concerned with only one topic: "the fullness of space, the endless ways space can be transformed, articulated, animated."[6] Indeed, the innovations of The Performance Group's productions at the Performing Garage revolved around how performers share the space with an audience, whether it meant using the entire space for performance and audience interaction as in *Dionysus in '69* (the audience perched high on platforms, sometimes over in a corner, sometimes dancing "in ecstasy" with the performers in the center of the Garage) or using the close proximity of performers to the audience members seated around the small, raised performance platform as in *Makbeth*. At the Performing Garage, the performance space was transformed with each production, because The Performance Group strove "to make the environment a function of the actions discovered by the performers."[7]

By the time Schechner published his theses on environmental theatre in this 1973 book, Michel de Certeau in France had likewise begun his own philosophical investigations of space that culminated in *The Practice of Everyday Life* (not translated into English until 1984). De Certeau's well-known definition "space is practiced place" is useful to understanding the idea of "space" that was circulating in New York's downtown arts scene in the mid- to late 1960s.[8] In the same way that the Performing Garage might be considered just a "place" until live bodies moving in it give the place a set of meanings, so, to de Certeau, "the street geometrically defined by urban planning is transformed into a space by walkers."[9] Place is made "space" by the social interaction of live bodies.

Schechner's theory of environmental theatre was of course not the only theory of space influential to theatre makers in the late 1960s. Peter Brook, whose 1965 Broadway production of Peter Weiss's *Marat/Sade* (exported from London) mirrored Albee's success on Broadway with *Who's Afraid of Virginia Woolf?* a few years earlier—"Downtown" aesthetics reaching mainstream audiences—published

another performance theory book concerned primarily with the transformation of any place into a space of performance: 1968's *The Empty Space*. This book begins with the famous proposal, "I can take any empty space and call it a bare stage. A man walks across this empty space whilst someone else is watching him, and this is all that is needed for an act of theatre to be engaged."[10] This concept was one that Joe Cino and Ellen Stewart believed themselves and had taught to numerous others years earlier in their off-off-Broadway performance venues. Since the early 1960s, Cino's tiny stage nestled within his fairy-lit cafe and Stewart's first incarnation of Café La Mama, simply a space she had designated in her dank basement on East Ninth Street, had exemplified Brook and de Certeau's assertions: any place can be a theatre space as long as the creators and the audience imagine and use it as such. The shared presence of those performing and those receiving make it so.

However, more influential to Downtown theatre makers in the late 1960s than perhaps either Schechner's or Brooks's books was Viola Spolin's *Improvisation for the Theater*. First published in 1963, Spolin's book, along with her work with Joe Chaikin in particular, was the methodological grounding for The Open Theater's first forays into improvisation and collective creation. And for Spolin, performer training and creating theatre nonhierarchically begins with understanding how space is shared. As she notes in the preface to her updated version of *Improvisation for the Theater*, one of the key ideas to her work is "[t]he need for players to get out of the head and into the space, free of the restricted response of established behavior, which inhibits spontaneity, and to focus on the actual field—SPACE— upon which the playing (energy exchange) takes place between players."[11] Those who have participated or run workshops in Spolin training will recognize further that her program of exercises begins with "orientation"—performers learning not to "act" but rather to become aware of "self, space, and environment."[12] "Direct contact with the environment" is what the performer is seeking, Spolin claims, and only when the space is shared equally, with "no outside authority imposing itself upon the players, telling them what to do, when to do it, and how to do it," can such direct contact occur.[13]

Any place can be a theatrical space according to these performance theorists. However, Schechner, Brook, and Spolin are also particular in their assertion that space needs to be encountered on equal terms and shared on equal terms. This idea of "shared space" is not merely indicative of the relationship between audiences and performers in the theatre in general, but specifically reflective of collective creation as a set of practices and a philosophy for making theatre. And it is of course not surprising that *Marat/Sade* as well as the productions at the Performing Garage and the productions of The Open Theater were all products of collective creation (albeit different types of collective creation). This notion of shared space (in Brook, Spolin, and Schechner) went hand in hand with practices of collective creation. It is a notion that helps to establish continuity across the diversity of off-off-Broadway and Off-Broadway theatre makers of this time. Indeed, while it is beyond the scope of this chapter, the notion of shared space (and the practices of collective creation that accompany it) also could be traced across other types of artistic creation occurring at this particular time and place (among the

"superstars" at Andy Warhol's Factory or in the dance studios of Merce Cunning-ham and Judson Memorial Church).

Quotation as Collaboration

The shared theatre spaces that connected Edward Albee and The Open Theater playwrights were not merely Café La Mama and Caffe Cino, where Albee was an audience member along with Megan Terry and van Itallie (whose plays may also have been up on stage on any given night in the mid- to late 1960s), but more importantly the Cherry Lane Theatre, the Off-Broadway venue that served as home for the Playwrights Unit. Prior to the Playwrights Unit taking up residency there in 1963, the Cherry Lane had a long history as an alternative theatre space (and specifically a long history involving collective creation). Built by the Cherry Lane Players, who—along with the Provincetown Players and the Washington Square Players—were part of the first wave of alternative theatre in New York City, the Cherry Lane had also served as the first public performance venue for The Living Theatre in the early 1950s. At the Cherry Lane in the 1960s, the Playwrights Unit, founded by producers Richard Barr and Clinton Wilder and Albee (all of whom had been working together since the US premiere of Albee's *The Zoo Story* in 1960), gave off-off-Broadway playwrights the opportunity to mount their plays Off-Broadway, with the understanding that a Broadway production could ulti-mately follow.[14] While production expenditures were limited, prominent actors such as Margaret Hamilton, Frank Langella, Nancy Marchand, and Elaine Stritch volunteered their time to perform in the Unit's short runs. Serving as an inspira-tion to the Unit, Albee himself had made the seemingly impossible journey from off-off-Broadway to Broadway with the 1962 critical and commercial hit *Who's Afraid of Virginia Woolf?* at the Billy Rose Theatre. With the Playwrights Unit, Barr and Wilder were looking for the next Albee. Surprisingly perhaps, Albee was, too. (He ran the Unit largely with his own money until it received a grant from the Rockefeller Foundation in 1966.) The Unit hoped to provide a production "lad-der," so that downtown playwrights could climb to commercial success uptown.

Theatre historians have debated the extent to which the Unit was successful in its goal before it disbanded in 1971.[15] However, it is undeniable that during the 1960s the Playwrights Unit offered a space for the exchange of ideas between off-off-Broadway playwrights and Broadway producers, actors, and playwrights in the same way that ideas were being exchanged among Albee and off-off-Broadway playwrights at, for example, Caffe Cino and Café La Mama. One result of this exchange was Albee's increased commitment to experimentation in his own work, resulting in the 1968 production of *Box/Quotations from Chairman Mao Tse-Tung*, perhaps the most challenging and antinarrative play to reach Broad-way in the 1960s. What *Box/Mao* shared with many off-off-Broadway plays in 1968—including Jean Claude van Itallie's *The Serpent*, created with The Open Theater—was the methodology with which these plays had been primarily created: quotation. De Certeau, again, helps to clarify how the methodology of creating a play through quotation relates to the prevalent idea of "shared space"

in the 1960s downtown arts scene. As de Certeau notes in *The Practice of Everyday Life*, in the same way that the "place" of a street is transformed into a "space" by those walking in it, "an act of reading is the space produced by the practice of a particular place: a written text, i.e., a place constituted by a system of signs."[16] The place of the page is transformed into a shared space through the act of reading, and playwrights composing scripts through quoting texts share the space of their pages with the voices of others in a way that is related to performers sharing a space with one another while devising work through collective creation. It is not coincidental that Terry, van Itallie, and Albee were all experimenting with the shared space of quotation in their plays, while at the same time they were all sharing spaces in performance venues throughout downtown New York.

Where Albee and The Open Theater Meet

Only two years before Albee embraced quotation in writing *Box/Mao*, the divide between the plays of Albee and those of The Open Theater seemed vast. Critical consensus on Albee's *A Delicate Balance*, which ran at the Martin Beck Theatre in 1966 for 132 performances, was that the play was safe and "empty"—in other words, representative of what was wrong with Broadway according to both off-off-Broadway-centric critics (such as *The Village Voice*'s Michael Smith) as well as those exclusively covering Broadway and Off-Broadway (such as *The New York Times*'s Walter Kerr). While strictly realist—standard for Broadway drama in 1966—the play was not "real" enough for Kerr. "The notion of a real universe" cannot be found in *A Delicate Balance*, wrote Kerr in his review, "despite its conventional suburban setting."[17] Kerr felt that the audience never finds out "what is wrong" with the characters. Smith, on the other hand, felt Albee, like his characters, had taken no chances. By the end, Smith wrote, "balance has been restored [to the characters] not by a heroic leap, but by removal . . . this play is a cop-out."[18] Despite its largely negative critical reception, the run was well attended, and *A Delicate Balance* was awarded the Pulitzer Prize—some said to make up for the Pulitzer Albee should have won in 1962 for *Who's Afraid of Virginia Woolf?*[19]

If the crowned mediocrity of *A Delicate Balance*'s "safe" dysfunctional family drama embodied Broadway drama in 1966, then the loud, youthful *Viet Rock*, written by Megan Terry and created along with The Open Theater, captured the spirit of off-off-Broadway. Presented first at Café La Mama and later Off-Broadway at the Martinique, *Viet Rock*—a musical collage depicting the Vietnam War's effect on families, the media, and government—divided critics in predictable ways. Kerr felt "barked at, leered at, stomped at and—in effect sneered at" with a message that was "simple sloganeering, hawk-talking in reverse."[20] Meanwhile *The Village Voice*'s Smith extolled Terry's audience-interactive play as "a breakthrough . . . a rare instance of theater confronting issues broader than individual psychology."[21]

However, the aesthetic/geographical division between Broadway's "safe" psychological realism and off-off-Broadway's issues-based political performance, invoked by Kerr and Smith, masks the downtown pedigree of a "Broadway playwright" such as Albee and the spaces he shared with Terry, as well as the fact that

Terry's work had roots in the Playwrights Unit. In 1963, Barr, Wilder, and Albee's production company (which later became the Playwrights Unit) presented Terry's *Ex-Miss Copper Queen on a Set of Pills* before Terry found a home with The Open Theater. In a 1968 *New York Times* article profiling the Unit, Terry emphasized that she stopped working with the Unit in the mid-1960s only because being a member of The Open Theater allowed her to work on more than simply her own plays.[22]

Not only do *A Delicate Balance* and *Viet Rock* have in common their playwrights' time in the Unit, but, despite the differences in style and genre, both can also be read as primarily concerned with the toll that losing sons to the Vietnam War took on American families. Whether they liked it or not, critics agreed that the emotional crux of Terry's play was the moment when the mother of a dead soldier asks if she will be able to recognize the body of her son whom she has come to see one last time. Likewise what has thrown the middle-class couple Tobias and Agnes off-kilter in *A Delicate Balance* is the death of their son, and the play depicts the need for (if not the presence of) healing. While Tobias and Agnes's son did not die in a war, it is surprising that no critic, past or present, has noted the possibility that the "nothing" that terrifies the couple's haunted guests as well as the couple's own family in 1966 is the specter of the Vietnam War.[23] This war was the often-unvoiced daily threat that loomed over American families in the late 1960s, including the family in *A Delicate Balance*, and it is this same specter that *Viet Rock* attempted to exorcise.

While *A Delicate Balance* and *Viet Rock* are, then, perhaps not as far apart historically and thematically as theatre critics considered them, Schechner in his introduction to the 1966 collection of Terry's plays notes an actual significant difference between Terry and Albee at that time: their methodologies. (It is interesting that Schechner's aforementioned suspicion of off-off-Broadway work as editor of *TDR* did not extend, at least by 1966, to Terry's plays, most of which were originally presented at Café La Mama.) Schechner compares Terry's work on *Viet Rock* to Shakespeare's: "[H]e assembled, reworked, manipulated, phrased, arranged."[24] According to Schechner, like Shakespeare, Terry is a "collagist." This is not an inaccurate way to describe how Terry built her play based on improvisations involving The Open Theater company and constructed her script from texts that the company, along with Terry, found or invented. On the other hand, in 1966 Albee was still writing plays alone in his room, so to speak.

By 1968, however, the similarities between the work being done off-off-Broadway by The Open Theater (Jean Claude van Itallie's *The Serpent*) and Albee's work on Broadway (*Box/Quotations from Chairman Mao Tse-Tung*) were more readily apparent in the shared space of these plays' pages.[25] Both plays were considered extremely "experimental," whether or not they were praised for this experimentation.[26] At the root of this experimentation, and the most important similarity between *The Serpent* and *Box/Mao*, is the methodology behind their construction: quotation.

Like Terry, van Itallie's work had roots in the Playwrights Unit; it is a space he had shared with Albee. Van Itallie's first major success was *War*, presented by the Unit in 1963. Unlike Terry, however, van Itallie ultimately did not feel the Unit appreciated his work enough. Characterizing the Unit's approach to assisting off-off-Broadway playwrights, van Itallie noted, "It was kind of patronizing . . . 'These

are baby plays by baby playwrights, and we're going to offer a kind of nursery school."[27] Oddly though, disillusionment with the Unit is actually a connection between van Itallie and Albee in 1968 as opposed to a difference between the playwrights. Concerned that playwrights were not getting a fair read by the Unit's then-manager Chuck Gnys, Albee submitted *Box* to the Unit under the assumed name Rayne Enders. It was rejected, and Albee tracked down the comment card for the play, which read, "Totally without point or interest; hopeless."[28] He expressed his disappointment and warned he might continue to submit under assumed names. By 1968, van Itallie felt his work was better understood elsewhere than the Playwrights Unit, and Albee likewise had doubts about the Unit's ability to understand his new directions. The shared space of the Unit was one about which they both had doubts.

Besides having been composed largely of quotations, *The Serpent* and *Box/Mao* also share a thematic connection. Both generally present the dangers of a declining Western civilization through the metaphor of "the fall from grace." *The Serpent* combines stories from Genesis with depictions of the assassinations of Martin Luther King Jr. and John F. Kennedy Jr. and choral statements based on the performers' own lives. In this "ceremony," the actors act as "priests"—more-knowledgeable guides to the "congregation" of audience members. As van Itallie noted in his preface to the play, "Words are a part of this ceremony, but not necessarily the dominant part."[29] Action and sound took precedence over words in this meditation on original sin and alienation. In many ways, *The Serpent* is about 1960s America's inability to take responsibility for the violence it witnessed daily through the media. A telling passage is the denial chanted together in the play by JFK's assassin and the chorus of onlookers: "I was not involved. / I am a small person. / I hold no opinions. / I stay alive."[30] The fall from Eden, for The Open Theater, symbolizes the separation of each person from another, from nature, and from his or her own actions. In the play, God casts out Adam and Eve with the curse, "Now shall come a separation . . . whatever you see or hear, You shall think it and see it and hear it, alone."[31]

Separation and alienation in contemporary culture is also the thematic center of *Box/Mao*. In *Box*, a woman's voice describes the devolution of art into craft and the inability of art to comfort in the face of large-scale atrocities; there is a reference to "spilling milk" while "seven hundred million babies" die of starvation.[32] Art, says the voice, can only "hurt" by reminding us of our humanity when forgetting and ignoring is more comforting. Onstage, the glowing frame of an enormous box is the only set element to accompany the piped-in voice, suggesting a coffin or the television through which audiences received daily images of worldwide violence. The *Box* monologue is then repeated, interspersed throughout the second play, *The Quotations of Chairman Mao Tse-Tung*. *Mao* features an actor imitating Mao Tse-Tung as he describes the inevitable downfall of Western imperialism, while a well-to-do woman on an ocean liner recounts to a silent minister her husband's death and her own near-death experience falling from the deck of another ocean liner years ago. Counterpoint to these already contrapuntal speakers is an "Old Woman" who recites portions of Will Carleton's poem "Over the Hill

to the Poorhouse," describing (in *King Lear* fashion) the downfall of a mother after her husband's death as she is passed from household to household by her uncaring children and eventually left to the mercy of the state. The three speakers never address one another. Mao and the Old Woman speak directly to the audience, and the death-obsessed "Long-Winded Lady" speaks to her minister, seated next to her on a deck chair. "Falling" and "dying" are ideas that link these three separate speakers, whether it is the fall and death of nations or individuals. Like *The Serpent*, *Box/Mao* combines contemporary political situations with questions about perceived universals in an extended reflection on alienation and death.

The scripts of *The Serpent* and *Quotations from Chairman Mao Tse-Tung* are made up primarily of quotations, often from other written texts. Director Joe Chaikin saw his role in *The Serpent* as a filter for his company's ideas. In his preface to the play, Chaikin writes that only late in the creative process does the director become important: "He must find ways to select the most cogent from among possible images."[33] Likewise, van Itallie's work as playwright came late in The Open Theater's *Serpent* workshops. Out of the improvisations, van Itallie provided text for those images that the company felt best conveyed their message. The words and the images in *The Serpent* are sometimes direct quotation, sometimes modified quotation, and sometimes invention. In terms of quoted images, for example, the company as accurately as possible tried to recreate the sequence of photos depicting Kennedy's shooting, which had appeared in newspapers internationally. This sequence is "played" backward and forward for the audience at various speeds. Sections of the book of Genesis are quoted onstage as well, such as the long list of "begats" that accompanies the group's simulated mass copulation. Other direct quotations include the pop song the company sings at the end of the show ("Moonlight Bay" at one point in the run) and van Itallie's quotation of the actors' own words about their personal lives, which he had transcribed during workshops ("My home was Cleveland. / Then I came to New York / And I didn't have to account to anybody.").[34]

Though working alone, Albee constructed *Mao* similarly: as a collage of direct quotations and his own texts. The script is two-thirds quotations from the published book *Quotations of Chairman Mao Tse-Tung* and Carleton's poem. Albee clipped out the quotations he wanted from these texts, cut up the monologue he had written for the Long-Winded Lady and the *Box* monologue, and "arranged the approximately one hundred and fifty cards on which he had written bits of dialogue into what he 'ultimately thought was a proper order.'"[35]

In 1968 quotation gave *The Serpent* and *Box/Mao* a sense of immediacy. Sections of *The Serpent* were a kind of 1960s reincarnation of the "Living Newspapers." Describing *The Serpent* and *Box/Mao*, critics highlighted the sense that audiences were being presented with current events, unfiltered. Likewise van Itallie felt direct quotation could allow The Open Theater to express their vision "as contemporaneously as possible."[36] The immediacy of King's April 1968 assassination was particularly fresh in audiences' minds and all the more shocking when presented onstage. Similarly audiences were shocked by the immediacy of *Box/Mao*. One critic noted his fears at "the thought that [Mao's] thoughts are being daily inculcated in millions of people."[37]

At the same time, Albee's use of quotation is in some ways more radical than van Itallie's in the way it disrupts Albee's typical creative process. For van Itallie, the quotations on the pages of *The Serpent* reveal the process of collective creation that occurred at The Open Theater during the development of the piece. For Albee, the quotations on the pages of *Box/Mao* reveal the individual playwright attempting to mimic a process of collective creation even though he is working alone. They reveal Albee's commitment to opening up his text to the texts of others—in other words, to creating community in a way that quotations can sometimes do. Albee creates a collaborative relationship between the words of other writers and his own words. The result is a challenging of authority—not of the writers Albee quotes, but rather of the authority of the playwright himself. It creates a shared space for writers on the page, similar to the shared spaces that existed in real life at the time in venues such as Café La Mama and Caffe Cino.

In addition, the use of collage in *The Serpent* and *Box/Mao* meant audiences had to play a more active role in making the meaning of these plays, filling in the gaps between the quotations. As Michael Rutenberg notes of *Box/Mao* in 1968, "[T]he spectator has taken on a new role as creator by collaborating with the playwright on the play's final design."[38] In this way *Box/Mao* most closely resembles *The Serpent*, in which "the audience is drawn to participate with the actors in a kind of eucharist," according to van Itallie.[39] The meaning of *The Serpent* was shared by "actor-priests" and the congregation all taking communion together in the performance space. The meaning arises not out of "the actor nor the audience, but by the silence between them."[40] Even Kerr, who hated *Box/Mao* in previews and barely tolerated it in his second viewing on Broadway, "gets" this new demand for participation in Albee's play, so similar to that being made on audiences in *The Serpent*. Audiences, he said, spend all their time in *Box/Mao* struggling to put together the play's meaning. Wrote Kerr, their experiences are like that of the Long-Winded Lady in Albee's play who says falling from a cruise ship is the same as "falling into a pile of autumn leaves."[41] The meaning is found in trying to work your way out.

In a strange way, Albee's design of the theatre space in *Box* also forces his audience to share in the meaning-making of the performance in a way that parallels the audience interaction in *The Serpent*. In *The Serpent*, the audience as "congregation" has direct contact with the cast members at certain moments in the ceremony. For example, the cast members share apples with the audience in the Adam and Eve sequence. This sharing of food erases the line, temporarily, between performer and audience but also implicates the audience in the "original sin," which is the evening's central meditation. It does not allow the audience member to hang back and say, "I was not involved," as the staged crowd does in the assassination scene. Similarly, *Box* presents and re-presents the empty space of the stage with the set element of the huge glowing box. As the audience members stare at this empty space while the monologue about art is piped in, they become aware of the empty space of the theatre itself. Albee seems to challenge the audience: if this space is to be filled, you will have to do it yourselves; don't simply rely on the performers.

Oddly enough, while *Box/Mao* may have called for collaboration with its audiences, it is shared space that Albee did not ultimately embrace in the same way in subsequent plays. Composing through quotation alters the function of the

playwright. As van Itallie noted in the preface of *The Serpent*, his job became that of an arranger of elements as opposed to an inventor. This diminished authority of the playwright is something Albee seems to have resisted. His script for *Box/Mao* may no longer have been exclusively "his words," but nonetheless Albee makes it clear in his note in the published *Box/Mao* that his authorial intention still determines the play's meaning: "For this play to work according to my intention, careful attention must be paid to what I have written about the characters."[42] About the punctuation and the rhythms he describes in the stage directions, Albee writes, "Please observe them carefully, for they were not thrown in, like herbs on a salad, to be mixed about."[43] Albee may have become a collagist with *Box/Mao*, but he let readers know that the work of assembly is best left to experts who apparently know best how to "mix things about."

If the collages of *Box/Mao* and *The Serpent* share significant similarities, it's also important to note the deeper similarities between the collages of *The Serpent* and *Viet Rock*. Like van Itallie, Terry had been practicing quotation as a method for play composition for some years. By 1968, Albee had merely caught up with this method of sharing space—perhaps because of his familiarity with the work being done by companies such as The Open Theater. For The Open Theater and other 1960s US theatre collectives, quotation became a methodology they would continue to embrace after 1968, as it allowed for a democratic writing process (in which no member of the collective is required to act as playwright), but also because it modeled, in the pages of the script and in performance, types of collectivity that were then shared with the communities attending these productions. For Albee, his experiment with sharing space through direct quotation was one he did not repeat to the same extent in subsequent plays. While quotation brought Albee closer to his off-off-Broadway counterparts in 1968, it was only a temporary connection.

Bibliography

Albee, Edward. *Box/Quotations from Chairman Mao Tse-Tung*. In *Selected Plays of Edward Albee*. New York: Nelson Doubleday, 1987.

Aronson, Arnold. *American Avant-Garde Theatre: A History*. New York: Routledge, 2000.

Barnes, Clive. "Theater: Albee's Adventurous Plays." *New York Times*, October 1, 1968, 39.

Bottoms, Stephen J. *Playing Underground: A Critical History of the 1960s Off-Off-Broadway Movement*. Ann Arbor: University of Michigan Press, 2004.

Brook, Peter. *The Empty Space*. New York: Atheneum, 1968.

Cooke, Richard P. "The Theater: Musical, Albee Style." *Wall Street Journal*, October 2, 1968, 18.

Crespy, David A. *Off-Off-Broadway Explosion: How Provocative Playwrights of the 1960s Ignited a New American Theater*. New York: Back Stage Books, 2003.

———. "A Paradigm for New Play Development: The Albee-Barr-Wilder Playwrights Unit." *Theatre History Studies* 26 (2006): 31–51.

de Certeau, Michel. *The Practice of Everyday Life*. Berkeley: University of California Press, 1984.

Harding, James M., and Cindy Rosenthal, eds. *Restaging the Sixties: Radical Theaters and Their Legacies*. Ann Arbor: University of Michigan Press, 2006.

Kerr, Walter. "Non-Sense and Nonsense." *New York Times*, October 13, 1968, D5.

———. "The Theater: Albee's 'A Delicate Balance' at the Martin Beck." *New York Times*, September 23, 1966, 44.

———. "The Theater: 'Viet Rock.'" *New York Times*, November 11, 1966, 38.

La Fontaine, Barbara. "Triple Threat On, Off and Off-Off-Broadway." *New York Times*, February 25, 1968, SM36.

Lowry, Glenn. "Broadway in Review." *Educational Theatre Journal* 20, no. 4 (December 1968): 594–99.

Novick, Julius. "About the One That Succeeds." *New York Times*, November 27, 1966, D1.

Nunce, Alan B. "Albee's 'Box Mao Box' in Premiere at Buffalo." *Christian Science Monitor*, March 11, 1968, 6.

Rutenberg, Michael. *Edward Albee: Playwright in Protest*. New York: Drama Book Specialists, 1969.

Sainer, Arthur. *The New Radical Theatre Notebook*. New York: Applause Books, 2000.

Schechner, Richard. *Environmental Theater*. New York: Hawthorn Books, 1973.

———. "Introduction: The Playwright as Wrighter." In *Four Plays by Megan Terry*. New York: Simon and Schuster, 1966.

———. "Who's Afraid of Edward Albee?" *Tulane Drama Review* 7, no. 3 (Spring 1963): 7–10.

Smith, Michael. "Review of 'A Delicate Balance.'" *The Village Voice*, September 29, 1966, 21.

Solomon, Rakesh H. *Albee in Performance*. Bloomington: Indiana University Press, 2010.

Spolin, Viola. *Improvisation for the Theater*. Evanston: Northwestern University Press, 1963.

Sullivan, Dan. "Albee Criticizes Pulitzer Board." *New York Times*, May 3, 1967, 48.

Terry, Megan. *Plays by Megan Terry*. New York: Broadway Play, 2000.

———. *Viet Rock*. In *Four Plays by Megan Terry*. New York: Simon and Schuster, 1966.

van Itallie, Jean Claude. *The Serpent*. New York: Atheneum, 1969.

Notes

1. This line, which is a paraphrase of Ludwig Wittgenstein's *Philosophical Investigations*, is spoken by the physicist/spy Kerner in Tom Stoppard's 1988 play *Hapgood*, while trying to explain unification theory.

2. See James M. Harding and Cindy Rosenthal, eds., *Restaging the Sixties: Radical Theaters and Their Legacies*; Arnold Aronson, *American Avant-Garde Theatre: A History*; and Arthur Sainer, *The New Radical Theatre Notebook* for examples.

3. Richard Schechner, "Who's Afraid of Edward Albee?" 9.

4. Stephen J. Bottoms, *Playing Underground*, 12.

5. Richard Schechner, *Environmental Theater*, 12.

6. Ibid., 1.

7. Ibid., 11.

8. Michel de Certeau, *The Practice of Everyday Life*, 117.

9. Ibid., 117.

10. Peter Brook, *The Empty Space*, 9.

11. Viola Spolin, *Improvisation for the Theater*, xv.

12. Ibid., 29.

13. Ibid., 6.

14. For a brief history of the Playwrights Unit, see David Crespy, "A Paradigm for New Play Development: The Albee-Barr-Wilder Playwrights Unit."

15. Crespy's *Off-Off-Broadway Explosion* argues that the Unit encouraged mainstream acceptance of the work of off-off-Broadway playwrights, while Bottoms's *Playing Underground* contends that the Unit was only a temporary home for off-off-Broadway playwrights who typically returned downtown after their time there.

16. de Certeau, 117.

17. Walter Kerr, "The Theater: Albee's 'A Delicate Balance' at the Martin Beck." This was Kerr's first review as the appointed drama critic of the *Times*, having served as a reviewer of *The New York Herald Tribune* for 15 years. It established his long string of negative reviews of Albee's work.

18. Michael Smith, "Review of 'A Delicate Balance.'"

19. Pulitzer judges John Gassner and John Mason had voted to award the prize to Albee, when the Pulitzer Advisory Committee blocked their nomination, citing the play's inappropriate language. Albee, still bruised from the earlier decision, was reticent to accept the award in 1966 for *A Delicate Balance* but finally decided that "while the Pulitzer Prize is an honor in decline, it is still an honor." See Dan Sullivan, "Albee Criticizes Pulitzer Board."

20. Walter Kerr, "The Theater: 'Viet Rock.'"

21. Megan Terry, *Plays by Megan Terry*. Smith's quotation is used as an endorsement in the book's front materials.

22. Barbara La Fontaine, "Triple Threat On, Off and Off-Off-Broadway."

23. Michael Rutenberg's chapter on *A Delicate Balance* in *Edward Albee: Playwright in Protest* summarizes critical interpretations of what exactly Harry and Edna, Tobias and Agnes's guests, were afraid of: from "death" to "the empty nest."

24. Richard Schechner, "Introduction: The Playwright as Wrighter."

25. *The Serpent* premiered at Colgate University in New York in 1968, toured Europe throughout 1969, and opened in New York City in 1970.

26. See Clive Barnes, "Theater: Albee's Adventurous Plays"; Richard P. Cooke, "The Theater: Musical, Albee Style"; Alan B. Nunce, "Albee's 'Box Mao Box' in Premiere at Buffalo."

27. Bottoms, 85.

28. Crespy, *Off-Off-Broadway Explosion*, 139.

29. Jean-Claude van Itallie, *The Serpent*, ix.

30. Ibid., 12.

31. Ibid., 41.

32. Edward Albee, *Box/Quotations from Chairman Mao Tse-Tung*, 262.

33. van Itallie, xvii.

34. Ibid., 53.

35. Rakesh H. Solomon, *Albee in Performance*, 109.

36. Julius Novick, "About the One That Succeeds."

37. Glenn Lowry, "Broadway in Review," 596.

38. Rutenberg, 219.

39. van Itallie, ix.

40. Ibid., xiv.

41. Walter Kerr, "Non-Sense and Nonsense," *The New York Times*, October 13, 1968.

42. Albee, 260.

43. Ibid., 260.

Against Efficiency

Théâtre du Soleil's Experimental Relations of Production

David Calder

Théâtre du Soleil has become synonymous in France with the phenomenon of collective creation. The company formed a few years before the student riots and workers' strikes of May '68 and began producing work collectively shortly thereafter. But we cannot identify May '68 as the context for Théâtre du Soleil's early work without examining the specific goals and actions of the workers' committees that were active during and after the Events of May. Any vague reliance on "context" ends by replacing concrete practices with nebulous zeitgeist. Instead, we must turn to the direct parallels between Théâtre du Soleil and the workers' committees and their respective "repertoires of contestation."[1]

During the late 1960s and 1970s in France, Théâtre du Soleil and numerous committees of factory workers embarked on experiments in relations of production, attempting to construct viable alternatives to the hierarchical organization and strict division of labor that plagued both heavy industry and the culture industry. I argue that Théâtre du Soleil's experiments in relations of theatrical production and the workers' committees' experiments in relations of industrial production are parallel movements. These parallel trajectories (in a geometrically impossible fashion) intersect during the Events of May, but each one has its own precursors. I cannot argue that Théâtre du Soleil based its collective creation practices exclusively on its interactions with workers during May '68—though we must not rule out the possibility that these interactions played a supporting role to the company's aesthetic influences. I do argue that the workers' committees and Théâtre du Soleil approached collective creation by attacking the prevailing division of labor in their respective spheres of activity, developing repertoires of contestation that departed from prevailing forms of protest and representation, and challenging the spatial and temporal relations of Taylorist efficiency through site-specific practices and traditional, popular forms.

Crossing Lines

Théâtre du Soleil developed out of *L'Association Théâtrale des Étudiants de Paris* [Paris Students' Theatrical Association; ATEP], a student group founded by Ariane Mnouchkine and Martine Franck in 1959 to reinvent the practice of French university theatre. Consciously opposing the prevailing practice of university- or even discipline-specific student theatre groups, ATEP sought universality in both its membership and its activities: the organization welcomed members from all Paris universities, including students of medicine, political science, law, and the faculties of arts and sciences. By 1961, ATEP included members from Sweden, Guatemala, Yugoslavia, Martinique, Egypt, Canada, and Australia.[2] ATEP also worked to transcend the boundaries between various aspects of theatrical production. ATEP's members organized free night classes in scenography, acting, and design with theatre professionals, including physical theatre classes with members of the Lecoq School and open conferences on contemporary theatre featuring such guest speakers as Jean-Paul Sartre.[3] Mnouchkine, then a student of psychology and psychoanalysis, directed her first play for ATEP, Henry Bachau's *Genghis Khan*, in 1961. Three years later, Mnouchkine, Franck, and eight of their ATEP colleagues founded Théâtre du Soleil as a *société coopérative ouvrière de production* [workers' cooperative production company]. Many young theatre companies of the period adopted the same legal status, an organizational structure recommended by both the actors' union and the Ministry of Culture.[4] But Théâtre du Soleil's ten cofounders vowed to continue in the collaborative spirit of ATEP by taking the *coopérative* label as an imperative and as a point of departure for their theatrical practice.

The next four years saw Mnouchkine direct productions of Gorki's *Les petits bourgeois* (November 1964), an adaptation of Gautier's *Le Capitaine Fracasse* (May 1966), and Arnold Wesker's *The Kitchen* (April 1967). Each of these productions did have a singular author and adapter/translator. But the company's rehearsal process for *The Kitchen* exemplified the artists' growing interest in collaborative working methods within the company and collaboration with working-class populations beyond the company membership. Wesker's script depicts the inner workings and hierarchical struggles of a restaurant kitchen. Before working with Wesker's text, Théâtre du Soleil adopted Jacques Lecoq's practice of the *enquête*:[5] "The students choose a site and a milieu of daily life that they're not familiar with, to observe it and integrate themselves into it in the course of four weeks. It's not an investigation in the journalistic sense of the term, which would content itself with simple observation and a few conversations, but a veritable integration into a milieu, so as to internalize what happens there. [. . .] Based on this lived experience, they construct a short performance, using the theatrical forms that seem best suited to transmit what they have felt."[6] To prepare for their roles as prep cooks, sous-chefs, and servers, the company members of Théâtre du Soleil embedded themselves in restaurant kitchens, not only to engage in conversation with restaurant workers, but also to perform some of the daily kitchen tasks themselves and embody the rhythm of the high-pressure work environment. The performers shared their experiences with fellow company members, improvised scenes

based on their *enquêtes*, and brought their embodied knowledge of the kitchen into subsequent stages of rehearsal. The production process for *The Kitchen* demonstrated the company's desire to produce popular theatre through engagement with working-class communities, to enrich their work through extensive research, and to break down pre-existing boundaries both between company members and between the company and other social groups. It was this play that Théâtre du Soleil would bring to workers in their occupied factories during May '68.

Théâtre du Soleil members were far from the only young people attempting to establish connections to working-class populations during May '68. The Events of May witnessed an attempted disruption of the very categories of student and worker and of the division between intellectual and manual labor. Kristin Ross argues, "What has come to be called 'the events of May' consisted mainly in students ceasing to function as students, workers as workers, and farmers as farmers: May was a crisis in functionalism."[7] Accounts of the period from both students and workers support Ross's claim. Daniel Cohn-Bendit remarks, "In the present system, they say: there are those who work and those who study. And we are stuck with a social division of labor [. . .] To start with we must reject the distinction between student and worker."[8] A May 11 pamphlet from the *Confederation Française Démocratique du Travail* [Democratic French Confederation of Labor; CFDT] echoes this sentiment: "We workers must not let ourselves be drawn into unjustified reactions [to the riots and burning of cars] that would cut us off from our age-old allies, the students."[9] The separation of intellectual and manual labor allowed the French government to contain protests and strikes and limit their ability to destabilize the republic. An administration could simultaneously offer limited concessions to striking workers or students and further marginalize them by labeling the strike an isolated incident. Liberal capitalism could then continue business as usual, having used this small rupture to forestall its collapse. By collapsing the wall between students and workers, the Events of May hoped to avoid such quick absorption by the capitalist system.

At the height of the protests, ATEP mentor Jean Dasté invited Théâtre du Soleil to perform *The Kitchen* in Saint-Etienne. Despite the production's previous successes—during its 1967 run it garnered numerous prizes and reached more than 60,000 spectators[10]—the Saint-Etienne performances were sparsely attended, likely because the working-class audiences to whom the play appealed were busy occupying their factories and manning picket lines. Faced with empty houses, Dasté brought Mnouchkine and a few other company members along with him to Villeurbanne, where, from May 21 to June 11, directors of France's public theatres gathered at Roger Planchon's Théâtre de la Cité to formulate a collective response to the Events of May and to reassess the role of cultural institutions in contemporary French society. There philosopher Francis Jeanson distinguished between the public—containing all those who had access to current cultural institutions—and what he called the nonpublic—"a human mass composed of all those who as of yet have neither access nor the potential to access the cultural phenomenon in its current and persistent form."[11] Théâtre du Soleil member Georges Bonnaud later recalled (not without some self-deprecation): "In Villeurbanne, Francis Jeanson's term, the 'non-public,' became the buzzword, the 'Open, Sesame' . . . We were

determined to find the non-public, to give them the desire and the opportunity to share our past and future culture! Jean [Dasté], on the way back, was skeptical of our level of enthusiasm. Now by virtue of the general strike, we were to find this non-public occupying their place of work, and such a cultural brigade were we that we were ready to gain access to these spaces, and we did."[12]

In their initial attempt to find Jeanson's "non-public," the company performed *The Kitchen* in the Loire Steelworks at Saint-Étienne, Grenoble's Neyrpic factory, Firminy's Merlin Guérin factory, and in the Paris region at the Citroën factories, the National Society for the Research and Construction of Aviation Engines (SNECMA), Renault-Billancourt, and Sud-Aviation.[13] In an article for *Le Monde*, Nicole Zand describes the atmosphere of one performance at SNECMA: "On rows of benches, chairs, perched on crates, ladders, forklifts, lathes, an attentive public composed almost exclusively of men, who were seeing theatre for the first time; those on the picket line, standing behind, took turns seeing a bit of 'the theatre.'"[14] After each performance, company members held discussions with the striking workers and helped turn the site of commodity production into a site of dialogue. The process did not always go smoothly. Georges Bonnaud describes a conflict with union representatives at Renault-Billancourt: "From the walkways suspended above the shop floor, the union representatives harangue our audience, who can do nothing but turn their backs on us. At this precise moment, we become nothing but smiling entertainers who profess their solidarity. Hadn't Georges Séguy [secretary general of the *Confederation Générale du Travail* (General Confederation of Labor, CGT)] proclaimed on 17 May, 'Fraternity, yes, but everyone where he belongs [*chez soi*],' sending back to their Latin Quarter all the students who had come to the gates of the Renault factory!"[15] CGT leadership welcomed the solidarity of students and artists so long as they remained within their delineated spaces in the Latin Quarter. Especially telling is the union representatives' position, in Bonnaud's recollection, on the elevated walkways usually used by Renault management for surveillance of the workers. Whereas nonunion strike committees welcomed Théâtre du Soleil and other outsiders into their occupied factories, union leadership appeared strangely attached to the spatial divisions that sustained the division of labor.

Rethinking Relations of Production

Renault-Billancourt had long stood as synecdoche for the working classes and factories of France by virtue of its size (thirty thousand workers), its proximity to Paris, and Louis Renault's early deployment of Taylorism and extreme surveillance methods. The massive factory, occupying an entire island in the Seine, was a laboratory for the importation and implementation of Taylor's scientific management in France. As had already occurred in the United States, factory labor became ever more monotonous, repetitive, and mind-numbing as fabrication processes were broken down into hundreds of simpler gestures. No doubt because of Renault-Billancourt's early adoption of Taylorism, the factory had also been a union stronghold: in 1945 half of its thirty thousand workers claimed membership in

the CGT, France's largest union.[16] In the 1960s, Renault-Billancourt continued to stand in for the entirety of the working class—a popular slogan became "*Il ne faut pas désespérer Billancourt*" ["Billancourt you must not despair"]—but it came to represent disenchantment with unions more than cooperation with them. During May 1968 Renault-Billancourt workers refused to accept the strike proposals of the CGT, a gross disappointment to CGT leaders that became a symbol for working-class tenacity.[17] In the wake of '68, as management regained control over the factory and resumed its usual relationship with union representatives, Renault-Billancourt workers abandoned the union in droves. Between 1968 and 1974, the number of unionized workers at Renault-Billancourt dropped from five thousand to three thousand,[18] even as strikes of unskilled and semiskilled workers continued.[19]

May '68 must be understood in part as workers' expression of their growing frustration not only with employers but also with unions as the prevailing mode of workers' representation—and with relations of production that necessitated workers' "representation" at all. At Citroën Nanterre, another factory visited by Théâtre du Soleil during their tour of *The Kitchen*, workers doubted unions' ability (and even their desire) to radically contest the prevailing relations of production. One worker, a CGT union member for twenty years, assembled the following history of union delay:

> In '36, we weren't ready yet. In '45, we weren't ready because there were Americans in the mix. In '58, we still weren't ready because, let's be honest, the OAS,[20] we had no idea where that was going. In '68, we're still not ready because the army, because this, that, and the other thing. The union is starting to get a little old. It's in on it, implicated in the whole mess. That, or the union's just caught in the system and can no longer free itself from it. [. . .] Here we are waiting, like reinforcements, but it's been twenty, thirty years. We form processions, we march through the streets, hands empty, mouths full of slogans. [. . .] They make us cry victory, it relaxes the guys, everyone goes home, breathes, then you see it's a crock. [. . .] On high, at CGT headquarters, they continue to chew on the same words or the same slogans, our treatment, our pensions, our retirement.[21]

This worker rejects union and management reforms in favor of revolution. He seeks not better treatment at the hands of his bosses but rather a total reassessment of the distinction between employer and employee, thereby rendering the union, the organization that lobbies the management on behalf of the workers, obsolete.

During May '68, qualitative demands for a "humanization of work" coexisted alongside more traditional quantitative demands for reduced working hours and higher wages.[22] These qualitative demands were not necessarily revolutionary or fundamentally anticapitalist—though many were—but they rejected the tight regulation, close surveillance, and mechanical repetitiveness of Taylorist factory production. They also challenged the relevance of the trade unions that had traditionally advocated for workers within the Taylorist regime. Qualitative demands "could not be dealt with at the national level. Thus, the emergence of qualitative demands was also accompanied by the decentralization of conflict as previously

marginalized voices—young, female, or immigrant unskilled workers—made themselves heard."[23] Qualitative demands for improved quality of life and work, irreducible to number of working hours or rate of pay, required site-specific forms of contestation and advocacy that national union headquarters could not provide. They also required perpetual improvement, experimentation, and negotiation of working methods and environments. "Such projects aim to make revolt durable and perpetual and to transform the factory into a site of uninterrupted contestation: the strike is only the beginning. Thus, in the eyes of their promoters, non-union structures join two traits: radical initial proposals and permanent contestation."[24] Qualitative demands achieved limited success in the aftermath of May '68. Following the Events of May, trade union workplace branches were given legal recognition.[25] Union representation and negotiation thus legally entered the production process, making possible the kind of site-specific activism unattainable by national union structures. But French lawmakers and business owners bargained with union leaders instead of with the worker-driven action committees so powerful during the '68 strikes. The French government opted for new concessions to familiar organizations rather than for a total reevaluation of the relations of production. The hierarchical opposition between management and worker was ultimately preserved, to the benefit of both corporate and union structures.

Though union representatives made Théâtre du Soleil feel unwelcome at Renault-Billancourt, the theatre company continued to tour occupied factories and was welcomed by nonunion strike committees at the eight Citroën factories, at Sud-Aviation Courbevoie, and at SNECMA Villaroche and Boulevard Kellermann.[26] The factory worker spectators of *The Kitchen* demonstrated an interest in Théâtre du Soleil's relations of theatrical production that mirrored the workers' concern for alternative, experimental relations of industrial production. Mnouchkine notes the differences between postshow discussions in the factories and those held with young people following earlier performances:

> The discussion was curious. In contrast to the talks with young people, during which we talked very little of the show and mostly of politics, and during which we had to justify every decision, [the workers] spoke of practical problems, of labor. Of our problems [as a theatre company], our financial difficulties, how the troupe operated, how much time we spent preparing, the cost, how we managed it. Little verbiage on the content of the play, they figured there was nothing to talk about, it was clear for them. [It was] the only time when we didn't hear, "it was great, it was great," but, "what kind of work did you have to do to make this?"[27]

Factory workers were less interested in the play's content, the everyday oppression inherent in the hierarchically organized workplace, and more interested in Théâtre du Soleil's own attempts to operate as a collective. Bonnaud remembers the response of a worker at Neyrpic in Grenoble: "[He] tells us how pleased he is, but also expresses his wish that we return with real theatre, because this, this he knows all too well, it's what he goes through every day. For him, theatre should be something else, something more!"[28] What *The Kitchen* omitted was workers' success. The play concludes with the restaurant manager shouting at his employees, "What

more do you want?" For Théâtre du Soleil's factory audiences, this final line was a starting point for political action and a catalyst for their subsequent discussions with theatre company members. The question marks the distinction between the quantitative demands pursued by union leadership—higher wages, fewer working hours—and the qualitative demands issued by nonunion structures. In fact, the quantitative wording of the restaurant manager's question, "what *more* do you want," perfectly illustrates a common misunderstanding of May '68. Workers and students did not seek *more*; they sought something qualitatively different.

After management regained control over the factories, Théâtre du Soleil found themselves once again excluded from workers' spaces. That summer the company members embarked on a retreat to reflect on their experiences in the factories and to decide how best to create popular theatre following the Events of May. Bonnaud recalls, "Our reflection put aside the concept of the 'non-public,' preferring to pose questions concerning our own identity: why make theatre, for whom, and how? The answers pointed to the necessity of collective creation as a mode of production and as a framework for the popular theatre we desired."[29] The company's first post-1968 project was *Les Clowns* (1969), often considered their first collective creation. Evident in the production is a concern for popular creative forms, notably clowning and commedia. The company members did not use a pre-existing script but collaboratively constructed the performance text based on their own improvisations. But Mnouchkine insists that this production was not in fact a collective creation in the same sense as their subsequent production, *1789*: "[*Les Clowns*] seemed to me to be the quintessence of each person's individual creation. There was no collective creation, and that was perhaps the production's major flaw. [...] We were all confronted with our own individual problems with creativity."[30]*Les Clowns* did not yet represent a fundamental reevaluation of the relations of theatrical production, remaining bound to the individualism of the performers.

By contrast, the company's rehearsals for *1789* attempted to reimagine the division of labor in the creative process. This production enabled Théâtre du Soleil to refine the collaborative rehearsal process and solidify their status as a cooperative. The rehearsal process for *1789* remains largely inseparable from the structural organization of the company. Actor and administrator Jean-Claude Penchenat describes the arrangement: "All members of the company receive the same monthly salary, twelve months a year: 1200 francs at the moment—or partial payment on account when money's too tight! The company is constituted as a workers' cooperative, directed by an elected committee."[31] While some distinctions persisted between performers and technicians—the technicians did not act in the production—all received equal pay and equal say in the operations of the company, technicians and performers all engaged in dramaturgical research, and performers contributed time and energy to the renovation of the performance space and the construction of scenery. Technical director Guy-Claude François adds, "The difference can be seen in the fact that there isn't really any specialisation. [...] For us, on the technical team, everyone, or almost everyone, has worked in the carpentry workshop. Lighting and acoustics require more knowledge, but present no more difficulties."[32] François's role as technical director, then, was one

of responsibility and not of privilege, as he helped newcomers develop proficiency in all areas of stagecraft.

Looking to move beyond the individual creative problems they had explored in *Les Clowns*, the company decided to create a play based on a common umbrella of experience, a collective memory shared by as many company and audience members as possible. They settled on the French Revolution of 1789 as the French *patrimoine* par excellence. "We started with what we knew about the French Revolution, from what we'd learnt about it at school and elsewhere. We started from this vast, optimistic story, with its incredibly bloodthirsty characters, with all of its clichés: the people in poverty, their revolt, the providential heroes."[33] But Théâtre du Soleil also wanted to look beyond clichés to the mechanisms that constructed the French Revolution as an event. How did the received history of the French Revolution come to be? How was this narrative fabricated? These questions necessitated intensive historical research, both of the grand narratives of French history and of the primary documents that those narratives alternately buried, distorted, or aggrandized. In the evenings, following performances of *The Kitchen*, company members attended lectures on the French Revolution by a Sorbonne professor. This more formal instruction gave way to collaborative historical research based on secondary textual sources, archival documents, and subsequent representations of the Revolution in theatre, film, and literature. "They attended conferences, studied period documents, read all the existing histories, saw films, informed themselves in every possible way. The model of the *enquête*, inherited from Lecoq, was adopted: everything they had learned was replayed before the other members of the company."[34] The company used their research discoveries as springboards for improvisation exercises and free play in the Palais des Sports, an indoor arena in western Paris. Mnouchkine explains, "There was no division of the work; apart from a young woman from Martinique who instructed us in the colonial situation, the whole troupe studied together. The work was not broken down until rehearsal, when we divided into five groups, each following up its own ideas. And these groups were never the same. It was stipulated that no four people could work together for longer than a single morning, and that each person must be prepared to abandon a part."[35] The company scrupulously avoided the specialization and hierarchy that comes from strict division of labor. Théâtre du Soleil promoted communal ownership of the means of theatrical production; ownership consisted not in any individual claim to a role but in a spirit of cooperation and mutual responsibility.

Company member Louis Samier describes the difference between creating a production with Théâtre du Soleil and working as an actor for other theatres:

> In other theatres, I was hired, paid for rehearsals and performances, but I remained a visitor, an outsider, an employee. I was accepted by the others here right away. They integrated me into the group they were forming, I felt a member of a company. *1789* has also prompted me to learn: I have read a great deal, thought about things. I discovered [the historians] Matthiez, Lefebvre, etc. The work with others is also different; I improvise, and am criticised by them. In other places you remain on your own. Not only do I feel like an actor here, but I find myself in tune with what

I am making; and what I'm making is myself, in the same way as my thirty-five comrades, in performance and outside of it. I can't imagine a professional future anywhere else, because I can no longer imagine working in "the profession" as it's usually understood. Here an actor is required to be a creator *in the production*. What comes through in the performance stems from what's outside the performance and is intimately connected to the group's life and work.[36]

Samier's unfavorable description of "other theatres" recalls the isolation of Taylorist factory production. This is not to equate the working conditions of actors with those of automobile workers. But Samier's delight at finding himself "in tune" with what he is making does evoke critiques of alienated labor. Collective creation ran counter to the prevailing trend, even among self-proclaimed leftist or popular theatres, of strict division of labor, bureaucracy, and corporate-style management practices. Guy-Claude François held a similar view: "The difference between us and other theatres is that they have a notion of consumption that presupposes specialist knowledge, a certificate, and in some sense you sell your knowledge."[37] French cultural decentralization policies (developed, paradoxically, by the centralized culture ministry of the French state) had resulted in regional theatres that were buildings rather than troupes. Administrative teams hired actors, directors, designers, and technicians as employees on a short-term basis.[38] The administrators of those theatres, if not their directors, attempted to bring culture to the working classes through simple geographic relocation. A theatre in working-class Villeurbanne was thus automatically a popular theatre. While geography certainly plays a pivotal role in affording workers access to cultural institutions, Mnouchkine and the other company members saw a need for relations of theatrical production that derived from their populist political commitments and not from commercial demands. Mnouchkine condemned the standard repertoire of political theatre as "alibi-productions,"[39] saying, "I'm sick of leftist plays produced in total collaboration with the commercial system. [. . .] The political development of a group is a process of slow maturation; it cannot be ahead of how the group actually lives. And what we have been doing until now is forging our instrument."[40] Théâtre du Soleil's relations and modes of theatrical production were not the result but the *process* of collaborative experimentation and constant reassessment. The company sought to fabricate an organizational structure and an aesthetic form that would not operate in coordination with but rather develop out of their political goals.

Against Efficiency

Théâtre du Soleil's collaborative process proved time consuming. Improvising the sequence that would become the storming of the Bastille took more than a month, with occasional pauses to work through other scenes. Mnouchkine and the company would spend days generating improvisations that proved unsatisfactory and were then discarded. Over the course of the entire rehearsal process for *1789*, company member Sophie Lemasson tape-recorded more than a thousand

improvisations, the vast majority of which never reached audiences beyond the company members themselves.[41] Rehearsal notes for the Bastille sequence document multiple stops and starts and frequent frustration. On July 29, the "linkage [among various improvisations] does not seem satisfactory, and the Bastille is abandoned for a while so as to be able to talk about it a little later on and verify the effectiveness or non-effectiveness of these improvisations." August 14 witnesses "general dissatisfaction." When "the day comes to an end, the actors go off dissatisfied, the 'storming of the Bastille' has not been found." Three days later, "[the] company gathers to discuss and try to define the difficulties [. . .] New groups are formed, and work starts again from scratch." On September 2 the company members make "[n]ew attempts at improvisation in small groups." In the afternoon, an improvisation from the morning "is taken up again, but there is no longer the dryness and clarity of the first sketch. Almost everyone is discouraged!" Using her directorial role to propose ideas for further collaborative work rather than to impose a specific solution, Mnouchkine "suggests [as an exercise] that the actors, in small groups of three or four, tell the story of the storming of the Bastille as they would to children of five or six, keeping to a strict narration of events, and forgetting any political interpretation for the time being." Ultimately this simple exercise, designed to extricate company members from their improvisational rut and to help them move on from repeated mistakes, became the foundation of the scene in performance. In performances of *1789*, each actor entered the audience, gathered a small crowd of audience members in a circle, and recounted his or her own version of the storming of the Bastille. Only after performing this supposedly apolitical exercise did the company continue, on September 4, "[w]ork on the political analysis of what provoked the 14th of July. Earlier improvisations on this theme are taken up again." The collaborative process was never efficient, and at times it was downright painful. Yet, as the rehearsal notes indicate, "Every stage in this lengthy and sometimes difficult progression was necessary to enable the constitutive elements of this event to emerge, and to discover a meaningful theatrical situation."[42] The theatrical production of *1789* was founded on excess, experimentation, and failure rather than on a streamlined progression from start to finish.

Collective creation prevented Théâtre du Soleil from generating a theatrical season of three or four mainstage productions like their counterparts in regional popular theatres. Théâtre du Soleil did not function as a well-oiled machine, but through improvisation, theatrical bricolage, and *ad hoc* decision making, thereby redefining artistic creation. Guy-Claude François explains, "For me, the notion of creation is a bit outdated. At Théâtre du Soleil, we 'create' more than elsewhere, in my opinion, even if we only make one 'creation' a year, and elsewhere they make two or three."[43] François's distinction is between creation as product or commodity, and creation as process. Mnouchkine contends, "[W]e would rather see the production escape us for a certain time, but with the group's approach being in tune with it. We prefer the production created by the group to be what the group wants it to be, not what the system of production wants."[44] Théâtre du Soleil insisted on deriving their theatrical approach from the political situation that they hoped to address. This resulted in a form of site specificity, a situational mode of

production, a completely *un*standardized production process tailor-made to fit a particular problem or milieu.

The members of Théâtre du Soleil do not refer to their work as site specific or situational, but Copfermann and Mnouchkine do distinguish between artisanal and industrialized or bureaucratized theatrical production. In their 1971 interview, Mnouchkine suggests that all theatrical work is artisanal, to which Copfermann counters, "Yes and no. Even if there's no industrialized theatrical production— though American musical comedy is actually exported—there is a bureaucratized theatrical activity that supplies spectacles as though producing soup tureens, one show identical to the next."[45] By contrast, says Mnouchkine, "We do not want to fall into a regular and normalised mode of *production*, which would devalue our work."[46] Critical here is the distinction between the mode and relations of theatrical production. Théâtre du Soleil's ongoing project consists of their organizational structure, their relations of theatrical production, the goal of a nonhierarchical collective that remains committed to each individual's expertise. The company develops this same project with every production they undertake. But their mode of theatrical production differs from one show to the next. "Each project is different from the last, each group distinguishes itself from others, each new theatrical adventure necessitates a total reapprenticing."[47] Here collective creation is not a single mode of production but a relations of production from which the collective continually experiments with different modes of production. In Marx's formulation, a mode of production is the sum of the relations of production and the productive forces (labor power and the means of production). Théâtre du Soleil developed collective relations of production—their nonhierarchical organizational structure—but their mode of production varied with each project. Innovation and experimentation in the workplace do not cease with the elimination of individualist competition.

Nor, however, is the site-specific political and aesthetic experimentation of Théâtre du Soleil based on pure spontaneity or a rejection of the old in favor of the new. The company's experiments are profoundly historical, based on both archival research (as with *1789*) and popular aesthetic forms drawn from performance history. During the company's factory tours of *The Kitchen*, company members recognized the need for a smaller-scale performance that would not monopolize factory floor space; they turned to traditional folk and workers' songs and, in a style reminiscent of 1936 Popular Front strikes, performed a small cabaret in a corner of the workspace.[48] Later they drew on clowning traditions in *Les Clowns* and fairground carnival traditions in *1789*. Williams refers to this continual borrowing as "a repeated rhythm of exploring forms from other times and places as a pedagogic *reculer pour mieux sauter*, a way forward into representing contemporary histories with critical distance."[49] Théâtre du Soleil operates via fits and starts, constant experimentation, and backward glances. Even in experimentation, the company opposes the lessons of history to the fetishization of the new.

During May '68, factory workers, too, had drawn from pre-existing repertoires of contestation. The Renault-Billancourt strike began with a procession that shut down production in all the massive factory's *ateliers*. The use of a processional to inaugurate strikes was then a longstanding French tradition, a practice that

dated to the early nineteenth century but recalled, in more recent history, the 1936 Popular Front strikes. Factory occupation also featured prominently in the Popular Front strikes. During those early factory occupations, strike committees began to organize in-house entertainment for the workers, including cabarets like the one offered by Théâtre du Soleil alongside their production of *The Kitchen*. Both Théâtre du Soleil and the '68 strikers returned to previous, popular forms: the aesthetic forms of commedia, clowning, folk songs, and fairground arts; and the strike forms of the 1930s. Both theatre and factory workers experimented with innovative relations of production, but their experiments were based on historical repertoires. In true experimental fashion, both the theatre and the factory actors based their improvisations on prior research.

After the strikes of May '68 came to an end, factory bosses sought to recuperate lost time by extending hours and increasing the rate of work (*cadence*). The heightened rhythm of the post-May workplace demanded increased efficiency from the workers. They responded with sabotage. At Citroën, assembly-line workers used a hammer to gently dent the frame used to construct every car door.[50] (In French, this frame is called a *cadre*—the same word refers to a midlevel manager.) The dent in the frame was anonymous, undetectable, and it caused every door built that day not to close properly. Every car off the assembly line had to be redone, and the bosses' attempts to recuperate lost time came to naught. This one act of sabotage spawned dozens of others in that and other Citroën factories. Sabotage challenged the Taylorist doctrine of efficiency, but it also pointed to workers' intimate knowledge of the machinery. Only when the production process broke down did the artistry and skill of the supposedly unskilled workers become apparent. In similar fashion, the failures, fits, and starts of Théâtre du Soleil are perhaps the most profound examples of the company's worth. By breaking down the process of theatrical production and working against efficiency, the company had created experimental relations of production suited to an alternate political reality. Their project was not to impose a new, uniform production process in place of another— collective creation in place of bureaucratized, industrialized production—but to continually refine an instrument capable of adapting to diverse political needs. Théâtre du Soleil does not represent a fetishism of organizational structure but a situational aesthetics and politics.

Bibliography

Where possible I have used published English translations for my citations. If a footnote refers to a French text, the translation is my own.

Bernoux, Philippe. *Un Travail à soi*. Paris: Editions Privat, 1981.

Bonnaud, Georges. "Chronique de l'illusion efficace (1968–1980)." In *Le Théâtre d'intervention depuis 1968: Études et Témoignages*, edited by Jonny Ebstein and Philippe Ivernel, 29–48. Lausanne: L'Age d'homme, 1983.

Bourges, Hervé. *The French Student Revolt: The Leaders Speak*. Translated by B. R. Brewster. New York: Hill and Wang, 1968.

Bradby, David. *Le Théâtre en France de 1968 à 2000*. Paris: Honoré Champion, 2007.

Copfermann, Emile. "Entretien avec Ariane Mnouchkine." *Travail Théâtral* 2 (1971): 3–12.

————. "Où est la différence? Premier Entretien avec les Membres de la Troupe." *Travail Théâtral* 2 (1971): 13–18.

Davis, Tracy C. "Nineteenth-Century Repertoire." *Nineteenth Century Theatre & Film* 36, no. 2 (Winter 2009): 6–28.

Dort, Bernard. *Théâtre en jeu: 1970–1978*. Paris: Seuil, 1979.

Filewod, Alan, and David Watt. *Workers' Playtime: Theatre and the Labour Movement since 1970*. Sydney: Currency Press, 2001.

François, Guy-Claude. "Devising a New Scenography for Each Production." In *Collaborative Theatre: Théâtre du Soleil Sourcebook*, edited by David Williams, 36–38. New York: Routledge, 1999.

Godard, Colette. *Le Théâtre depuis 1968*. Paris: J. C. Lattès, 1980.

Goetschel, Pascale. *Renouveau et Décentralisation du Théâtre, 1945–1981*. Paris: Presses universitaires de France, 2004.

Kiernander, Adrian. *Ariane Mnouchkine and Théâtre du Soleil*. Cambridge: Cambridge University Press, 1993.

Magniadis, Jean. "Evolution de la Condition des Salariés." In *La France Ouvrière, Tome 3: De 1968 À Nos Jours*, edited by Claude Willard, 53–65. Paris: Éditions de l'Atelier, 1995.

Miller, Judith Graves. *Ariane Mnouchkine*. New York: Routledge, 2007.

————. *Theater and Revolution in France since 1968*. Lexington: French Forum, 1977.

Mnouchkine, Ariane, and Irving Wardle. "Equal, but Not Identical." In *Collaborative Theatre: Théâtre du Soleil Sourcebook*, edited by David Williams, 26–29. New York: Routledge, 1999.

Parsons, Nick. *French Industrial Relations in the New World Economy*. New York: Routledge, 2005.

Rauch, Marie-Ange. *Le Théâtre en France en 1968: Crise d'une Histoire, Histoire d'une Histoire*. Paris: Éditions de l'Amandier, 2008.

Rosenfeld, Michael. "Celebration, Politics, Looting and Riots: A Micro Level Analysis of the Bulls Riot of 1992 in Chicago." *Social Problems* 44 (1997): 483–502.

Ross, Kristin. *Fast Cars, Clean Bodies: Decolonization and the Reordering of French Culture*. Cambridge, MA: MIT Press, 1995.

————. *May '68 and Its Afterlives*. Chicago: University of Chicago Press, 2002.

Schnapp, Alain, and Pierre Vidal-Naquet, eds. *The French Student Uprising, November 1967–June 1968: An Analytical Record*. Boston: Beacon Press, 1971.

Sirot, Stéphane. *La Grève en France: Une Histoire Sociale (XIXe—XXe Siècle)*. Paris: Editions Odile Jacob, 2002.

Steinhouse, Adam. *Workers' Participation in Post-Liberation France*. Lanham, MD: Lexington Books, 2001.

Taylor, Diana. *The Archive and the Repertoire: Performing Cultural Memory in the Americas*. Durham: Duke University Press, 2003.

Théâtre du Soleil. "Devising through Improvisation: The Storming of the Bastille." In *Collaborative Theatre: Théâtre du Soleil Sourcebook*, edited by David Williams, 32–35. New York: Routledge, 1999.

Vigna, Xavier. *L'Insubordination Ouvrière dans les années 68: Essai d'histoire politique des usines*. Rennes: Presses Universitaires de Rennes, 2007.

Williams, David, ed. *Collaborative Theatre: Théâtre du Soleil Sourcebook*. New York: Routledge, 1999.

Zand, Nicole. "*La Cuisine* à l'usine." *Le Monde*, June 16–17, 1968, 19.

Notes

1. I draw here on complementary understandings of repertoire from theatre and performance studies, including those of Diana Taylor and Tracy C. Davis, as well as sociologist Michael J. Rosenfeld's term "repertoires of contention" (Michael Rosenfeld, "Celebration, Politics, Looting and Riots: A Micro Level Analysis of the Bulls Riot of 1992 in Chicago"). Unlike Taylor, I am less concerned with tracing a direct line of transmission from one embodied performer to another. In my case, this would involve identifying the specific individuals who transmitted past strike practices (marches, occupations, barricades) to younger strikers. Instead I am concerned with what Davis calls "multiple circulating recombinative discourses." (Tracy Davis, "Nineteenth-Century Repertoire"). Students and workers need not have received direct, firsthand transmission of embodied strike practices. Knowledge of past factory occupations certainly could have come from fellow, older factory workers, but it could also have come from untraceable anecdotes, news coverage, the education system, or a striker's own research. A repertoire of contestation will, however, be culturally specific and draw on enough prior information to be comprehensible to audiences. The best example of the French repertoire of contestation is likely the barricade—though I would hardly confine repertoires of contestation within national boundaries.
2. "Program: Genghis Khan," Théâtre du Soleil, http://www.theatre-du-soleil.fr/thsol/nos-spectacles-et-nos-films,3/nos-spectacles,157/genghis-khan-1961/programme.
3. Ibid.
4. See David Bradby, *Le Théâtre en France de 1968 à 2000*; and Denis Bablet and Marie-Louise Bablet, "Vers un théâtre autre," Théâtre du Soleil, http://www.theatre-du-soleil.fr/thsol/a-propos-du-theatre-du-soleil,1/l-historique/vers-un-theatre-autre.
5. I leave the term untranslated throughout. *Enquête* encompasses investigation, inquest, inquiry, report, and study.
6. Lecoq, *Le corps poétique*, quoted in Bradby, 53.
7. Kristin Ross, *May '68 and Its Afterlives*, 25.
8. Hervé Bourges, *The French Student Revolt: The Leaders Speak*, 82–83.
9. Alain Schnapp and Pierre Vidal-Naquet, *The French Student Uprising*, 552.
10. Georges Bonnaud, "Chronique de l'illusion efficace (1968–1980)," 29.
11. Villeurbanne declaration, quoted in Marie-Ange Rauch, *Le Théâtre en France en 1968*, 490.
12. Bonnaud, 30.
13. Rauch, 266.
14. Nicole Zand, "*La Cuisine* à l'usine," 19.
15. Bonnaud, 30.
16. Kristin Ross, *Fast Cars, Clean Bodies*, 16.
17. Xavier Vigna, *L'Insubordination ouvrière dans les années 68*, 32.
18. Ibid., 227.
19. Nick Parsons, *French Industrial Relations in the New World Economy*, 157.
20. The OAS (*Organisation de l'armée secrète*; Secret Army Organization) was a right-wing French nationalist militia that carried out assassinations and terrorist bombings to prevent Algerian independence.
21. Quoted in Vigna, 65.
22. Parsons. See, in particular, pages 11, 75, 94–95, 157.
23. Parsons, 158.
24. Vigna, 65.
25. Parsons, 135.

26. Bonnaud, 30.
27. Emile Copfermann, "Entretien avec Ariane Mnouchkine," 12, my translation. Subsequent references to the Copfermann interview are cited from David Williams's English translation. This particular passage is omitted from Williams's abridged version.
28. Bonnaud, 30.
29. Ibid., 31.
30. Ibid., 19.
31. Ibid., 31.
32. Ibid., 30–31.
33. Ibid., 18.
34. Bradby, 63.
35. David Williams, *Collaborative Theatre*, 27.
36. Ibid., 30.
37. Ibid., 38.
38. Colette Godard, *Le Théâtre depuis 1968*, 39.
39. Williams, 19.
40. Ibid., 26.
41. Bradby, 63.
42. All citations of rehearsal notes are quoted from Williams, 32–35.
43. Williams, 38.
44. Ibid., 19.
45. Copfermann, 10, my translation. As with note 27, this passage is excluded from Williams's abridged translation.
46. Williams, 22.
47. Bradby, 54.
48. Rauch, 265–66.
49. Williams, xiii.
50. This anecdote comes from Vigna, 98–99.

From Mao to the Feeling Circle

The Limits and Endurance of Collective Creation

Victoria Lewis

Lonnie Ford came in and said, "In order for criticism/self-criticism to work, we all have to be equal, see. And ain't one of you equal to me. Ain't one of you come up from where I come up, you don't know shit about my life, and you can't say . . . anything to me as an equal, so this shit's over." And it was over.

> —*Dan Chumley, San Francisco Mime Troupe ensemble member*

One of the important things to me about the process in Lilith was just those feeling circles that we had where you would just sit down and everyone would have a chance to say how they were feeling, and no one could speak back . . . And that was sacrosanct . . . you could say how you felt and be who you were, and not expect to be criticized for it.

> —*Joan Mankin, San Francisco Mime Troupe ensemble member*

This chapter provides a historical comparison of the collective practice of three theatre ensembles that emerged along the West Coast of the United States in the 1970s and 1980s: the San Francisco Mime Troupe; Lilith: A Women's Theatre (San Francisco); and Family Circus Theater (Portland, Oregon). I was an ensemble member of both Family Circus Theater from 1973 to 1976 and of Lilith: A Women's Theatre from 1978 to 1981. Family Circus modeled itself after and was formally mentored by the Mime Troupe, and Lilith absorbed several former Mime Troupe members over the years. My analysis draws on the limited scholarship of West Coast people's theatre, as well as personal interviews with company members from the late 1990s and 2010, Lilith's collaborative diaries, and my own ensemble experience. Though I seek to historicize and problematize all three companies' utopian claims for collective practice, I do not intend to denigrate the groups' radical aesthetic-political projects. I find their efforts toward structural reforms noble, the dramatic results often joyous and generous, and their legacy foundational to all such efforts today.[1] If there is one cautionary note sounded in this

tale, it would be the difficulty in all utopian efforts to sustain what Victor Turner called "permanent liminality"—the impossibility of institutionalizing *communitas* and maintaining absolute equality among all participants.[2] I do incline toward the bottom-up strategies over the top-down, as I observe the former stand a better chance of resisting the inevitable accumulation of power in theatre practice at all times but especially when combined with a radical political agenda.

All three companies, two socialist agitprop, the other feminist, shared an aesthetic and practice that connected them to an older and larger project of people's theatre and collective creation extant since the eighteenth century. Like Romain Rolland, who in 1903 in *The People's Theatre* called for the rejection of a "servant's literature" that depicted lower-class characters on the stage as "skulking valets," these late twentieth-century companies dedicated themselves to the reform of depiction of stereotypes. Like Rousseau before them, they wanted to escape the "dark prisons"[3] and "gloomy cavern[s]" of traditional venues that "close up a small number of people in melancholy fashion."[4] Instead they sought out nontraditional venues in parks and market places, redesigning the audience/spectator relationship. And foremost, they, too, championed movements for social change. Rejecting the top-down, elite theatre, they embraced popular "people's" culture, learning juggling and tap dancing and incorporating popular genres such as folk and rock music, the detective story, comic books, melodrama, and musical theatre into their comic, transgressive performances.

But the San Francisco Mime Troupe, Family Circus, and Lilith differed from earlier manifestations of people's theatre in two telling ways. First, these alternative theatres incorporated concrete strategies to dismantle hierarchical structures, techniques including collective organization of companies, collaborative writing, consciousness raising, and Maoist criticism/self-criticism. It was not the first appearance of some of these strategies; the Provincetown Players and the Living Newspapers of the Federal Theater Project had utilized collaborative creation, companies going back to the Shakespeare's King's Men had been collectively owned, and members of Dullin's Atelier took turns cleaning the stables and making dinner. But during the 1960s a multiplicity of strategies could be employed within one company—collaborative creation, collective organization, group-discussion techniques, and shared duties—in conjunction with an articulated, oppositional agenda dedicated to creating a new theatre and society. Two of those strategies and their limitations—Maoism and feminism—will be discussed here.

Second, the alternative theatre of the 1970s appropriated the term *people* in a sense not originally understood in 1794 by the Jacobin framers of the first call for a "People's theatre."[5] By the late 1970s the term *people* had shifted from the class-based connotation of the past to mean variously a counterculture characterized by lifestyle or one that was community-based and defined by gender, ethnicity, sexual orientation, and so on.[6] The "people" from the 1970s and into the 1990s was thus defined on a new basis of *marginality*, whether of ethnicity, colonialization, gender, or sexual orientation. Family Circus and the San Francisco Mime Troupe continued to equate the "people" with the working class, though in actuality they were just as often perceived as proponents of a counterculture rather than the working class. For Lilith, "the people" became the women's community. I argue that Lilith's

formation as a feminist theatre company determines not only their group process but also their play development technique, their approach to physicalization, and their manipulation of the amateur/professional binary that has played such an important role in the history of collective creation. Though my emphasis here will be on group process, these related discussions may be of future interest in terms of the collective project undertaken by this volume.

Background

Core members of each of these groups differed in their training in ways that would directly impact their future practice and that of the companies they helped to shape. In 1957 Ronnie Davis, who would found the Mime Troupe in 1959, traveled to Paris on a Fulbright Fellowship to study mime with Etienne Decroux, the so-called puritan revolutionary. Decroux, ex-butcher, mason, and hospital worker, brought not only a socialist consciousness to the theatre but also a rigorous technique and a challenging critique process. Decroux, Davis recounts, approached his work "with a seriousness few Americans could abide."[7] Davis was drawn to Decroux, "the master," who taught without the excess of "improvisation we Americans feel so essential to learning."[8] Granted, Davis shocked Decroux disciples when he dared to perform after only six months of study, rather than six years,[9] but the training left its mark. Decroux was not a method accessible to amateurs. Tom Leabhart talks of the "years, tears and discouragement" Decroux's students experienced trying to master his demanding techniques.[10] As Eugenio Barba has noted, Decroux was "perhaps the only European master to have elaborated a system of rules comparable to that of an Oriental tradition," transmitting to students "a rigorous closedness to theatre forms other than his own."[11] As we will see later in this chapter, Dan Chumley, longtime San Francisco Mime Troupe member, in his present career as an international teacher and activist, today practices a theatre training that draws on an Eastern tradition grounded in a clear distinction between student and master.

Carolyn Myers, a core member of Lilith, developed in a different atmosphere, exploring Viola Spolin's improvisational techniques early in her training.[12] Now famous for inspiring the commercially successful Second City, we may forget that Spolin began as a student of Neva Boyd, recreational director of Hull House in the 1920s. Spolin's methods were created to improve the social welfare of immigrant families at the turn of the last century, through physical and vocal improvisatory games accessible to all participants whatever their skill (or language) level.[13] Spolin insisted, "Everyone can act. Everyone can improvise. Anyone who wishes to can play in the theater and become 'stageworthy.' . . . 'Talent' or 'lack of talent' have little to do with it."[14]

Due to the widespread adoption of Spolin's techniques at all levels of theatre training and production, few theatre artists today are unaware of the democratic sweep of her legacy. What is less familiar is Spolin's indebtedness to a radical political agenda. Once the threat of the House Un-American Activities Committee trials had passed, playwright John Howard Lawson declared that Spolin's roots "are

clearly in the Marxism of the thirties . . . She actually accomplished for acting what many of the creators of early people's theatre were trying to accomplish through their scripts: the visualization of a Marxist world view that located the source of our oppression and the key to our liberation in objective reality."[15] Thus Myers's earliest skill training was in a performance methodology that rejected hierarchical concepts of "talent"; was indifferent to virtuosity; and, some argue, provided an efficacious tool for social change and transformation.[16] Myers's expertise in improvisation would continue to grow during her years with Lilith and beyond. What the Mime Troupe's Davis perceives as Americans' indulgent preference for improvisation over physical technique becomes, in Myers's hands, a tool for radical social change.

The divergent career paths of the two leaders owe something to their access or lack of such to theatrical training. Unlike Davis, who pursued his enthusiasm for movement training with the blessing of the elite arts establishment (the aforementioned Fulbright), Myers was initially rejected by educational gatekeepers during her undergraduate years. She recalls, "I had a really terrible experience in my first acting class [in college] . . . the teacher told me that I was too ugly to go on in theater and that he liked me a lot and that I was a really good person, I should change my major, that there was no room for me."[17] One is struck by the parallel between Myers's career path and that of another theatre educator and reformer, British Dorothy Heathcote (1926–2011). Heathcote developed her radical theatre education reforms working, like Spolin, with underserved populations, displaced people who were economically and socially disadvantaged. And, like Myers, Heathcote was told early in her theatre training that, despite her brilliance, her physical type would prevent her from a career as an actress.

Nonetheless, though this chapter draws clear boundaries between the companies discussed as evidenced by the sharp difference in the founders' backgrounds, in fact individual artists moved back and forth between not only these groups but other West Coast ensembles as well: the Dell'Arte Players, Pickle Family Circus, Make-A-Circus, and so on. For example, when comedienne Joan Mankin (who played the titular character in the Mime Troupe's 1970 *The Independent Woman*) joined the Lilith ensemble for the development and production of *Moonlighting*, she brought with her Chairman Mao's Four Minute Exercises, which remained in the women's company's warm-up and workshop repertory for years. Teatro Campesino's Etiquette Rules for Touring found their way into a Lilith journal in 1977 and included such sound advice as, "Be polite to people who are responsible to do something (food, business, etc.) . . . Don't put down people's town . . . Don't tell everybody about your personal idiosyncrasies." Pickle Family Circus offered juggling workshops to Mime Troupe members.[18] This cross-pollination was possible not only because all believed in the need for social change and theatre's ability to support and affect such change but also because, as noted before, the actors, musicians, and writers shared a (mostly) common aesthetic: a physical, accessible style accompanied by music and movement—a comic lightness that Claudia Orenstein coined the "festive revolutionary" in her study of the Mime Troupe.[19] The "festive revolutionary" offered the spectator at a comic performance a kind of *structural*, experienced optimism that disrupted their adherence to hierarchies.

Similarly, critic Anthony Caputi proposed that comedic structure serves as "proof of the world's capacity to change unexpectedly for the better."[20] Thus political efficacy was located not only, perhaps not even primarily, in content but in aesthetic structure. All these artists, whether Maoist, Marxist-Leninist, socialist feminist, or radical feminist, agreed in practice, if not in theory, with Mikhail Bakhtin's claim for the liberatory power of the comic: "[L]aughter could never become an instrument to oppress and blind the people. It always remained a free weapon in their hands."[21]

Models of Participation: Maoism versus Feminism

The central group process of the San Francisco Mime Troupe in the 1970s (after the company removed Ronnie Davis as director in favor of collective process)[22] and their "sister" company Family Circus Theater in Portland, Oregon, was a Maoist-inspired technique known as criticism/self-criticism. The emblematic practice of Lilith's company process was the "feeling circle," rooted in the consciousness-raising techniques of early feminism, which I connect to the anarchist Peter Kropotkin's Mutual Aid. Both practices emerged from a desire to establish a horizontal, nonhierarchical participatory working process—to create *communitas*. In practice, however, the two approaches offered radically different solutions to the problem of cultural change: one top-down and the other bottom up.

Family Circus and the San Francisco Mime Troupe—Applied Maoism

I first encountered the writing of Mao Tse-Tung in Portland, Oregon, in 1973 in a workshop given by the San Francisco Mime Troupe for the company members of Family Circus. Mao's position on cultural work as set forth in his 1942 paper "Yenan Forum on Literature and Art" had great appeal for a generation in search of *communitas* and impatient with the hierarchical rigidity of societal institutions, including those of "legitimate" theatre. For Mao, creating a people's culture did not mean "raising the workers, peasants and soldiers to the 'heights' of the feudal classes, the bourgeoisie or the petty-bourgeois intellectuals; it means raising the level of literature and art in the direction in which the workers, peasants are themselves advancing, in the direction in which the proletariat is advancing."[23] Mao provided a tool to ensure that cultural workers would not be cut off from the masses through elite privilege.[24] The practice was popularized in the West by William Hinton's *Fanshen: A Documentary of Life in a Chinese Village*, published in 1966. Hinton tells of peasants turning the tables on the landlords who had oppressed them. After facing the accusations of the villagers (criticism), the landlord was expected to respond with a self-criticism in which he confessed his past wrongdoing and promised to reform.

Criticism/self-criticism was adopted with fervor by cultural ensembles in the West, as it promised a technique through which to shape the internal mechanisms of companies to match the political message of anticapitalism and anti-individualism they were espousing to the public. Criticism/self-criticism seemed to offer the way

out of hierarchy and domination. In practice, however, more than one performer experienced this method of group interaction as more oppressive than liberating. The technique placed each member of the company under public scrutiny by the entire collective. Failure to adhere to revolutionary ideals in personal and professional behavior was the most common topic of discussion. Then the person under discussion had to criticize himself and end by reciting the Maoist slogan: "I dare not say that I have finished." San Francisco Mime Troupe member Joan Mankin has problematic memories of the regular Monday-night criticism/self-criticism sessions. She recalls, "We had criticism sessions a lot, and you were supposed to follow this pattern where, first you would say something nice about the person, and then you would beat them to shit, and then you would go back and say something nice about them to end it, something positive."[25] Deb Pex, the director and founder of Family Circus, championed the introduction of criticism/self-criticism into the company in the early 1970s, partly at the instigation of the Mime Troupe. Today, however, Pex severely criticizes the method: "Looking back it was one of the most destructive processes . . . the brutality of that way of dealing with each other without support. We were using a process worked out during the Chinese revolution when peasants who were pissed off at their landlords . . . put them in a hole and spit on them."[26]

The primary focus of attack of criticism/self-criticism as I experienced it in Family Circus was a class analysis in which middle-class/bourgeois behavior was equated with individualism and capitalism while working-class, revolutionary behavior was equated with collectivity and socialism. Our first allegiance was to the collective, the company. We were not allowed to give our individual names to the press. Relationships outside the company were suspect and subject to criticism. Joan Varney, one of the founding members of Family Circus, recalls being criticized for "bourgeois ideas" such as not taking the last of the food on the serving plate. Varney found that her idea of group-centered generosity was judged "a white, nicey, bourgeois ideal, and you should always, without hesitation, take that last bit of food on the plate . . . So, I always felt like, 'God, I can't even be nice now because being nice is middle class. And goddammit, I'll take that last bite on the plate because I'm working class mentality.'"[27]

Under the guidance of the San Francisco Mime Troupe, Family Circus embarked on a study of Marxist thought. One favored text was *Quotations from Chairman Mao-Tse-Tung*. Known as "the little red book" (the text measured 5.5" × 3" × 1" and was covered in red, leather-like plastic), the book contained quotations from Mao's writing and speeches intended to galvanize and challenge the masses. Varney was reluctant to embrace the company's new direction. Raised a Protestant in a small Oregon town, Varney was familiar with religious methods of control, bringing to the company's socialist experiment a skepticism unavailable to the more "sophisticated," urban ensemble members of both companies. She recalls her reaction to a week-long workshop in criticism/self-criticism: "I was very stand-offish because . . . one of the things [we had to do] was pass around the little Red Book and read passages out of it . . . and I wouldn't do it . . . I've had little red New Testaments, too. It feels like Bible study to me."[28]

Over time, criticism/self-criticism, a process designed to relieve oppression and give voice to the silenced, became a tool to crush dissent and intimidate those in the group who veered from a particular political line. Eventually Family Circus succumbed to rifts in the company. Varney speaks to the pain of that final period: "And I really did feel so hurt by the whole situation because I felt like I had given so much of my life and heart to making this thing [Family Circus] work, and then people were just kind of acting like I was a bum, and you know, like I had these bad ideas, and like I was a bad person, and I was really hurt, very hurt."[29] Nonetheless, Family circus continued to employ the Maoist model until its demise in 1979— if ambivalently. During the collapse of Family Circus, Varney and her colleague Judith Rizzio would comically challenge each other with an overused refrain from the company's criticism sessions: "Are you a *true* revolutionary?" Though no one in Family Circus was able at the time to effectively question the process, many women defected from the company over the years because of the oppressive atmosphere due in no small part to criticism/self-criticism.

In the San Francisco Mime Troupe, by contrast, the process was abruptly abolished in 1974 as soon as the first African American joined the company. Dan Chumley recalls, "Lonnie Ford came in and said, 'In order for criticism/ self-criticism to work, we all have to be equal, see. And ain't one of you equal to me. Ain't one of you come up from where I come up, you don't know shit about my life, and you can't say . . . anything to me as an equal, so this shit's over.' And it was over."[30]

Lilith Process: Separating to Be Equal

Any mention of Negro blood or Negro life in America for a century has been an occasion for an ugly picture, a dirty allusion, a nasty comment, or a pessimistic forecast.

—*W. E. B. Du Bois,* Crisis, *June 1924*

Nobody can live in perpetual deferment of their sense of selfhood, or free themselves from bondage without a strongly affirmative consciousness of who they are.

—*Terry Eagleton,* Nationalism, Colonialism, and Literature

Women were in a particularly bad place in that we didn't understand who we were because the roles that were open to us were so torqued that we couldn't understand, and so I felt that the only way we could develop was to take time with just ourselves.

—*Carolyn Myers, 1998 interview*

Historically, the founding of Lilith: A Woman's Theatre in 1974 was part of a larger movement in American theatre in the late twentieth century toward collectives organized around marginalized and stigmatized identities including those of gender, race, sexual orientation, and physical and intellectual disabilities. As discussed in the introduction, the designation of the collective unifying force behind the

"people" in "people's theatre" changed over the course of the twentieth century from that of working class to that of marginalized identities or "imagined communities," to use social critic Benedict Anderson's useful designator.[31] These new identities were forged in the marches and actions of the civil rights movement; the fields of the United Farm Workers; the streets of the Miss America Pageant in Atlantic City, 1968, and the Stonewall Riots, 1969; public buildings, as with the 28-day sit-in at the San Francisco HEW building demanding civil rights for disabled people, 1977; as well as classrooms, living rooms, and kitchens across the nation. The theatre collectives that emerged in tandem with these social movements—such as Teatro Campesino in 1965, the Negro Theatre Ensemble in 1967, Teatro Esperanza in 1971,[32] Lilith: A Women's Theatre in 1974, San Francisco Gay Men's Theatre Collective in 1976, Wry Crips Disabled Women Theatre Collective in 1985, to name only a very few—answered, from their various standpoints, W. E. B. Du Bois's 1924 call for a theatre that was "about us, by us, for us and near us." Social critic Terry Eagleton attributes such cultural agendas in oppressed minorities to a claiming of collective identity that must move from an acknowledgement of a shared negative status, as evidenced by an exclusion from the dominant culture in terms of participation, representation, education, and employment, toward the creation of a positive culture around the stigmatized identity.[33]

The relationship of the community- and identity-based companies to the mixed, Anglo-American, male-led companies was varied, as we will see in the discussion of women's ensembles later. Sometimes the relationship was positive, or at the least neutral. Carolyn Myers and Terry Baum of Lilith had no quarrel with their previous mixed companies. Similarly, in 1964, emerging playwright Luis Valdez trained for a year with the San Francisco Mime Troupe before founding Teatro Campesino, taking from the Mime Troupe an aesthetic practice and political theory he would apply and transform in his new company.[34] But all, like Du Bois, had been depicted in various ways as "ugly . . . dirty . . . [and] nasty" in popular and elite entertainments, and they encountered discrimination and prejudice in seeking training and employment as theatre artists. Many turned to collective creation to fashion a new image for themselves, their communities, and the larger American theatre.

The "Ah-Ha" Moment

At my first women's music festival there were . . . 500 women, and they all had their shirts off, and the singer Gwen Avery was at the piano . . . everything turned over . . . just seeing 1000 breasts, it was just like "DOINNNGG!" That whole thing of . . . believing that everybody except me was like a magazine image or something—was completely shattered, and I loved it so much . . . [the] sense that this was something brand new under the sun.

—*Carolyn Myers, Lilith: A Women's Theatre*

Though the call for a "people's theatre" was issued in France in 1794, it would take almost two centuries for women to find a place in that revolutionary agenda,

though not for want of trying. Playwright Olympe de Gouges presented "A Declaration of the Rights of Woman" to the National Assembly in 1791, asking that all masculine privilege be abolished.[35] For her efforts the playwright was sent to the scaffold. She had "forgotten the virtues appropriate to her sex."[36] In response to this systematic exclusion, revolutionary French women organized as a minority group and sought to influence public policy on their own behalves. The Revolutionary Republican Women,[37] founded by actress Claire Lacombe and chocolate-maker Pauline Léon, were part of a larger spontaneous and widespread popular participatory activity that existed outside of official republican control. But on October 30, 1793, the National Convention decreed that "[w]omen's popular clubs and societies, under whatever name they may exist, are forbidden."

In the United States in the 1970s, many women found themselves in a similarly contradictory historical moment, cast as second-class citizens in movements for social change. The performing arts were particularly susceptible to the excesses of objectifying male behaviors permitted by the "sexual revolution." Actor Peter Coyote, and an early ensemble member of the San Francisco Mime Troupe, in his memoir *Sleeping Where I Fall* recalls touring with the troupe's *Minstrel Show*. The male company members would use the opening musical number to identify their night's sleeping partners in the audience, communicating *sotto voce* to one another: "'The redhead in the third row is mine' or 'Hands off the blond with the big tits in the furry sweater.'"[38]

The dynamics of gender politics were not confined to relationships between actors and audience. As Charlotte Canning documents in *Feminist Theaters in the U.S.A.: Staging Women's Experience*, by the late 1970s many women in the alternative theatre scene were defecting from their companies in order to join all-women companies. These departures took place in avant-garde as well as political companies. Though Martha Kearns of the Bread and Puppet Theatre found her company "stunning," "gorgeous," and "beautiful," she eventually left because she was "disenchanted by their one, single-minded view of women; which meant women should be barefoot and pregnant, and not be artistic leaders in the theater. Nor were the roles for women particularly interesting, and I didn't like that."[39] Roberta Sklar left The Open Theater after struggles in the company over *The Mutation Show* (1974): "I had somehow thought I was 'equal' with the men in the company even though I knew the outside world did not think so . . . When it came to struggles the men could no longer see the issues as political, suddenly it was very personal."[40]

Carolyn Myers and Terry Baum of Lilith: A Women's Theatre follow this pattern. But for both Baum and Myers, the desire to found and join all-women companies was not only a running *from* the oppression of male-dominated companies; it was equally a running *toward* the possibility of working with women. Baum left Bear Republic, which she had founded with two men, and created Lilith because she simply "wanted to work with women."[41] Carolyn Myers, then a member of a mixed company, Guerilla Theater, joined Baum in Lilith out of a similar motivation: "I don't remember feeling oppressed with the men I worked with [in the Guerilla Theater]. I felt very close to them, but I also . . . was very excited about the idea of working with all women . . . [I]t was actually sort of puzzling to me the amount of time we spent worrying about alienating men and did we hate

men. I always found that sort of shocking because that wasn't the way I felt, and it didn't seem like it was a real important discussion to me."[42] For others, the need for change grew out of a disjuncture between personal experience and political theory. Joan Mankin left the San Francisco Mime Troupe after five years to join Lilith because, in her words, "I felt like my politics weren't coming from any experience that I knew about, because the Mime Troupe at that time was very ideological, we were always having these discussions about Marx and Mao."[43]

Lilith Process: The Feeling Circle

For Mankin, the antidote to the excesses of Maoist criticism/self-criticism was Lilith's Feeling Circle. She recalls, "One of the important things to me about the process in Lilith was just those feeling circles that we had where you would just sit down and everyone would have a chance to say how they were feeling, and no one could speak back . . . And that was sacrosanct . . . you could say how you felt and be who you were, and not expect to be criticized for it."[44] Every rehearsal, company meeting, and workshop began with the group gathered in a circle. Harriet Schiffer, artistic director from 1983 to 1986, explains, "We take a moment to have each member share her feelings—this is a brief statement of where she is at . . . The hope is that with this time to share our feelings, we can leave the day, any problems or frustrations, behind and begin to focus on the work at hand."[45] Other significant ground rules for the practice included no interruptions, no cross talk, and no discussion.

With the hindsight of thirty years, the "feeling circle" may seem not only naively self-involved but, worse, a harbinger of a privatized culture to come, where self-help trumps political action, the public sphere has all but collapsed, and we are left "bowling alone." But, as we know from our immediate history, the consciousness-raising techniques of the women's movement, from whence the feeling circle came to the theatre, profoundly impacted the public sphere. For example, the Boston Women's Health Collective, which began with a story circle of 12 women recounting their experiences of childbirth, eventually changed the American practice of medicine, particularly our rights as patients.[46]

The use of consciousness raising as a tool for social change was not the sole property of feminism in those turbulent years. Experiments designed to realign the social and political power structure through bottom-up organizational structures flourished: peer mentoring, cocounseling, and, of course, 12-step programs. Nor did consciousness raising begin in the 1960s. One of the earliest formulations of the practice can be found in Russian aristocrat and anarchist Peter Kropotkin's *Mutual Aid: A Factor in Evolution*. Kropotkin, opposing the ascendant Social Darwinism of his day, argued that cooperation, not competition, was at the heart of mankind's evolution—that the claiming of a collective identity is an important strategy of political and social reform. Kropotkin formulated a noncompetitive model of social organization—mutual aid, or self-help. One of the first goals was a "cognitive restructuring," or, as we knew it in feminism, the famous "ah-ha" moment, when one's personal problems become shared and social and thus

susceptible to the force of collective action. The other characteristics of mutual aid or self-help can be used to analyze the Lilith practice. In addition to *cognitive restructuring*, the group process provided *learned adaptive skills*—training in theatrical expertise. Through the feeling circle and other techniques for creating a shared safe space, the group provided *emotional support* for *personal disclosure*, the storytelling at the heart of Lilith's dramaturgy. Through the shared responsibilities of company management and the conducting of public workshops, all members experienced a growth in *socialization*. By *taking actions together*, in the producing of plays and the support of political actions in the women's community, the ensemble members found *empowerment* and increased *self-reliance* and *self-esteem*.[47]

I stress this Kropotkin connection to further my efforts to historicize collective theatre practice, suggesting that top-down and bottom-up reform efforts are interwoven with issues of collective practice. This tension appears early in the evolution of the people's theatre. At the same time that the women's clubs were legislated out of existence, Jean-Jacques Rousseau, in his famous *Letter to D'Alembert*, was outlawing comedy, women, and Molière on the stage in the service of the revolution.[48]

Lilith ensemble member Michele Linfante provides an illuminating anecdote about her apprenticeship with the Mime Troupe before joining Lilith. As a working-class woman, ex-Catholic, and one of the few in the room without a college education, she struggled to define her own political position in the Mime Troupe's highly charged creative and political environment, some years before identifying as a feminist. Linfante remembers,

> I didn't even know yet I was an anarchist . . . I didn't know what an anarchist was, but [the Mime Troupe's] . . . Marxist politics. That wasn't washing for me. You know the time when Christ was alive was not that different from Lenin, . . . [times when change was] really happening . . . But then after that moves on, all you're left with is the structures. And . . . Marxism to me was just as heavy and weird as Catholicism, which I was running from. You know, you have a big massive structure that doesn't have any vibrancy, doesn't have any light.[49]

Lilith Process: Authorship

Come, I beg you, come and find your souls again in the people's theater, in the people themselves.

—*Jules Michelet*, L'Etudiant

He [the writer] too must cease to be the autocrat he has always been in the past, and must learn to put his own ideas and original touches to the back of his mind and concentrate on bringing out the ideas which are alive in the psyche of the masses.

—*Erwin Piscator*, The Political Theatre

Armed with a deep commitment to feminist thought and process, Carolyn Myers of Lilith fulfilled Michelet's command to find her art in the people themselves. Unlike Piscator, she did not need to "put down" her own ideas in order to give

voice to the "psyche of the masses." She explains, "Lilith's thing was . . . to be *at one with the audience*. We wanted to be the voice for the audience . . . We wanted women to *recognize themselves* in what we were doing. That was really important."[50] Thus the plays, for Lilith, were an extension of the consciousness-raising process in that they provided the audience a theatrical "ah-ha" moment, a moment of acknowledgement of a shared oppression. In 1976, founder Terry Baum in a company discussion of their mission explicitly identified the goal of their plays as "consciousness-raising tools [so that] others see that they've had similar experiences [and can] begin . . . [a life] . . . of political perspective."

An impromptu Lilith performance of *Moonlighting*, a comic review on women and work, at a Canadian ferry station illustrates this point. Facing a five-hour delay, the troupe decided to perform a shortened version of the play for their fellow stranded motorists. They distributed fliers and got a good turnout. After the show on the ferry, Myers overheard a family discussing the Lilith performance. The woman defended the play against her husband's and son's criticisms, saying, "No, I worked in a factory during the war, and that's exactly what it was like." Myers remembers, "It was one of my most exciting moments I ever had. See . . . that's what I wanted. I wanted people in the audience to say, 'Yes, that's happened to me, that's what it is' . . . that feeling that if *you're not alone*, if *you're not isolated* in your feelings of oppression, then does that mean that together you're having a collective experience, not an individualized neurotic experience?"[51] The relationship of the individual to the collective is at the heart of political theatre, and the Mime Troupe and Lilith offer different solutions to the chicken-and-egg riddle of which comes first, the "personal" or the "political?" The San Francisco Mime Troupe's Dan Chumley passionately affirms, "You are incredibly unique, and that goes without statement. Having said that, you haven't said enough. What you need to say is what's the commonality, what's the thing that connects us, because that's where social action takes place."[52] For Chumley, the personal stories fade in importance to give place to the "commonality" of what he terms "a theatre of argument," where "social action takes place."

For Myers, the personal story was the *sine qua non* of Lilith's storytelling and politics. Her life experience had led her to believe that: "I felt that very strongly . . . [that] we had all been lied to . . . and that we were detached from understanding what was really going on . . . we had to learn to trust ourselves and to trust each other, and the way to do that was through an intense process of truth-telling . . . to listen to other people tell true stories about their lives and have those moments of recognition and realization. I . . . felt that was the only truth . . . that was the only thing you could count on—you and the people you were with telling the truth about their lives." But this dramaturgy was as connected to social action as the Mime Troupe's, based as it was on the assumption that the sum total of the myriads of personal stories would prove that "[y]ou're having a collective experience and some of it is coming from *outside forces* that *you can choose to change together*."[53] Myers's contribution to the company manifesto in 1976 states her personal aesthetic/political principles: "The personal is political; process is product; craft is art; the individual is collective; the collective is individual."[54]

Both Lilith and the San Francisco Mime Troupe championed a method of script development that challenged the autonomy and privilege of the individual playwright, though in fact both companies relied on the dramaturgical talents of a few members to create their scripts: Joan Holden in the case of the Mime Troupe and a combination of Carolyn Myers, Terry Baum, and Michele Linfante for Lilith.[55] Holden minimized her importance, insisting she was a journalist, not a playwright, shaping newspaper stories and company improvs.[56] Myers considered herself a mere channel for the ensemble, though she was most often responsible for turning the hours of improv and personal stories into a comic, involving script.[57] For Myers, scriptwriting was another opportunity to fulfill her central creative task, which was not individual expression and the display of artistic mastery but rather the articulation of an authentic, shared identity. She did not view this work "as particularly *my* writing . . . There was nothing negative about that at all to me . . . I don't remember ever feeling hurt or defensive or anything about it [the reception of her writing in the group]. It was all just towards making it work better because it would *come totally from everybody*, you were just like sort of the channel for structuring it."[58]

The Mime Troupe also parted dramaturgical company with Lilith in its insistence on the single hero. Chumley reflects, "[F]eminist dramaturgy in some way leaves me cold . . . [weaving] together these emotional strands . . . [with] no single thread that leads us through."[59] Arguably, drama, with its privileging of the individual narrative, is an ill-suited form for the fostering of collective action.[60] Many of Lilith's plays were reviews, a favorite form of the political theatre, and one that easily accommodates a collective writing process.

Family Circus's script development was very much writing by committee (unlike the other companies, no one emerged as the dominant writer). The political line was positioned between Maoist and feminist politics, partly due to the makeup of the company, which included lesbian and gay artists, emerging feminists, and Marxists. During the creation of a children's play *Garbage: An S.O.S. from Outer Space*, a company member was criticized for song lyrics that arguably blamed children instead of MacDonald's for creating litter. One of the women ensemble members spoke up for mothers who had to clean up after their children, and the song went forward uncensored. Even longer discussions centered on the sexuality of the aliens from outer space: a man and woman supported the heterosexual norm; two men took a role away from a woman company member; removing all sexual reference implied that sexuality was wrong, and so on. The ensemble member assigned to costumes was criticized for spending ten dollars for materials from a fabric store instead of using secondhand clothes (25 cents a pound) from the local Goodwill. The "business" (as opposed to the artistic) meetings were run with criticism/self-criticism and ran twice as long.

The creation of new dramas has always been a stumbling block for political theatre. Rousseau might demand "authors before actors," but in fact he ended up producing mass pageants instead of plays. As chronicled elsewhere in this collection, collective script writing in the 1960s and 1970s gave way to individual authors over time, until the rise of devised theatre in the 1990s.

Lilith Process: The Workshop

It is my opinion that workshops are more important than people dream of.

—*Richard Schechner,* Performance Theory

Like many collectives of the time, Lilith made their living by touring.[61] Venues ranged from small coffee houses, to universities, to prestigious international festivals. And whenever possible, the company offered workshops for an additional fee. Thus the workshop was a minor but important element in the company's survival. A great deal of the Lilith journal from 1976 to 1977 covers workshop planning, execution, and evaluation. A typical two-hour workshop included the four minute exercises, isolations, body leads, sound and movement, verb walks, and improvisations with games like "duck, duck, goose" thrown in as the spirit moved. Longer six-hour storytelling workshops soon appeared, modeled after the troupe's own collective script development process—for example, a dream workshop employing mime, collective storytelling, a sound circle, and so on.

The importance of the workshop extended far beyond the financial, however. In a sense, the workshops, even more than the performances, fulfilled the troupe's desire for social efficacy—a chance to train and empower their spectators. The workshops created a liminal, extradaily space in which the actors and their audience became equal members of a new women's community. Myers did not consider herself the "expert" during the workshop process: "I don't think I saw myself as separate from the other women I was working with . . . I don't think I ever thought of these people as less educated or anything than myself . . . I had a very utopian, anarchistic idea that each person within themselves, if we could just get down to who we really were, it would sort of naturally emerge into something fantastic. In the workshop process, I felt that happening."[62] Myers emerges in the pages of the journal as the troupe's guide into the workshop process, her handling of improvisations deemed "brilliant" by her colleagues. As she testifies in the previous quote, the workshop affirmed her "utopian" belief in the efficacy of the Lilith process. In the workshop process, true *communitas* was found. No religious mystic offers a better account of what Victor Turner calls "spontaneous *communitas*" than Myers describing a workshop experience as a participant in a Provisional Theater workshop: "[The workshop] was in the Mission district [in San Francisco], and you walked in early in the morning, and we were there all day . . . I just couldn't believe it when we walked out and it was getting dark . . . I really had been in a total time warp . . . I had been in this timeless space . . . it wasn't until an hour or two later that I realized how tired I was. I had no sense of that . . . I was out of body . . . It was inspired." No less than the ardent followers of Mao, however, Myers would discover that "permanent liminality"—institutionalized *communitas*—is impossible to achieve.

Limits of the Lilith Process: The Failure to Be Truly Inclusive

Over time, Myers discovered that the leap from individual women "telling the truth" about their experiences to creating a collective identity was not always

successful. Her early belief in the power of the "revolution" to solve personal problems did not take into account "the complexity of pain that people carry." The process of self-discovery had been a positive, "joyous" experience for Myers. She was "frightened" when workshop participants "uncovered stuff and what they came to right away was agony . . . I didn't know how to help them out of it." Today, in language not unlike that originally applied by feminists to the work of their male ww arrogance, an assumption that everybody had the same experience as me." One of the severest tests of the inclusiveness of the Lilith process came in 1977, when the company decided to diversify and create a project for a multiracial cast.

Sacrifices, a fable about the women's movement set in the far future, featured, for the first time in Lilith, an ethnically mixed cast. During the creation of *Sacrifices*, the Lilith process, according to Myers, "devolved." The black women in the company "hated" the process: "They felt oppressed by everything we did." At root of the problem was a withholding of stories: "[They] didn't feel like sharing their experiences as black women with us. They felt like they were becoming subjects for our play, that we wanted them in there to investigate their ethnicity . . . before, I always thought we were sharing our stories out of a common experience, but that wasn't how they felt. They felt we were sort of mining their experience to use it for our show."[63]

Early on, a collective decision was made to exclude racism from this future world. Myers recalls writing "as though race didn't exist," a decision she now judges "unsound," as the strength of Lilith plays had always been their "honesty." Prior to *Sacrifices*, the company had always talked "as honestly as they could about their own experience."

Myers points to other process decisions that affected this ill-fated experiment. The company doubled in size, but none of the new members (essentially the women of color) were brought in as collective members. They were hired on for the show. Though in *Sacrifices,* the "hired help" were women of color, in later productions such as *Daughters of Erin*, the outside hires were white, and a similar breakdown in the process occurred. Thus a professional model of employment superseded a community model, making it difficult for the Lilith process to operate. An additional step toward professionalization and specialization in the creative process was the designation of Myers as the "writer" as distinguished from the actors.

The rehearsal and development of *Sacrifices* eroded the integrity of Lilith's collective process in two ways: first, by the failure of the process to expand from a gender-based conception of community to include women of diverse ethnicities, and second, by the imposition of hierarchical professional structures onto horizontal practice. This conflict would continue to simmer until the troupe's first major split in 1980, when de facto leader Terry Baum left the company over a management dispute.

Collective Creation Twenty-First-Century Style

[Proletarian Theatre] will gradually be able to do without "professional actors"
as it accumulates players from its own audiences ... for the first task facing
the Proletarisches Theater is to spread and deepen the understanding of the
Communist idea ... Skill and talents will not produce this result.

—*Erwin Piscator, 1920*

So what are the arguments against using professional actors, stage machinery, and
the whole institution of the theater? They're just as absurd as the contention that
revolutionary magazine must on ideological grounds be produced on Gutenberg's
handpress instead of on a modern rotary press. The important thing is always the
aim: the best performances are the most effective propaganda.

—*Erwin Piscator, 1930*

Times change. In 1920, Piscator wanted nothing to do with professional actors. He
would find the right actors for the proletarian theatre in the proletarian audience.
Ten years later, he'd changed his mind. The best politics need the best artists.

So too with our players here. Most interviewed had faced the failed expecta-
tions of their earlier work: the dogmatic, top-down excesses of criticism/self-
criticism, and/or, conversely, the oppressive naiveté of the feeling circle. Longtime
San Francisco Mime Troupe ensemble member Dan Chumley, still active in politi-
cal theatre and collective process, has come to rethink the role of hierarchy and to
question the troupe's break with founder Davis in 1970. Because of his extensive
work in Asia over many years, Chumley now places increasing importance on the
role of the "master" in theatrical process and tradition. Looking back, he recalls,
"[I]n some ways, Ronnie was my master ... I learned more from being in argu-
ment and in situations where he jammed stuff into you ... academia tends to think
of its students as customers, and so you don't get that kind of [training like] the
John Donne poem, where the poet invokes the god to wind, blow, break, batter
me ... But in some ways, that was Ronnie's school."[64]

Chumley is also now convinced that a strong leader is not incompatible with
making theatre within a collective structure. He characterizes the troupe after Davis's
departure "like ... family with divorce, you know ... in some ways, separated from the
mentor and the master ... It create[d] ... a kind of schizophrenia." Chumley offers a
counterexample of a political theatre collective in 1970 that transitioned to a collec-
tive while retaining their leader or "master"—La Candelaria in Colombia led by San-
tiago Garcia. The company feels "sane" to Chumley: "[T]he master says, 'Yeah, okay,
we're a collective. The fuck, I'm still the director, but we're collective, it doesn't matter.
Words don't matter that much, let's make plays.'" As proof of the success and the
wisdom of this compromise, Chumley singles out the "continuum in style" that Can-
delaria has achieved, a not-surprising emphasis for an artist who values the mastery
of physical, comic technique in the service of a viable and accessible people's theatre.

And what of Lilith's Carolyn Myers, whose utopian, liminal practice was able
to bridge the gap between audience and spectator, amateur and expert, individual

and collective until the crisis surrounding the production of *Sacrifices*? Myers never played a major role in a Lilith production after *Sacrifices*. She left the ensemble after the European tour of 1979 and moved to Ashland, Oregon, to raise her two daughters. Not surprisingly, there she was sought after as a teacher and, for 15 years, created plays with teens under the sponsorship of the local Planned Parenthood Association. Like Heathcote and Spolin, she used the accessible, transformative techniques of improvisation to work with young adults.

But Myers also continued to perform professionally and formed a woman's comedy troupe: the Hamazons.[65] While retaining her respect for and identification with her audience, like Dan Chumley, she acknowledges the need for expertise in the political theatre. The times have changed, as she explains: "[W]e used to have the culture with us . . . everyone in audience in agreement with you. When that isn't true [in 2010], when you don't have that, it's even more important that you keep your craft very strong. You don't all agree on those values—you don't have that to bank on."[66]

As far as political agenda, the Hamazons do not align themselves politically beyond one article of agreement: to never put anyone down. Though this credo seems to fly in the face of received practice in stand-up comedy, which mines a deep strain of self-hatred and disrespect, the troupe keeps their audiences laughing.

Myers attributes their success to the process of improvisation itself, which serves as a metonym for her core ideology as a theatre artist: "What people like to see—of course it's wonderful when you are incredibly clever too—but what people really like is to see you saving each other, having a great time—that element of game so missing for so many people now. And people yearn for it and I think they yearn for it even more now when there is such a climate of despair."[67] From Myers viewpoint, her mission is unchanged since she first began with Lilith. "My life's work," she asserts, is to create a counternarrative that challenges the classic story, from fairy tales on down, that the transgressive woman will be punished. Her latest performance strategy to relay this message is a character called "Theresa Thesaurus" who solicits an old cliché from the audience and, through a virtuosic comic display that would leave Jon Stuart gasping, uncovers a hidden message from the "Goddess" about feminine power. Myers is still a practicing "festive revolutionary," to return to a term introduced at the beginning of this essay, one for whom comedy acts as a kind of *structural*, experienced optimism—proof, as Caputi proposes, of the world's capacity to change unexpectedly for the better.

None of the theatre artists interviewed here equate the failure of methodology with an indictment of the collective process. Family Circus's wonderful comedienne Joan Varney, who never performed again after the collapse of Family Circus, values the ambitions of those times. Today Varney heads a landscaping crew at a San Francisco hospital. Little red books aside, she asserts,

> I try to bring to my work some of the process that happened in Family Circus . . . A lot of the stuff we learned, not necessarily the criticism stuff, but just getting along and tolerating each other, I would like to see all that handed on to the culture from first grade: tolerance, compromise. All of those things, each year. I already know what the subject would be called: Getting Along.[68]

Bibliography

Anderson, Benedict. *Imagined Communities: Reflections on the Origins and Spread of Nationalism*. London: Verso, 1991.

Bakhtin, Mikhail. *Rabelais and His World*. Bloomington: Indiana University Press, 1984.

Brownmiller, Susan. *In Our Time: Memoir of a Revolution*. New York: Delta, 1999.

Canning, Charlotte. *Feminist Theaters in the U.S.A.: Staging Women's Experience*. London: Routledge, 1996.

Chumley, Dan. Interview with the author. December 4, 1998.

Coyote, Peter. *Sleeping Where I Fall*. Washington, DC: Counterpoint Press, 1998.

Davis, Ronnie. *The San Francisco Mime Troupe: The First Ten Years*. Palo Alto: Ramparts Press, 1975.

Eagleton, Terry, Frederic Jameson, and Edward Said. *Nationalism, Colonialism, and Literature*. Minneapolis: University of Minnesota Press, 1990.

Fields, Belden. "French Maoism." In *The 60's without Apology*, edited by Sohnya Sayres, Anders Stephanson, Stanley Aronowitz, and Fredric Jameson, 148–77. Minneapolis: University of Minneapolis Press, 1984.

Jameson Fredric. "Periodizing the 60's." In *The 60's without Apology*, edited by Sohnya Sayres, Anders Stephanson, Stanley Aronowitz, and Fredric Jameson, 178–209. Minneapolis: University of Minneapolis Press, 1984.

Katz, Alfred H. *Self-Help in America: A Social Movement Perspective*. New York: Twayne Publishers, 1993.

Lawson, John Howard. Introduction to *People's Theatre in Amerika*, by Karen Malpede Taylor. New York: Drama Book Specialists, 1972.

Leabhart, Thomas. *Etienne Decroux*, Kindle edition. Routledge Performance Practitioners, 2007.

Lewis, Victoria. "Theatre without a Hero." In *Bodies in Commotion: Disability and Performance*, edited by Philip Auslander and Carrie Sandahl. Ann Arbor: University of Michigan Press, 2005.

Linfante, Michele. Interview with the author. December 4, 1998.

Mankin, Joan. Interview with the author. December 2, 1998.

Myers, Carolyn. Interview with the author. December 1, 1998.

———. Interview with the author. August 17, 2010.

Natalle, Elizabeth J. *Feminist Theatre: A Study in Persuasion*. Metuchen, NJ: Scarecrow Press, 1985.

Orenstein, Claudia. *Festive Revolutions: The Politics of Popular Theater and the San Francisco Mime Troupe*. Jackson: UP of Mississippi, 1999.

Pex, Deb. Interview with the author. August 23, 1998.

Roessler, Shirley Elson. *Out of the Shadows: Women and Politics in the French Revolution, 1789–95*. New York: Peter Lang, 1996.

Rolland, Romain. *The People's Theater*. Translated by Barrett H. Clark. New York: Henry Holt, 1918.

Rousseau, Jean-Jacques. *Politics and the Arts: Letter to M. D'Alembert on the Theatre*. Translated by Allan Bloom. Ithaca: Cornell University Press, 1960.

Schiffer, Harriet. Lilith newsletter. Spring, 1984.

Spolin, Viola. *Improvisation for the Theater*. Evanston: Northwestern University Press: 1963.

Tsetung, Mao. *Selected Readings from the Works of Mao Tsetung*. Peking: Foreign Language Press, 1971.

Turner, Victor. *Ritual Process: Structure and Anti-Structure*. Hawthorne, NY: Aldine De Gruyter, 1995.

Varney, Joan. Interview with the author. December 3, 1998.

Notes

1. These six years informed my many decades of work since leaving Lilith. In 1980, I traveled to Los Angeles, finding an artistic home at the Mark Taper Forum. For several years I was a member of the Taper's Improvisational Theatre Project, which created youth theatre using techniques of collective creation similar to those I had practiced in Family Circus and Lilith. More significant, I founded a theatre lab—Other Voices—and for twenty years created and developed new plays and community-based documentaries with a variety of underserved communities (blue-collar workers, teen mothers, and people with disabilities) under the umbrella of this elite, hierarchical regional theatre. If nothing else, my apprenticeship in the collective ensembles prepared me to work with contradictions.
2. Victor Turner, *Ritual Process*, 140.
3. Romain Rolland, *The People's Theater*, 78.
4. Ibid., 125.
5. On March 10, 1794, the Committee of Public Safety composed of Saint-Just, Couthon, Carnot, Barere, Prieur, Lindet, and Collot d'Herbois decreed that "the old Théâtre-Francais shall be solely devoted to performances given by and for the people at certain times every month. The building shall bear the following inscription on its facade: PEOPLE'S THEATER . . . The repertory of plays to be performed at the people's theater must be submitted to and passed by the Committee. Each municipality is commanded to organize productions which are to be given free to the people every decade." See Rolland, 74.
6. Critic Fredric Jameson attributes this shift in the meaning of "the people" to a "slippage" in the term *proletarian* that occurred historically in Maoist rhetoric. This slippage coincides with the appearance of the rhetoric of "the personal is political," permitting women to claim status as a class and an international youth counterculture to claim revolutionary credentials. For further discussion, see Fredric Jameson, "Periodizing the 60's."
7. Ronnie Davis, *The San Francisco Mime Troupe*, 14.
8. Ibid., 14.
9. Ibid., 15.
10. Thomas Leabhart, *Etienne Decroux*, location 603–10.
11. Eugene Barba quoted in Leabhardt, location 704–14.
12. Carolyn Myers, interview with the author, August 17, 2010.
13. Ibid.
14. Viola Spolin, *Improvisation for the Theater*, 3.
15. John Howard Lawson, "Introduction," xiii.
16. Another pivotal influence was Steve Kent and the Provisional Theatre Company. Myers studied with and produced the company while studying at University of California, Santa Cruz.
17. Myers, interview with the author, 1998.
18. Michele Linfante, interview with the author. All three companies offered training in skills for their members because (1) many members had been excluded from traditional training and (2) at that time traditional training did not include the fairground skills required for the new people's theatre performance style.
19. Claudia Orenstein, *Festive Revolutions*, 12–13.
20. Anthony Caputi, *Buffo: The Genius of Vulgar Comedy* (Detroit: Wayne State UP, 1978), as quoted in Orenstein, 23. Caputi's characteristics of popular theatre apply to all the ensembles mentioned here, including Lilith: (1) simple and bold, (2) songs, (3) frequent

asides, (4) free use of the stage, (5) dancers and acrobats, (6) flamboyant physical acting style, and (7) audience not required to have great range of sensibility or intelligence.

21. Mikhail Bakhtin, *Rabelais and His World*, 94.
22. As San Francisco Mime Troupe collective member Dan Chumley recalls it, the Mime Troupe was preparing for their first Brecht play, *Congress of Whitewashers*, and by Davis's "dictum" was reading Marx and Lenin. Chumley recalls, "That's where the end came for Ronnie because when we started Marx, we started on Mao, and Mao led to collective and collectivity, and he was not prepared to make that leap."
23. Mao Tsetung, *Selected Readings from the Works of Mao Tsetung*, 264.
24. Belden Fields, "French Maoism," 169.
25. Joan Mankin, interview with the author.
26. Deb Pex, interview with the author.
27. Joan Varney, interview with the author.
28. Varney, interview with the author.
29. Ibid.
30. Dan Chumley, interview with the author.
31. Benedict Anderson, *Imagined Communities*.
32. For a more complete discussion of other teatros to emerge in this period, see Chapter 12 in this collection.
33. Terry Eagleton, Frederic Jameson, and Edward Said, *Nationalism, Colonialism, and Literature*, 37.
34. Chapter 12 in this volume.
35. DeGouge also sponsored petitions for homes for the elderly, hygiene in hospitals, public works, projects for the unemployed, the opening of schools to the people and to women, and the rights of minorities—in short, an enlightened program of social welfare.
36. Shirley Elson Roessler, *Out of the Shadows*, 75.
37. The Revolutionary Republican Women, an organization started by chocolate-maker Pauline Léon and actress Claire Lacombe, was an entirely women's political organization with a radical feminist agenda.
38. Peter Coyote, *Sleeping Where I Fall*, 47–48.
39. Elizabeth J. Natalle, *Feminist Theatre*, 13.
40. Ibid., 12. For more on Sklar's defection, see Charlotte Canning, *Feminist Theaters in the U.S.A.*, 60–62.
41. Canning, 59.
42. Myers, interview with the author, 1998.
43. Canning, 59.
44. Mankin, interview with the author.
45. Harriet Schiffer, Lilith newsletter.
46. Susan Brownmiller, *In Our Time: Memoir of a Revolution*, 180–85.
47. Alfred H. Katz, *Self-Help in America*, 22–31.
48. Jean-Jacques Rousseau, *Politics and the Arts*.
49. Linfante, interview with the author.
50. Myers, interview with the author, 1998.
51. Myers, interview with the author, 1998.
52. Chumley, interview with the author.
53. Myers, interview with the author, 1998, emphasis mine.
54. Lilith journals, unpublished.
55. It is clear from the Lilith journals that many hands were on the scripts. It is possible that the process was more like the "gang" writing of television sitcoms than I credit.

But Myers functioned at the very least as the "Grand Editor," to borrow Joan Little-woods's title as recorded in Atillo Favorini's chapter in this collection. During my years with Lilith, there was a move towards solo playwrights. In fact, Michele Linfante received a playwriting award from the California Arts Council for her one-act comedy *Pizza*.

56. Chumley, interview with the author.
57. Several chapters in this collection investigate the "density of collective creation" (Favorini, Chapter 5). See also Calder, Chapter 10.
58. Myers, interview with the author, 1998.
59. Chumley, interview with the author.
60. See Victoria Lewis, "Theatre without a Hero."
61. During the European tour of 1979, the salary was $100/week.
62. Myers, interview with the author, 1998.
63. Ibid.
64. Chumley, interview with the author.
65. Recently Myers reunited with Lilith founder Terry Baum to form the comic review touring piece *A Coupla' Crackpot Crones* (http://www.crackpotcrones.com).
66. Myers, interview with the author, 2010.
67. Ibid.
68. Varney, interview with the author.

Who's in Charge?

The Collective Nature of Early Chicano Theatre

Jorge A. Huerta

Introduction: What's a Chicano?

It is impossible to discuss Chicana/Chicano theatre without first addressing the political nature of the very term *Chicano*. While the feminists of the 1970s taught us that a feminist recognizes the elision and oppression *and does something about it*, so it is with anybody who refers to herself or himself as a Chicana or Chicano. Nobody knows the etymology of the term, but we do know that during the tumultuous 1960s, progressive and radical Mexican Americans rejected the hyphenation and began calling themselves Chicanos as an affirmation of an identity that was neither Mexican nor American. To be a Chicana or Chicano means you are trying to bring about social justice for your communities.

In the late 1960s, students walked out of high schools throughout the Southwest to protest the poor education they were getting in barrio schools; those who had managed to gain admittance to colleges and universities were often politically active as well. These students were mainly the children of working-class Mexican immigrants, born either in the United States or in Mexico. Their demands were often simple: "Teach us about *our* history, *our* culture, literature, heroes and heroines, not just about the Euro-Americans and Western European traditions." In their search for an identity they could relate to, the most radical elements of this emerging movement referred to the southwestern United States as "Aztlán," the mythical homeland of the Aztec peoples, and called for a return of the land. In other words, Chicanos would shout, "We didn't cross the border, the border crossed us!"

Anger and frustration were the driving forces behind the student movements throughout the United States, and this anger led to mobilizations and demonstrations on a national level. Yet the mainstream media basically ignored this movement and refused to draw attention to "those radical Chicanos," who, they

feared, were carrying machetes, if not firearms. Looking back at that time, it is dis-heartening to realize that, even when millions of immigrants and their supporters marched in every major city in 2006 and again in 2009, *nobody noticed.*

What could not go unnoticed were the efforts of the Farm Workers Union under the leadership of the late Cesar Chavez and Dolores Huerta, who gener-ated national and international attention as they revealed the horrors of the living and working conditions of the farm workers in the fields of California and other states. Out of their efforts and complementing their goals was born the Teatro Campesino, the Farm Workers Theatre, in 1965, under the guidance of a young Chicano named Luis Valdez.

The First Valdezian Chicano Family in Crisis:
The Shrunken Head of Pancho Villa

Luis Valdez was born in 1940 to a migrant farm worker family in Delano, Califor-nia: the very site that would become the first headquarters of the Farm Workers Union. The second of ten children, Valdez excelled in school despite the constant movement from farm to farm as his family followed the crops. He was admitted to San Jose State College at a time when very few Spanish-surnamed people were even graduating high school in California.[1] Valdez became an outspoken critic of injustices, a well-known and charismatic student speaker at political rallies, and a member of the first student brigade to Castro's revolutionary Cuba in 1964. This visit to Cuba (a life-changing experience) inspired him to write "[t]hat we support Fidel Castro as the real voice of Latin America, declaring to the world with dignity that social justice must be given to Latin America."[2] This statement would put him on federal watch lists for years to come. It was also a rallying cry to all Chicanos to see their struggles as part of a worldwide movement and to acknowledge and reject US imperialism in Latin America.

In 1964 the theatre department at San Jose State produced Valdez's first full-length play, *The Shrunken Head of Pancho Villa*, and his fate was sealed.[3] This iconic comedy is the first play by a Chicano about Mexicans living in the United States. The play is an absurdist look into the lives of a Mexican farm worker couple and their four children, living in California a generation after the Mexican Revolu-tion (1910–c. 1920). Although Valdez scripted the play, not a collective, I believe the work prepared the young playwright for his life in the theatre. The next step for the young activist was a yearlong stint in the San Francisco Mime Troupe's emerging Marxist collective. Four years later he described his amazement when he first witnessed the Troupe performing: "I'd been searching for something with the play [*Shrunken Head*], with my whole life as a Chicano ... So I walked out into that street that afternoon and there was the San Francisco Mime Troupe and it was fantastic: the light, the color, the sound."[4]

The San Francisco Mime Troupe: Basic Training 1964–65

The San Francisco Mime Troupe was founded by Ron G. Davis in 1959.[5] Having begun as a dance group, the Mime Troupe was very physical in its style. As their work evolved, they employed many of the conventions of the commedia dell'arte, as well as Brechtian techniques and Marxist analyses—important influences on Valdez's artistic and political development. Because the Mime Troupe performed their political sketches outdoors, using masks, farce, political satire, and a "Gorrila Marching Band," Valdez saw the efficacy of this style as a possible tool for educating farm workers about the need for a labor union. The physical, presentational style of the Mime Troupe seemed very fitting for a farm worker audience. Thus when he proposed starting a theatre troupe to Cesar Chavez and Dolores Huerta in 1965, they agreed, and the rest, as they say, is history.

El Teatro Campesino: Taking the Fight to the Fields

When he gathered a group of striking farm workers with the intention of interesting them in some sort of theatrical expression of their situation, Valdez had his work cut out for him. These people were mostly Mexican immigrants; some spoke only Spanish, while others, such as the Filipinos, did not speak Spanish, so imagery was most important. Knowing he would encounter linguistic differences, Valdez had brought commedia-style masks with him to help demonstrate the various "characters" who would eventually populate what he came to call "actos." Having learned from the examples of the political theatre and agitprop of the 1930s as well as from Brechtian *lehrstück* [learning pieces], Valdez asked the workers to demonstrate the conflicts that arose as a result of the strike. The nonactors, none of whom had ever studied theatre and perhaps had never even seen a play, had stories to relate and conflicts to expose and discuss. As one person tried to tell what had transpired that day on the picket line, Valdez asked if others had seen this, and when they had, he asked them to show everybody by imitating the event.

When people objected that they were not actors, Valdez reminded them that they were there on the picket line; they had seen this conflict, and he urged them to show everybody what they saw. Theirs was "the theatre whose stage is the street." Valdez had also brought cardboard signs that he could place around the necks of actors to define them ("Campesino," "Scab," "Grower," etc.) as they began to volunteer to play out the developing scenario. Masks, signs, and exaggeration all came into play as the farm workers–cum–actor/demonstrators collectively improvised and created the first dramatizations of the problems faced by farm workers and the union organizers.

Especially effective was the pig-face mask used to demonstrate the villains, whether the growers, their hired guns, or the farm labor contractors who would lose their cushy jobs should the workers succeed in unionizing a particular grower.[6] Thus was born the collective creation process guided by Luis Valdez, who had earned the trust of the workers, not only because he had also been a campesino, but because he did not dictate to them. He did not tell them what their

situation was like but instead asked them to tell him. Singing *huelga* (strike) songs and performing their actos gave this rag-tag troupe of striking farm workers hope and a sense of pride and ownership. The staged victories against the enemies were symbolic, at best, but the physical humor and the biting satire hit home. For a few moments, at least, these invisible workers, subalterns at the bottom of the socio-economic ladder, had a voice and could laugh at themselves and their enemies.

When the Teatro Campesino began to perform away from the fields, in schools, union halls, community centers, and universities, the troupe inspired other young activists to form their own teatros. In 1968, Luis Valdez's younger brother, Daniel, who had been a founding member of his brother's troupe, founded Teatro Urbano in San Jose, California, changing the focus from farm worker issues to the much broader needs of the majority of Mexicans and Mexican Americans who were urban workers. Lacking scripts, Daniel and his troupe collectively created actos about education, police brutality, and so on. His troupe, like the Campesino, employed many songs, original and traditional, that complemented and enhanced their performances. More teatros followed, and thus a national Chicano theatre movement was born. Teatros were popping up throughout the western United States and even Chicago, inspiring Valdez and his troupe to host the first Chicano Theater Festival in Fresno, California, in 1970.

We're Not Actors: Politics versus Aesthetics

What made the Chicano theatre movement unique, I believe, was the fact that the people who were in the midst of creating theatre that addressed a myriad of social problems had no historicoaesthetic framework on which to base their creative efforts. Chicanos, by virtue of their working-class, marginalized subjectivity, were not exposed to the wealth of Mexican theatre history and dramaturgy. In 1965 there were no published playwrights who were expressing the realities of life in the Mexican/Chicano barrios of this nation.

Also during this period, because of federally funded affirmative action programs like the Educational Opportunity Program (EOP), thousands of underrepresented and low-income students were given scholarships making it possible for low-income, minority students to enter universities and colleges. And due in no small part to the political climate of the time (think the civil rights movement, riots everywhere), minority students were admitted to universities across the country. The shock of this experience was one of the first themes addressed by the student teatros that began to emerge as the cultural and performative arms of the Chicano student organizations.

Chicano high school and university students had formed a national coalition of organizations calling themselves MEChA, an acronym for *El Movimiento Estudiantil Chicano de Aztlán* [Chicano Student Movement of Aztlán].[7] As a wing of the campus MEChA organization at University of California, Santa Barbara, the students called their teatro Teatro Mecha (a colloquial term for "match"). Santa Barbara holds particular significance, because a major manifesto was written there in 1970 titled *El plan de Santa Barbara*. Its collective authors wrote, "We take as our credo what José Vasconcelos once said at a time of crisis and hope: 'At this moment

we do not come to work for the university, but to demand that the university work for our people."[8]

It is no great revelation to state that theatre has been (and continues to be) a luxury—a pastime for the upper classes who can afford the time and the tickets to see professional theatre. Thus it was in Mexico and other Latin American and Caribbean nations. And if working-class Chicanos had been denied access to higher education prior to the War on Poverty and other social programs, now that they were enrolled in colleges and universities, they were certainly not going to pursue the theatre as a profession. Instead they wanted to bring about changes in "the system," changes that would improve the living and working conditions for their communities. Thus many of the students participating in the student teatros of the period were not theatre majors but were basically passing through, as it were, with no pretenses of doing theatre for the rest of their lives. Their focus was on educating—on politics rather than aesthetics, especially when the only models they had were the effective but rudimentary actos. These groups were collectives out of necessity, not because of any grand design.

The Radical Theatre Festival of 1968: Bringing It All Together

In 1968, three of the most important collectives of the time, the Bread and Puppet Theatre, the San Francisco Mime Troupe, and the Teatro Campesino, held a "Radical Theater Festival" at San Francisco State University. This historic event was documented and transcribed in a pamphlet in which the directors of the three companies—Ron G. Davis, Peter Schumann, and Luis Valdez—along with moderator Juris Svendsen discussed the nature of their collective work. According to all three men, the message was paramount. In Valdez's words, "That's the most important thing. You've got to have something to say or get off the fucking stage."[9] Echoing Valdez's declaration, Davis put it this way: "I've always said to myself that if the protest is more important than what we do in the theater, then we should go to the protest. That means we must do something very significant."[10]

Obviously, these theatre artists were not interested in the professional theatre. As Davis explained, "Yet we are not 'professional' in that we do not wish to end up on Broadway or commercial TV or on film. Our work springs from community and from ideological commitment."[11] And it did. In Schumann's words, "We don't have this big interest in theater . . . Most of the people in the company are not actors or mimes. Most come for political reasons. We actually have a hard time with actors, when we do get actors into the plays."[12] By now (1968) the Teatro Campesino had performed at the Théâtre des Nations in Nancy, France, as well as on the steps of the US Senate, bringing national and international attention to the farm workers' unionizing efforts.

The Long Road to a Collective: The Challenges of Building Trust

During this moment in time, with protests raging in the streets and on university campuses all over the world, trust was difficult to come by. It was common

knowledge among progressives that there were agents and provocateurs in every organization, and there was little or no trust of "the Man" after centuries of official lies and neglect. In January of 1970, in protest of the war in Vietnam, students from the University of California, Santa Barbara, burned the Bank of America in Isla Vista, the apartment community next to the campus. When my family and I arrived the following summer to begin my doctoral studies in dramatic art and to direct Teatro Mecha (which the reader will recall is Chicano slang for "match"), the irony of the name was not lost on me. I discovered a campus rife with anxieties and flush with a kind of symbolic success. All the radical students wanted to take credit for the burning; it was a badge of honor to have participated in that act of civil disobedience, especially against a corporate giant. Of course, Bank of America immediately built a fortress-like bank on the same site, but the protests persisted on campus and off.

I found myself teaching a course in Chicano dramatic literature with no plays or books about the subject in print. I also created a workshop in Chicano theatre, learning what a collective theatre is all about in praxis. Teatro Mecha was mainly a folkloric dance troupe, with only one member who was a theatre major. Many of the students had seen a teatro perform, and thus had an idea of what actos and protest songs were, but they had no experience in creating actos—neither did I. But as a former high school drama teacher and director, I certainly knew what it meant to direct a play.

For the dramatic literature course, I relied on the plays of the Black Revolutionary Theatre, attempting to make the transfer from the ghetto to the barrio. However, as Harry Elam Jr. affirms in *Taking It to the Streets*, his book comparing the early Teatro Campesino and the Black Revolutionary Theatre, their goals were often very distinct. Anger fueled both agendas, but the revolutionary and sometimes violent objectives of many Black Revolutionary plays were contrary to the farmworkers' movement, based on Cesar Chavez's Ghandi-inspired philosophy of nonviolence. Still, angry students had burned the Bank of America a few hundred yards from my classroom. Anger and frustration had to be contained if anything viable was to be accomplished.

In the workshop, theory and practice were to be put to the test: create theatrical statements about issues that were relevant to the creators, the majority of whom were the first in their families to go to college. Thus, just as Mr. Valdez had done in his first gathering of striking farm workers, I asked the students what they wanted to do and what changes they wanted to bring about. Access to higher education was prominent as a theme, as was the fact that all the students had been advised by their high school counselors or teachers not to go to college. Thus education became the common theme as we began to improvise scenarios I termed "The High School Counselor." While teaching high school, I had used Viola Spolin's significant work *Improvisation for the Theatre* and was able to employ many of her techniques and exercises with the students in my workshop. Over the next two quarters, we began to develop common goals and objectives for the class as well as for the teatro.

El Teatro de la Esperanza: Building Trust with the People

In the spring of 1971, the Teatro Campesino published their first anthology of actos, a volume that remains singular in its purpose and achievement. The collection traces the evolution of the Teatro Campesino's actos from 1965 to 1970, from farm worker issues (*"¡Si se puede!"* "Join the Union!") to the war in Vietnam ("Hell, no, we won't go!"). That same spring we formed a national coalition of Chicano theatres that we grandly called El Teatro Nacional de Aztlán [The National Theater of Aztlán], or by its acronym, TENAZ, which means "tenacious" in Spanish. In support of our new coalition-building efforts, Valdez and his company offered their newly published actos to any teatro who wanted to produce them, royalty free. The Campesino's actos also dealt with poor educational opportunities, the vendido stereotype, and a brief acto critiquing the Chicano movement, ironically titled "The Militants." Armed with these excellent actos, I directed the members of Teatro Mecha in *Los vendidos* [*The Sellouts*], *La quinta temporada* [*The Fifth Season*], and "The Militants." We produced these for one of the last meetings of MEChA that spring. As we expected, "The Militants" was not popular among the young leadership of the organization, undoubtedly due to the fact that the acto very effectively satirized the then current debate over what constituted a "true Chicano," as in, "I'm more Chicano than you are because I have a mustache!" It was prophetic.

Dissention in MEChA was brewing, and when half of the organization chose to join a community-based coalition that had taken over a warehouse in the barrio of Santa Barbara, which they called La Casa de la Raza [The Home of the People], they were expelled from the campus organization. I and six members of Teatro Mecha chose to join forces with the new student group, La Raza Libre [The Free People] in direct defiance of the campus Chicano leadership. And thus was born El Teatro de la Esperanza [The Theatre of Hope] in the spring of 1971.

The publication of the Teatro Campesino's actos marked a turning point for early Chicano theatre. The actos gave student groups everywhere a basis for their collective creations; some groups produced the actos verbatim, while others either adapted the actos to fit their specific political goals or used the published actos as models for their own collective creations. The antiwar movement was now in full swing and the antiwar actos in the anthology were being produced across the country to great acclaim, as were the other actos. The conventions of the Campesino's actos could now be studied and used effectively by other teatros and adapted to other urgent issues.

I and the members of the incipient, newly liberated Teatro de la Esperanza began working out of the Casa, converting a space at the back of the massive warehouse into an intimate theatre we called "El Nido" ["The Nest"]. Our vision was to create and nurture Chicano theatre in our little nest, a safe haven from campus politics, but not, we learned, free from community politics. We were also receiving funding from a federal grant that paid us to work with at-risk male teenagers, otherwise called juvenile delinquents. Our six high school dropouts were all on probation, and the administrator of our grant termed them "The Trust Company,"

an obvious allusion to the fact that these youths had lost the trust of their parents, teachers, and others.

It was our job to earn *their* trust, and we took the term seriously as we conducted theatre games with these skeptical, angry, young men, eager to see them create their own realities on stage. Thus we became like social workers, attempting to "rehabilitate" these hardened young men whose lives were nothing short of tragic. We were also rehearsing our own actos, written by my students in the Chicano dramatic literature course. One of the actos, titled *Trampa sin salida* [*Trap without Exit*], was about *pachucos*: East LA street youth not unlike our Trust Company members. The young men advised us on gesture, language, and attitude—especially attitude. Our intention was to involve the teens in our collective process, giving them a sense of purpose. Our work with the Trust Company boys introduced us to the social work aspect of Chicano theatre—a path that many students across the country took as they later worked in schools and other social programs throughout the West and Midwest in an effort to bring about social change through what we now term *applied theatre*, as seen in other chapters in this collection.

By the fall of 1971, the Teatro de la Esperanza had a core group of five serious drama majors: undergraduates who had been introduced to this thing called Chicano theatre and who saw teatro as a potential way of life. Vital to the group's aesthetic and political growth were workshops with Luis Valdez and members of his teatro. By now the Teatro Campesino members were living and working collectively in their new home of San Juan Bautista, a historic farming town south of San Jose, California. Like the Mime Troupe, the Teatro Campesino paid the company members small stipends that allowed them to focus on the development of the troupe and its aesthetic growth. By necessity everybody participated in all aspects of production, from preparing meals to cleaning the rehearsal space or designing and making props, scenery, and costumes.[13] The members of Esperanza saw this vibrant example of communal living and working as one model to emulate, but as full-time students they were not in a position to make that kind of commitment. As we observed the Teatro Campesino during this period, it was also clear that Luis Valdez was a very charismatic leader, almost a guru, whose singular vision guided the teatro. He had begun to write and direct his own plays with the company, but he was not writing in isolation. The collective process remained crucial to Valdez's artistic evolution.

Also important to the growth of Esperanza were the TENAZ festivals and workshops, crucial meeting places of other student and community-based teatros from throughout the United States, Mexico, and Puerto Rico. The workshops were conducted by people with experience in various aspects of theatre making from Ron G. Davis on commedia techniques to Luis Valdez and other directors and playwrights from Mexico and Latin America. The late Mexican playwright Emilio Carballido was especially generous in giving his time to conduct playwriting workshops as the more serious writers began to emerge from the collectives. Non-Latino companies, such as the Mime Troupe and the Provisional Theatre of Los Angeles, experienced influences from the teatro movement. The Mime Troupe began to hire Latina and Latino actors, and the Provisional Theatre collaborated with Teatro de la Esperanza on various productions in the 1980s.

Latin American Influences

The Latin American influences on Chicano theatre in general, and Esperanza in particular, cannot be overlooked. One such encounter occurred in 1972 at the First Latin American Theatre Festival in San Francisco, California, when the Esperanza members met Enrique Buenaventura (1925–2003) for the first time. The late Buenaventura was the founding director and playwright of El Teatro Experimental de Cali (TEC), one of Colombia's (and Latin America's) leading theatre collectives. Like Valdez, Buenaventura was the undisputed leader of his company, writing plays in collaboration with the members and also directing most of the plays. Through his work with the TEC, Buenaventura became an outstanding spokesman for a collective process that would influence many other groups and individuals. Like Valdez's troupe, the TEC members lived collectively.

The play the TEC presented was *La orgía* [*The Orgy*]: one of Buenaventura's most produced plays to date.[14]*La orgía* is a parable in which a destitute, aging courtesan relives fantasies of her youth by paying street beggars to reenact real or imagined characters representing her lost lovers. The characters, who represent the hegemony, end up murdering the old woman, leaving her mute son alone in his desolation. The stage directions are unclear whether her son actually speaks the following, but the text reads, "Then he goes to the front of the stage and asks the audience, "Why, why did this all happen . . . Why?"[15] Metaphor, symbolism, guignol—the Western European influences are clear in this critique of colonialism and hegemonic structures in Colombia (and elsewhere). The production was riveting and challenging, an example of the excellent, professional, social protest theatre of Colombia. The acting, design elements, and dramaturgy gave the members of Esperanza new goals to achieve as they searched for forms beyond the acto.

The play Teatro de la Esperanza produced at this festival contrasted sharply with the sophistication of the TEC: a frothy little one-act comedy titled *Brujerías* [*Witchcraft*],[16] written by Rodrigo Duarte-Clark for my Chicano dramatic literature class. In his remarks about the play and the production, Buenaventura told the members of the teatro that as we became more specific in our themes we would become more universal. We left that festival energized and newly committed to a life of teatro as we drove down the Big Sur coastline back to Santa Barbara. The Teatro Campesino had provided us with a Valdezian vision of the Chicanos' existence told in broad, comic sketches; the TEC had introduced us to a much more complex and challenging form of playwriting and praxis—a practice and political analysis that would inform subsequent productions.

The teatro members continued to be involved in the ever-growing TENAZ coalition, sharing techniques and learning from the workshop leaders and the productions that we would witness at the festivals. The Fourth Chicano Theater Festival was held in San Jose, California, in 1973 and attended by teatros and representatives of more than fifty troupes from across the country, as well as Mexico and Puerto Rico. For many TENAZ members, the highlight of that festival was the Teatro Campesino's performance of *La gran carpa de los Rasquachis* [*The Great Tent of the Underdogs*], a landmark piece of collective creation guided by Luis Valdez's progressively sure hand.[17] This festival led naturally to the largest festival the

TENAZ leadership had yet organized, El Quinto Festival de los Teatros Chicanos: Primer Encuentro Latinoamericano [The Fifth Chicano Theatre Festival: First Latin American Encounter]. Held for two weeks in Mexico City and environs, the Quinto Festival was a culture shock for all involved. Political debates raged around certain productions, but most important, Latin Americans were introduced to the Chicanos, who they saw as surviving *en la barriga del monstruo* [in the belly of the monster]. Further, the Chicanos were introduced to the works of Augusto Boal, Alan Bolt of Nicaragua, and a host of other vital instigators of what was termed El Nuevo Teatro Popular [New Popular Theatre]. These men and women were battling US imperialism and horrible oppression in their countries, yet they managed to (barely) stay alive and critique the sociopolitical situation. Their politics were founded in centuries of oppression; their theatre sprang from university theatre and their Western European roots.

The Chicano Docudrama: *Guadalupe*

By the fall of 1973, Teatro de la Esperanza had coalesced into the collective that would create one of the hallmarks of early Chicano theatre: *Guadalupe*, a docudrama based on an actual incident in 1972–73. In fact, this was the first docudrama created by Chicanas and Chicanos, due in no small part to the influences of all that had preceded its creation: workshops with world-renowned directors and playwrights, varied and various performances by the Brechtian-influenced Latin American and US theatre companies, and practical knowledge the theatre majors in the group had acquired during their studies. The play revolves around a group of Mexican farm workers in the town of Guadalupe, an hour's drive from Santa Barbara. The schools in this rural town of about one thousand inhabitants were not treating the majority Mexican students with respect: punishing them for speaking Spanish, offering no bilingual education, and the like. When a parents' committee was formed, the power structure opposed their efforts in typical fashion, to the point of arresting three of the parents who had organized a protest against the school board. The US Commission on Civil Rights investigated the situation and wrote a scathing report titled "The Schools of Guadalupe: A Legacy of Educational Oppression." And the teatro members used the subject matter for their next production.

In their own version of ethnography, the teatro members visited the town of Guadalupe, meeting with the parents and others who had been affected by the neglect of the hegemony, as they gathered material for their play. They interviewed the parents as well as the students and even attended mass at the local Roman Catholic parish to see what the priest, a Spanish missionary, had to say. Everybody in town knew that these "radical" Chicano students were up to something, including the priest, who unceremoniously admonished his congregants (in Spanish): "Those of you who follow Cesar Chavez will go directly to Hell!" The group returned to the rehearsal hall with conflicts and scenarios rife for dramatic interpretation. Of course, they included a scene in the little church, quoting the priest, an aging but living vestige of colonization. The group would select a

conflict to dramatize, determine the objectives of each character and the scene itself in regards to the evolving play, and then improvise the scene. The actors would alternate while others took notes, selecting dialogue that would best serve the needs of the scene, and then one person would script the scene and bring it back to rehearsal. In this manner, everybody participated in one aspect or another, including in directing a scene, although I was the principle director. In 13 scenes, interspersed with choral transitions that narrated the action, the teatro told the story of a community under siege.[18]

La víctima: A Model of Collective Creation

After a very successful tour of the provinces of Mexico with *Guadalupe*, it was time for me and my wife, Ginger (musical director and business manager), to step aside and let the Esperanza members continue to create exciting and necessary theatre without us. The core members had been with the troupe since its inception and were now ready to take on the paradigm of a true collective, one in which all voices participated in the creative and directorial process. In Mark S. Weinberg's words, "Perhaps most significant was the development of a collective process and the departure of Jorge Huerta. [José Guadalupe] Saucedo, in a typically self-deprecating fashion, described the decision to become a collective in terms of an equality of ignorance among group members as well as a collective feeling fostered by the type of training and group decision making under Huerta's directorship."[19]

Saucedo was being self-deprecating; I was confident that he and the other core members were now equipped to tackle the responsibilities of a collective without a singular director. Moreover, I was not a dictator, nor a guru, and as the group evolved it was clear that the truly serious members of the teatro were learning all aspects of production, including direction. My wife and I knew that it was time to move on; it was time for me to document and produce Chicano theatre as social commentary through a university position, since I now understood the opportunity and the responsibility of being the first Chicano to earn a doctorate in theatre.

Working under the same model we had established with the creation and staging of *Guadalupe*, the teatro members collectively wrote and directed an even more successful docudrama, *La víctima* [*The Victim*], which combined fact with fiction to explore the recurring problem of mass deportations of Mexicans when the US economy is in trouble (sound familiar?). The factual aspects of the play were detailed in the historical reality that in the 1930s, during the Great Depression, the federal government blamed Mexicans and thus deported them in large numbers, breaking up families regardless of the fact that the children were born in the United States. Consequently, the play follows the life of a young Mexican girl whose family flees Mexico during the Revolution; she grows up in the United States, marries, and has two children. In a riveting and dramatic scene, the mother is separated from her little boy at the train station. Holding her baby girl in her arms, she screams for her boy on the other side of the stage, looking for his mother. Freeze. A guitar strums and another Mexican *corrido* ushers us into the next scene.

The actors remain on stage throughout the production, sitting on the sidelines, watching the action, and changing minimal costume or prop accessories while a new scene unfolds in the life of the little boy, Sammy. Sammy is adopted by another family, fights "those commies" in Korea, and becomes a border patrol agent. In the final scene of the play, Sammy finds himself interrogating his mother and deports her even though he knows instinctively who she is. This play was premiered in 1976, toured the United States and parts of Europe, and has been produced by various Latino theatre companies. Given the xenophobia that currently reigns in the United States, the Los Angeles–based Latino Theater Company produced *La víctima* in 2010—living proof of the docudrama's efficacy and urgency.

Conclusion: "Sinvergüenzas"

While most of the theatre collectives being discussed in this collection were started by people with at least some training in the art—those who knew about the practice and politics of making theatre—the Chicanos who formed the early teatros were distinct. The mostly young people who attempted to emulate the Teatro Campesino and/or other emerging teatros were novices at making any kind of theatre. Thus they wrote their actos out of necessity, sometimes creating skits overnight to suit the next day's political rallies. They were unsophisticated, raw, and *sinvergüenzas* [shameless]: a common term used by Mexicans to describe audacious behavior. This shamelessness allowed these incipient theatre practitioners to go beyond the norm, for they had no sense of what "the norm" was. In effect, they were "thinking outside the box" without ever having "the box" in the first place. But with the creation of the Chicano Theatre Movement in the early 1970s, these young people could begin to learn from the more experienced practitioners, essentially becoming part of a larger collective.

If university theatre departments were not going to offer classes in Chicano theatre as practice and literature, then the students had to seek assistance outside the university campuses, even as they immersed themselves in campus politics as student leaders and activists. Most of the people who were involved in TENAZ and nonaffiliated teatros went on to become professionals: professors, doctors, lawyers, teachers, community activists, and so on. But their experiences in the collective processes of Chicano theatre will stay with them forever, as they continue to seek social justice for all.

Bibliography

Acuña, Rodolpho. *Occupied America: A History of Chicanos.* 3rd ed. New York: Harper and Row, 1988.

Bagby, Beth. "El Teatro Campesino: Interviews with Luis Valdez." *Tulane Drama Review* 11 (Summer 1967): 70–80.

Brecht, Bertolt. "On the Everyday Theatre." In *Poems on the Theatre*, 5–9. Translated by John Berger and Anna Bostwick. Suffolk: Scorpion Press, 1961.

Broyles-González, Yolanda. *El Teatro Campesino: Theater in the Chicano Movement*. Austin: University of Texas Press, 1994.

Buenaventura, Enrique. *La Orgía*. In *Colombian Theatre in the Vortex: Seven Plays*, edited by Judith A. Weiss, 199–213. Lewisburg, PA: Bucknell University Press, 2004.

Clark, Roderigo Duarte. *Brujerías*. In *El Teatro de la Esperanza: An Anthology of Chicano Drama*, edited by Jorge A. Huerta, 39–62. Santa Barbara: El Teatro de la Esperanza, 1973.

Davis, R. G. *The San Francisco Mime Troupe: The First Ten Years*. Palo Alto: Ramparts Press, 1975.

Elam, Harry J., Jr. *Taking It to the Streets: The Social Protest Theater of Luis Valdez & Amiri Baraka*. Ann Arbor: Michigan: 1997.

Guerra, Victor. "An Interview with Rodrigo Duarte-Clark of El Teatro de la Esperanza." *Revista Chicano-Riqueña* 7, no. 1 (Spring 1983).

Huerta, Jorge A. *Chicano Theater: Themes and Forms*. Phoenix: Bilingual Press, 1982.

———. ed. *Necessary Theater: Six Plays about the Chicano Experience*. Houston: Arte Público, 1989.

———. *El Teatro de la Esperanza: An Anthology of Chicano Drama*. Santa Barbara: El Teatro de la Esperanza, 1973.

———. "El Teatro de la Esperanza: Keeping in Touch with the People." *The Drama Review* 21, no. 1 (March 1977): 37–46.

Kourlisky, Françoise. "Approaching Quetzalcóatl: The Evolution of El Teatro Campesino." *Performance* 2 (Fall 1973): 37–46.

El plan de Santa Barbara. Santa Barbara: La Causa Publications, 1970.

"Radical Theatre Festival." San Francisco Mime Troupe, 1969.

Shank, Theodore. *Beyond the Boundaries: American Alternative Theater*. 2nd ed. Ann Arbor: University of Michigan Press, 2002.

Spolin, Viola. *Improvisation for the Theatre*. Evanston: Northwestern University Press, 1963.

Steiner, Stan, and Luis Valdez, eds. *Aztlán: An Anthology of Mexican-American Literature*. New York: Vintage, 1972.

Verdugo, Jaime. *Trampa sin salida*. In *El Teatro de la Esperanza: An Anthology of Chicano Drama*, edited by Jorge A. Huerta, 12–27. Santa Barbara: El Teatro de la Esperanza, 1973.

Versenyi, Adam. *Theatre in Latin America*. Cambridge: Cambridge University Press, 1996.

Weinberg, Mark S. *Challenging the Hierarchy: Collective Theatre in the United States*. Westport, CT: Greenwood, 1992.

Weiss, Judith A., , and , ed. *Latin American Popular Theatre*. Albuquerque: University of New Mexico, 1993.

Notes

1. See the US Census for 1960, when 80 percent of Spanish-surnamed people were not going beyond the eighth grade in California.
2. Stan Steiner and Luis Valdez, *Aztlán*, 218.
3. *The Shrunken Head of Pancho Villa* continues to charm and delight audiences. See Bibliography for publications of this play.
4. "Radical Theatre Festival," 19.
5. For a more complete discussion of the San Francisco Mime Troupe, see Chapter 11 in this collection.
6. For more on the incipient Teatro Campesino and the troupe's early actos, see Beth Bagby, "El Teatro Campesino: Interview with Luis Valdez"; Jorge A. Huerta, *Chicano*

Theater: Themes and Forms, 12–27; and Luis Valdez, *Early Works: Actos*, and *Bernabe and Pensamiento Serpentino*.

7. For more on the Chicano student movement of the 1960s and 1970s, see Rodolfo Acuña, *Occupied America*, 333–38 and 391–92.
8. *El plan de Santa Barbara*, 11.
9. Luis Valdez, "Radical Theatre Festival," 22.
10. R. G. Davis, "Radical Theatre Festival," 30.
11. R. G. Davis, "Introductory Note," in "Radical Theatre Festival," 7.
12. Peter Schumann, "Radical Theatre Festival," 22.
13. It is important to call attention to Yolanda Broyles-González's critique of this period regarding the role(s) of women in the Teatro Campesino (*El Teatro Campesino: Theater in the Chicano Movement*). The women she interviewed for her book were mostly very critical of the casting of women and the general machismo of the company, with Luis Valdez receiving the brunt of their and the author's critiques. Women whom Broyles-González did not interview have personally told me that "it wasn't that bad," but their views are not on the historical record and will remain anonymous here.
14. See Bibliography for publications of Buenaventura's *La Orgía*.
15. Judith A. Weiss, ed., *Latin American Popular Theatre*, 213.
16. See Bibliography for publications of Clark's *Brujerías*.
17. For a paradigmatic analysis of the Teatro Campesino's *Gran carpa de los Rasquachis*, see Françoise Kourlisky, "Approaching Quetzalcóatl: The Evolution of El Teatro Campesino."
18. See Bibliography for publication of Teatro de la Esperanza's *Guadalupe*. For more on this docudrama and its impact, see Huerta, "El Teatro de la Esperanza: Keeping in Touch with the People," and *Chicano Theater: Themes and Forms*; and Mark S. Weinberg, *Challenging the Hierarchy: Collective Theatre in the United States*, 63–67.
19. Weinberg, 67.

13

Collective Creation in Quebec

Function and Impact

Jean-Marc Larrue

Although collective creation transcended national borders and became a truly international movement, the various parts of the world where it emerged did not experience it in the same fashion, nor did the movement have the same impact or meaning in different regional contexts. Associated with the counterculture movement that began with the Algerian War (1954–62), peaking with the May '68 upheavals, and ending with the withdrawal of all American troops from Vietnam in 1975, collective creation in Quebec was also part of an unprecedented liberation movement involving Francophone Quebecers. This movement manifested itself in Quebec in two ways: the assertion of the distinctive character of Francophone identity, and a search for greater political, economic, and cultural independence in an environment dominated by Anglophones across Canada and the rest of North America. This merging of counterculture ideology with postcolonial dynamics was the source of the particular nature of Francophone collective creation in Quebec, and it accounts for its historical importance.[1]

Ever since the collective creation of plays blossomed as a theatrical practice in the 1960s, it has increasingly established itself as a powerful movement in postmodern and contemporary theatre—perhaps the most powerful in terms of the questions raised; the creation- and production-related processes engendered; and the experiments initiated on new relationships to space, the body, the object, acting, the "other" (the audience), the protagonist, and the "text," which have left a palpable mark on most theatrical forms. Of course, collective creation, as a movement, has not yet ended and has left more than just traces! There are a few great groups left over from those tumultuous times, such as The Living Theatre and Théâtre du Soleil, and these groups, despite their multiple metamorphoses, which the most orthodox commentators would describe as heresies, still stand as canonical figures. And what is more relevant are the so-called direct heirs of collective creation, such as Pig Iron or Robert Lepage, who are still on the rise with unabated vitality. Above all, there has been a marked return to the "collective" approach—no

longer the "communes" of the 1960–70 period, but rather grassroots groups that take the stage here and there to defend what they are, what they want, or even just to express themselves.

Indeed, what we are witnessing in these first decades of the twenty-first century is a genuine resurgence of intervention theatre, community troupes, and regional theatre, whose activities are being increasingly covered in the theatrical press.[2]

The phenomenon of globalization that has characterized so much of contemporary life has undoubtedly played a part in this development, since globalization not only eliminates—or tends to eliminate—boundaries but also standardizes how space is organized and negates cultural differences. And this leads to push-back, as people arise to defend their particular heritage, culture, language, or way of life—in short, specific features of their lives that would otherwise be ignored or swept away. That is why asserting a specific identity was precisely one of collective creation's primary objectives in the 1960–70 period, in terms of giving a voice to people who did not have one. Admittedly, times were somewhat different then, since, although the globalization process had already begun, it was less obtrusive, and that generation had other priorities, particularly the overthrow of the old order of colonialism, marginalization, elitism, hierarchy, and privilege. Such goals were easier to achieve in a group than alone. Nonetheless, both yesterday and today, the collective approach remains the most effective way for theatre to define, assert, defend, and impose an identity that the prevailing "system" at best ignores or at worst ridicules and belittles.

It is from this particular perspective of identity assertion that I want to address the origins and early evolution of collective creation in Quebec. While such an approach might seem reductionist, particularly given collective creation's tremendous contribution to both theatrical practice and Quebec society in general, the impulse to assert their identity has continually galvanized Quebec's "best and brightest" from the early 1960s to the early 1980s (i.e., from the Quiet Revolution,[3] with its slogan of "masters of our own house," to the first separatist referendum[4]) and stimulated the most vigorous debates. While this assertiveness was due to Francophone Quebecers' awareness of their potential in all fields (political, economic, artistic, and so on), they felt that in order to realize their potential they had to exorcize their old demons and fears,[5] and expose themselves fully with the confidence to assert themselves against the dominance of Anglophones in economics and politics and the dominance of the French in culture thanks to the models inherited from modernism. While all this might seem relatively clear now, things at the time were much more confused.

The Issues of Collective Creation in Quebec

Let's start with this era,[6] which indeed corresponds to one of the richest and most turbulent phases of collective creation in Quebec. But what is collective creation? In an ambitious research project on the subject in the late 1970s,[7] Fernand Villemure proposed an initial, no doubt overly cautious definition as a direct reaction to what he was seeing: "Collective creation is artistic creation by

several people/authors. It is a theatrical piece in which the actors are more than just the interpreters of the text of a single author, because they help develop the content and/or form of the show concerned. They are author-actors."[8]

Lorraine Hébert, herself a driving force and careful observer of the era, has added the essential dimension of improvisation to this first rough definition: "So, what is meant by collective creation is any group production in which the actors are more than just interpreters (primarily through use of improvisation), and all the participants contribute to developing the production."[9]

In general, this is how collective creation is presented these days in most historical books and theatre dictionaries dealing with the topic. These definitions emphasize a creative process that primarily stems from group improvisation and that challenges the relationships among artists that traditionally form the basis of the practice, including those between authors, actors, and directors. Even for Quebec observers and historians, collective creation is thus first presented as an antidote to specializations and the old hierarchies: the puppet-actor, instrument-actor is no more and is replaced by the responsible actor, master of his or her words and body. This egalitarian and democratic conception of the actor—theatre-historian Roy Montgomery upholds the concept of "ultrademocracy,"[10] very typical of 1960s idealism—has clearly Marxist connotations, as reflected in this resounding statement by Jean-Claude Germain, one of collective creation's dominant figures in Quebec: "We actors were no longer going to put on those purple, Oriental robes to seduce you in your comfortable, perfumed palaces. We were declaring the independence of the actor—emancipation from the degradation of the actor-worker's lot. Out of the weird brothel-prisons and into the streets and the world, we are leaving those disreputable areas behind."[11]

Those Quebec actors, who left the well-worn paths of existing theatre, rejected and fled the "disreputable areas"—the traditional companies and theatres and what led to them (theatre schools)—were generally in their early twenties. To clearly set themselves apart from the "other" theatre and be recognized as such, they described themselves as "Jeune Théâtre" ["Young Theatre"]. This revolt against the dominant form of theatre clearly reflects a generation gap. Although the name Jeune Théâtre became more clearly defined over the years as the movement underlying it became institutionalized, collective creation and Jeune Théâtre were practically synonymous in the beginning, with the latter serving as the banner for the former.

However, to return to the "disreputable areas," while these were the same everywhere, there was an aggravating factor in Quebec: What did they offer Quebecers who went to such despicable places? Outdated, "fraudulent,"[12] bourgeois or decadent shows for sure, as everywhere else. However, the aggravating factor in Quebec was that these shows came from elsewhere—France, England, and sometimes the United States—and what was worse, the words came from elsewhere with a sensibility from elsewhere and were spoken by characters from elsewhere. The language that Francophone Quebec audiences heard on their stages was, in fact, different from their everyday language: It was the French of France or an "international" French that no one actually spoke, and the plays presented were primarily European plays presented in their French version (from France). As for Quebec drama,

it mostly embraced the French model. As a result, despite the surge of a new gen-
eration of dramatists, such as Gurik, Barbeau, and Loranger, stimulated by the
very recent triumph (1968) of Michel Tremblay's *Les Belles-soeurs*,[13] the Quebec
stage did not at all reflect the reality of its spectators. It was as if the daily language
and universe of Francophone Quebecers had been banished from their theatre.[14]
In short, Quebecers in the 1960s did not have the words to express themselves.

And it is truly this quest for an original language, firmly and collectively
adopted as a reflection of the day-to-day experience of Francophone Quebec-
ers, that is the distinctive characteristic of collective creation in Quebec in these
tumultuous years and that accounts for Jeune Théâtre's vigor, development, and,
to some extent, success. Jeune Théâtre was thus certainly not a marginal or ephem-
eral phenomenon, given that from 1972 on, the collective creation productions of
the young troupes were more numerous than those of the institutional theatres.

The urgency to acquire an original dramaturgy—written in the Quebec ver-
nacular or improvised by Quebec characters—gave the movement tremendous
momentum. Jacinthe Potvin, a theatrical practitioner and a member of the
Théâtre de Carton (a group specializing in theatre for young audiences), offers
enlightening comments as to how Jeune Théâtre was very clearly different from
Living Theatre, Grotowski, or Open Theater:

> We now need to launch our own words (Quebec French) into the world. Everyone
> needs to have the opportunity to discover the theatrical dimension of our daily lives.
> We need to free ourselves from all the dominations and tyrannies that have surrepti-
> tiously or overtly infiltrated our culture and art. We have to dislodge idols . . .
>
> In the mundane story of our lives, there is an urgent need to create theatre
> because, from now on, we would like to speak to people in their own language, the
> language of their actual experience in the here and now. And since this kind of the-
> atre does not exist, it is up to us to create it![15]

It was necessary then to not only create a new kind of theatre, which reveals
what we are in terms of "the theatrical dimension of our daily lives," but also do
so away from the "disreputable areas" where the language and theatricality of the
daily life of "others" reigned. The issues became more complicated and confused,
since the creation of a new type of theatrical performance called for a redefinition
of theatrical space. Indeed, to what more appropriate places could one go in order
to express to people the "theatrical dimension of their daily lives" in their own ver-
nacular? Wherever people find themselves—in other words, in their streets, villages,
schools, and factories—no matter where but, at all costs, not in the "disreputable
areas" of the institutional theatres. Those were the theatres that, as Jean-Claude
Germain recalls, "have prudently not taken a position or even acknowledged
the political, economic and social turmoil that has shaken up Quebec" and that,
"declining any responsibility," have made themselves the "irresponsible inter-
preters of a universal cultural truth"[16] now considered to be alienating. On the
other hand, the Jeune Théâtre artists were "responsible," and if they chose to
create—and speak—collectively, it was because they found that approach to be
more effective. Unlike The Living Theatre, which launched itself into collective

creation in 1964 because it could not "go back to the old order of the theatre,"[17] the young Quebec artists that devoted themselves to collective creation between 1969 and 1985 had not experienced the "tyranny" of either the author or the director; they had only known the "tyranny" of foreign theatre: "[C]reating collectively was a necessary choice because such unison is deployed in the convergence of our concerns that we urgently need to speak with a common voice."[18]

These remarks lead to an initial conclusion. While participating in the broad movement of artistic, social, political, and moral protest that shook the entire Western world, Quebec collective creation was nonetheless initially different because of its wish to create a national dramaturgy—in other words, a dramaturgy in which ordinary spectators could recognize themselves and become aware of their own reality. This was understandably a popular form of theatre, which explains why certain collective creation groups opted for the more militant practice of intervention theatre.

Jeune Théâtre's Flagship Troupes: A Brief Account of the Beginnings

The history of collective creation is neither simple nor linear, and it would be pointless to look for a "premiere." As has been discussed elsewhere in this book, collective creation has deep roots that go way back beyond the hippy generation and, in fact, lie in the field of transhistorical social phenomena. Nevertheless, one of the first landmark moments in Quebec collective creation occurred in September 1969 when a collective called the Théâtre du Même Nom (TMN), which was founded and directed by Jean-Claude Germain, presented its play *Les Enfants Chénierdans un autre grand spectacle d'adieu* in a small Montreal auditorium. The collective's initials—TMN—were full of irony, because they indirectly referred to the Théâtre du Nouveau Monde (TNM), the most important and prestigious theatrical theatre in Quebec—in short, "the disreputable area par excellence."

This TMN show, which was presented in an empty space, portrayed the theatrical world itself, thereby taking revenge on the "grand," unmistakably foreign repertoire. In other words, the TMN was clearly on the path defined by Jacinthe Potvin that would lead to the development of a new form of Quebec dramaturgy. It was like a wrestling match in which *Les Enfants Chénier dans un autre grand spectacle d'adieu* pitted Les Enfants Chénier [the Chenier children] of "original"[19] Francophone Quebec stock "in the left corner" against the champions of France and High Culture (Molière, Musset, Giraudoux, etc.) "in the right." The outcome of this match was naturally a foregone conclusion.

First Round

Marivaux steps forward hesitatingly. TMN's Jean-Luc Bastien and Louisette Dussault of TMN look at him with amusement. With the help of Nicole Leblanc and Gilles Renault, they rapidly overpower him. Marivaux becomes short of breath. He puts out his tongue. He starts to look ridiculous. All this is quickly followed by an arm-lock

and a trip-up. Marivaux gives up, is thrown to the ground and suddenly looks very old . . .[20]

The other major figures of the universal theatre palpably underwent the same fate. *Les Enfants Chénier dans un autre grand spectacle d'adieu* not only ridiculed and attacked institutional theatre—the dominant theatre, the "theatre of others" and their defenders; it also offered a radical new form of theatre—at least in the eyes of most of the spectators present—that was based on the configuration of the space, the acting, the gestural vocabulary, the music, and the relationship with the audience.

Michel Bélair, an influential critic of the time, justifiably ranked this production among the landmark events of Quebec's cultural history, attributing to it the same significance as the creation of *Les Belles-soeurs*.[21]

With this show, the TMN established the principle of the "economic aesthetics" (Germain's term), which subsequently characterized all Jeune Théâtre productions until the early 1980s. These "economic aesthetics" were, in fact, only a local variant of Grotowski's "poor theatre" and the totally bare stage that Peter Brook advocated. From the outset, much of collective creation has thus, in fact, focused its meager resources and complete attention on the actors, hence the emphasis on all components of acting (particularly its physical dimension) and the importance given to costumes, props, and the sound environment. And, as Artaud recommended, there was no scenery as such. This kind of minimalism was clearly not the exclusive preserve of Jeune Théâtre—quite the contrary, since the same went for the vast majority of collective creation troupes from San Francisco to Algiers. This aesthetic choice, which was not truly a choice but rather a necessity[22] (since it was initially motivated by the scarcity of the troupes' resources), was endorsed by The Living Theatre, thereby endowing it with unquestionable political and artistic value: "We need to work with meagre resources because we need to confront the established power with such resources; we will overthrow it with ingenuity and invention—with our superior intelligence and convincing beauty."[23]

After the resounding success of *Les Enfants Chénier dans un autre grand spectacle d'adieu*, the TMN explored the theme of the ordinary Quebec family in *Le Grand rallye de canonisation d'Aurore l'enfant martyre (ou Aurore 1)*,[24] including elements of folk culture in the performance that took the form of a ritual celebration. Then right in the middle of the events of October 1970,[25] the group created *Aurore II ou la Mise à mort de la Miss des Miss*, a brutal criticism of Quebec society in which music played a prominent role.

This leading troupe in the history of Quebec collective creation was dominated by Jean-Claude Germain, who was not only its founder and the main author of its texts but also the director of its shows. This vaguely outlined status as "actor-ideator-director"[26] or "centralizer-coordinator-regulator"[27] was not a unique case. In fact, with Nicole Leblanc, his partner on stage and in life, Germain formed what Montgomery calls "a pair bond"[28]—a generally older or more experienced couple who led the group, infusing it with their spirit and orienting its approach. And therein lies one of the main well-known paradoxes and challenges of the collective creation of the time: how to combine a profoundly egalitarian ideology with a

form of operation that almost inevitably led to a certain form of authority. While the TMN was not immune to the fragmenting pressures of the "authority crisis"[29] experienced by most collectives of the time both in Quebec and elsewhere, it did not succumb. The TMN's association with Jean-Claude Germain, like Megan Terry's or Jean-Claude van Itallie's with The Open Theater, for example, shows that collective creation could come to terms with the presence of an author.

Although the TMN offers the example of a collective creation troupe that gave one of its members particular status, the Grand Cirque Ordinaire (GCO), another flagship Jeune Théâtre troupe, upheld the principle of absolute equality and rejected, at least in theory, all forms of leadership.

Made up of actors[30] from professional theatre schools (and sometimes in disagreement with these schools[31]) who grouped around Raymond Cloutier, the GCO also came into existence in 1969. The GCO differed from the TMN in two respects: first, it was a touring troupe supported and funded by an institutional theatre,[32] whereas the TMN was sedentary and based in Montreal; and second, the GCO led a genuinely communal life—at least from September 1969 to December 1971. Like The Living Theatre, the GCO was a group both in life and on stage. In the spirit defined by Grotowski, the GCO created a form of popular theatre in which the actors had real roles as creators and were able to improvise in both designing and performing the troupe's shows.

The troupe's first creation, *T'es pas tannée, Jeanne d'Arc?*, is definitely the most significant play of this entire period—the Quebec equivalent of The Living Theatre's *Paradise Now*. On the basis of an outline produced by Raymond Cloutier after three weeks of open workshops during which the members explored all the acting techniques they knew, ranging from Stanislavski and The Living Theatre to The Open Theater and Grotowski, *T'es pas tannée, Jeanne d'Arc?* blended circus, singing, puppets, monologues, and improvisations (which originally constituted 70–80 percent of the show) with excerpts from Berthold Brecht's *The Trial of Joan of Arc at Rouen, 1431*.

Premiering in Pointe-Claire (a mostly Anglophone suburb west of Montreal) on November 13, 1969, the play was subsequently performed more than 180 times throughout Quebec and even made into a film:[33] "The show opens with a circus parade to the sound of drums, horns and trumpets [all the troupe's members are musicians]; the music, singing and dance continue to alternate with the dialogue and recitations in a whole that recreates the atmosphere of a popular festival. As in a circus where clowns perform tumbles and tomfoolery to make fun of the audience between the acrobats' somersaults and tightrope walking, the actors alternate periods of greater and weaker intensity with stretches of tragic tension or bursts of comic joy."[34]

The play, which portrayed Joan of Arc more as a symbolic character than a historical one, draws a parallel between the historical circumstances leading to her trial and condemnation and Quebec's sociopolitical situation in 1969: allegorical characters wearing enormous masks—the Church, the Invader, Justice—lead Joan to her death.

The play mixes the considerably modified historical account of Joan of Arc with scenes featuring ordinary Quebecers. As in the TMN's plays, both the language

and world of Francophone Quebecers are omnipresent. After *Jeanne d'Arc*, the GCO created *La Famille transparente* in 1970, based on an episode in its first show. This was followed by *Alice au pays du sommeil* [Alice in Sleepland], "a children's story but based on the events of October 1970," and lastly *T'en rappelles-tu Pibrac?* on the situation of hundreds of thousands of unemployed Quebecers. All these productions, in which improvisation played a key role, continued the sensitizing and awareness-raising process begun with *Jeanne d'Arc*. The GCO not only revived forms and addressed themes that had previously been ignored on Quebec stages; it also endeavored to reach remote audiences off the regular touring circuits. And it aspired to create a new relationship with this audience based on their participation in the show—hence the idea of the circus as well.

However, exhausted by two years of travelling and communal life as well as by internal tensions caused once again by interpersonal conflicts over issues of authority and privilege, the GCO suspended its activities between December 1971 and February 1973, before continuing as an actors' cooperative until it took another break between April 1974 and April 1975. The troupe gave its last show in 1976, precisely at the time when the Parti Quebecois won the provincial election. The GCO's brilliant and highly irregular career testifies to the difficulty of living collective creation without any compromise.

Both the TMN and the GCO truly acted as pioneers, opening up theatrical pathways that had not previously been explored in Quebec and demonstrating that another kind of theatre was possible. They exerted a considerable influence on young artists, who were quick to follow in their footsteps. This influence was particularly strong because both groups had professional ambitions. The TMN offered the example of a relatively united group dominated by a leader, whereas the GCO personified the egalitarian ideal—an ideal that explained the importance of improvisation in both creating and performing shows. One of the GCO's last productions,[35] *La Stépette impossible* (1975), is totally improvised. Another note-worthy and distinctive feature of the GCO is that it never stopped questioning its own practice and challenging its directions. According to the members, although artistic and ideological reflections occupied an inordinately large place in the group's life, the GCO clearly owed its energy and daring to these reflections.

Théâtre Euh! and Militant Collective Creation

Emerging from the same movement as the TMN and the GCO, Théâtre Euh! was jointly founded in Quebec City in 1970 by Clément Cazelais, who had recently graduated from the Conservatoire, and Marc Doré, one of the pioneer teachers of improvisation in Quebec. This group both established and demonstrated the prac-tice of political militantism within Jeune Théâtre. The founding of Théâtre Euh! is thus a key moment in the early history of collective creation in Quebec, and the path followed by this radical group during its eight years of existence is more or less representative of the career of many militant creative collective troupes in Montreal, Quebec City, or elsewhere. At the outset, these troupes were not significantly differ-ent from the TMN or the GCO: a number of young artists, whether professionally

trained or not, constituted themselves into a troupe for a given collective creation project with a view to creating theatre that, with or without a leader, promoted a cause. Whereas the GCO and the TMN targeted a very large audience—ideally all Francophone Quebecers—the militant collectives based their action on a more focused group, such as women, workers, immigrants, neighborhood residents, or the unemployed. When contacting the target groups with which they associated and systematically interacted, the troupes generally ended up becoming more deeply involved in political struggle and thereby developed a theatre of intervention, agitation, and propaganda.

In keeping with this model, Théâtre Euh! thus moved from a nationalist-tinged anarchism to a Marxist-tinged variety, and ultimately to an unvarnished class struggle. The group's first production, *Quand le matriarcat fait des petits* (1970), is often presented as the counterpart of Michel Tremblay's *Les Belles-soeurs* in collective creation theatre. However, from a staging standpoint, the show is more similar to *T'es pas tannée, Jeanne d'Arc?* Somewhat in the way that "ordinary people" paraded before the crushing symbolic figures represented by the masks of traditional Quebec in the GCO play, the family members in *Quand le matriarcat fait des petits* express themselves in front of an outlandish and grotesque image of the mother represented by a giant puppet. Structured in sketches, the play primarily consists of a series of scenes within which the actors improvise. Here again, as in the TMN and GCO productions, and as in the entire first phase of Quebec collective creation, typification dominates characterization and the interchangeable sketch-based structure dominates the linear storyline. Nonetheless, the language is clearly Quebecer. In its second production, *Cré Antigone*, Théâtre Euh! adopted a discourse reflecting its Marxist-Leninist shift.

Cré Antigone
Act 122: Tribute to the organization [...]
What does continued oppression depend on?
US!
What does the smashing of oppression depend on?
US!
Let the beaten down get up.
Let the defeated fight.
Let those who understand their situation learn how to maintain it.
For today's victims are tomorrow's conquerors.
And "never" becomes "today."[36]

In 1970, Théâtre Euh! began to draft what has remained until today the most elaborate, ambitious, and clearly articulated manifesto ever produced by a Quebec troupe. This manifesto, titled "Une foi en l'homme créateur"["Faith in Creative Man"], called for the cultural decolonization of Quebec and its theatre, which implied once again the question of language and identity, the redefinition of artists and their responsibilities, a new aesthetic (deliberately incomplete), a new style (clownish acting), the rejection of the traditional theatrical venue, and collective creation (the only mode of nonbourgeois creation).[37] Written and perceived as a

genuine "total refusal"[38] of the dominant forms of institutional theatre and the old ways of doing things, Théâtre Euh!'s manifesto attracted the general support of young troupes and all artists eager for renewal, even though it advocated the abolition of specialized functions and a strict egalitarianism within troupes and even vigorously defended the concept of class struggle by and through art. Albeit provocative, Théâtre Euh! had not yet become doctrinaire—and this reassuringly not only made it appealing but also accounted for its remarkable influence on the community.

> We are not colonizers, missionaries, prophets or the Jesus Christs of a new religion: "culturalism" (everything in the head, nothing in the underwear).
> We do not bring culture,
> We do not have a monopoly on the truth,
> We are not the messiahs of the "Trip-Too-Much."[39]

Without being messiahs, Théâtre Euh!'s members were well aware of where and how to promote their ideas, and they had no difficulty imposing themselves on the organization to which most collective creation troupes belonged: the Association Québécoise du Jeune Théâtre (AQJT). By dominating the discussions, Théâtre Euh! and its allies progressively led the organization toward an interventionist theatre based on Marxist ideas, thereby ostracizing certain AQJT troupes that were more concerned with artistic exploration as such. Albeit accused of "bourgeois" sympathies, the latter were soon to have their revenge, since the "research-based theatre" they practiced ultimately imposed itself in all forms of theatre in Quebec from the early 1980s on.

From 1971 to 1975, the field of collective creation thus experienced a radicalization of its discourse and action. Needless to say, all the troupes that practiced collective creation—both the militants and the "artistics"—were socially engaged and justifiably felt they were participating in Quebec's social and cultural revolution. However, this action became increasingly involved in grassroots struggles in neighborhoods, factories, daycare centers, and kitchens, in keeping with the logic of class struggle.

This radicalization was ambiguous and led the AQJT to redefine itself at its 1976 convention:

> Whereas all the Association's Jeune Théâtre troupes are defined by:
> —the desire to act collectively;
> —the desire to create and express themselves;
> —the desire to become closely involved with their community;
> —the desire to be politically involved;
> we define the AQJT's overall objective as follows:
> the AQJT is a group that encourages and develops theatre whose priority is to participate in the evolution of the Quebec people towards a democratic and egalitarian (socialist) society.[40]

This was going too far! In fact, 1976 marked both the peak and the beginning of the decline of militant theatre in Quebec, which by 1978 had reached a state of total collapse. Prey to incessant and ever more painful splintering (both ideological and interpersonal), Théâtre Euh! imploded. It was not alone. The vast majority of militant (and Marxist) troupes[41] that emerged during the 1970s similarly fell apart and disappeared within a few months.[42]

This was partly due to the political situation in Quebec: in 1976, the Parti Quebecois (the sovereignist party) took power in Quebec City and introduced into the political scene the identity assertion discourse that artists and writers had adopted until then. However, other factors were at play. The fall of Marxist ideals and the profound ideological transformation within Western society with the advent of neonarcissism[43] also explains in part the rapid disappearance of militant collectives and their aging members: Jeune Théâtre's artists now had obligations, as well as new needs and other expectations. A growing gap thus developed between the troupes for which theatre was not an end in itself and the others—between the professionals or would-be professionals on the one hand and the amateurs or semiprofessionals on the other. The crisis that emerged was, in fact, between collective creation as a mode of theatrical production and the commune as a lifestyle.

While the 1980s marked the end of militant collectives, they also witnessed the triumph—and the imminent metamorphosis—of troupes that, like Pig Iron[44] in the United States, devoted themselves primarily to the artistic renewal of theatre from the outset. Pilloried by Théâtre Euh! and the AQJT in 1976, these "research-based theatre" troupes and those that originated from them ended up dominating Quebec theatre in the late twentieth century. Now that the question of language and identity was settled, it seemed to be completely normal to henceforth hear Quebec French on stage—and now that the collective destiny of Quebecers was in the hands of politicians, the way was clear for the most daring artistic explorations. And that was how Jean Asselin's Omnibus (1970); Jacques Crête's Eskabel (1971); Gabriel Arcand's Groupe de la Veillée (1973); Gilles Maheu's Les Enfants du Paradis (which became Carbone 14 in 1975); Jean-Pierre Ronfard, Robert Claing, Robert Gravel, and Anne-Marie Provencher's Théâtre Expérimental de Montréal[45] (1975); and Jacques Lessard and Robert Lepage's Théâtre Repère (1980) launched themselves into an unprecedented creative frenzy and gave Quebec theatre many of its most remarkable works.[46]

Most of these troupes, to which must be added around twenty young audience theatre companies,[47] are still active today, and although they have adopted a hierarchal structure and have returned to a more traditional casting system, they still retain a few characteristics of the collectives of the early days.

Epilogue

Collective creation in Quebec was a participant in both the countercultural revolution that occurred in most Western countries during the 1960s and 1970s and in the national liberation movements that heralded the end of the great colonial empires in the wake of World War II. It participated in these movements not only

in its origins, destiny, and means and sources of inspiration but also in its strategies and productions. Indeed, it was Quebec's particular sociopolitical situation at the time that gave collective creation there its amazing distinctiveness. First of all, its resonance—collective creation in Quebec had the impact of a huge earthquake on all areas of Quebec, a visibly stronger and more lasting impact than anywhere else. And second, its identity-asserting mission—where again, even though the issue of language and culture is not particular only to Quebec,[48] it generated a fusional dynamic in Quebec between audiences and artists the intensity of which, at the level of the entire nation, has no known comparison. And it is this rare balancing between an emerging artistic practice and the need felt by a community composed of millions of members to assert its potential both to itself and to the rest of the world that constitutes the uniqueness of Quebec collective creation and marks it as one of the most decisive movements in the history of theatre in Quebec.

Bibliography

Aragonès, Nuria, and Orencia Moreno. "Le cas particulier de la creation collective dans le théâtre espagnol: de la troupe Els Joglars en Catalogne à La Cuadra de Séville." In *Vies et morts de la création collective / Lives and Deaths of Collective Creation*, edited by Jane Baldwin, Jean-Marc Larrue, and Christiane Page, 215–226. Sherborn, MA: Vox Theatri, 2008.

Baldwin, Jane. "Collective Creation's Migration from the Côte d'Or to the Golden Hills of California: The Copiaus/Quinze and Dell'Arte Company." In *Vies et morts de la création collective / Lives and Deaths of Collective Creation*, edited by Jane Baldwin, Jean-Marc Larrue, and Christiane Page, 31–51. Sherborn, MA: Vox Theatri, 2008.

Beck, Julian. *La vie du théâtre*. Paris: Gallimard NRF, 1978.

Cloutier, Raymond. "Petite histoire." *Jeu* 5 (Spring 1977): 7–16.

Bélair, Michel. *Le Nouveau théâtre québécois*. Montréal: Leméac, 1973.

Cheniki, Ahmed. *Le théâtre dans les pays arabes: Chronique d'une expérience singulière*. Sherborn, MA: Vox Theatri, 2013.

Dutil, Christian. *Vers une transformation du processus de la création collective en théâtre au Québec*. Master's thesis, University of Sherbrooke, 1982

Germain, Jean-Claude. "C'est pas Mozart, c'est le Shakespeare québécois qu'on assassine." *Jeu* 7 (Winter 1978): 9–19.

Godin, Jean Cléo, and Laurent Mailhot. *Théâtre québécois II*. Montreal: Hurtubise HMH, 1988.

Le Grand Cirque Ordinaire. *T'es pas tannée, Jeanne d'Arc?* Montreal: Les Herbes rouges, 1991.

Hébert, Lorraine. *La fonction de l'acteur québécois dans la création collective*. Master's thesis, University of Montreal, 1976.

Larrue, Jean-Marc. "La Création collective au Québec." In *Archives des lettres canadiennes*, Volume 10: *Le Théâtre québécois 1975–1995*, edited by Dominique Lafon, 151–80. Montreal: Fides, 2001.

———. "Théâtre amateur et affirmation identitaire." In *Le Théâtre des amateurs—Un théâtre de société(s)*, edited by Suzanne Héleine and Marie-Madeleine Mervant-Roux, 185–206. Rennes: Théâtres en Bretagne, 2005.

Malina, Judith, and Julian Beck. *Paradise Now: Collective Creation of The Living Theatre*. New York: Random House, 1971.

Montgomery, Roy. "The Ideal of the Group in the High Era of Collective Creation: Theoretical Sources." In *Vies et morts de la création collective / Lives and Deaths of Collective Creation*, edited by Jane Baldwin, Jean-Marc Larrue, and Christiane Page, 97–121. Sherborn, MA: Vox Theatri, 2008.

———. "Three American Radical Theatre Groups Considered: The Living Theatre, The San Francisco Mime Troupe and The Performance Group." In *Vies et morts de la création collective / Lives and Deaths of Collective Creation*, edited by Jane Baldwin, Jean-Marc Larrue, and Christiane Page, 122-148. Sherborn, MA: Vox Theatri, 2008.

Olsen, Christopher. "Transformation, Identity, and Deconstruction—Part of the Survival Kit of Collective Theatre in 2007." In *Vies et morts de la création collective / Lives and Deaths of Collective Creation*, edited by Jane Baldwin, Jean-Marc Larrue, and Christiane Page, 162–79. Sherborn, MA: Vox Theatri, 2008.

Potvin, Jacinthe. "Au Théâtre de Carton, de la création collective au texte d'auteur." *Le Devoir*, May 11, 1985, vii.

Sigouin, Gérard. *Théâtre en lutte: Le Théâtre EUH!* Montréal: VLB éditeur, 1982.

Syssoyeva, Kathryn Mederos. "Pig Iron: A Case Study in Contemporary Collective Practice." In *Vies et morts de la création collective / Lives and Deaths of Collective Creation*, edited by Jane Baldwin, Jean-Marc Larrue, and Christiane Page, 180–97. Sherborn, MA: Vox Theatri, 2008.

Villemure, Fernand. "Aspects de la création collective au Québec." *Jeu* 4 (Winter 1977): 57–71.

———. *Inventaire des créations collectives au Québec depuis 1965*. Sainte-Foy: self-published, 1974.

———. *Aspects de la création collective dans le théâtre québécois.* Sainte-Foy: self-published, 1976.

Notes

1. This chapter originally appeared in *Vies et morts de la création collective / Lives and Deaths of Collective Creation*, ed. Jane Baldwin, Jean-Marc Larrue, and Christiane Page (Sherborn, MA: Vox Theatri, 2008), under the title "Se dire! La création collective a l'affirmation identitaire au Québec (1969–1976)."

2. At least six books and two magazine issues in Britain or America have been devoted to new collective theatre since 2001.

3. This is the name given to the period from 1960 to the Montreal Universal Exposition in 1967 ("Expo 67").

4. Or "sovereignty" or "separation." The question for Quebecers was whether Quebec should stay within the Canadian Confederation or withdraw. The response was in favor of remaining in Canada in 1980 and then again in 1995 (the date of the second referendum).

5. Which was the program of *Le Refus Global* [Total Refusal], a key manifesto published by a group of artists—the Automatistes (including the painter Paul-Émile Borduas)—in 1947.

6. The following pages draw on a research project funded by the Social Sciences and Humanities Research Council of Canada (SSHRC). In this article, I deal with a relatively brief but very rich and turbulent period of collective creation in Quebec from the standpoint of identity assertion. This chapter synthesizes some of my previous writings, including, in particular, "La Création collective au Québec," which presents a more complete picture of the movement up to the late 1980s.

7. The results of this research were published in two books: *Inventaire des créations collectives au Québec depuis 1965* and *Aspects de la création collective dans le théâtre québécois.* Both these documents can be found in the library of the National Theatre School in Montreal. Villemure also reported on some of his research in the magazine *Jeu* ("Aspects de la création collective au Québec.")

8. Villemure, *Aspects de la création collective dans le théâtre québécois*, 1. All translations are done by Neil Macmillan, unless otherwise noted.

9. Lorraine Hébert, *La fonction de l'acteur québécois dans la création collective*, 48.

10. Roy Montgomery, "The Ideal of the Group in the High Era of Collective Creation," 105.

11. Hébert, 68.

12. This expression comes from Julian Beck, *La vie du théâtre*, 120–21.

13. The play became scandalous in two respects: it was written in the vernacular French of Quebec (*joual*), and it portrayed the daily life of women in a working-class neighborhood of Montreal.

14. This was not always the case. In the early twentieth century, the greatest success on Quebec stages featured Quebec characters, events, and language. The progressive disappearance of Quebec French from theatrical stages was due to the advent of (highly European) modernism in theatre in the late 1930s.

15. Jacinthe Potvin, "Au Théâtre de Carton, de la création collective au texte d'auteur," VII.

16. Jean-Claude Germain, "C'est pas Mozart, c'est le Shakespeare québécois qu'on assassine," 13.

17. Beck, 120–21.

18. Potvin, VII.

19. We would say "native" these days.

20. Michel Bélair, *Le Nouveau théâtre québécois*, 70.

21. Ibid., 133.

22. See, for example, the directions taken by Théâtre du Soleil and Robert Lepage, as their resources grew.

23. Beck, 105. We also need to share Roy Montgomery's observation that The Living Theatre in those days very much exemplified what it advocated. See Roy Montgomery, "Three American Radical Theatre Groups Considered: The Living Theatre, The San Francisco Mime Troupe and The Performance Group," in *Vies et morts de la création collective / Lives and Deaths of Collective Creation*, ed. Jane Baldwin, Jean-Marc Larrue, and Christiane Page (Sherborn, MA: Vox Theatri, 2008), 123–30.

24. The story of Aurore was based on an actual event: in the early 1920s, a young girl called Aurore died from the effects of cruel treatment by her stepmother (Aurore's father had remarried after her mother's death). The case was on the front pages of newspapers in Quebec for weeks and gave Quebec theatre the greatest success in its history with more than 6,000 performances of *Aurore, l'enfant martyre*. The play was then made into a film, which was also a phenomenal success.

25. The so-called October Crisis was a major period in Quebec history. Two underground cells of the FLQ (Front de libération du Québec) took two hostages: Quebec government minister Pierre Laporte and British diplomat James Richard Cross. Although the latter was freed by his kidnappers, Laporte was found dead in the trunk of a car. This dual kidnapping marked the end of a period of insecurity, and notably the disappearance of the FLQ, which was a revolutionary group modeled on the liberation movements of the time in Africa and Latin America.

26. Hébert, 82.

27. Christian Dutil, *Vers une transformation du processus de la création collective en théâtre au Québec*, 38.
28. Montgomery, "The Ideal of the Group in the High Era of Collective Creation," 119.
29. Jane Baldwin reminds us that this pitfall is not new. It partly explains the relative failure of Copeau in Bourgogne (see Jane Baldwin, "Collective Creation's Migration from the Côte d'Or to the Golden Hills of California"). Furthermore, although there are no statistics on the subject, it is known that the vast majority of collectives of the 1960–70 period were unable to resist the tensions engendered by the presence of increasingly assertive leaders. See Christopher Olsen's article "Transformation, identity, and deconstruction."
30. Paule Baillargeon, Jocelyn Bérubé, Pierre Curzi, Suzanne Garceau, Claude Laroche, Gilbert Sicotte, and Guy Thauvette.
31. See Raymond Cloutier's column on the GCO, "Petite histoire."
32. Le Théâtre Populaire du Québec, which was funded by the Quebec government.
33. Le Grand Cirque Ordinaire, *T'es pas tannée, Jeanne d'Arc?*
34. Jean Cléo Godin and Laurent Mailhot, *Théâtre québécois II*, 116.
35. The group was also responsible for *La Soirée d'improvisation* (1970), *L'Opéra des pauvres* (1973), *Un prince, mon jour viendra* (by the group's actresses; 1974), *La Tragédie américaine de l'enfant prodigue* (1975), and *Rose Latulipe* (1976).
36. Gérard Sigouin, *Théâtre en lutte: Théâtre Euh!* 51.
37. Ibid., 53–60.
38. See note 4.
39. Sigouin, 58.
40. Cited by Dutil, 11–12.
41. These troupes included Les Gens d'en Bas, Le Tic Tac Boum, La Gaboche, Le Théâtre communautaire du Sud-Ouest, Le Théâtre d'la Shop, Le Théâtre à l'Ouvrage, and Le Théâtre su'a Trotte.
42. With the remarkable exception of Théâtre Parminou (founded in 1973), which specialized in theatrical commissions (from unions, action groups, etc.).
43. See Christopher Lasch's insightful book on the issue: *The Culture of Narcissism: American Life in An Age of Diminishing Expectations* (New York: Norton Paperback, 1991).
44. See Kathryn Mederos Syssoyeva, "Pig Iron."
45. In 1979, due to the discomfort of its actresses, the TEM split into two groups: Le Nouveau Théâtre Expérimental and the Théâtre Expérimental des Femmes (the kernel of the future Espace GO in 1985).
46. Jean Asselin received some of his training with Étienne Decroux; Gabriel Arcand worked with Grotowski; Gilles Maheu also participated in Decroux's workshops and then spent some time with Eugenio Barba's Odin Theatre.
47. Including Théâtre de Carton, Théâtre Sans Fil (1971), Théâtre de la Marmaille, Théâtre de l'Oeil, Famille Corriveau, Théâtre du sang Neuf (1973), Grosse Valise, Théâtre le Carrousel, Théâtre de Quartier (1975), Théâtre du Gros Mécano, Théâtre l'Arrière-Scène (1976), and Théâtre des Confettis (1977).
48. See, for example, Ahmed Cheniki's forthcoming book *Le théâtre dans les pays arabes*; and Nuria Aragonès and Orencia Moreno, "Le cas particulier de la creation collective dans le théâtre espagnol."

Notes on Contributors

Jane Baldwin taught acting, modern drama, introduction to theatre, and humanities at the Boston Conservatory. Her books include *Michel Saint-Denis and the Shaping of the Modern Actor*; *Theatre: The Rediscovery of Style and Other Writings* (as editor); and *Vies et morts de la création collective / Lives and Deaths of Collective Creation* (coedited with Jean-Marc Larrue and Christiane Page). Her writings have appeared in *Theatre Topics*, *L'Annuaire théâtral*, *Theatre Notebook*, *Theatre Journal*, and *Theatre History*, among others. Most recently, she authored "Michel Saint-Denis: Training the Complete Actor" for the second edition of *Actor Training* (edited by Alison Hodge).

David Calder is a Fulbright Fellow and a doctoral candidate in the Interdisciplinary PhD in Theatre and Drama (IPTD) at Northwestern University. His current research examines how artists and industrial workers jointly negotiate urban redevelopment in contemporary France. His essay "Making Space for a Creative Economy: The Work of La Machine" was cowinner of the 2012 TDR essay prize.

Laura Cull is senior lecturer in theatre studies and director of Postgraduate Research for the School of Arts at the University of Surrey, United Kingdom. She is author of the book *Theatres of Immanence: Deleuze and the Ethics of Performance* and editor of the collection *Deleuze and Performance*. In 2008, Cull founded the PSi Performance & Philosophy working group, of which she was chair from 2008 to 2012. She is now one of the founding conveners of Performance Philosophy—a new professional association for researchers interested in the intersection of performance and philosophy.

Attilio Favorini is the author of *Memory in Play: From Aeschylus to Sam Shepard* and editor of *Voicings: Ten Plays from the Documentary Theater*. He is also the author of nine plays, including the award-winning *In the Garden of Live Flowers* (with Lynne Conner) and *The Gammage Project*. Former editor of *Theatre Survey* and founding chair of the department of Theatre Arts at the University of Pittsburgh, he also founded and directed the Three Rivers Shakespeare Festival.

Jorge A. Huerta is a leading authority on Chicana/o and US Latina/o theatre who has published a number of articles, edited three anthologies of plays, and written the landmark books *Chicano Theatre: Themes and Forms* and *Chicano Drama: Performance, Society, and Myth*. Huerta has directed in theatres across the country

and has lectured and conducted workshops throughout the United States, Latin America, and Western Europe. In 2007 Huerta was honored by the Association for Theatre in Higher Education for "Lifetime Achievement in Educational Theater." In 2008 he was recognized as a "Distinguished Scholar" by the American Society for Theatre Research.

Michael Hunter is a director, performance curator, and lecturer in the humanities at Stanford University, where he received his PhD in drama. His research focuses on the use of performance and aesthetic strategies to negotiate marginal sexual subject positions, particularly in cases prior to sexual liberation movements. Hunter runs a regular performance series in his home and is a founding member of The Collected Works.

Jean-Marc Larrue is professor of theatre history and theory at Université de Montréal, Canada. He is codirector of the Research Center on Intermediality (CRI). His research mainly focuses on theatre, modernism, and media. He is the author or coauthor of several works: *Yiddish Theatre in Montreal, Les Nuits de la "Main"* (with André-G. Bourassa), *Le Monument inattendu, Le Théâtre à Montréal à la fin du XIXe siècle*, and *Théâtre au Québec—repères et perspectives* (with André-G. Bourassa and Gilbert David). He is the editor and coeditor of books and journals on theatre: most recently *Lives and Deaths of Collective Creation* (with Jane Baldwin and Christiane Page), *Mettre en scène*, and *Le son au théâtre*. He is the recipient of grants from the Social Sciences and Humanities Research Council of Canada (SSHRC) and the Fonds québécois de recherche sur la société et la culture (FQRSC). Larrue has also been president of the International University Theatre Association (AITU/IUTA) since 2008.

Victoria Lewis was an ensemble member of two people's theatre collectives from 1976 to 1980: Family Circus Theater, Portland, Oregon, and Lilith: A Women's Theatre, San Francisco. In 1982, as an Artist in Residence at the Mark Taper Forum in Los Angeles, she founded the Other Voices Project, creating documentary plays with communities and directing a play laboratory for writers with disabilities. This work culminated in the anthology *Beyond Victims and Villains: Contemporary Plays by Disabled Writers*. In 2000 Lewis received her PhD in theatre from UCLA, and she is currently a professor in the Theatre Arts department at the University of Redlands in Southern California.

Scott Proudfit is assistant professor of drama in the English department at Elon University in North Carolina. Before receiving his PhD at Northwestern University, he worked with the Actors' Gang and the Factory Theater in Los Angeles and with Irondale Ensemble Project in New York, often on devised plays. In addition, for seven years he covered the New York and Los Angeles theatre scenes as an editor for the publications *Back Stage* and *Back Stage West*. His essay "Framework for Change: How SITI Company Recomposed the L.A. Theatre Landscape" will appear in the forthcoming *Collective Creation in Contemporary Performance*, also published by Palgrave Macmillan.

Kris Salata is associate professor in performance at the School of Theatre, Florida State University. He focuses his research on phenomenological, ontological, and epistemological aspects of theatre practice with emphasis on performance as research. His most recent book, *The Unwritten Grotowski: Theory and Practice of the Encounter*, focuses on the notion of "living legacy" in theatre practice.

Kathryn Mederos Syssoyeva holds a PhD in theatre history and directing from Stanford's Department of Drama and Graduate Program in Interdisciplinary Studies. Her current work includes *Collective Creation in Contemporary Performance* (edited with Scott Proudfit; forthcoming from Palgrave Macmillan) and *Meyerhold and Stanislavsky at Povarskaia Street: Art, Money, Politics, and the Birth of Laboratory Theatre* (in development). A specialist in devising, physical theatre, and Meyerhold's biomechanics, Syssoyeva has taught performance and scenic movement at Yale School of Drama, Stanford University, Colby College (where she was Guest Artist in Residence in 2008), and Florida State University.

Index

Printed in the United States of America